MOUNTAINS

MASTERWORKS OF THE LIVING EARTH

MOUNTAINS

MASTERWORKS OF THE LIVING EARTH

KEVIN KLING

PAUL TAPPONNIER

Abrams, New York

THE GEOLOGIST'S EYE

Contrary to what the geographer wanted the Little Prince to believe in Antoine de St. Exupéry's classic tale, mountains are not eternal, unchanging in their majesty. Far from being immutable landmarks, mountains, like all living things, are born, then grow and mature until, finally, they succumb to time's onslaught. Earth creates them in the course of endlessly repeating cycles. There are young mountains and old ones. Some are steep, others smooth. Just like in the biological world, there are different species and breeds of mountains. One can even speak of "real" and "false" mountains. Their originality, and their beauty, too, lies in the fact that they bring vertical dimension to an otherwise flat world. To fully perceive the dynamic nature of mountains, one needs to look through a set of eyes that is different from that of a climber or hiker. A third eye must be developed: that of the geologist.

How do mountains form and change? How long does that take? Why do they rise up in one place as opposed to another? What is their destiny? To find the answer, we must first train the eye. Contemplate the natural workshops that Earth presents to us. Learn to decipher the landscapes that Earth so tirelessly sculpts. Roam all over this planet of mountains. The Himalayas and Tibet, whose flamboyant young peaks stretch for thousands of miles. The Pamir, the Celestial Mountains, and the Altai, little-known mountain ranges of Central Asia, still in their infancy. Still others, in Africa, or like the Andes, along the ocean. All are vertiginous and inspire devotion and legend. All are sources of life, and sometimes, of death. But how do we unravel their story? That is the Ariadne's Thread we shall presently trace.

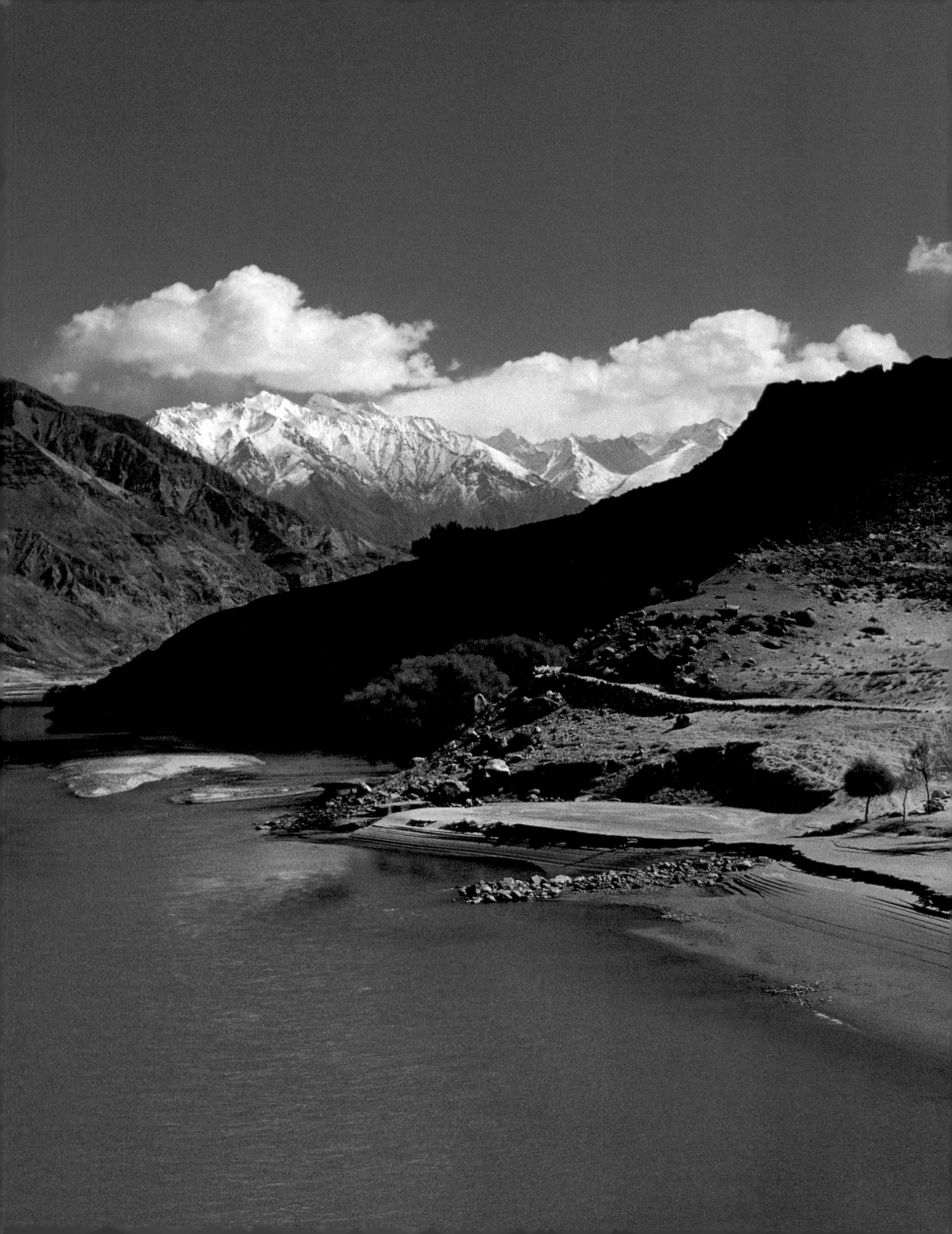

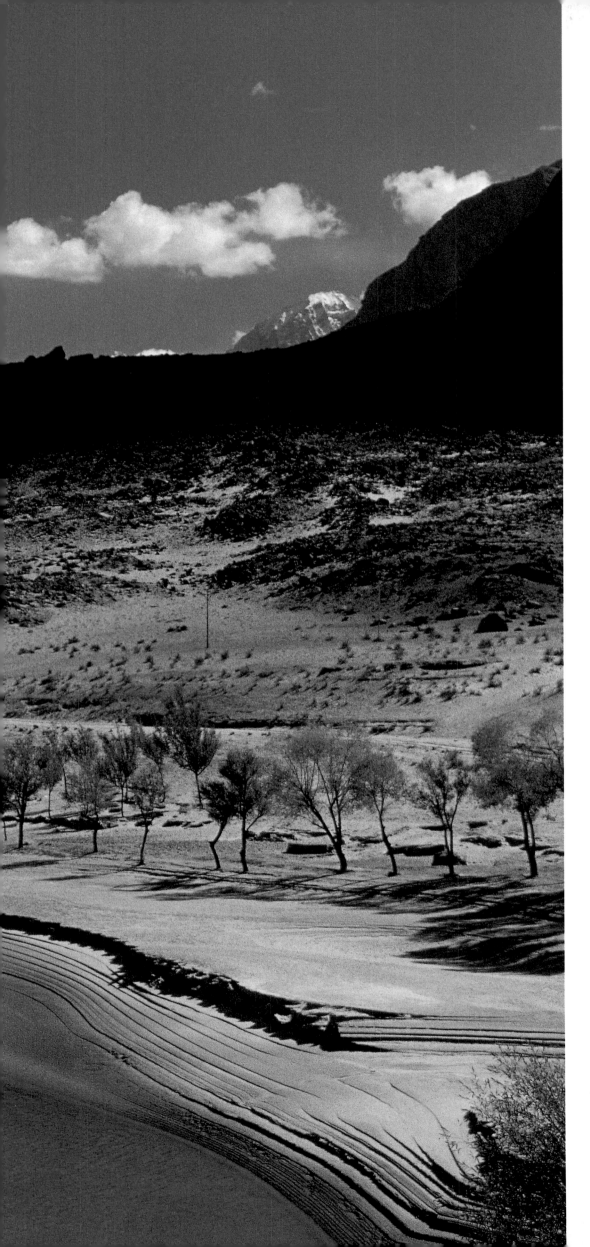

CONTENTS

THE SHYOK, KARAKORAM
Born in the high Tibetan plain of Aksai Chin, formerly
part of Indian Kashmir, the Shyok River crosses the
Karakoram and Ladakh batholiths before joining the
Indus River upstream of Skardu. Few large rivers abrade
this much granite.

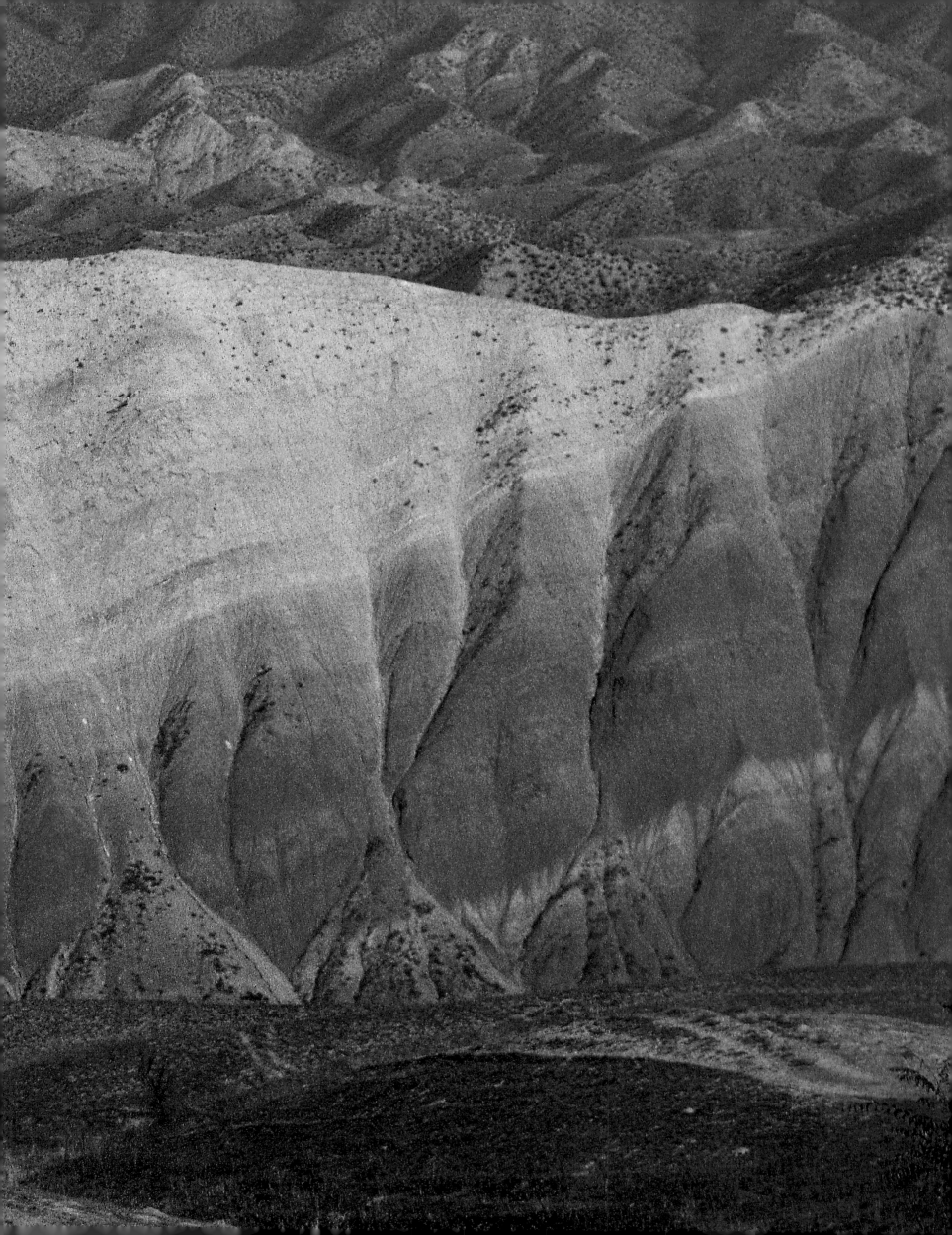

SEVEN MOUNTAIN SCENES

SEVEN MOUNTAIN SCENES

EARTH CONTINUOUSLY ERECTS MOUNTAINS. An inexhaustible builder, it never ceases its labors. However, like Penelope of Greek mythology, who spent her nights undoing her days' work, the earth destroys with the same obstinacy that it creates. No matter where we are in the world, we are drawn more often than not to what is still just a work in progress, initiated ages ago perhaps, but, nonetheless, never completed. This makes our investigation into the origins and growth of mountains difficult. How do we turn back history's clock and leap over a geological time measured in millions of years? Fortunately, the insight of James Hutton and Charles Lyell about two centuries ago has been confirmed: we now know that the present is the key to the past. In the last 30 years, the theory of plate tectonics conferred legitimacy on this principle of uniformitarianism: Earth's current movements provide the rules that enable us to decode its evolution over 4 billion years. Now the question becomes, where today can we observe the birth and "life" of a mountain?

The western Alps, undeniably the world's most meticulously studied relief contribute, alas, only incomplete clues. For a long time, earth scientists believed these mountains stopped growing during the late Miocene era, an epoch that also marked the emergence of humankind's early ancestors. Today, we can tell that the Alps are not in a very active stage of growth, because the displacements measured by high-precision positioning stations do not exceed the background noise. There is little doubt that, impeded by the lands surrounding it, Italy, this finger of Africa, is unable to continue its penetration into Europe as robustly as before. Some even believe that the Alps are in the process of becoming "undone"; and the suggestion of a current uplift, no matter how slight, arouses endless infighting. But why squabble over fractions of millimeters when we can observe movements that are 10 or 100 times greater in other regions.

We must direct our search elsewhere—to the other side of Eurasia, to a land that just happens to offer a garden of young mountains, a veritable nursery in a region subject to immense forces, a land whose geology has long remained mysterious.

It is here where Earth has built its most magnificent cathedrals. From the Ganges plain to the Siberian taiga, it has erected this dizzying relief that assembles the world's highest peaks. Were we to look at Earth from Venus or Mars using the same technology that permits us to observe these two neighbors, these are the only mountains we could see. Three million square miles of summits and valleys, an area ten times larger than France. The highest altitudes on the earth. The Himalayas, the Karakoram, and the Pamirs are the only mountains to approach or exceed 26,000 feet. They form a continuous wall for nearly 2,000 miles—the same distance that separates Bar Harbour, Maine, from Miami, Florida. North of this wall, one can travel more than 600 miles from north to south and roughly 1,300 miles east to west without ever descending below 13,000 feet. This is the Tibetan Plateau—the roof of the world. Farther north, the Tian Shan and the Altai, two ranges higher and longer than the Alps, separate Siberia from the dunes of Takla Makan, a desert whose name means literally "where one enters but never leaves." And, still farther north, there are the Sayan Mountains, a relief cut by Lake Baikal. The largest lake on earth, it fills a crevasse more than a mile deep and contains 20 percent of the world's fresh water that is not stored in the form of ice.

One can find mountains in all stages of birth and life in this zoo of reliefs. Earth's surface vibrates. The geography endures abrupt upheavals. Tectonics are at work. It all began with the violent crash between two continents. This struggle continues today punctuated by devastating seismic jolts like those that recently struck Sumatra and Pakistan.

"Tectonic" (from the Greek word tekton: *one who constructs, as in architecture) is the name that has been given to the deformation of Earth's crust, the roof of our planet.*

In Asia's garden of mountains, distances are immense, views seem endless, and the tectonic mechanisms are laid bare. Here the earth appears without its clothes. There are no forests, no cultivated hedgerows to cover it. At most, the steppe offers just a scant layer, concealing no more than does a leotard—usually just rocks and the naked earth. What luck for understanding the underlying anatomy, and consequently, the movements of the land. It is a paradise for the geomorphologist, a researcher as enamored with form as any sculptor or dancer. An arid climate combined with the youth of the reliefs has preserved the purity of the landscape, surfaces, and curves, facilitating their reading. Let us contemplate them.

Birth

Tian Shan ▲▲ The Dzungarian steppe is home to the Kazakh nomads who erect their yurts in the shelter of valleys facing the Tian Shan, or "Celestial Mountains"—a name that reflects their image from a distance: the mountains' glittering icy peaks float like vessels above the desert's yellow mist that shrouds their base. The Tian Shan extend nearly 1,300 miles across Central Asia and are, after the Himalayas, the largest mountain range of Eurasia. One of its highest summits, Khan-Tengri ("Lord of the Sky" in Mongolian), soars to almost 23,000 feet.

The area west of Urumqi, capital of Xinjiang, is still relatively unmarred by human pollution. Austere and parched, the steppe gently ascends towards the south. Two rows of low hills conceal the base of "Borohoro," the high range. We are far from the summit, perhaps 30 miles. Staring at the closest hills, the "third eye" detects that their shape is somewhat unusual. Stretching exactly parallel to the range, the long, smoothly rounded hills resemble the backs of whales breaking the surface of the ocean. Their relief is of constant and moderate height, only a thousand feet high at most. Where the hills meet the steppe, the small conical tombs of Muslim cemeteries lean here and there on a slightly steeper slope. Herds of bactrian camels, their chocolate brown coat growing full with the onset of winter, slowly climb these gentle inclines. Far from the cotton fields of the plains and the irrigated valleys, they have become the camels' last refuge. In the river-gouged valleys, where the season's first ice is starting to

form, it is as if we could pull back the skin of the whales and see what lies beneath. The first layer, right beneath the skin is a thick one, arched like the hills' backs. It is made of pale yellow loess, a "cement" of fine grains of dust deposited by the wind. Below the loess are alternating layers of gray gravel and pinkish clay deposits, identical to those left during present-day floods. These layers, too, are curved like the surface. From one valley to the next, for nearly a hundred and fifty miles, one only sees variants of the same form.

But usually rivers deposit the mud and gravel that they carry on a flat surface. And flowing water rarely travels uphill…. Arched surface, curved deposit layers, the origin of the hills becomes clear. The "whale backs" are no more than the vaulted summit of large geological folds. Like the camels, the hiker who crosses these folds to get closer to the Borohoro won't have to exert himself too much. Only about a thousand feet to climb gradually in just five miles? A Sunday stroll for grandparents! Common sense would indicate that gentle, rounded hills should be old: Compare the venerable French Massif Central to the young Alps, or the Blue Ridge Mountains to the Rockies. Here, however, the opposite is true. Like a tablecloth pushed back on a table, the surface of the steppe is actually folding. Right before our eyes. It's because they are just newborns that these long wavelength folds are so gentle, so young that the climate's aggressive forces have hardly had time to crack their surface. Although small isolated gullies have scratched the steeper slopes above the Kazakh cemeteries, erosion has had no time to build an organized network of incisions, to lead a strategic attack and carve depressions at the summit. Only the transverse valleys cut through by large rivers bringing glacial meltwater from the summits of Borohoro mar the integrity of these folds. These rivers, dubbed antecedents, were flowing long before folding began.

Newly born? Since when exactly? The mantle of loess on the surface of the folds provides a clue. China is famous for this yellowish soil (*huang tou*) that fertilizes its plains north of the Yellow River, and from which the river derives its name (Huang He). This ultra-fine mineral " flour," ground by the friction of rock against rock at the base of glaciers, is dispersed by the winds as the melting of glacier ice exposes the grinding areas. Therefore, it is primarily between glacial eras that most

of this accumulation occurs. The thick layer of loess that now coats the Tian Shan foothill folds covered the plains 120,000 years ago, just before the onset of the last glacial cycle. Only about a hundred thousand years… As small as they are, these baby folds are thus growing very fast: 1,000 feet in 100,000 years, or about a tenth of an inch per year. That's 30 times slower than a human being, but fast enough to erect a 10,000-foot rampart in just a million years. In geological time: an instant.

So it really is the birth of a future high mountain that we are witnessing here. Its infant form is this alignment of smooth, rounded whale backs. Daughter of the mighty Borohoro, she will soon protect her approach with crests as steep as those of her mother mountain farther to the south.

The winter calm that reigns on the steppe and the gentleness of the landscape seem to be shepherding an uneventful, nearly imperceptible, birth. However, nearly a hundred years ago to the day, on Christmas Eve 1906, the entire piedmont of the Tian Shan from Urumqi to Dushanzi was devastated in just a hundred seconds. The Manas earthquake, 8.0 on the Richter scale, raised the whales' backs by 10 feet for 120 miles along the range. Apparent calm. Deceptive peace. The curving of the hills is generated by a succession of violent jolts. Vestiges of this last trauma are still visible with, of course, the third eye. When analyzed in detail, it seems that such growth-inducing seismic events tend to recur every eight or nine centuries.

Qilian Shan ▲▲ Before us stands Jiayuguan, farthest fortress of the Great Wall of China, 1,500 miles west of Beijing. The red-lacquered corner turrets and the massive battlements of the Han ramparts are set in the foreground of an even more massive natural wall: the ice-capped Qilian Shan. Behind us, to the north, extends a flat piedmont already as high as the ski stations in the pre-Alps. Here, northern Tibet erects its first mountain wall, which climbs to almost 19,000 feet, facing the Gobi desert.

Altitude emphasizes the crystal clear transparency of the October air. Between the Great Wall and the mountains stretches a 500-mile-long corridor of oases fed by the melting of the ice caps and dotted by millions of yellow poplars: the Gansu corridor, an ancient trade route of enormous strategic value due to its location between the Middle Kingdom and its western "colonies." Protecting it has been essential: for two

thousand years, it has served as the mandatory passageway for caravans. Without this ice at the border of the desert, neither the oases nor the Silk Road would have existed. No caravans, laden with goods, could have survived the trek across the vast, dry expanses of the Gobi. Today, trains have replaced the caravans of Bactrian camels. You can spot them from far away, from 20 miles or more: thin black lines pulled silently in the distance by steam engines with big, red wheels.

Here, as along the Tian Shan, between the foot of the mountain and the poplar groves, stretches a row of dry hills, ochre or gray in color, carved by rivers. They barely rise above the ramparts of the Jiayuguan fortress. Gravel and silt deposited by the rivers has been freshly exhumed. Yesterday's mud and pebbles, successively scattered and then buried with the thaw of summer snows, these deposits are already folded. Not much grows on such loose and permeable rocks that have been thrust above the water table: hence their aspect and color. Only sheep can graze on these parched slopes.

The element of the landscape that is key to understanding the movement is a nearly insignificant detail at the foot of as tall a mountain. It is a step that heaves the earth up a few meters along the base of the gray hills and that doesn't have the geometric regularity of manmade structures. The step was not created to delineate a field's edge or to channel water. It is in harmony with the landscape, integrated into it like a gear in a machine. Closely hugging the northern base of the hills, it runs across all the valleys. All along the way, it faces north. East of Jiayuguan, it is rounded and covered by artemisia, blending in with the décor of the steppe. To the west, it is still a steeply sloping escarpment uncovering the soil and boulders beneath the surface. It is riddled with holes where pikas have dug their tunnels.

How do we explain this small "detail" in the landscape? In the east as in the west, it formed suddenly, in just tens of seconds. It represents the superficial scar, more or less softened by time, left by two great seismic events. Two earthquakes, that occurred at very different times but had the same effect. This seismic step offers material proof of the jolts that helped raise these hills. The earthquake on the western side happened "yesterday." It shook the entire region in 1932. All at once, the fault, which plunges 13 miles under the mountain, slipped seven to ten feet. The entire mountain was pushed up by roughly that

amount relative to the poplars in the corridor. The displacement cut and raised the grassy base of the hills, creating the "fresh" step that one can follow today for nearly a hundred miles. In the ground torn asunder by this seismic "explosion," rodents could easily feel right at home, and still today, they dig to their heart's content. The earthquake on the eastern side occurred more than 1,800 years ago. Its scarp, worn by erosion and smoothed out by weathering, has almost melted into the landscape, as an abandoned country wall gradually deteriorates into a mound of stones. In 180 AD, the caravaners of the Han Dynasty lost one of their main rest stops. Luo Tuo Chen, "the City of Camels," had to be deserted when its aqueducts collapsed irreparably. But though worn by time, this escarpment, too, is the undeniable mark of an ancient uplifting jolt.

So, for those who know how to read landforms, the panorama towering above the Great Wall comes to life. And it is all the more impressive for being a *living* landscape. Every frame of the film is an earthquake. If the Qilian Shan range remains ice-capped in spite of erosion, it is because its height increases with each seismic tremor. The fault that emerges at the base of the hills is the engine of this uplift, somewhat like an escalator. The Qilian Shan are constantly rising and also slowly advancing towards the Gobi. Little by little, earthquake after earthquake, they are overthrusting the Gansu corridor. The hills are folded today where the fault, or "Qilian Shan Thrust," steepens to reach the surface. On the summit of these hills, the oldest gravel has only had to "live" through a hundred or so tremors. Here, too, a baby mountain is growing in front of another that is still young. A young mountain that, just to maintain its height, must seismically regain, every 2,000 years, all those feet lost to erosion. To grow taller and faster, it has to do better than that—an earthquake every few centuries.

MATURITY

Muztagh Ata ▲▲ Kashi, an oasis at the confluence of four rivers, in the "far west" of China. At the westernmost tip of Turkistan's largest desert: the Takla Makan, whose migrating dunes cover the Tarim basin. On a clear spring day, looking westward, two long, ice-capped crests tower over the fields of green wheat. At almost 25,000 feet, Muztagh Ata and Kongur

Shan are the highest summits of the Pamir: a height challenging that of the loftiest Himalayan summits. An ancient branch of the Silk Road, which leads to India, by way of the Khunjerab Pass and the Indus valley, goes around them. This is the route that Marco Polo followed on his first journey to the court of the Mongol emperor Kublai Khan. Today, it takes only a few hours to travel from Kashi to Karakul Lake, the misnamed "black lake." Depending on the time of day, this small lake more closely resembles a turquoise or an emerald inserted between the two giant peaks. More than thirty glaciers flow down the flanks of the two mountains.

These two flanks show astonishingly pure profiles. South of the lake, Muztagh Ata, "Father of Ice Mountains," forms an almost perfect dome. Its white ice-cap, which feeds its glaciers, is a smooth cover of uniform thickness. The dome is only cut by a few glacial valleys. Deep but disjointed, they have not yet destroyed the extraordinary form of the mountain. In between them, the flank of the Muztagh slopes steadily down to a flat piedmont that is covered by moraines that at one time dammed much bigger lakes. Karakul is only a relic of this earlier landscape. Bactrian camels are able to climb the almost gentle slopes of Muztagh Ata. This is one of the rare mountains where they replace sherpas and mules as the porters. Under the ice cap, in the ice-cut cliffs that bound the glacial valleys, are two very different rock layers: one light, the other dark. Both are perfectly parallel to the layer of ice. Green amphibolites and white gneiss, they can also be found in blocks in the moraines. These two types of metamorphic rocks only form at depths of more than 10 miles.

Layers that are gently inclined like the surface of a dome whose gradual slope the camels climb! Déjà vu? Could it be that Muztagh Ata is simply a geological fold? Like those more commonly observed in shallow sedimentary layers? In spite of its altitude, its ice cap, its deep rocks, and especially its mighty size? A giant fold, in the prime of life, as yet barely touched by glacial erosion? To verify this, we only need to turn the third eye to the left of Karakul Lake. There, we see that the two rock layers swerve 180 degrees, faithfully wrapping the "nose" of the Muztagh, "the head of a giant whale."

Thus, a thousand kilometers to the west of the Great Wall, the landscapes of China's Far West offer an image of mountain growth that is even deeper, in the true sense of the word,

and more dynamic. It is a unique sight: the ice caps that crown the two highest summits of the Pamir at 26,000 feet actually sketch the clean contours of mighty folds. The highest mountains on the planet are quite simply folds! These gigantic whale-backs comprise roughly 12 miles of hard rock, not a couple thousand feet of gravel like the Jiayuguan hills. Nevertheless, the mechanism is the same. This time, it's a hefty chunk of the earth's crust that has been arched up, and it continues to be folded above the great thrust that brings down the mantle of the Tarim and dives all the way to 125 miles beneath the surface. Obviously the age is also different: it took 10 million years to form such domes.

As a bonus, more so here than in the young hills of the Tien Shan or Qilian Shan, the tectonic movement has contributed blazing colors to the landscape: carmine, vermilion, and purple. This is far downstream from Karakul, but before the edge of the Tarim, where the thrust faults that dive under the Muztagh and Kongur emerge today. These faults have slipped so fast and for so long that they have jumped several tens of miles into the piedmont, from one row of hills to the next. The colored layers are actually ancient sandstone, oxidized like clay in a potter's oven and thrust to the surface. Hardened and "cooked" layers, once buried under the thousands of feet of younger and duller alluvium continuously carried down and deposited by today's rivers and streams— debris from the Pamir's summits. Here, therefore, we can see the whole cycle of creation and destruction that characterizes the long life of mountains.

Chomolungma ▲ It is from the north that the Himalayas' highest peak, Chomolungma — or Everest, in colonial parlance—reveals its origins. Whereas its south side is in large part hidden by other 26,000-footers, such as Lhotse and Nuptse, one can contemplate the entire north face from the hot springs near Dingri. A vertical wall crowned by a narrow yellowish cornice. It was there that British climbers George Mallory and Andrew Irvine disappeared in the early 1920s. The highest summit, a small pyramid perched atop more solid foundations, is to the right, or west. This is the realm of ice. In the Himalayas, it covers nearly every rock above 20,000 feet. Here, however, the north face rises so steeply that ice simply can't hold on everywhere. Ledges of hard rock stick out from bottom to top. All are parallel. All uniformly inclined toward

the northeast. From the summit down to the base, the whole face of the mountain mirrors this slight inclination. Even the cornice slopes in that direction, which explains the position of the pyramidal peak. Chomolungma is a mountain that leans toward the north. So it comes as no surprise that one of the routes most favored by climbers on their way to conquering the summit is through the North pass.

Ancient strata of limestone form the parallel ledges under the crest. They were deposited in a shallow sea more than 400 million years ago at the beginning of the Paleozoic era (Cambro-Ordovician). They cap layers of metamorphic rocks deformed while still deep in the earth's crust as if by a rolling mill. These layers, inclined towards the northeast as well, are penetrated by much younger white granite, which dates back to the birth of the Himalayas some 25 million years ago. The sheer scale of the vertical uplift is staggering. If we put back, on top of this already 29,035-foot mountain, the 32,000 feet of marine sediments that were "calmly" deposited on top of the Ordovician strata for a span of 350 million years before being scraped off by erosion, then the total uplift amounts to more than 12 miles above the level of the sea. A sea that only disappeared definitively during the Lutetian period, a time when the stone used for the construction of Paris was still compacting.

Why does Everest lean to the North? It's because of the northward incline of a large thrust ramp. This "slippery" ramp, lubricated by melted granite, has raised the whole flake of crust, scalped off its foundations, while the rest of the Indian plate plunged under the mountain range. All the way to the summit of Everest, then, the steady slope that dominates the landscape quite simply mirrors the northward plunge of India. Today, more than 15 miles beneath the "alpine" meadows where yaks graze, a similar thrust fault continues to orchestrate the Himalayas' uplift. Here, as elsewhere, it all started with a huge fold of the earth's crust, something that only a few sections of the north flank still hint at. Exposed head-on to the force of monsoons, the southern flank of the fold has long since been destroyed. It's given way to the vertiginous walls of gneiss, schist, and white granite that tower above the Nepalese hills from the Makalu to the Daulaghiri. Here, one more stage of the evolution of mountain ranges is unveiled: a second large thrust fault supplanted the first, whose deepest

part—the rolling mill—is now exposed at the surface, carried up by this rock elevator that doesn't seem like it will stop any time soon.

In the Himalayas, the destructive force of erosion and, on the southern flank, the density of the vegetation, make it more difficult to read the landscape, but it's also earthquakes, some with magnitudes as great as 8.0 or even 9.0. (1897, 1905, 1934, 1950), that preside over the fastest tectonic uplift of all, that of the highest mountain range on Earth.

Kailas ▲▲ Kailas: one of the most sacred Buddhist sites. And without a doubt the most revered of mountains. Lamas and pilgrims circle clockwise at the foot of its vertical cliffs of gray and russet sandstone. For Tibetans, and anyone acclimated to the 13,000-foot-high plateau, the Kora, or holy circuit, is almost easy. A couple of narrow passages, some steep sections here and there, and just one high pass to the north, but for most of the route, glaciers that have now vanished opened and leveled the way. Why such intense worship? Perhaps because man can only be spellbound in the face of the grand finale of such a tectonic opera in several acts.

At only 22,000 feet or so, the "very precious" Kangrinpoche, or Mount Kailas in Western atlases, is far from being one of the highest world summits. However, because of its location on one side of the broad valley that separates the Himalayas from Tibet and India from Asia, the suture between the two continents, it is visible from great distances. From the west as well as from the east. Its shape, almost a perfect pyramid, is a beacon for travelers, a magnet for the eyes. It resembles a giant *stupa*. At its foot, the still waters of large lakes— Mansarovar and Raksas—also sacred, mirror the divine perfection of the landscape.

This collection of splendors owes everything to geology. The mountain stupa rises precisely at the water divide in the suture. At the very foot of the mountain, the waters aren't sure where to go. But to the east, west, and north, they eventually find their way, through divergent channels, that carry them off in different directions for thousands of miles. They feed the flow of four rivers that travel to opposite seas. Two of them go west. The largest, the Indus, originates as the "Lion's Source" (Shi Quan) on the north side of Mount Kailas; its tributary, the Sutlej, begins just to the south. Far down stream, as the two head toward the Arabian Sea, they unite their waters in the

plain of Punjab, transforming it into a fertile garden. The Brahmaputra (Yarlung Zangbo) and the Ganges originate to the southeast and the southwest, respectively. They flow eastward to join the Bay of Bengal, on the other side of India. The Indus and Brahmaputra rivers, after following the suture in opposite directions for over 600 miles, each cross the Himalayas at either end. There they cut deep hairpin gorges around two sister mountains, Nanga Parbat and Namche Barwa. Why be born so close only to end up so far?

The pyramid of Mount Kailas is remarkable for its almost perfectly level rock ledges, a landform rarely seen at such elevation. Each face displays a uniform succession of horizontal steps. Giant staircases that could have been constructed by a builder-god more obsessed with immortality than were the Pharaohs. No doubt a direct route to Nirvana for those who know how to climb them.

What are they made of? This construction of astonishing uniformity is simply a pile of sedimentary layers stacked one on top of another, preserved largely intact in their original position. Thousands of feet of russet sandstone and conglomerates of large rounded purple and green pebbles that were deposited by ancient rivers on a coastal plain when the collision of plates was just beginning, when the sea was giving way to the land, when the Himalayas were still only a blueprint. This is the famous "Indus Molasse" that can also be found in Leh and Hemis, in Ladakh, and south of Lhasa as well. It covers the last beds of fossil oysters and nummulites of the Thetis sea. Their age is Lutetian, again, the same as that of the rock from which the Great Sphinx of Giza was carved. Having been "gently" raised to nearly 22,000 feet, as if by a hydraulic lift, these sediments were later sculpted into this multifaceted pyramid by glaciers. A step pyramid, like an enormous version of the one in Saqqara.

And the parting of the waters? Here the main branch of the Karakoram fault stops. A dextral strike-slip fault coming from the northwest to join the suture, creating the basin that is filled by the Mansarovar and Raksas lakes. "Dextral" means that if you sit on one side of such a fault and look across, everything on the other side will move to your right. Imagine sitting atop Kangrinpoche, on the Tibet side. Looking southwest, you contemplate the Himalayan range shifting to the right, dragged northwestward by India. This movement forces the

Indus and the Sutlej to flow toward the setting sun, while the rest of the Tibetan waters, to our left, flows east. These east-bound waters are not deviated by the Karakoram fault.

False Mountains

Semien ▲▲ The "Roof of Africa" rises in Ethiopia. This is not Africa's highest summit. Other peaks, such as Kilimanjaro or Ruwenzori, may be higher, but they are isolated peaks. The reliefs in Ethiopia form a high plateau, roughly the size of England, at an altitude of about 10,000 feet. Shaped like a crescent, this plateau looks out over the Red Sea and the Gulf of Aden from a steep escarpment that drops off abruptly into the desert salt flats of Afar. More than ten summits reach above 13,000 feet, the highest of which, Ras Dashen, crowns the Semien Mountains at 15,157 feet.

Newly born from Lake Tana—where the Ark of the Covenant was allegedly once hidden—the Blue Nile tumbles over its first cataract, Tis Issat, or "smoking water," in Amharic. From the heights of a black cliff, it falls into a black chasm. The golden Semien steppe is bordered on the east by giant stairs, the "traps," composed of endless stacks of the same black rocks: basalts. Fantastical pinnacles rise here and there: some vertical and as high as the Eiffel Tower, their inaccessible summits bleached white by colonies of eagles. Others are twisted or tilted sideways like the Tower of Pisa. How did this landscape, made from one single rock type, come to be? These giant stairs and pillars? Basalt is the hottest and most fluid type of lava, the same that, today, spits forth from Kilauea in Hawaii and from Etna in Sicily, as fast rivers and scarlet fountains. We are thus walking on the solidified remnants of a volcanic eruption of titanic proportions. The herculean pillars are ancient chimneys, enormous frozen conduits, through which massive amounts of lava flooded the landscape.

Nowhere is the breadth of this eruption more strikingly visible than at Lima Limo, a sharp precipice that drops 6,000 feet, bringing to mind the Grand Canyon. A cliff cut by the headward retreat of the tributaries of the Nile that have eaten through the mountains of lava. Here, the gelada baboons, well adapted to the cold of high altitudes with their lion-like manes, have taken up residence. Busy foraging in the soil to find their meals, they only spare their surroundings a haughty glance or two. A couple of yawns reveal that even their fangs are leonine. However, at the slightest sign of danger, they scamper over the edge, finding shelter in the trees rooted in the cracks below. For the geladas, these rocky cliffs are a refuge. But for those of us who can't hang from branches, the vertigo is real and certain. As far as the eye can see, mesas and pinnacles below are made of uniform layers of basalt lava flows, each several meters thick. Each one stretches for many miles. Thousands and thousands of feet thick under the entire high plateau of Semien! Hundreds of thousands of cubic miles of lava. An ocean of basalts that has solidified under our feet. With the third eye, we can take a closer look at the slopes of the lava flows. When the lava first gushed out, it was onto a surface that was barely arched. How long did it take for these layers of basalt to pile up? Given the volume, surely a long time? Wrong! Argon dating leaves no doubt: it took just one million years, 30 million years ago!

Such gigantic amounts of plateau- or flood-basalts originate about a hundred miles underground, when the head of a "plume" of especially hot mantle makes its way up to the lithosphere—the cold outer shell of the earth that carries both oceans and continents. The impact point of the plume head at the base of the lithosphere is referred to as a "hot spot." The heat melts the base of the shell, which cracks, instantly releasing torrents of basaltic magma. It is a true cataclysm! In the time it takes for the effusion to dry out, the upper atmosphere, laden with sulfur-rich aerosols, blocks the sunlight, sending Earth into a long volcanic winter, lowering the global temperature by 18°F or so. Volcanic eruptions of such magnitude have wiped out entire animal species and reorganized the biosphere. Fortunately these occurrences are very rare.

That's the way the roof of Africa came to be. A geyser rush of fiery mantle caused the Eastern part of the old continent to bulge, creating a broad dome, 500 miles in diameter. Its vault fractured, opening a way, through the giant chimneys, for the flows that rapidly covered up the ancient basement over tens of thousands of square miles. In just a few hundred millennia, this basaltic flood created the Ethiopian traps, since then incised by the Nile and its tributaries. This high equatorial plateau, watered by two monsoons, source of the Nile and the

Awash rivers and a cradle of civilization since ancient Egypt, owes its good fortune to one of Earth's brief hiccups.

These mountains have nothing in common with the Himalayas or the Central Asian ranges. They are not ranges. Rather than rising, the rocks of the deep crust have a tendency to sink. There is nothing really tectonic here: barely any deformation, no horizontal transport. Just layer upon layer of lava, plastered atop the landscape. Artificial mountains, in a sense. Tectonically speaking, it is altogether fitting to classify them as "false mountains." And actually, that label would apply to every volcano.

Tibet ▲▲ It is the most paradoxical of landscapes. A huge, endless prairie no matter which way one turns to contemplate it. Rich grasslands with slowly meandering rivers, where horses, sheep, and black bovines graze freely. By the thousands. We could easily be in Texas, or in Holland, or, at any rate, in one of those flat lowlands at sea level. Yet, the sky is a darker blue, and the light, blinding. We tread on tufts of edelweiss. The black bovines have long hair and Auroch horns. Instead of mooing, they snort: they are yaks. We are more than 15,000 feet above sea level, in the heart of the Tibetan Plateau, on "the roof of the world."

An entire prairie as high as Mont Blanc? A plain as big as all of Western Europe? Contrary to popular belief, most of Tibet is a desperately flat steppe. In spite of the altitude, there are no high cliffs. Sometimes the horizon is blocked by "small" mountains. White, of course, because the snow line starts just above 16,000 feet. These mountains are home to lazy glaciers, but their relief stays fairly modest: barely 5,000 feet above the plateau. Nothing like the icy walls of the Nepalese Himalayas or the Bernese Oberland. Moreover, large lakes punctuate the flat landscape of Tibet. They offer sanctuary to countless geese, Mandarin ducks, and other migratory birds. The names of these lakes reflect both the high altitude and the immensity of the region: Tengri Nor, "Lake of the Sky"; Koko Nor, or Qinghai Hu, "Blue Sea." The water, whether it comes from the monsoon crossing the Himalayan barrier, or the melting of snow and ice remains captive here.

Captive water: here is the key to unlocking the origin of this landscape. If we now travel north about 400 miles, the panorama changes. Still the steppe, but a steppe that becomes increasingly dry. The altitude has decreased. At only 9,000 feet, the Qaidam desert is unbelievably flat. It's all that's left of what was once an immense lake, 120 miles wide by 360 miles long. Yet, the elevation difference between the high plains and their surrounding summits has increased. There are now steep, high cliffs and deep canyons. The most spectacular are those cut by the Yellow River. This great river, the only one now able to escape northern Tibet, is engaged in a titanic battle for survival; a fight to the death that it is likely to lose against the rapid uplift of mountains that seek to dam it. It is the largest river here and the last one to make it out. Many times in the past, it has lost an entire branch of its upstream drainage basin, the watersheds of tributaries choked by thrust faults. Only a few were recaptured. Many times when it weakened during cold, dry glacial periods, its own powerful flow was dammed by such faults, as evidenced by thousands of feet of accumulated debris—silt, sand, and sandstone—trapped upriver by mountain uplift. Only later, when it regained the upper hand, during hot and humid pluvial periods, could the Yellow River cut again across mountains and sediment alike to incise the staggering vertical-walled canyons that reach depths of more than 2,500 feet.

How did the Tibetan Plateau form? The high prairies strewn with large lakes, the Qaidam basin's flat desert, and the Yellow River's fight for survival, are strands that when woven together create a plausible scenario. Tectonics has defeated the fundamental principle of fluvial erosion, which dictates that streaming surface waters, driven by their own weight, always return to the ocean. Not here. Disoriented, no longer "smelling" the sea, the rivers of the Tibetan Plateau built their own deltas inland, and at higher and higher elevations. Cut off from their usual outlets, beheaded catchments encircled by mountains had no other choice but to fill with alluvium and water. Almost to the brim. Almost to the top of the mountains. Their levels flattened out as they grew in altitude, as is the case today of Qaidam. That is how the "roof of the world" ended up so flat, this "mountain-plain" at 15,000 feet! The same is probably true of the Andean Altiplano, which is covered with salars and surrounded on all sides by cordilleras.

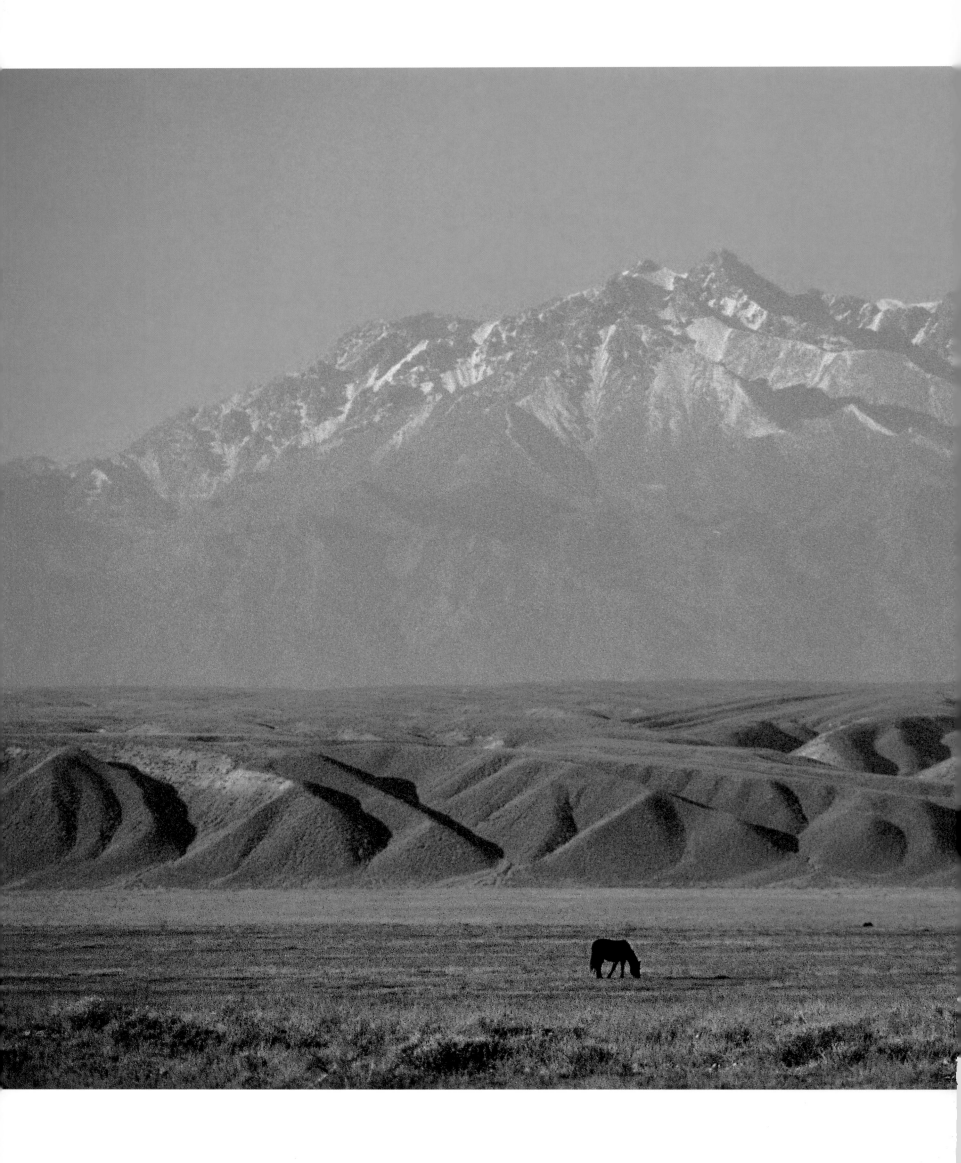

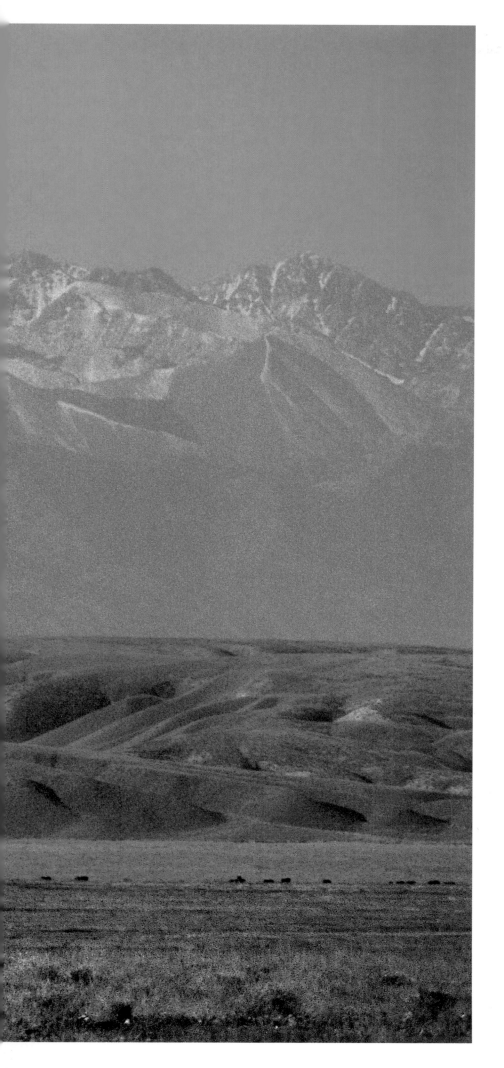

Hill,
DUSHANZI, XINJIANG

The snow-covered crest of the northern Tien Shan (Celestial Mountains) forms the horizon, but it is in the foreground that the surface of the land is alive. Beyond the solitary horse grazing on the steppe, is a small, elongated hill made of formerly flat lying gravels deposited when our ancestors were still tracking herds of wooly mammoths. That was "yesterday." Today, these gravel layers are folded in a smoothly arched ridge that resembles a whale back breaking the ocean's surface. This geological "whale" is about 1,000 feet high, 4 miles wide, and 15 miles long. Seen from above, it resembles a weaving shuttle. Little rills, steep and narrow, have already incised the frontal part of the fold. From the moment of its creation, it is subjected to forces that seek to destroy it. Erosion's mission is to erase all that stands out. Yet, this little fold will become a mountain. And quite rapidly: already 1,000 feet and 10-degree slopes in just 100,000 years! Another 600,000 years and it will be nearly 7,000 feet high. Such hills, longer than they are broad, form above thrust faults that ramp up from a depth of a few miles to the surface. Here, the hidden thrust roots 25 miles south of the hill, beneath the high range in the background.

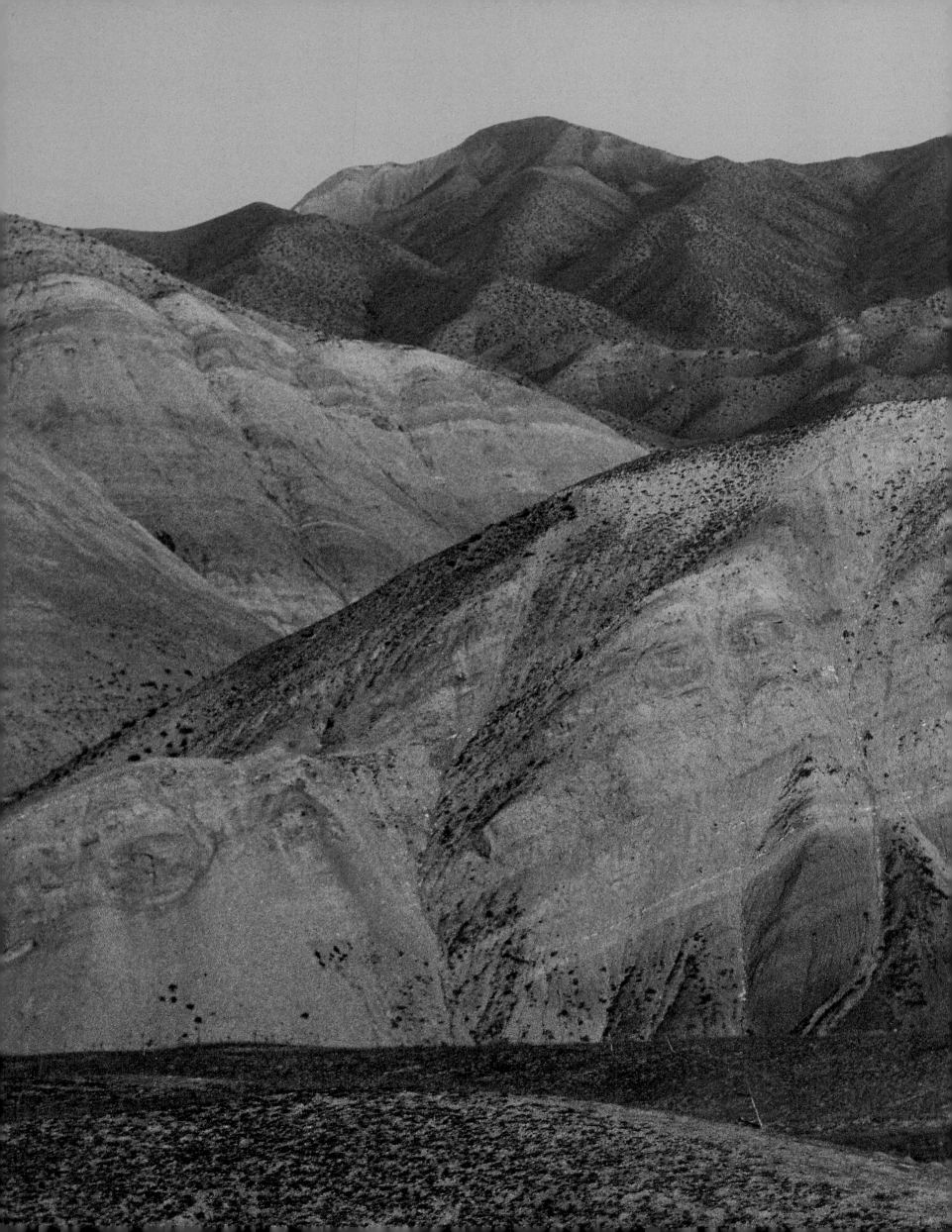

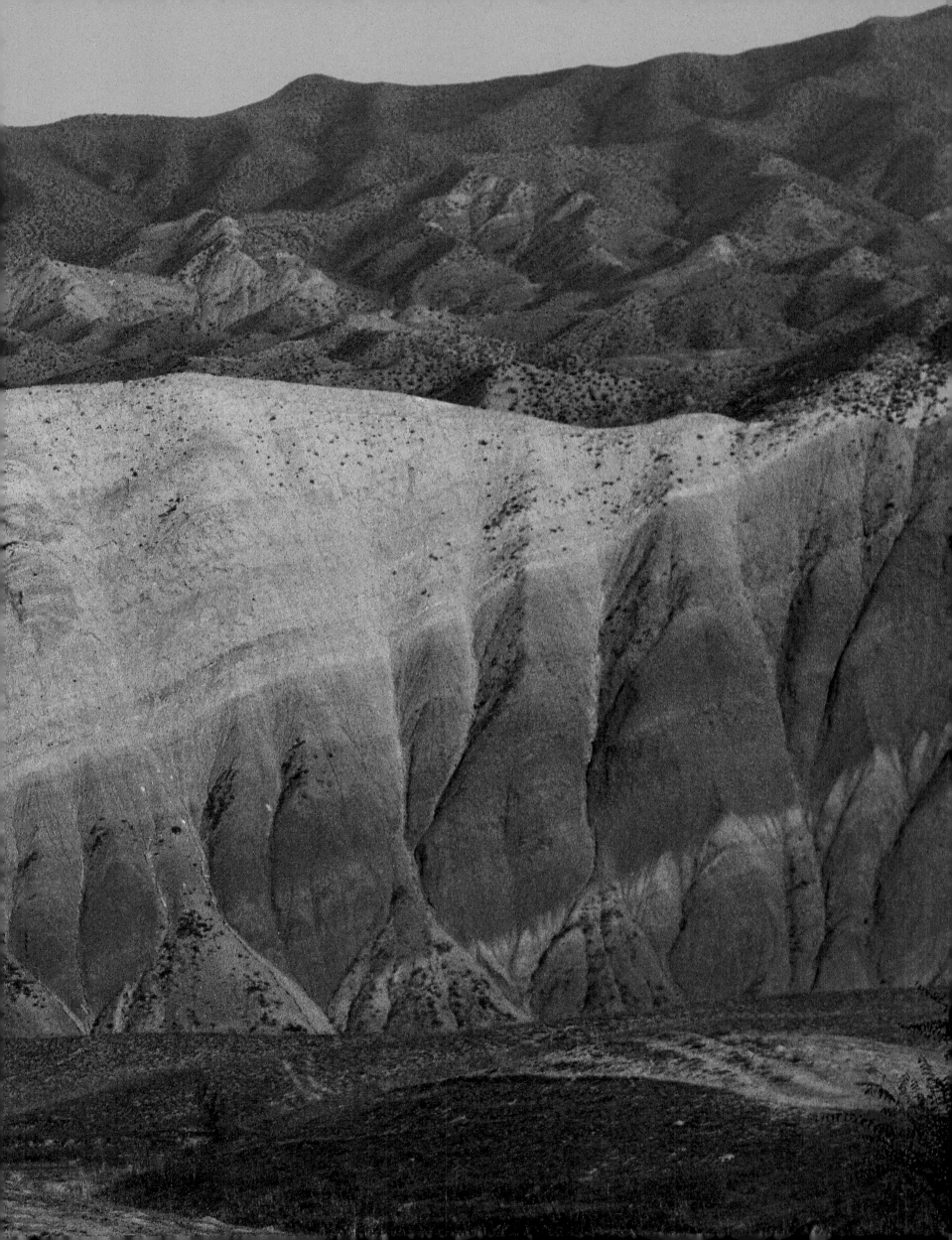

preceding pages

PINK SANDSTONE, TIEN SHAN

Ten million years ago, these pink, ochre, and gray layers of sandstone at the foot of the Tien Shan were still mud and sand spread by rivers far in the foreland of the range.

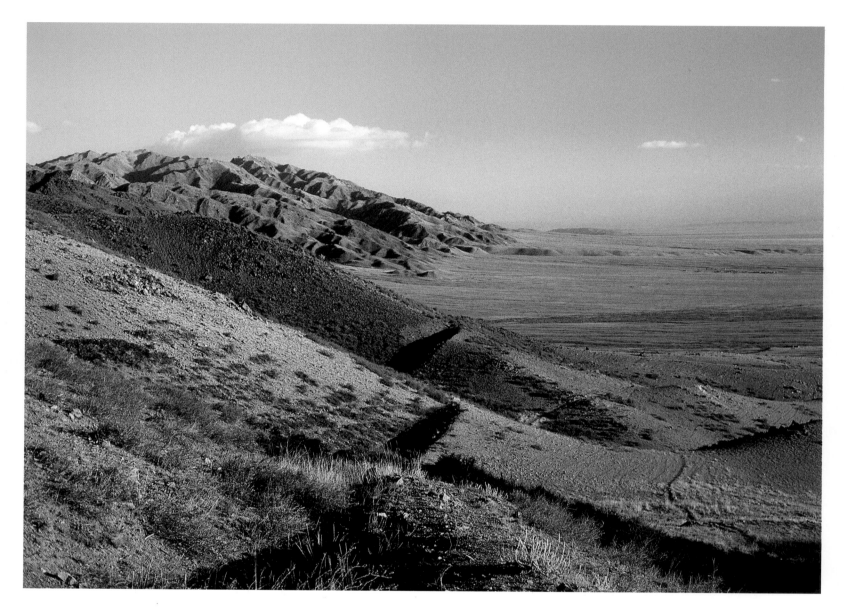

EARTHQUAKE SCAR, DZUNGARIA

The escarpments shaded dark by the setting sun are the scar left by the 1931 Fuyun earthquake. In one instant, the base of the hills below them slipped horizontally 25 feet towards the north. This seismic rupture can be traced for 100 miles along the western edge of the Dzungarian plain.

SHELTERED TERRACE, TIEN SHAN

Kazakh nomads have assembled their two yurts on the lowest terrace, near the riverbank where poplars grow. They are sheltered by higher, older terraces covered with white loess. All rivers that flow from the Tien Shan cut deeply into their old beds, which become hanging terraces in the process.

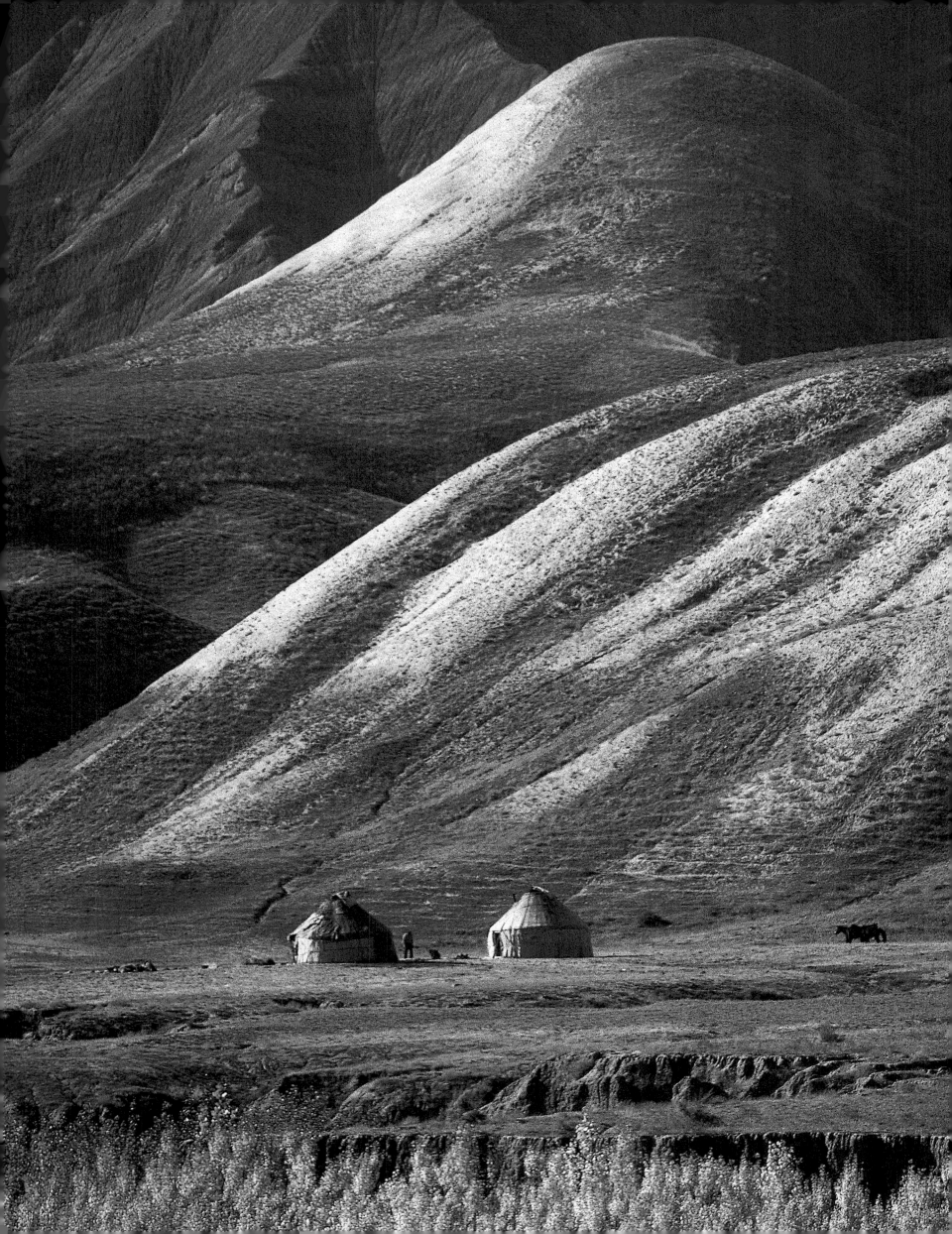

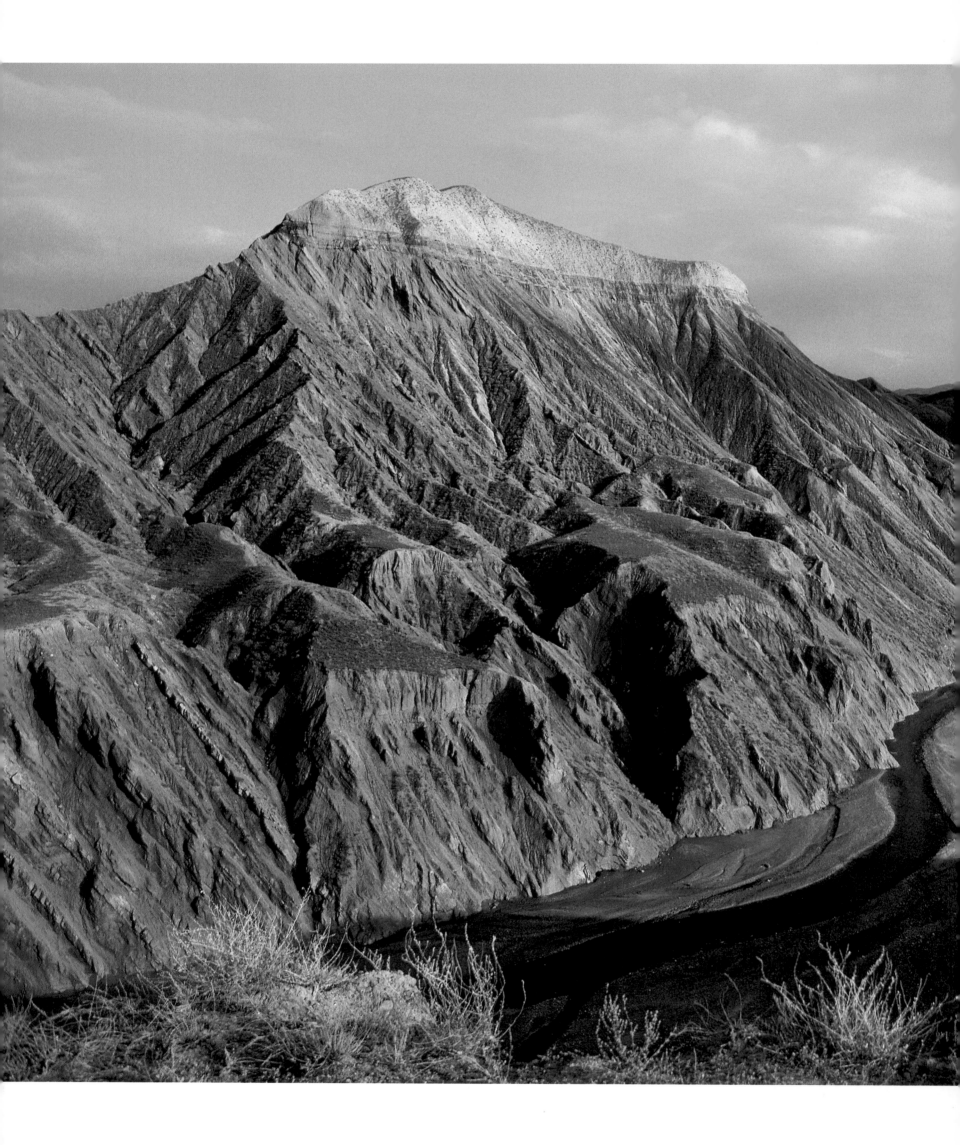

JINGOU GORGE, XINJIANG

The valley of the Jingou He (Golden Gorge River) cuts across the young folds that rise north of the Tien Shan, exposing dynamic evidence of their growth. Below the artemisia tufts in the foreground, the river braids its channels in the grey gravels it carries at the bottom of the gorge. On the opposite bank, we see brick-red strata of sandstones leaning about 50 degrees southwards, to the right. Relentlessly, the river incises deeper and deeper, as it fights to maintain its course across all these uplifting rocks. Clear proof of such uplift is seen at mid-slope in the red sandstones: shreds of a flat, grassy ledge topping a thin layer of consolidated gravel, the remains of a half riverbed now raised 60 feet above the water. And there is more. High above this degraded terrace, layers of white and gray deposits inclined five to ten degrees southward crown the hillcrest. Also laid atop the abraded sandstones by the river, they are the last remnant of yet another abandoned riverbed: a much older and higher one that has been rising for a much longer time; perhaps since about 120,000 years ago, given the thick white loess, once washed by the river, that it contains.

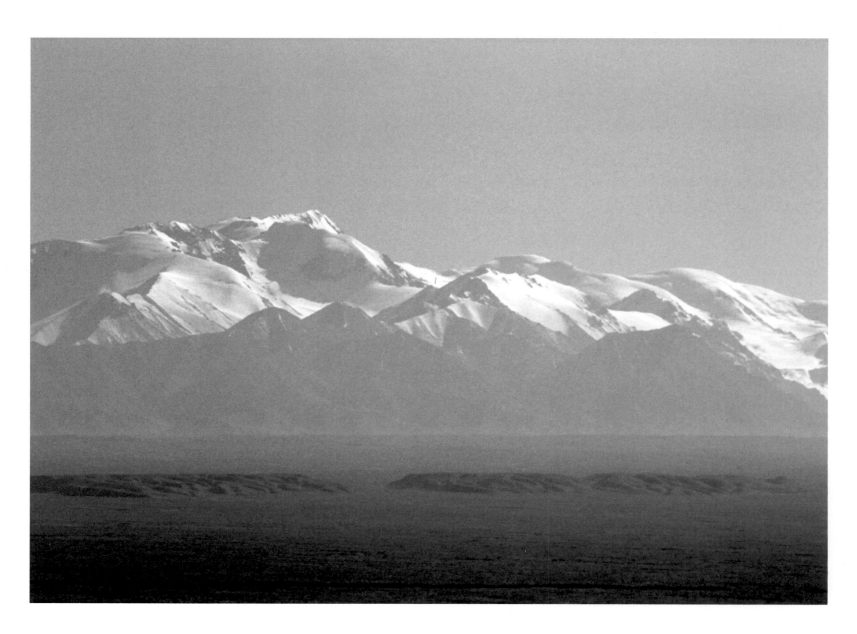

INFANT FOLD, GANSU, CHINA

The thrust fault that engineers the rise of the mighty Ta Xue Shan (Great Snowy Mountain) surfaces 10 miles north of it, folding modern alluvial fans: hence the elongated ridge visible in the foreground. The gray gravels capping this ridge were deposited only 10,000 years ago. It is quite rare to see this young a fold. During the last earthquake, in 1932, its apex, now barely 70 feet high, grew by four more feet.

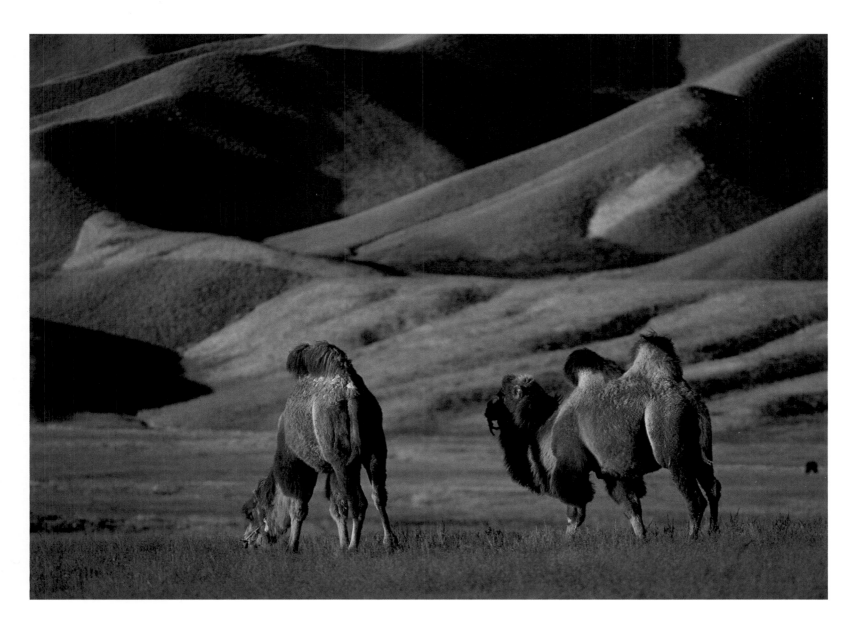

BACTRIAN CAMELS, SHAWAN, DZUNGARIA

Seen here in their natural ecological niche, these magnificent Bactrian camels have the thick coat and two upright humps that make them ready to confront the Central Asian winter. They have been the "ships" of the Silk Road for more than 1,500 years.

following pages

RAISED TERRACES, QIRA, XINJIANG

Between its headwaters in the Kunlun mountains and the Tarim Desert, where it finishes in swamps, the Qira River crosses the "tail" of the Tekelike Tagh, a 15,000 foot-high foreland mountain. There it becomes deeply entrenched in an amazing staircase of 11 uplifted terraces, beds of coarse boulders consolidated into conglomerates that cap strata of red sandstone exposed by the ongoing uplift of the mountain.

Seismic fault,
KARACHINGAR,
DZUNGARIA

Whether or not the mountain takes its name—"dark fight" in Turkish—from the cataclysm that periodically shakes it, we don't know. One thing is certain, however: every 2,000 years or so, its flank is torn apart by the dislocation of a great earthquake: a tremor strong enough to throw camels and horse-riders to the ground, and to fracture granite all the way to the surface. The scar left by the last cataclysm, which dislocated a thousand hills over a length of 100 miles in August 1931, is awesome. The size and sharpness of the tear are most breathtaking at the foot of Karachingar. Follow the shaded scarp that slices the slope reddened by the first winter cold, above the small hill on the right. See how clear the slip between the wound's two edges is: the grass-covered slopes on either side can be slid back to reconstruct the smooth, intact mountain flank of the 1920s. During the earthquake, the summit of Karachingar rose 30 feet in seconds. A seismic event is in fact nothing more than a quantum of sudden slip on a fault patch. It is the repetition of such events that builds relief. Ten large earthquakes build a small hill. Fewer than five hundred suffice to erect a tall mountain.

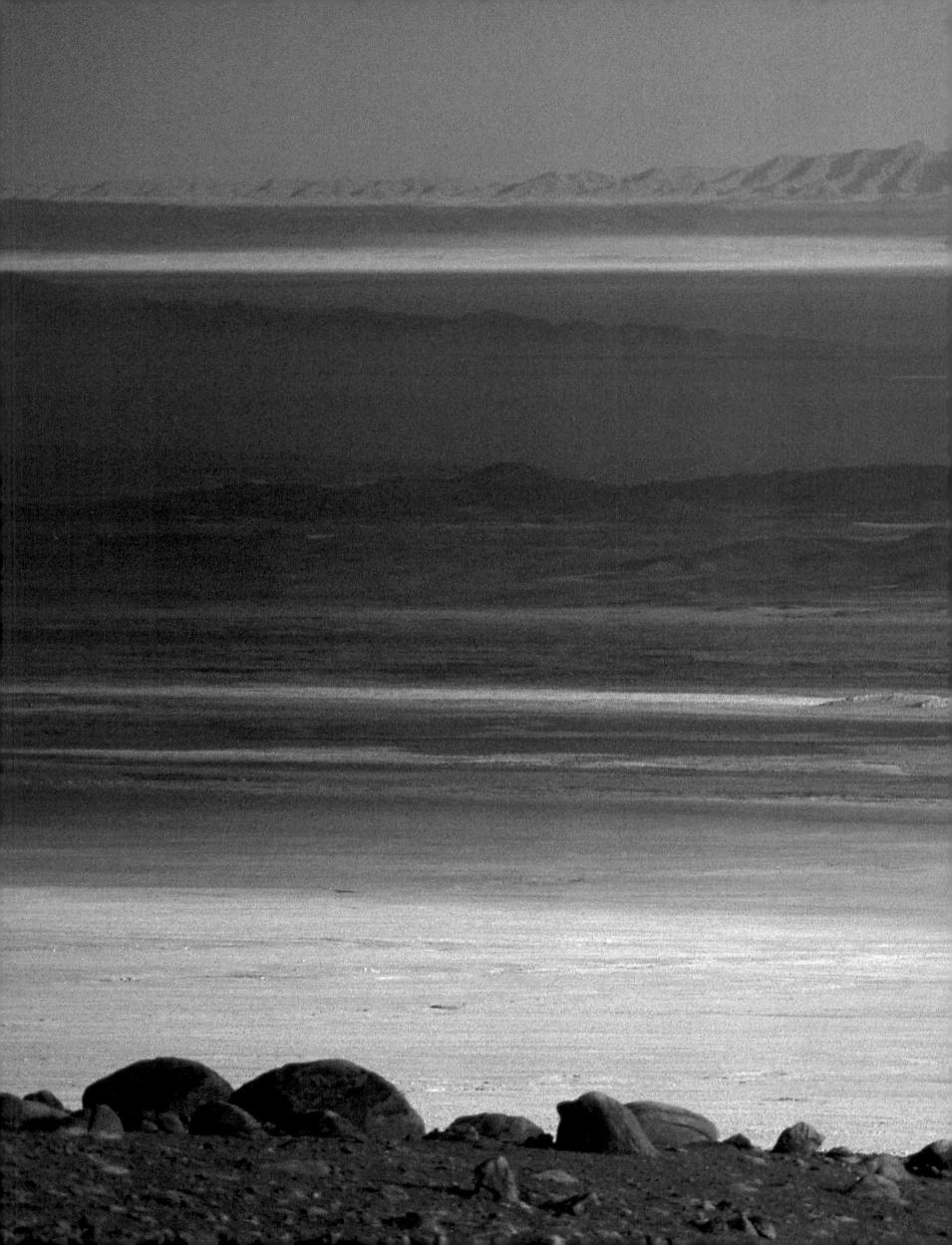

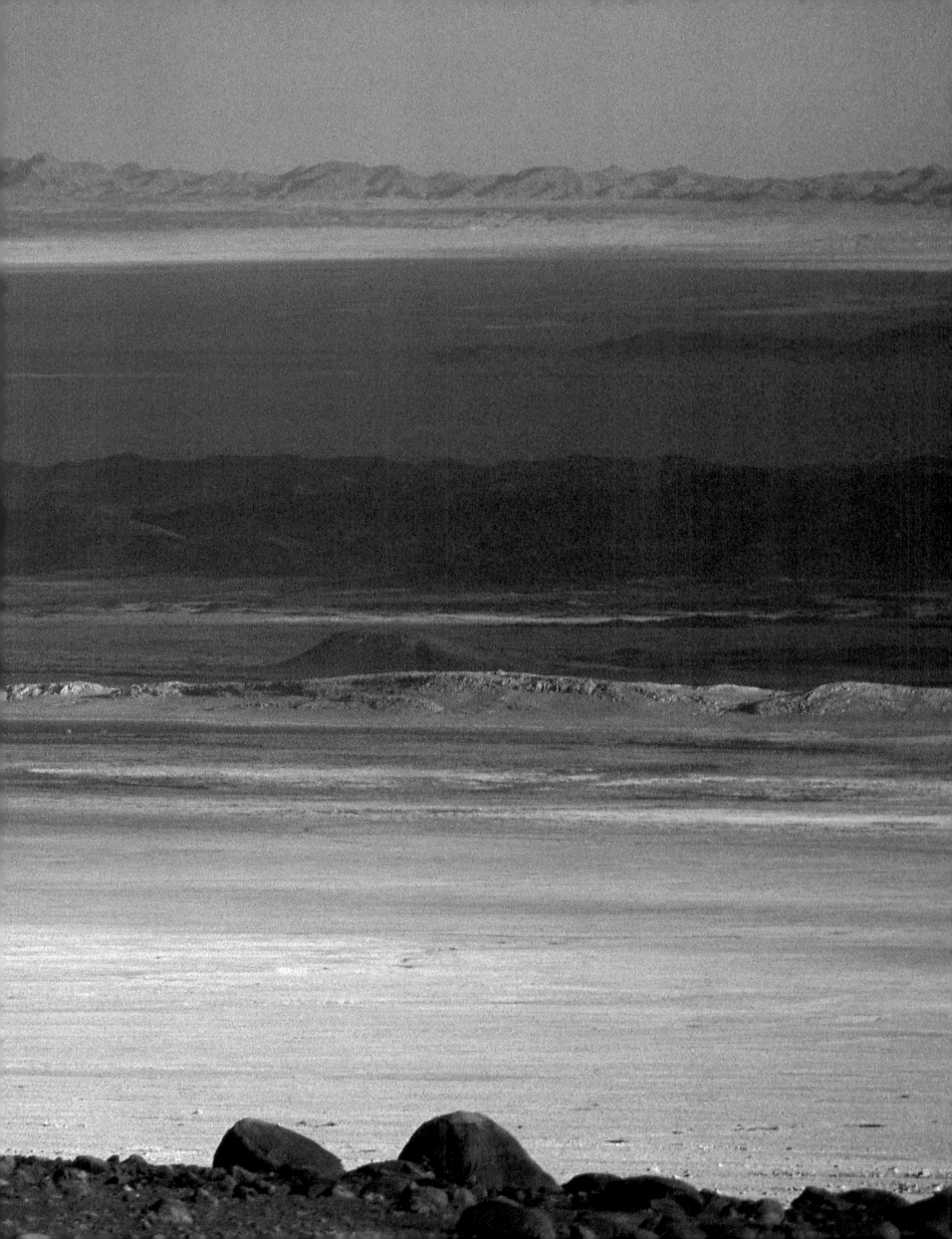

preceding pages

YOUNG HILLS, GOBI ALTAI, MONGOLIA

As India keeps approaching Siberia, the entire Mongolian southwest has started to feel the colossal pressure it exerts on Asia more than 1,500 miles to the south. The gray ridge on the horizon is a fold, the boulder-paved ledge from which we contemplate it, a rising terrace.

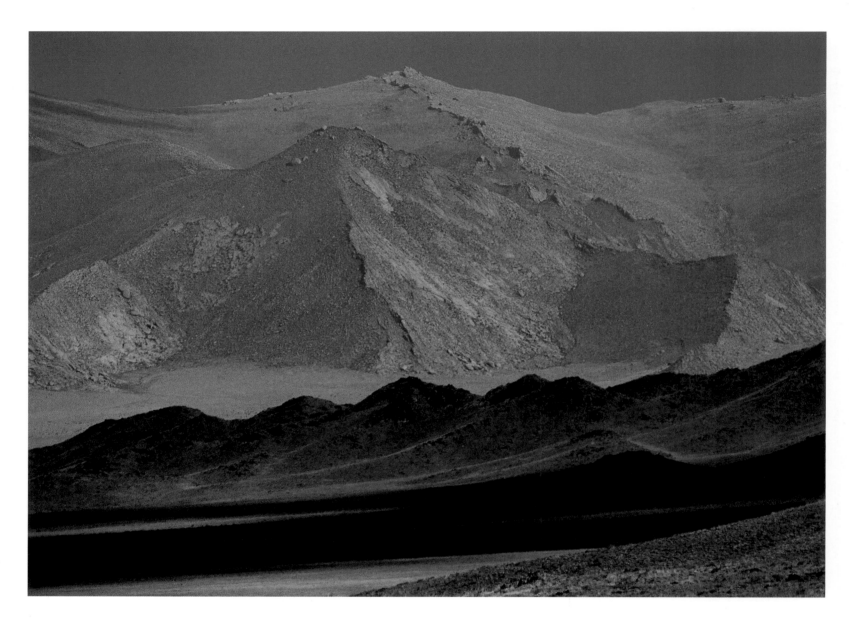

ANCIENT BASEMENT, BAYAN OLGYI AYMAG, MONGOLIA

Over tens of millions of years, erosion can abrade so much material that it ends up exhuming deep crustal rocks to the surface: here, in the Altai of northwest Mongolia, are granites that crystallized six miles deep, injected with veins that mark the crests.

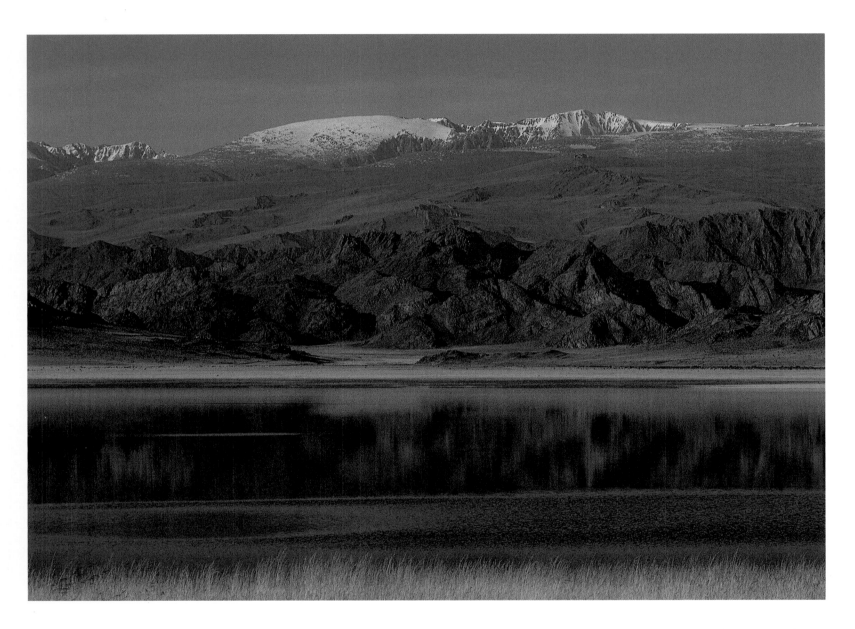

RESURRECTED MOUNTAINS, UVS AYMAG, MONGOLIA

The altitude of some Mongolian mountains already flirts with 13,000 feet. Snow-covered most of the year and pushed up along just-reborn thrust faults, they are among Asia's youngest mountains.

following pages

RED SANDSTONE, BYANHONGOR AYMAG, GOV ALTAI, MONGOLIA

Sandstone, the archetypal continental deposit found at the foot of most Asian mountains, becomes an increasingly deeper red as it ages.

pages 38-39

OLD FOLD, BAYAN AYMAG, MONGOLIA

Following the horse-riding shepherd on the opposite shore of the lake, sheep and goats tumble down a rocky spur. Hardened by metamorphism, the dark layers that plunge steeply to the right were folded more than 300 million years ago.

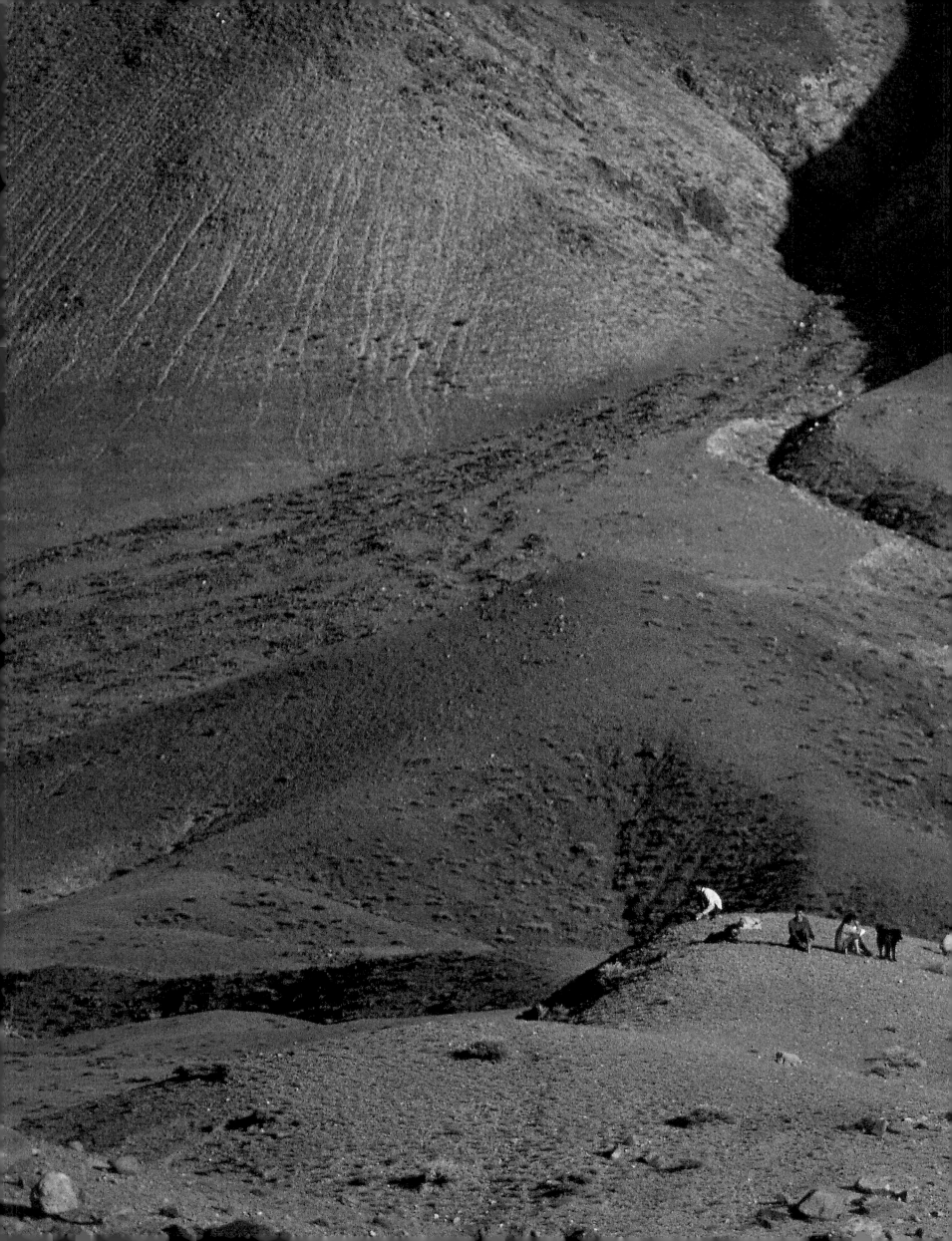

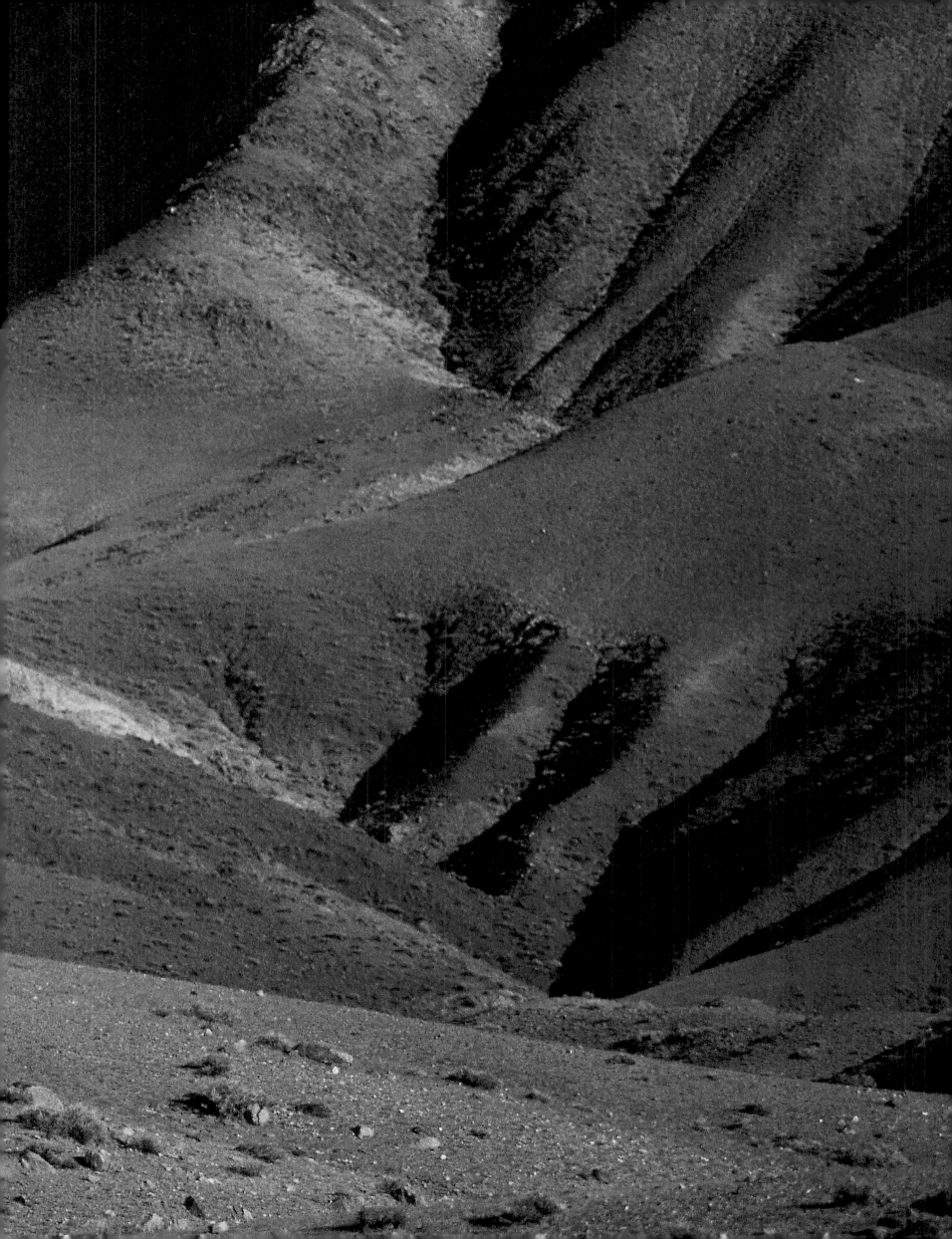

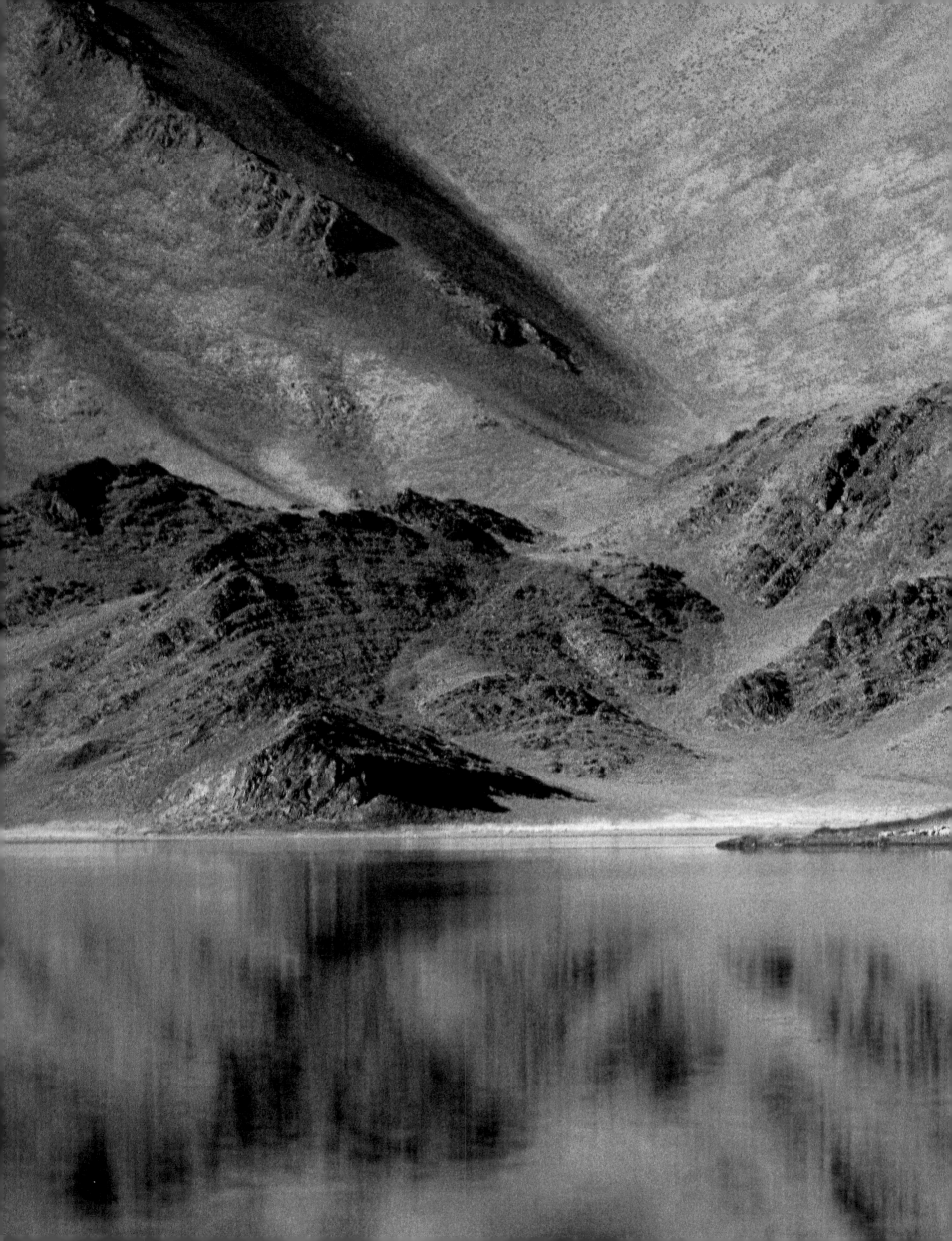

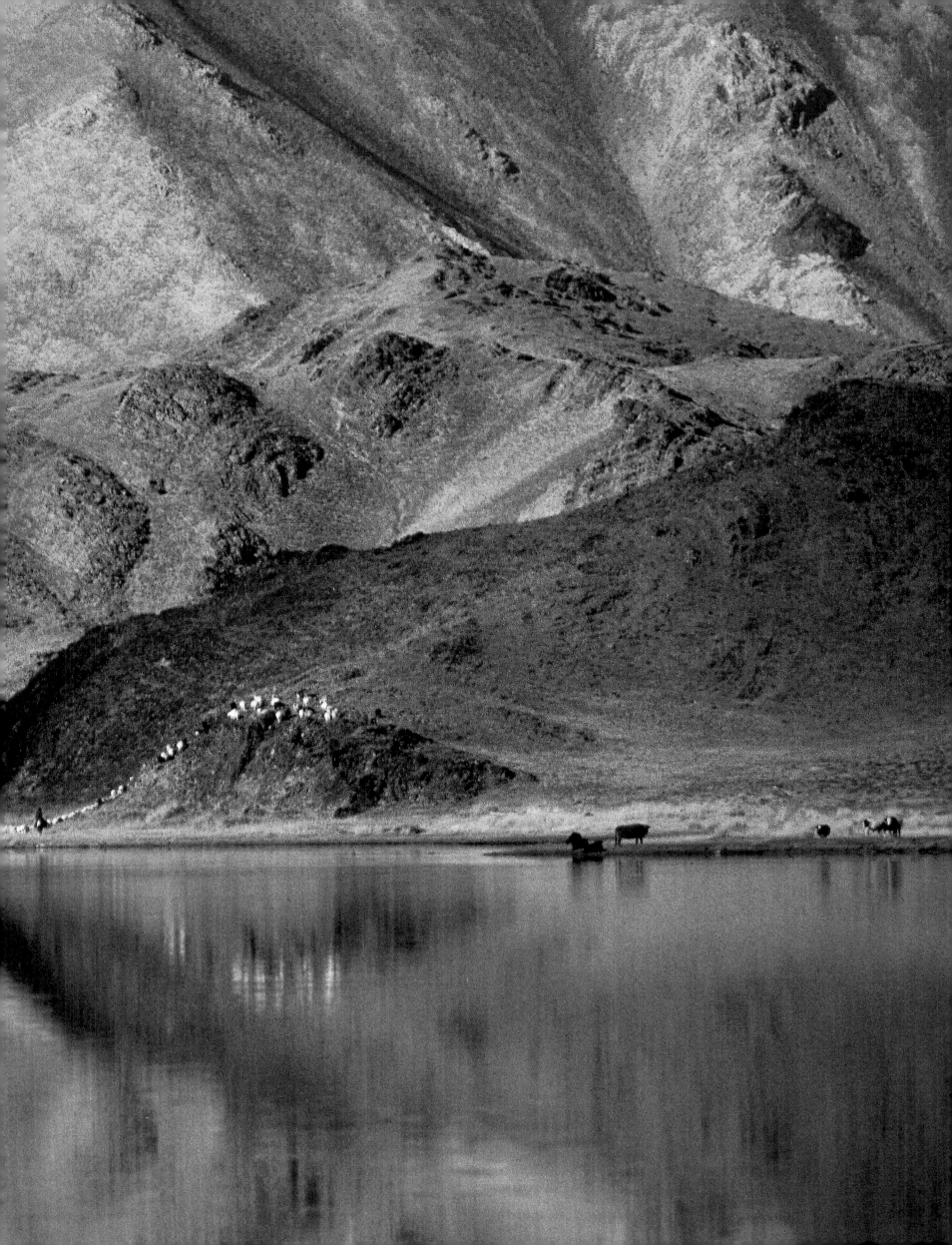

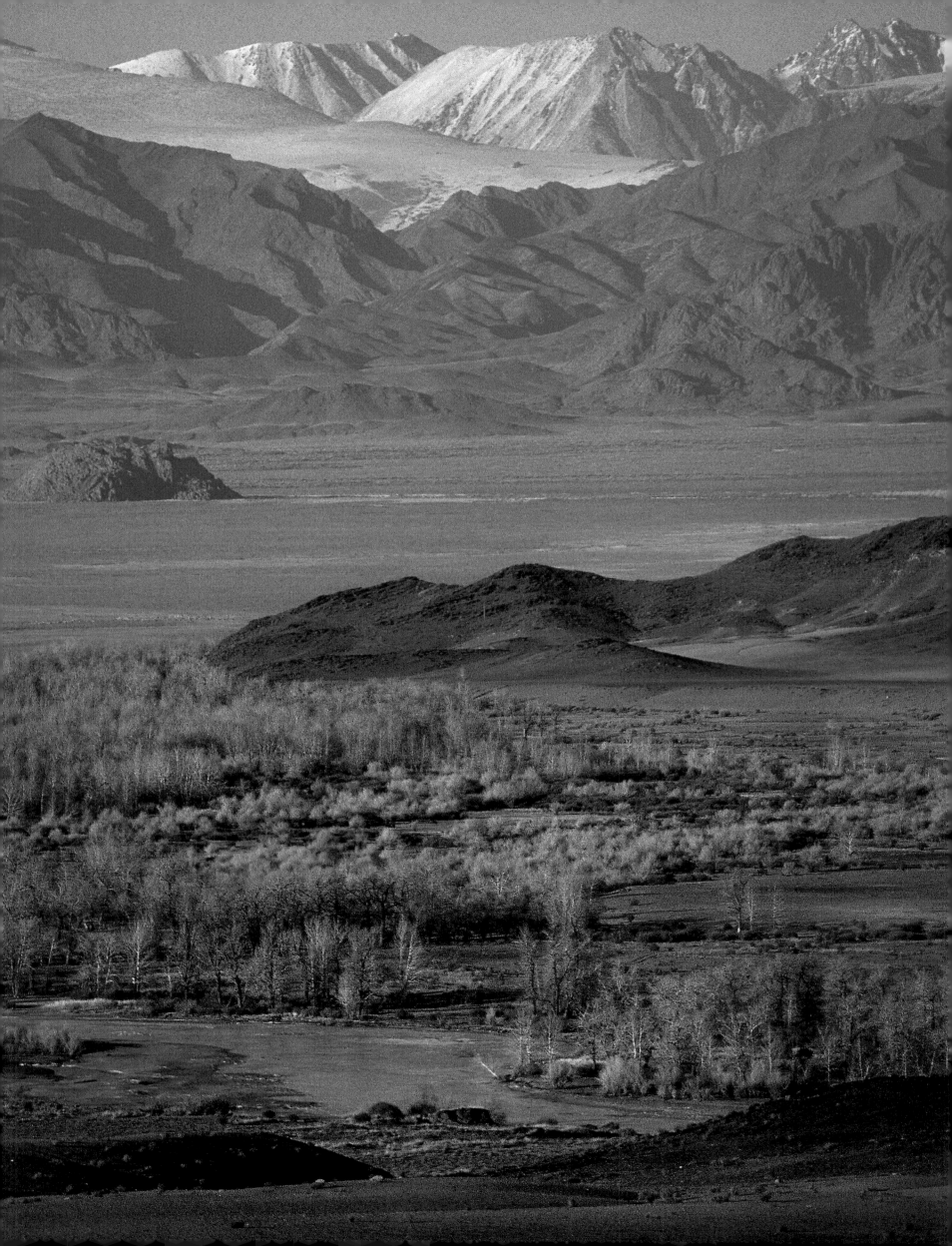

INFANT RELIEF, ANCIENT ROCKS; MONGOLIAN ALTAI

Studying the rocks that make up the bulk of this relief will not bring insight into its origin. Their geological history is ancient, frozen for hundreds of millions of years. By contrast, the mountain's uplift, of only a few kilometers, began "yesterday." Only geomorphology, the study of superficial landforms, can yield the key.

STEPPE AND HORSEMEN, UVER KHANGAI, MONGOLIA

Boundless land where riding on horseback remains easier than driving a car, the Mongolian steppe is not as flat as its name might suggest. Subtle ridges of vaulted sandstone and gravel separate flatter basins, a sign that a tectonic revival has just begun.

following pages

LIVING SLOPE, BAYAN OLGYI AYMAG, MONGOLIA

Steepened by ongoing uplift and partly covered with eolian deposits, the slope towering above the lake has become unstable. In its steepest, top part, parallel channels coming from the summit feed small debris- and mud-flows with each rainfall. At mid-height, above the gentler incline that ends in the yellow grass along the lakeshore, the light-colored, scalloped scarp marks the frontal lobes of a massive slide.

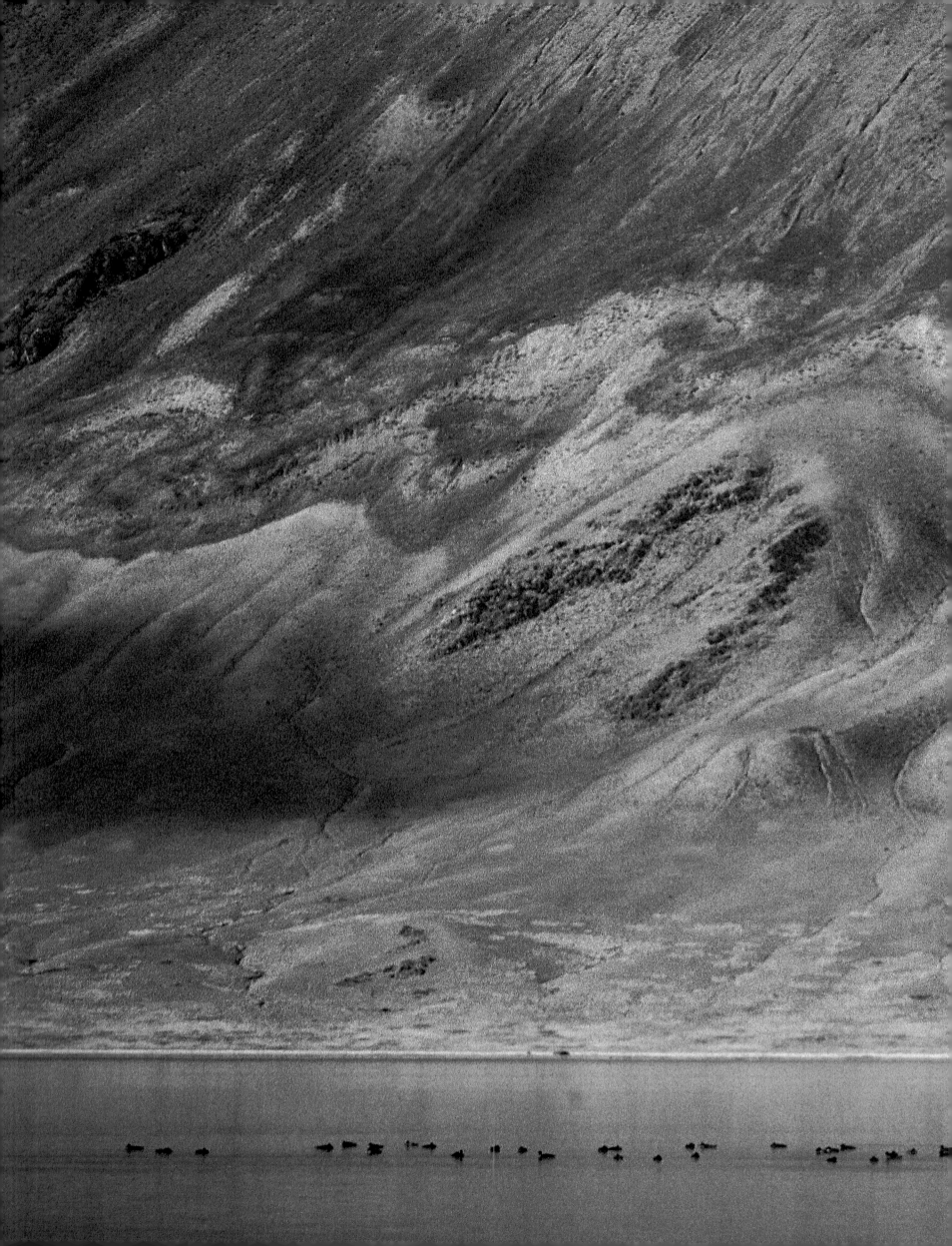

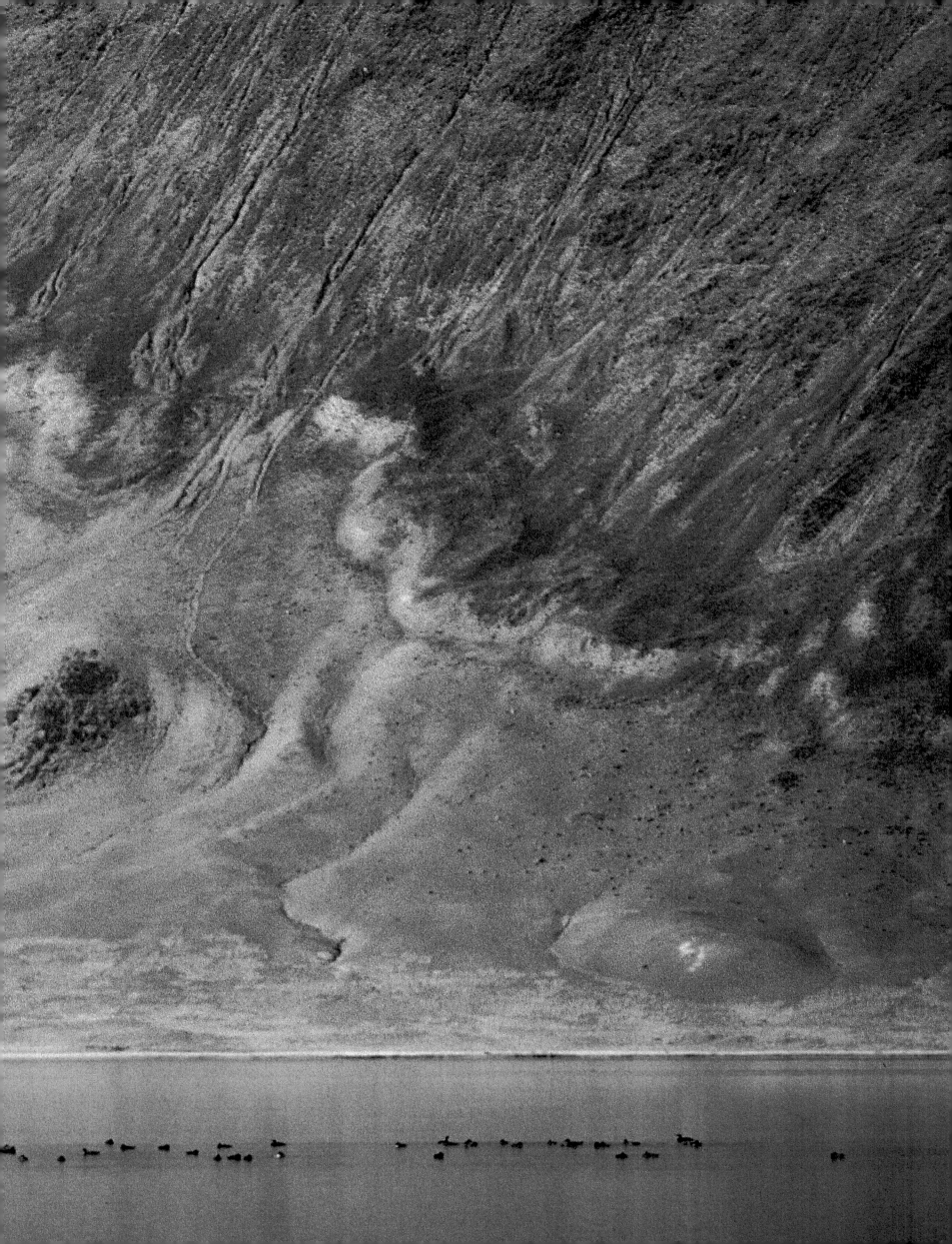

Tectonic tilt,
UVS AYMAG, MONGOLIA

The pink, frost-splintered granites in the foreground cooled hundreds of million years ago. Also very old are the dark rocks beyond the frozen lake. Such barren rocks, which are not hidden under sediment, save for the thin veneer along the lakeshore, have been worn by erosion into a land surface with subdued relief called a peneplain. At first glance, it looks as if we are contemplating an ancient geological landscape, long frozen dead. Yet, the very absence of sediments and the surface roughness suggest otherwise. Besides, the lake is nearly 7,000 feet high, and the snow-covered mountain crests are above 11,000 feet. In actual fact, the entire landscape before us is rising. The clearest sign of movement is the left-leaning, snow-lined plane that reaches the summit: unquestionable evidence of tectonic tilt. Such tilting started at most a few millions years ago. Behind the crest, a thrust fault lifts up the ancient rocks of the whole mountain. Result: the initially horizontal surface of this slab of crust dips ever more to the left.

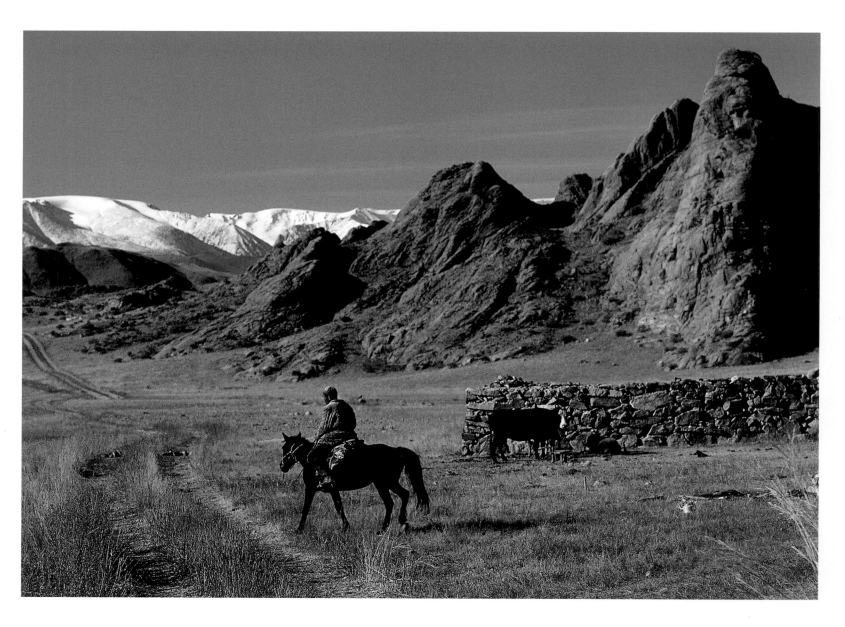

BAYAN OLGYI, MONGOLIA

A remarkably flat, snow-covered mesa looms above eroded red granites: such contrast typifies the western
Mongolian landscape.

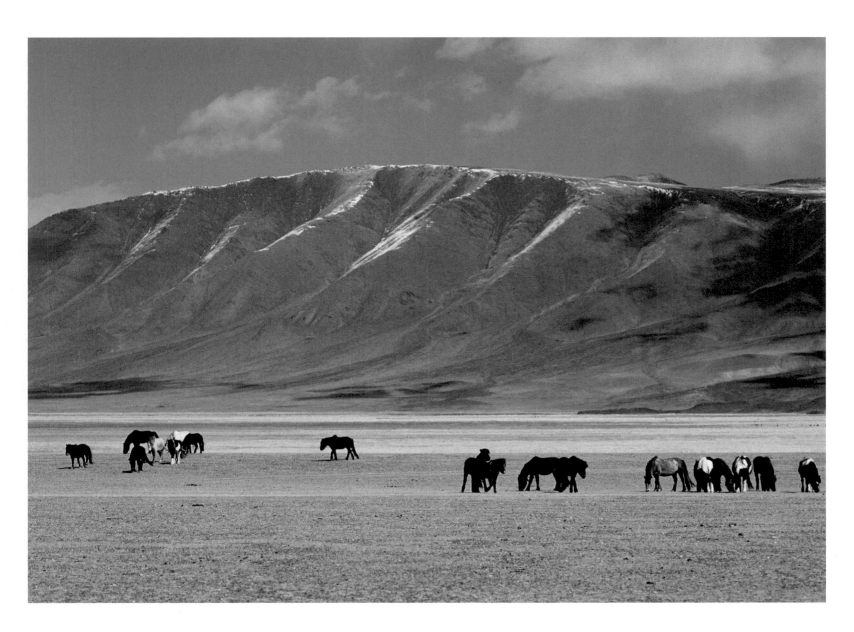

ACTIVE THRUST FAULT, HOVD AYMAG, MONGOLIA

Not long ago, the summit of this mountain table was level with the prairie where the horses graze. That was
before it was raised 3,000 feet by the thrust fault whose trace one can make out at mid-slope, where the alluvial
fan apexes meet the end of the gullies.

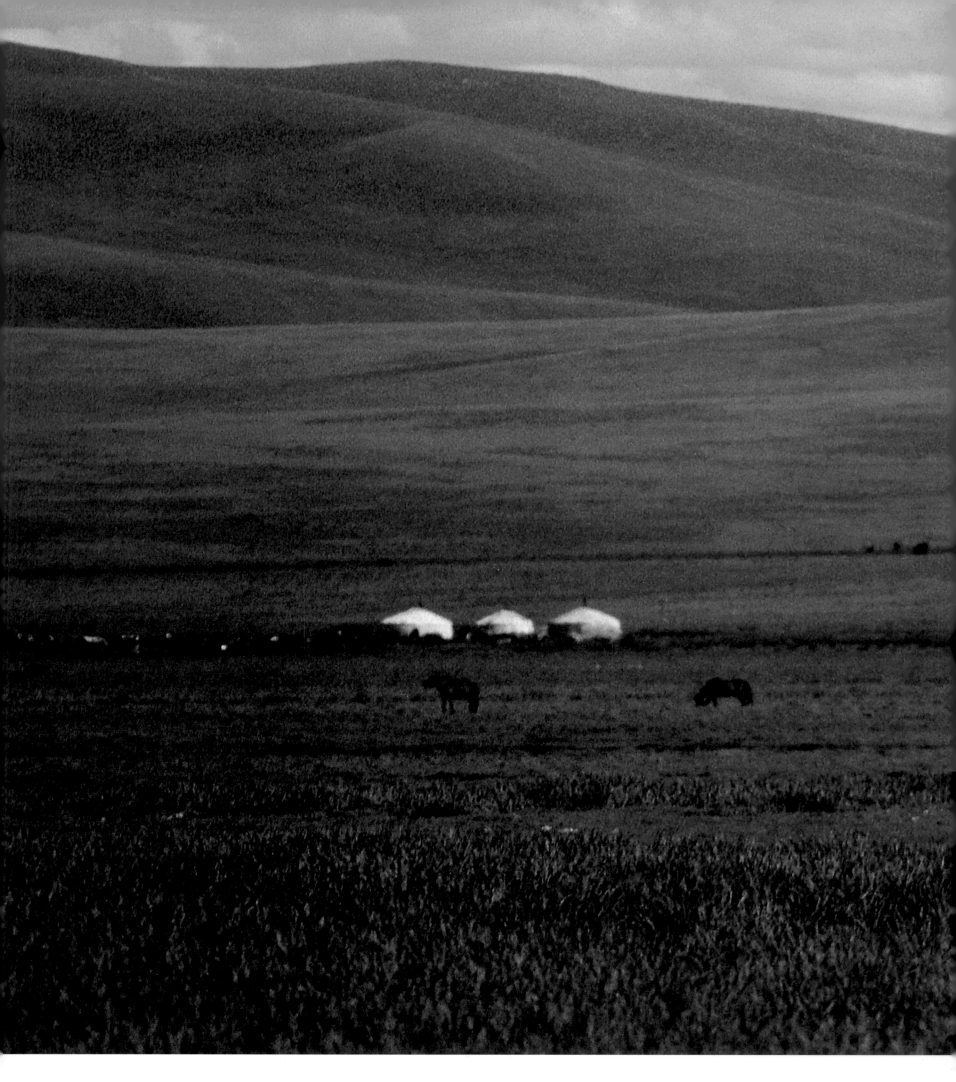

SUMMERTIME STEPPE, ARKHANGAY, MONGOLIA

In summertime, Central Mongolia's steppes turn into some of the world's richest grasslands. This is nomad land *par excellence*. A single large round *ger* (yurt) of white felt shelters an entire family. The *urga*—a long pole with a lasso at the tip—is used to drive unruly horses back to the fold.

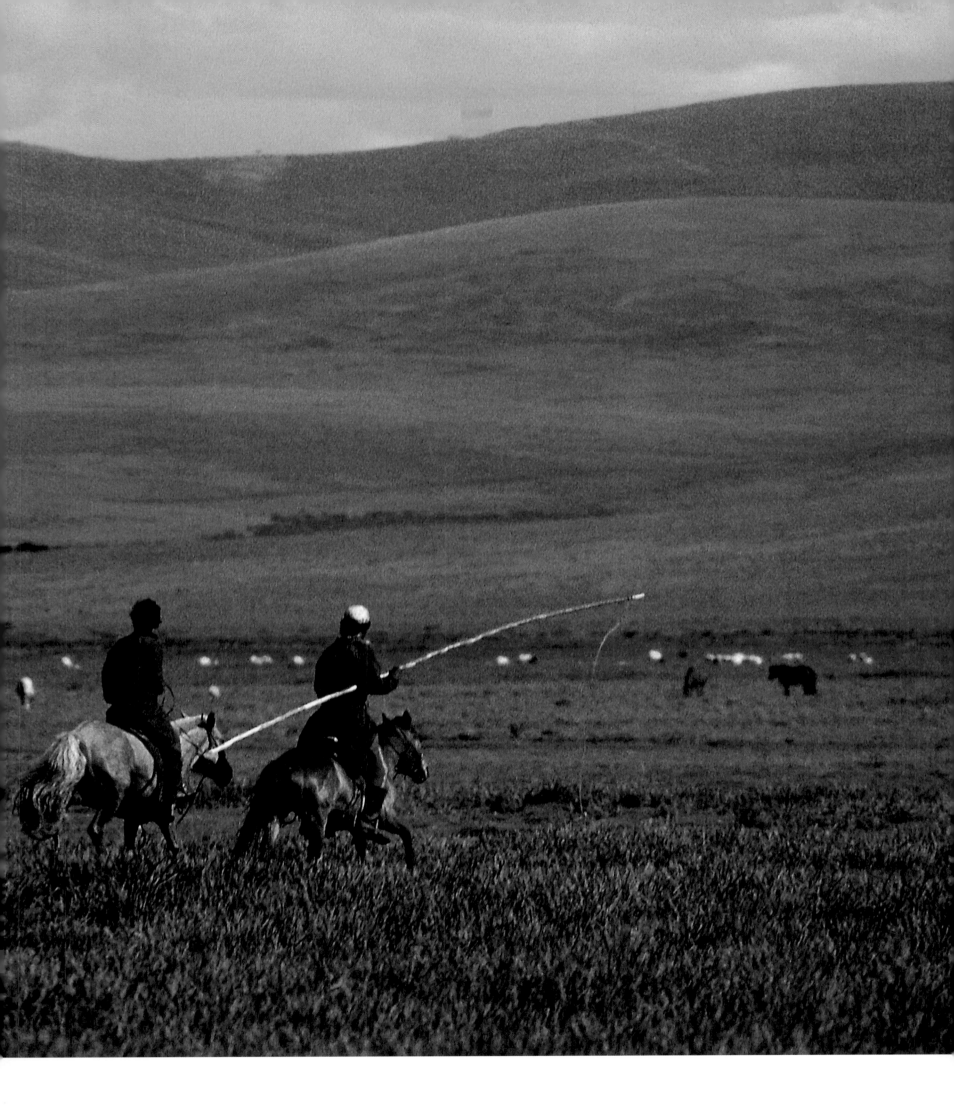

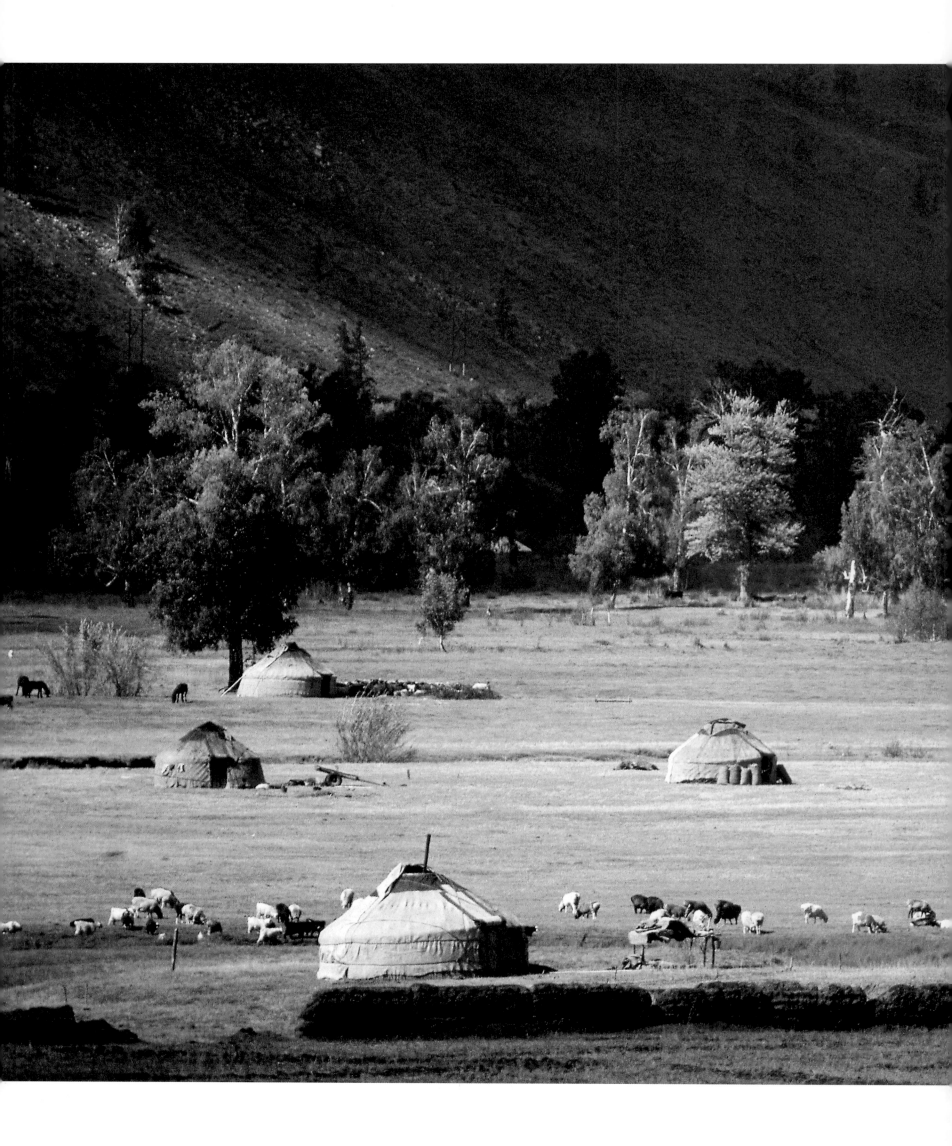

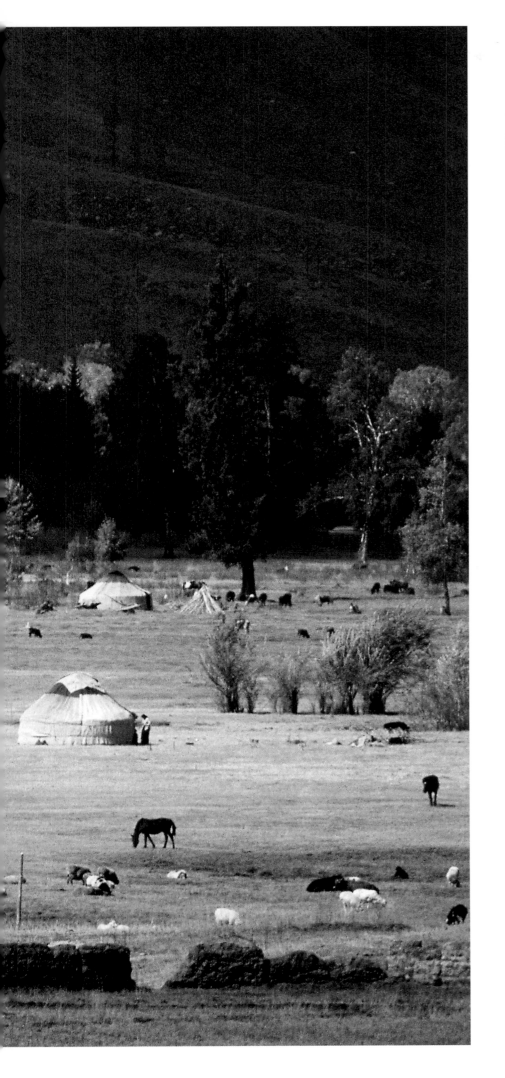

Hanging basin,
KAYIRTI, ALTAI, XINJIANG

Peaceful haven set between arid slopes, the small plain of Kayirti is a favorite resting place for the Kazakh nomads. Mid-mountain oasis shaded by large willows and aspens, this stopover on the seasonal herd migration path is a site of communal meetings and festivals. From spring to autumn, it teems with people and animals: camels, horses, sheep an goats, of course, not to mention huge, ferocious dogs, as well as hooded, chained golden eagles. Here, in late summer, the herders make the new felt, dense and warm, that will cover their yurts the following winter. Layers of combed wool are first soaked with water and compacted around shafts that horses drag round and round in the moist grass. The resulting mat is then pressed and rolled back and forth, under the forearms of each and everyone in the family, in the full warmth of the sun outside the yurts. Unbeknownst to the nomads, this well-watered, fertile enclave owes its existence to the passage of the Fuyun active fault. Earthquake after earthquake, the fault dams a little bit more the flow of the Irtysh river, whose headwaters spring just north, on the Altai summits. Repeated fault-slip slowly enlarges this small sediment trap. The price to pay is 100 seconds of cataclysm every 2,000 years, but under their yurts, the Kazakh have much less to fear than sedentary dwellers living in "hard" buildings.

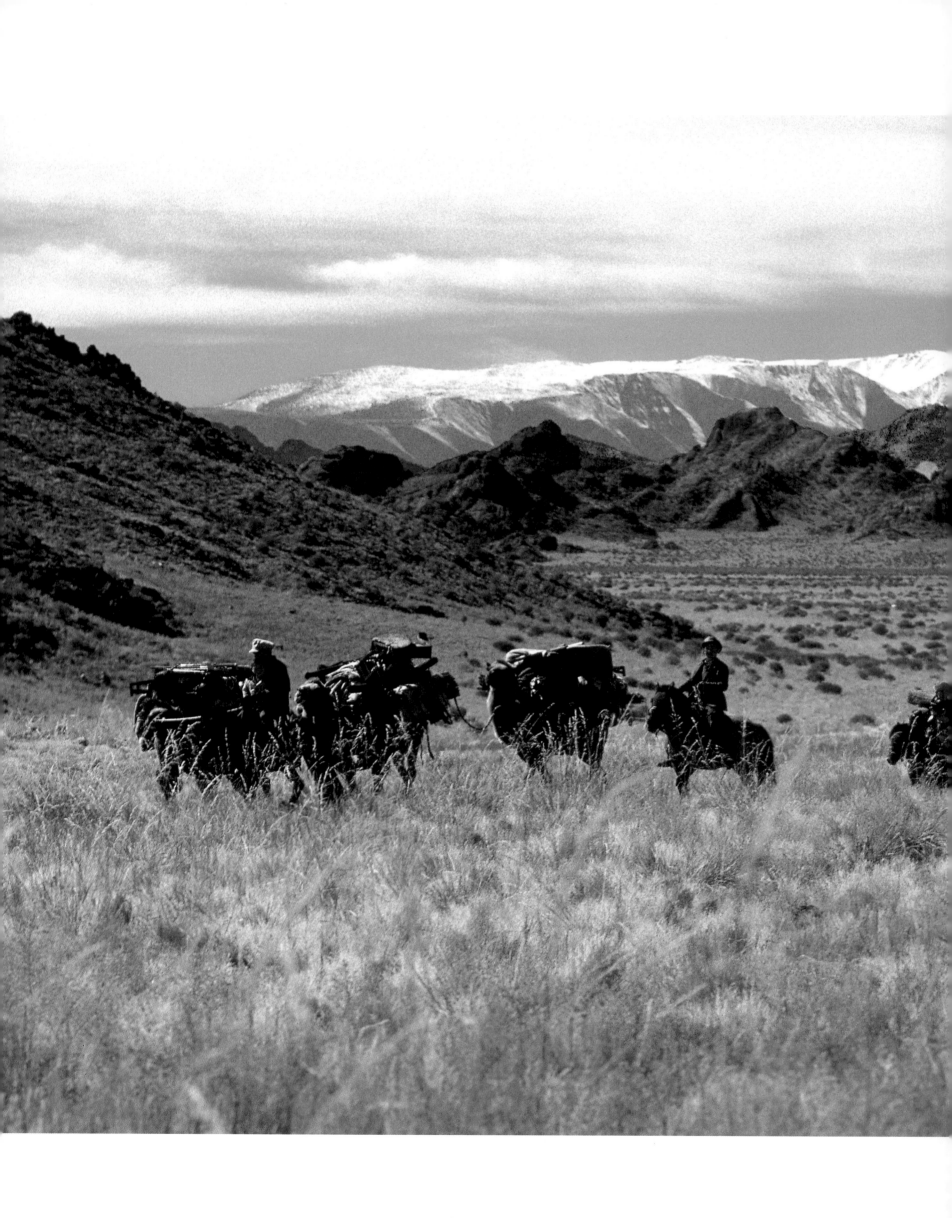

Table mountain, BAYAN OLGYI, HOVD AYMAG, MONGOLIA

The pastoral nomad family is making its way through bushes and reeds. From one campsite to the other, yurt, furniture, and food sit securely lashed between the two humps on each of the five camels. A day's journey is enough to cover the 10 miles or so separating good pastures, even though the path wanders through a maze of small crests of hard rock dotting the peneplain. Towering above the landscape, the mountain in the rear is crowned with an extraordinarily flat surface, already powdered with snow. A few millions years ago on the geological calendar, this high table was at the same elevation as the steppe upon which the caravan roams. It was part of it. In the China–Mongolia borderland, most of the mountains that rise in response to India's great push, 1,700 miles to the south, display such flat summits. Small crustal slivers heaved by thrust faults that have just awakened from a 300-million-year-long sleep, these ridges have not yet lost the stamp of their origin. Each mesa shrinks rapidly, nibbled away on all sides by receding gullies, but the remaining hanging flats testify to the youth of such resurrected relief.

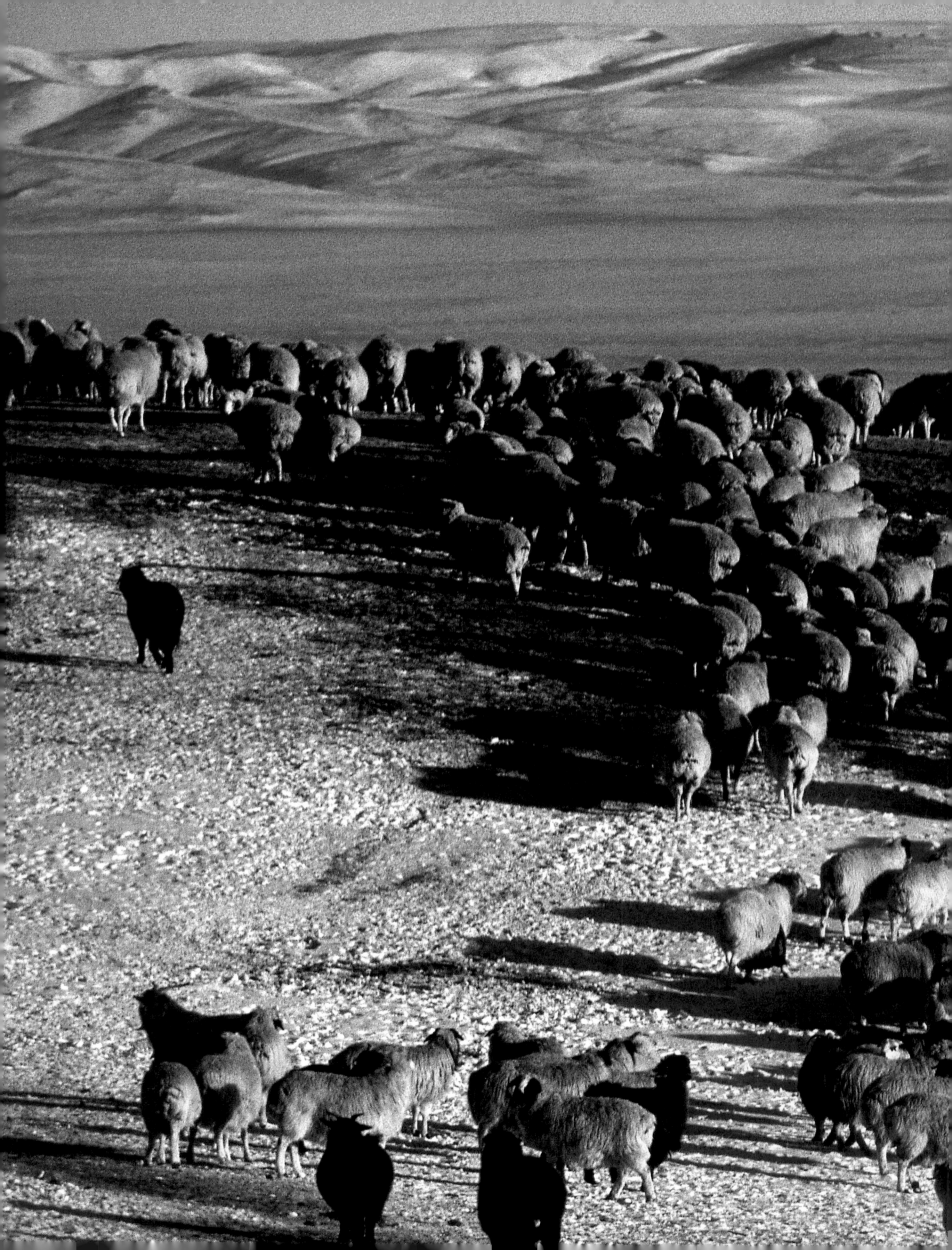

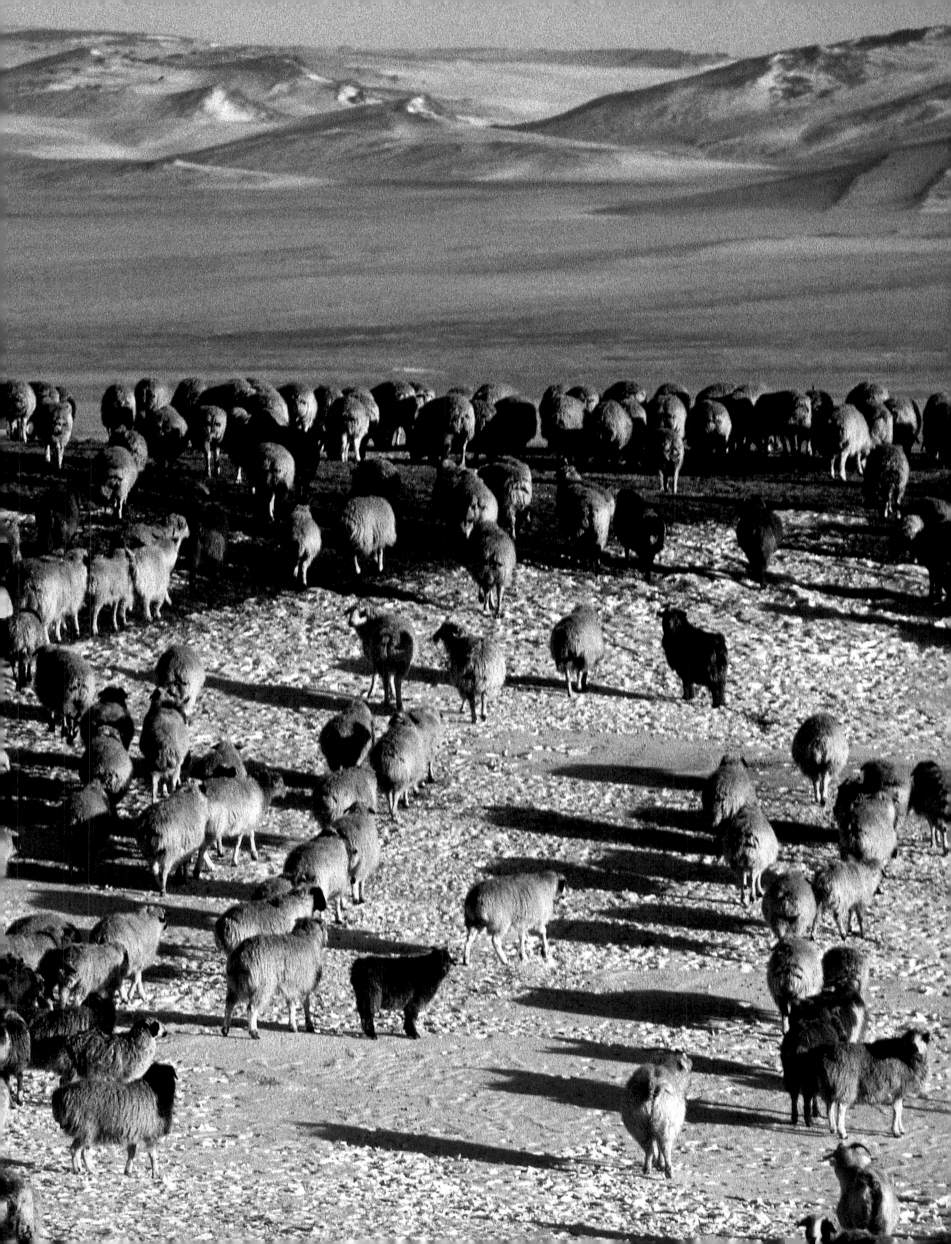

preceding pages

WINTERTIME STEPPE, ZUMMOD, MONGOLIA

Even when fully exposed to the steppe's fierce cold winds, the sheep, equipped with thick wool coats, are able to graze on the yellow grass hidden under the snow. During the dzuds, however, terrible winters with intense, long-lasting cold that freezes solid unusually thick snow, they can perish by the thousands.

REJUVENATED PENEPLAIN, HOVD AYMAG, MONGOLIA

Silhouetted against the evening light, a rider and his camel weave a path through metamorphic rock pinnacles. Beyond these small back-lit crests, looms the summit of a young mountain crowned with a fragment of flat plain: the unmistakable stamp of the rejuvenation of the Altai and Gov Altai landscapes due to the Indian collision.

NOMADIC SHEPHERDS, ARKHANGAY, MONGOLIA

In the steppes of Mongolia, the horse is king. It is here that the species flourished. Half wild, horses still roam freely in large herds. They remain the favorite mount of Mongol and Kazakh shepherds.

following pages

EDGE OF THE PAMIR, OYTAG VALLEY, XINJIANG

Soaring high above the oasis' poplars, the near-vertical slabs of vermillion and carmine-colored sandstones defend the approach of the Pamirs. The blazing colors result from the oxidation of iron, a process that takes time—here, about 140 million years. Long buried beneath miles of younger sediments, these steeply folded strata now override the gray gravels and sands that rivers continue to deposit in the Tarim basin.

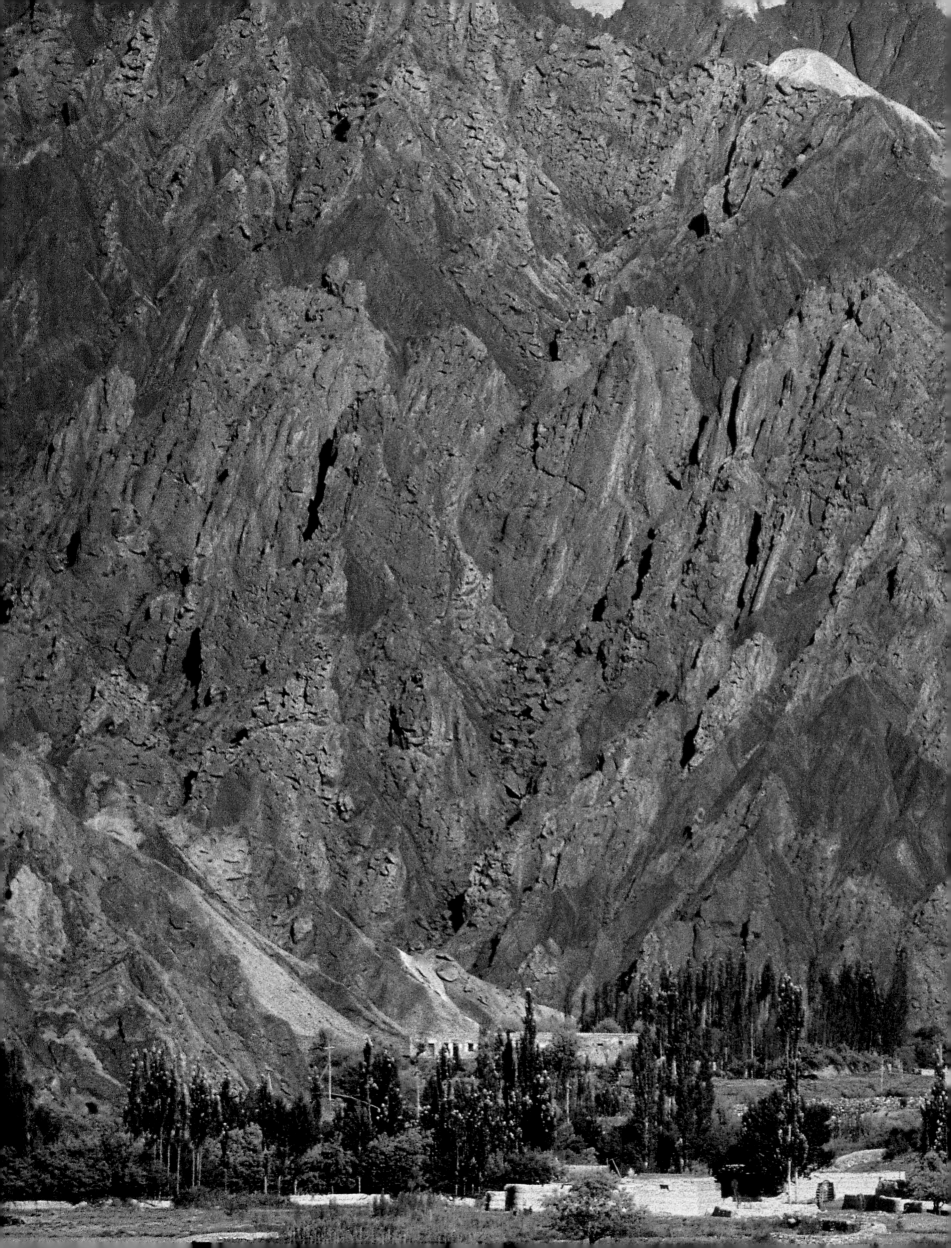

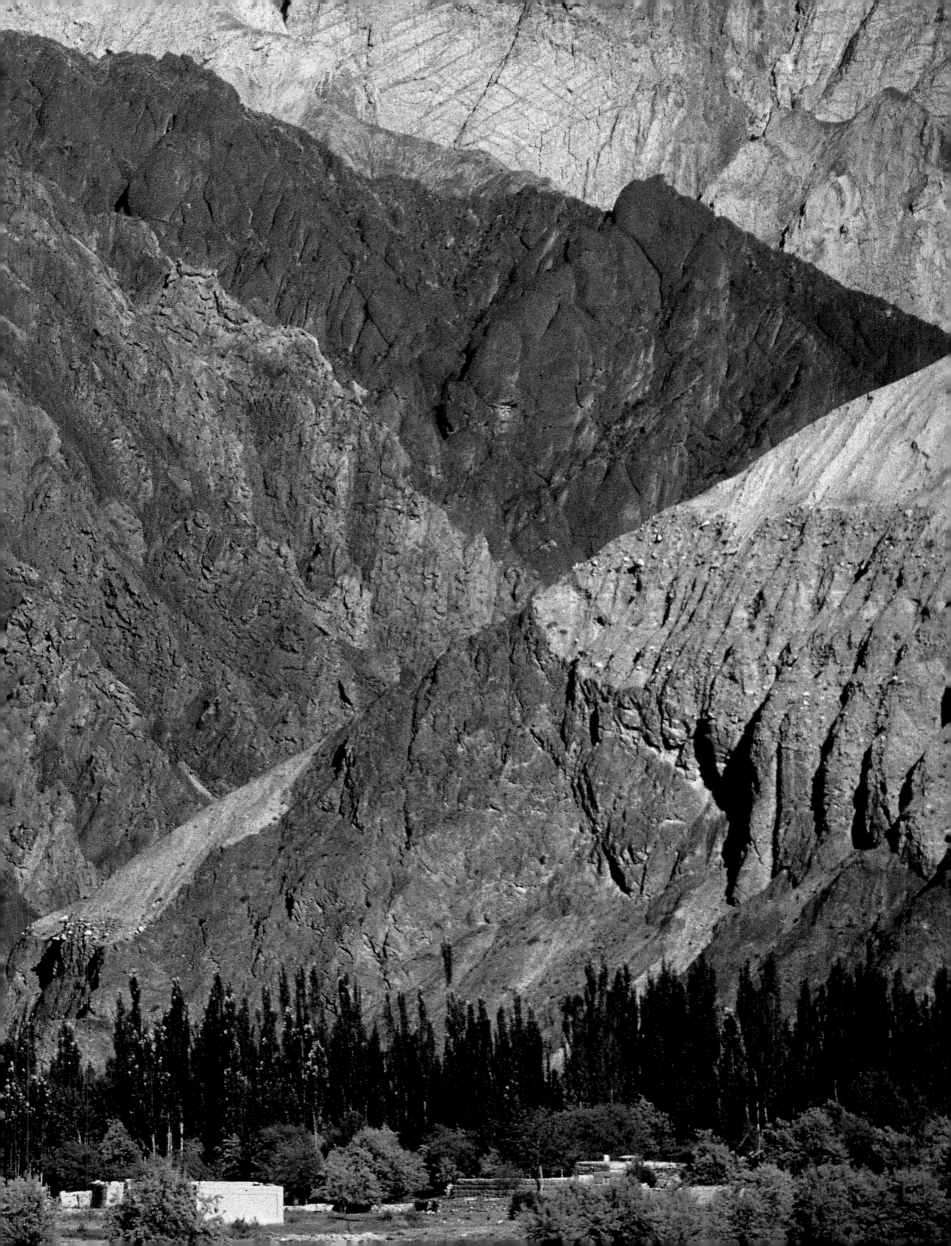

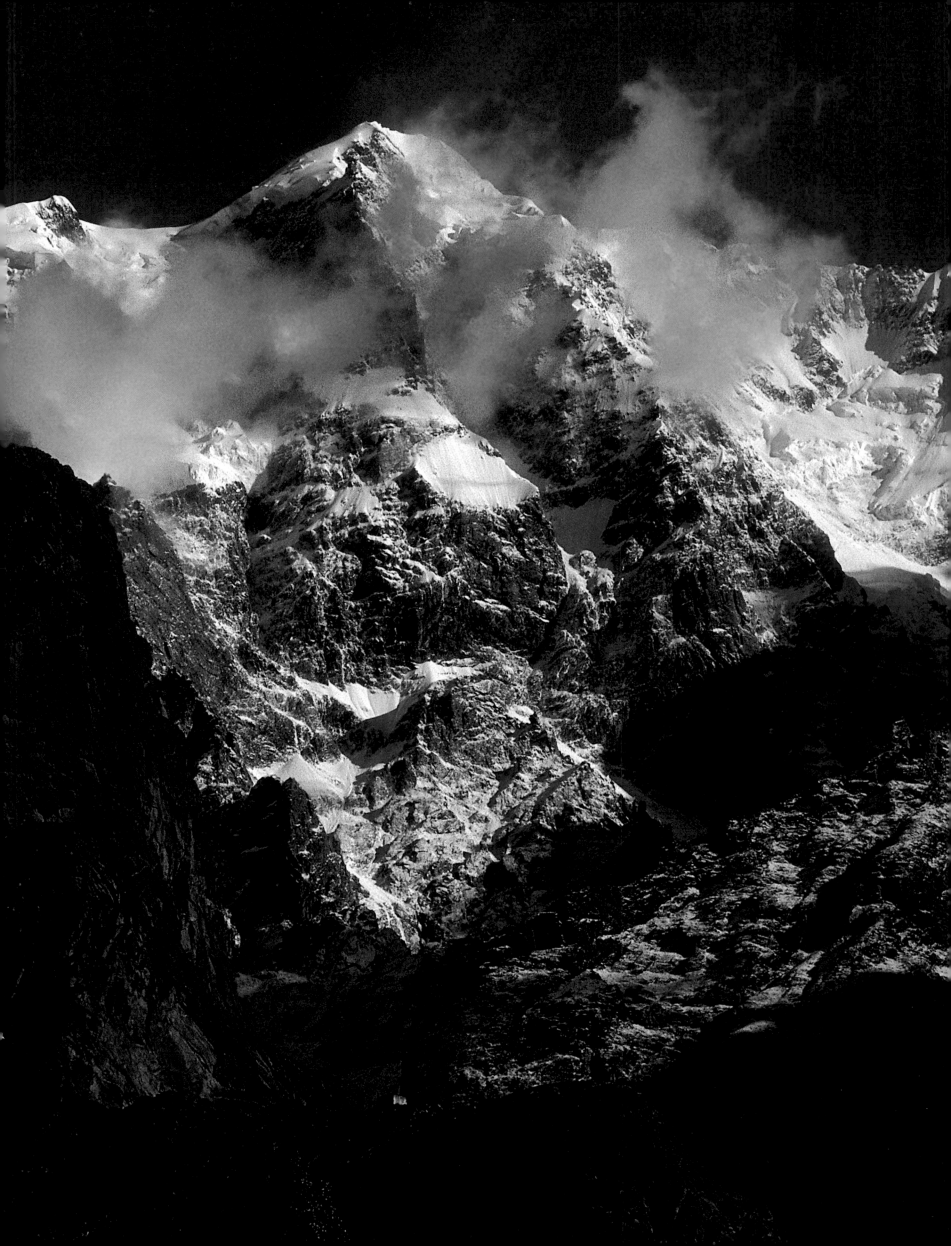

THE EARTH MACHINE, ARCHITECT OF MOUNTAINS

THE EARTH MACHINE, ARCHITECT OF MOUNTAINS

FOR NOW, WE CAN ONLY IMAGINE what other planetary systems must be like. Planets that have recently been discovered orbiting faraway stars excite the mind, but they are only specters, and likely to remain so for some time. Their surfaces, just a fantasy straight out of science fiction. Will we find mountains like the Himalayas or the Rockies? It's hard to say… In the meantime, we should enjoy our mountains. They may be unique.

In our own solar system, we now know that Earth is the only remaining architect of mountains or, to be more precise, mountain ranges. There are reliefs, on Mars, Venus, or the Moon, or on the large satellites of Jupiter, Saturn, and other gaseous giants. Even some very high reliefs, but more often than not, they are the result of impact cratering or volcanic construction. No mountain ranges on Mars, or cordilleras that the eye can follow for thousands of miles. On Venus, some long ridges, but apparently rather ancient. Why this singularity that makes our world unlike and more varied than others?

The term "mountain ranges" is often wrongly used to designate mid-ocean ridges, or the shoulders of the great continental rifts. But while volcanoes and high basaltic plateaus are like plastered "papier-mâché" additions, the reliefs associated with mid-ocean ridges and rifts might be labeled "anti-mountains," because the mechanism leading to their formation essentially creates negative vertical relief, by subsidence. First and foremost, a rift is a deep valley that deepens further until entirely flooded by great lakes (Lake Baikal or Tanganyika, for instance), then by the sea (as is the case of the Red Sea). There are, of course, false mountains and anti-mountains on Mars, Venus, and most other celestial bodies, since volcanism is a common process in the universe.

HEAT AND WATER: PLATE TECTONICS

A brief reminder of geophysics is sufficient to understand Earth's unique nature. In simplified terms, there are two essential elements: it is hot, and its surface is covered with water. It is large enough to have retained much of its initial heat, and to keep generating more. And being neither too close nor too far from the sun, it inhabits this miraculous "eco-zone" that guarantees the constant presence of water in liquid form on its surface. Since its birth 4.5 billion years ago, the Earth has been a stable thermal machine, well heated and efficiently cooled. Like a well-tuned engine that never stalls or races, it throbs and hums at a rather steady continuous rate. Because Mars is too small, its adolescent bursts of volcanic activity quickly fizzled out. On Venus, Earth's sister planet, they've lasted a long time, but with no organized pattern, creating a chaotic inferno shrouded by a dense, impenetrable atmosphere. Too close to the sun, Venus lost its water.

By contrast, the transfer of heat that keeps the engine running on earth is an exceptionally ordered process. From its core, as hot as 9000°F, to its surface, which is cooled to an average of 60°F or so, this process is orchestrated by the force of gravity. A contrast in temperature results in a contrast in density. What is hot, therefore lighter, rises (like a hot-air balloon), and what is cold, therefore heavier, sinks. This circulation of ascending and descending currents, called convection, organizes the transfer of heat. A circulation similar to the swirls you see in Japanese miso soup against the black lacquer background of the bowl. These ample currents slowly but inexorably churn the full thickness of the earth's mantle—nearly 1,900 miles —at speeds of up to about four inches per year.

Though the Earth's mantle constantly flows due to this powerful churning, it is not liquid as is often believed or depicted.

This is because, although extremely hot (above 2200°F), it is subjected to massive pressure (more than 30,000 atmospheres) and therefore cannot melt. Instead, it is a malleable solid, whose plastic behavior is comparable to iron when it is being wrought.

Solid and rigid, in part because quenched in the metallurgical sense of the word by the cold ocean water, Earth's outer shell, or lithosphere (rock sphere), is broken into plates: a dozen principal, well-known plates, and a few smaller ones. On the surface of a mantle that is perpetually tossed by convection, the plates can do nothing but "dance." Their ballet never ends: they separate, they slide, they come together and inevitably collide. This is *plate tectonics.*

Plate boundaries are narrow, and run continuously for thousands or even tens of thousands of miles. They are remarkably stable, and can function steadily for tens of million of years or more. Why such localized activity combined with such longevity? First of all, because there is water, one of whose properties is to soften and lower the melting point of all rocks. But also, more specifically, because plate tectonics operates in a way that maintains a constant surface area. The oceanic lithosphere—which is continuously created by partial melting of the mantle along the axes of "oceanic ridges" (the mid-ocean basaltic cracks on either side of which plates move apart)—is continuously recycled along other zones where it plunges back into the mantle from which it was originally born. The latter zones are called "subduction zones" from the Latin "to lead underneath." A similar process is illustrated by the pattern of rafts of frozen basaltic crust at the surface of lava lakes. The rather steady positions of both the creation and the plunge zones ensures the stability of movements, at least in the middle and at the edges of the oceans. The birth of a new plate boundary, while sometimes necessary, is such a rare phenomenon that, today, it is hard to find more than two or three examples around the globe. The mosaic of the Earth's plates and their movements are thus well defined, and this surface order contributes to the maintenance of the subterranean order.

It is plate tectonics which sets the dynamics of our planet apart. Although geologists specializing in the early history of the Earth—a period made obscure by the paucity of evidence—are not fully in agreement, this unique operating mode was probably bestowed at birth, as was the global ocean which we now know formed almost immediately, in a few tens of millions of years. A mechanism dictated by the very presence of this ocean. Plate tectonics probably couldn't exist without a watery envelope to quench the plates. No such well-ordered and long-lasting mechanism is observed on any of our planetary neighbors.

The deformations of certain Archean rocks (more than 3 billion years old) have been interpreted as incompatible with plate tectonics as we understand it now. Nevertheless, the geochemistry of the oldest zircons (older than 4.2 billion years) is concordant with the cycles observed at present. The engine of the earth as a young planet, likely hotter and more dynamic than today, may have run faster, but probably not differently.

CONVERGENCE, SUBDUCTION, AND "FALSE" MOUNTAINS

Mountain formation, either directly or indirectly, is the work of plate tectonics. Therefore, it is no surprise that Earth displays many mountain ranges, while few if any can be found elsewhere. The basic mechanism is quite simple. The theme is always the same, with only a few variations.

Mountain ranges form only where two plates or, on a smaller scale, two large blocks of Earth's crust come together. There can be no vertical growth without horizontal convergence. In mountain ranges, the whole dynamic of rock and relief uplift is based on converting horizontal shortening into vertical rise. Quite unlike what one still sees in most animations, real mountains do not sprout up like mushrooms, rising without any other change to their surroundings.

Obvious? Not as much as you might think. Only 30 years ago, other ideas were still very much in the mix. Certain theories even postulated that only gigantic vertical "pistons" could have pushed up these colossal masses of rocks from the depths of the earth!

The convergence of two plates invariably leads to one plate diving under the other. There can be no other outcome.

The diving plate, the one sinking into the mantle, is the denser of the two. In practice, and all things being equal, it is also colder. Specifically, it is the plate that has had the most time to cool down: the older of the two. The boundaries along which the plates converge and dive—the "subduction zones"—are therefore the principal construction sites for the earth's mountains. In order for them to grow long and wide—remember the Himalayas and the Andes are 1,500 and 4,300 miles long, respectively, and that their width ranges from 125 to 250 miles—it clearly takes time. In the realm of plate tectonics, time is not a problem. Given that the process of subduction along a convergent boundary can continue for tens of millions of years, all the necessary time is available to build a chain as long, wide, and high as the most majestic we know.

Is subduction then a factory for mountain-building? Yes and no. It is not quite as simple as that. First off, we must acknowledge that, in general, the most common subduction zones—the oceanic subduction zones—do not really produce mountains. They are the most numerous and longest of subduction zones, where convergence is the fastest, since the oceanic lithosphere, which is nearly always denser than the continental lithosphere, whose thick crust is light, is generally "ready" to sink. Look at the Mariana Islands, the Philippines, Japan, the Kamchatka Peninsula, the Aleutian Islands, Sumatra, Java, and the Antilles. None of these typical subduction zones—along which large slabs of the Pacific, Indian, and Atlantic oceanic lithospheres dive—is the site of high mountain ranges. Instead, they are distinguished by strings of islands whose volcanic summits rise above the ocean, or rows of active, young, and old volcanoes that pile up at the edge of a continent. Oceanic subduction zones, then, generally give birth to "false" mountains. This is because most oceanic plates dive quickly and in their entirety. As they descend into the mantle, they drag down their thin, water-soaked basaltic crust, which heats up and melts, producing magma in abundance.

CONTINENTAL COLLISION: A FACTORY FOR MOUNTAINS

A different process occurs when a continental raft is dragged into a subduction zone. Take the case of India, for example. Once a large island like Australia is today, India was situated on the southern edge of an ancient ocean dubbed Thetis by geologists (after the Greek nymph, daughter of Nereus and mother of Achilles). Once a vast ocean, separating Asia from India, Thetis' only remnants, doomed as well, are located north of Libya and Egypt, in the eastern Mediterranean. For tens of millions of years, the Thetis oceanic lithosphere plunged under Asia, pulling the Indian island along on this northward journey. During this time, the Asian continent's edge witnessed plenty of volcanism and large granite intrusions, but no real mountain building.

Remember that the boundaries between continents and oceans are not plate boundaries, in general. In the past, for instance, the Indian plate included half of Thetis' oceanic lithosphere north of the Indian subcontinent. Today, it includes the northern half of the Indian Ocean, north of the Indian oceanic ridge. Let us recall, as well, that the lithosphere is not the earth's crust. To make things simple, it is a layer of cooled mantle (typically 45–60 miles thick), surmounted by either a thin oceanic crust of dense basalts (about 4 miles), or a thicker continental crust of light granites (approximately 20 miles). This radical difference between continents and oceans, unique to Earth, is a direct result of plate tectonics.

The mountain factory does not really start until the edge of India comes into contact with that of Asia. This is the beginning of continental collision. Contrary to what usually happens when a small object rams head-on into a larger one, this initial shock did not stop the continent's motion. It merely slowed it down. The lithosphere of India continued to dive, a descent it is logical to call "continental subduction." However, India's crust, roughly 30 miles thick, resists downward motion. It is too light. Once again, it is a matter of density.

Rather than following the downward "conveyor belt" of its own mantle, the buoyant Indian crust, scraped off by the edge of the Asian plate, stays on the surface. Imagine a carpenter's plane (Asia) sliding over a board (India) and shaving

off a huge flake (a sliver of India's crust). This is an easy *décollement,* because the continental crust is poorly welded to the mantle. Granitic rocks at the base of the crust are sufficiently hot, and thus soft, to offer little resistance. Think how easily a slice of cheese slides on a piece of bread if there is butter spread between the two. Or how smoothly a carpet slides over a waxed floor. The relative lightness and the weak bonding between the continental crust and the mantle are the two keys of mountain building. Result: most of Earth's mountain ranges are made from slivers of continental crust. And not a single real mountain range is made only from slivers of oceanic crust.

The boundary separating the crust and the mantle is a chemical interface between two layers of very different rocks. This interface is named the Mohorovicic discontinuity, or "Moho," in honor of Andrija Mohorovicic, the Slovenian geophysicist who discovered it roughly a hundred years ago. Above the Moho, rocks are richer in silica and have granitic chemistry. Below, they are richer in iron and magnesium, the typical rock being peridotite. When crossing this interface, the velocity of the fastest traveling seismic waves (P waves) increases abruptly from about four miles/sec to five miles/sec, while density increases from about 2.7 g/cm³ to 3.2 g/cm³. The "normal" continental Moho (i.e. of a continent whose surface is just above sea level) lies 20 to 25 miles below our feet. Above the Moho, in a layer several thousand feet thick, the normal geothermal gradient (the increase in temperature as a function of depth) leads to temperatures close to 1100°F, at which granitic rocks are easily deformed, hence the above comparison with butter. It is at this level that crust and mantle detach from one another.

The initial flake, the first sliver of crust detached from the mantle, has no choice but to ride over (overthrust) the surface of the Indian crust still intact farther south. The first great Himalayan thrust fault is born. The ride of this crustal sliver initiates the transformation of horizontal convergence into vertical uplift. You can't have mountains without thrusts, the only type of fault able to bring about this transformation. Soon

after impact, therefore, all the mountain-building gears are in place, as is the raw material. The assembly line is rolling. The Thetis Ocean has given way to a narrow suture zone outlined with shards of mantle and basaltic crust. And the continental crust of the still subducting plate begins to thicken.

It would be tempting, at this point, to think we've covered all the bases. Not quite … Because unlike the well-oiled regime of oceanic subduction, continental subduction, and the related production of mountains, cannot proceed without adjusting to the changes that result from the very growth of mountain ranges. It is a process punctuated by skips, jolts, jumps, and migrations, under the harsh dictatorship of gravity. Nothing can escape this force, especially mountains, which weigh so much.

THE ALTITUDE OF MOUNTAINS, CONTINENTAL ICEBERGS

Mountains are high by definition. But why do they stand at the altitudes that we're familiar with? A little higher than 15,000 feet in the Alps, the Caucasus, the Zagros, or the Altai. A little higher than 26,000 feet in the Himalayas. A little higher than 20,000 feet in the Andes, Tian Shan, and Kunlun ranges, and in Alaska. Why aren't they higher?

Back to the example of the crustal sliver that overrides continental India. Since it peeled off from the mantle just above the base of the crust, its thickness is on the order of 20 miles. If such overthrusting continued, it would eventually pile nearly 20 miles of crust on top of India. The result would be a mountain over 98,000 feet high! This is obviously not the case.

Mountains behave a bit like icebergs in the ocean. Ice floats, as it is slightly lighter than water. But everyone knows that the submerged, hidden part of an iceberg is far greater in size than what we see above water, as the tragic sinking of the *Titanic* illustrated. The higher the visible tip of the iceberg, the deeper it reaches. Archimedes' principle, the hydrostatic law governing the balance of depth and pressure in fluids, also applies to geophysics. It is called isostasy. The lighter continental crust "floats" on the higher-density mantle. As with icebergs, the altitude of a mountain is isostatically

compensated by a root, and the higher the mountain the deeper the root.

> *For a continental crust whose average altitude is close to sea level, the base of the iceberg—the Moho, the crust-mantle interface—is at a depth of about 20 miles. The relationship between altitude and depth of the Moho depends only on the relationship between the densities of the crust and the mantle. For a small relief of about 6,500 feet, the Moho sinks to a depth of 28 miles. Beneath a higher mountain range, 16,000 feet or so, it sinks to approximately 45 miles.*

This is what happens to the sliver of Indian crust piling on top of India, a superposition that increases the crust's thickness twofold. With isostasy, everything comes back to normal. No more reliefs four times higher than the Himalayas, given that a 45-mile-deep Moho corresponds to a mountain range about 16,000 feet high. The order of magnitude becomes plausible again. Remember that, since the 26,000-foot peaks of the Himalayas are separated by deep valleys, the average height of the whole range is greatly reduced. In mountains, therefore, most of the crustal thickening and mass is in the root, as sensed as early as 1740 in the Andes by Pierre Bouguer, father of the isostatic theory, who first observed that a plumb line deviates from the vertical at the foot of a high mountain.

More than a century later, Astronomer Royal George Airy quantitatively elaborated on this theory. And it remains one of the pillars of modern geophysics, although with substantial modification. Indeed, the iceberg analogy is imperfect: while an iceberg floats freely in the water surrounding it, a mountain range is connected to its neighboring regions. We must therefore substitute a "regional" isostasy for the iceberg's "local" isostasy in order to take this interdependence into account. Once again, let us refer to the example of the plunging Indian plate. Like a steel blade, the subducting plate bends under the enormous weight of the huge crustal sliver that rides over it. For each kilometer of length of the range, this weight is approximately 4,000 billion tons for a sliver 100 kilometers wide! The effect of such elastic bending is a distribution of the isostatic compensation of the relief over a broader area transverse to the range. Thus, the whole plate supports the weight of the range. The counterpart of the bending is the creation of a "flexural" basin in front of the range: a deep trough, where India is most strongly pushed down. This is the Ganges basin. Similar foreland basins border most mountain ranges. In addition to the Indus–Ganges plain south of the Himalayas, there is also the Danube basin, north of the Alps; the Po basin, north of the Apennines; and the Mesopotamian basin, south of the Zagros belt, to mention only four. These great basins, which often reach depths of more than 10,000 feet, fill with most of the debris torn from the mountains by erosion. Because let's not forget that erosion also contributes to reducing the height of mountains.

THE WIDTH OF MOUNTAINS AND ALTITUDE SICKNESS

Under most mountains, the observed depth of the Moho (30 to 45 miles) indicates a twofold increase in crustal thickness, at the most. Except in rare areas, the temperature and pressure recorded in minerals from exhumed rock samples show that the depth at which they were buried does not exceed these values. Why would collision only double the normal crust rather than triple it, or more? It seems that, notwithstanding isostasy and erosion, there is a limit to how high mountains can reach.

The act of climbing higher and higher, whether up a ladder or a slope, is exhausting. One must fight against the force of gravity that is pulling everything down. The effort— the work—of the cyclist climbing up the hairpin turns of a pass is stored as gravitational potential energy, which increases as he ascends. When he coasts down the other side, it is this energy, this capital, that he spends in his descent. The potential energy is converted into kinetic energy, propelling him, this time without effort. However, even the best racers have their limits and cannot climb indefinitely higher. It is the same for mountains. Tectonic forces that raise rocks up into the atmosphere, or push the light continental crust down into the mantle, work against gravity. There are enormous quantities of potential energy stored in the reliefs and roots

of mountains. Even in the most dynamic collision zones, the amount of energy required to further raise the highest peaks will eventually run out. There is, however, always enough to start raising lower areas of the foreland. Convergence can thus continue.

Rather than grow indefinitely, mountain ranges, therefore, tend to broaden—it's easier. Once again, it's gravity that sets the limits. To accomplish such widening, the bordering thrust faults migrate into the foreland with a series of successive jumps. Typically, an "old" thrust fault wears itself out when it reaches the respectable age of 10 to 15 million years. Too exhausted to raise its rock burden any higher, it abdicates and is supplanted by a younger thrust, which slices off a new sliver of intact crust in front of the already high mountain range. Uplift by this second fault will ultimately unroof the first, exposing the rocks it has sheared, flattened and folded at depth. These are the deep metamorphic rocks (i.e. transformed by heat, pressure, and deformation) found in the heart of all mountain ranges (commonly schists, marbles, and gneiss) in what are called *internal zones*. Meanwhile, hidden thrust action continues farther out in the foreland, beneath the *external zones*.

This law of nature can be observed everywhere. In the Himalayas, the Alps, and elsewhere. We see this evolution as we descend from the "crystalline" (internal) higher Himalayas at the base of which one finds the laminated gneiss forged by the now-dead first thrust fault (Main Central Thrust, or MCT), which heaved up Everest, Annapurna, and their neighbors. Continuing down toward the "external" Siwalik folds, we cross Central Nepal under which the now-active thrust fault (Main Frontal Thrust, or MFT) is diving. Today, it is this fault that is busy propelling Katmandu upwards. We see the same when passing from the metamorphic "internal" Italian Alps (Monte Rosa, Matterhorn, Gran Paradiso), to the "external" massifs (Bernese Oberland, Mont Blanc, Oisans), then to the pre-Alpine and Jura folds. Even in Taiwan, a small, young, and frisky collision mountain at the outer edge of China, we are already seeing a migration of the most active thrusts into the foreland, as the great Chichi earthquake reminded us in 1999. No surprise,

since on the Pacific side, the range is already over 13,000 feet high.

BABY MOUNTAINS, CLONING, AND SPONTANEOUS GENERATION

Without exception, mountains are the offspring of earthquakes. In human time, their growth occurs in jolts, infrequent but violent. Several meters with each big quake. One or two earthquakes per millennium. These small increments accumulate bit by bit. The typical rate of growth for a mountain is thus just a few millimeters per year, or a few thousand meters per million years, and a little less where erosion is strong.

It is these seismic jolts that tear the naked steppe and produce the gradual emergence of the smoothly shaped folds at the foot of the ranges of Central Asia. The mechanism we see at work here is precisely the migration discussed above. It orchestrates the widening of an already-mature range. A young thrust, propagating stealthily beneath the foreland's thick sedimentary deposits, surfaces farther away from the range and gives birth to a new ridge where once there were only gentle alluvial fans. This type of "birth," the most commonly observed, is actually just a form of cloning. The original range already exists and does nothing more than graft itself onto the surrounding plain.

Examples of true birth, in areas that are flat for hundreds of miles around, with no mountain ranges in sight, are much more rare. However, for those flying over the remote borders of China and Mongolia, scanning the landscape below with the third eye, some unusual clues betray this type of birth.

The *gobis*—deserts paved with pebbles rather than covered with sand—make up more of this vast region. In some places, the veneer of pebbles is so thin that it barely hides the subjacent rocks: an ancient bedrock exposed without its make-up, with its vertical dykes and abraded granitic plutons piercing complexly folded sediments; a platform whose surface was planed to near flatness over countless millions of years. Such monotonous landforms chiseled from hard rock are called peneplains. In the spring or fall, when it is cold enough for the snow to coat only the tops of the mountains,

peculiar, perfectly flat summits stand out. Viewed from above, they resemble islands, with the "fractal" complexity of their edges recalling that of shorelines. These mesas, Barkol Tagh, Gichgeniyn Nuruu, Ikhe Bogdo, already stand 10,000 or even 13,000 feet high.

Perfectly flat tabletops hewn from the same hard and timeworn rocks as the surrounding peneplain? There's only one possible interpretation: these mesas are blocks of peneplain that rose up as intact pieces, like the keys of a piano. In general, one side of the table is bounded by a steeper cliff, at the base of which runs one of the ancient faults that lacerate the peneplain. The flatness that characterizes the summits of these small mountains—small because the whole region is already approximately 5,000 feet high—is nowhere as evident as in southwestern Mongolia. In fact it is the rule. Some blocks are both uplifted and tilted, their surfaces gently inclined away from the fault.

What we are witnessing here is truly the "spontaneous" generation of reliefs in the midst of an old and stable craton smoothed by erosion over hundreds of million of years. A true birth in the middle of a flatland. Or should we say "rebirth"? What causes this exceptional event? At more than 1,500 miles from the Himalayas, Mongolia is located right where the push transmitted by the collision, which is progressing inexorably northwards, has finally reached the threshold necessary to resuscitate long-dead faults. It all starts with many small overthrusts and small mountains. Only a few of these faults will ultimately grow and spread out to connect the weakest zones, eventually giving birth to just one or two large ranges. It is likely that the Tian Shan and the Altai, both very far from any plate boundary, were born in such a manner. In Central Asia, it's not already established subduction that ends up creating a mountain range, but the range itself that heralds the birth of a deep subduction zone hidden under the deforming crust.

INDUSTRY AND CRAFT:
THE ASIA–INDIA FACTORY

We can only marvel at the mountain-building productivity of East Asia. But why there rather than elsewhere? As we come to a pause in our explanatory journey, we are now better equipped to retrace the unfolding of the most spectacular collision ever between two continents. Once separated by 2,500 miles of ocean, today welded together. It is an extraordinary saga, told in multiple episodes, that puts an end to an unbelievable odyssey across the equator. It has no equal in Earth's recent history.

The story begins with the initial break-up of the southern supercontinent, Gondwanaland, and the subsequent opening of new oceans, including those that became the present-day Indian Ocean. Like huge cracks in an ice shelf, rifts first propagate, then widen and deepen. Separated by new seas, the four continents of the southern hemisphere and India are born. Then comes the rapid demise of the original Thetis Ocean, subducted under the southern edge of Asia. So, drawn into the adventure right from the start, 80 million years ago, India—along with neighboring Australia—engages in a mind-boggling journey. At a rate of nearly 50 feet per century, it races north, covering 2,500 miles in 25 million years!

The great encounter begins 55 million years ago. For roughly 1,800 miles, the sub-marine edges of India and Asia weld together and surface rapidly. Asian mammals swiftly invade India, annihilating the endemic fauna of marsupials that safely basked on the vast island. Isolated remnants of the engulfed Thetis Ocean, identified through diagnostic green rocks ("snake stones" or ophiolites), lie wedged along the suture zone that nowadays channels the Indus and Yarlung Zangbo rivers.

This, however, is only a prelude. The collision of the two plates does not stop India. Nothing like a car crash! Its velocity, relative to Siberia, Asia's stable part, slows only from four to two inches per year. Like a battering ram, India continues to smash into the continent that it has just encountered. In order to reach its present geographic position, it still needs to penetrate an additional 1,500 miles! The only feasible strategy is to clear the way. So, like a snowplow, India pushes huge slices of the continent aside, toward the Pacific. First and foremost, it shoves Indochina out of the way, which is forced to slide 500 miles southeastward, past China, along the Red River fault.

The Indian mantle continues its downward plunge, even more slowly, diving at an average rate of nearly one inch per year. Its crust is being scraped off by the edge of the Asian plate, as if by a bulldozer. Overlapping slivers of crust pile up on top of one another. In the last 25 million years, this crustal stacking has built the Himalayas, whose summits now defy the jet stream. Melting of the buried slivers of crust has produced silica-rich liquids that crystallized, forming the most emblematic Himalayan rock: a white granite speckled with tourmaline prisms. Erosion continues to sculpt the sheer faces of the high Himalayas. The resulting debris is carried to the ocean and eventually builds up the underwater deltas of the Ganges and Indus rivers: huge, unstable hills of mud that collapse in silent avalanches, cascading across the ocean bottom as far as 600 miles offshore.

And we haven't yet reached the end of the story. One would think that the combined actions of the snowplow and the bulldozer would have sufficed for India to penetrate the 1,500 miles into Asia. Far from it. Hundreds of miles remain unaccounted for. For the most part, they've been concealed beneath the Tibetan plateau. Under its thick crust, three ancient suture zones—fragile scars in the continent squeezed in a vice—have given way, one after the other, north of Lhasa. Each one in turn has absorbed large slabs of Asian mantle. Blocked by the mountains born above these hidden subduction zones, large rivers have been kept from reaching the ocean. They were forced to deposit their load of sand and mud in closed inner-mountain basins, thus explaining the construction, in three stages, of the high Tibetan plateau—flat as the plains of Northern Europe but 15,000 to 16,500 feet above sea level: a first plateau in the south, contemporaneous with the beginning of the collision; then, a second at the center; and finally, a third, still unfinished, to the north. There, Tibet continues to grow at the expense of the Gobi Desert. Today, in the Qaidam, a flatland covered with salt marshes, one can witness the architect, Earth, working with its two tools: tectonics and sedimentation. The result is a small plateau that is barely 10,000 feet high, but that, for 6 million years, has been rising at full speed, with sediments filling up the space between the ranges that encircle it!

Finally, we must not forget, yet farther north, the young ranges of Central Asia: the Tian Shan, the Altai, and other Mongolian mountains. Some are still just "babies" whose births, still in progress, help to clarify the origins of all the others.

If this saga continues at the same pace, and if erosion does not take the upper hand, the face of Asia will be unrecognizable. In 50 million years, India will have shrunk to one-third its size. The Himalayas will tower over Bombay and Madras. The Tibetan plateau will have swallowed Central Asia almost up to Siberia, doubling in surface. And to top off this cosmetic transformation, Mongolia, North China, and Manchuria together will form a new peninsula between two new seas— extensions of the Yellow Sea and the Sea of Okhotsk into the heart of the continent.

In the Mediterranean and elsewhere, Earth has set up a few small workshops. Short-lived or temporary ventures, they turn out the occasional artisanal product. In Asia, by contrast, it runs an enormous mountain factory, operating at an industrial rate for tens of million of years.

WORLD SUMMITS

From the swampy floor of the Kung Co trough, the planet's highest mountain peaks shine in the rarefied atmosphere of the high plateau. Isolated on the left, to the east, is Chomolungma, or Everest (29,035 feet); to the right is Cho Oyu (26,748 feet), with summit powder snow and clouds blowing away in the jet stream.

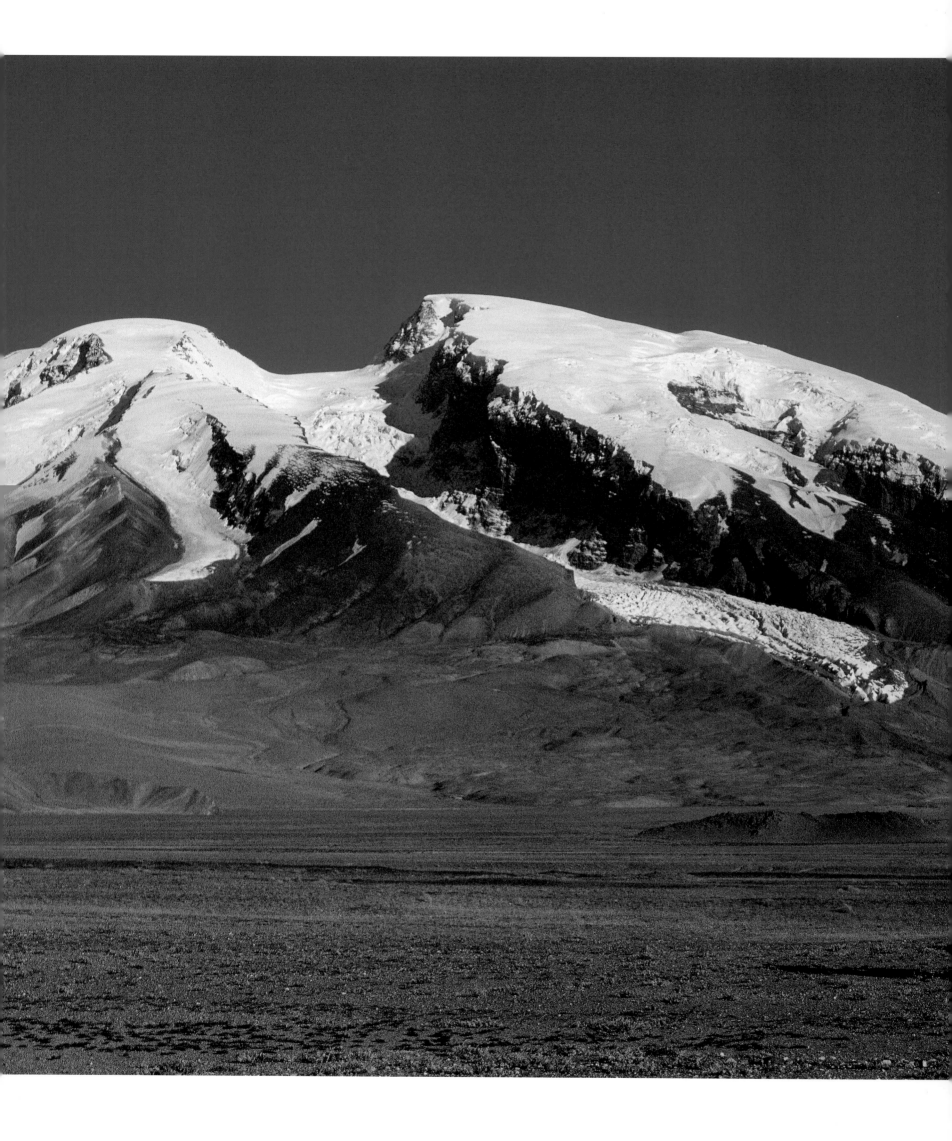

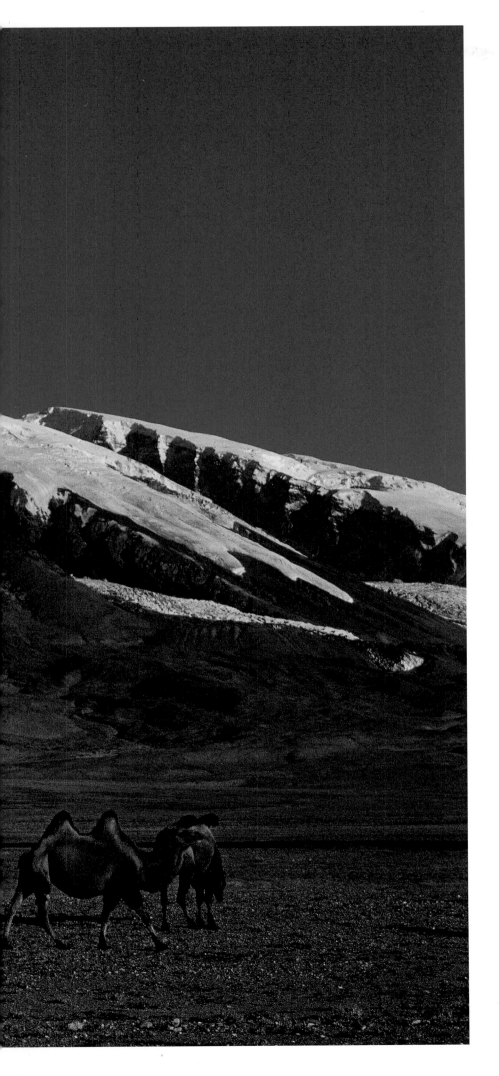

FATHER OF ICE MOUNTAINS, XINJIANG

To the Turkic-speaking Uyghurs, and Kirghiz and Kazakh nomads who live in the region, the icy summits of the Pamir have a "father": Muztagh Ata. It is the place where the great leaders' souls find eternal residence. At an altitude of 24,756 feet, it is not the range's highest peak. That distinction belongs to its neighbor, Kongur Shan, which rises an additional 568 feet. But it is Muztagh Ata's perfect shape, a smooth ice-capped dome whose gentle flanks Bactrian camels climb easily, that justifies its top rank of regional pantheon. Unique for a mountain of such height, this shape is also the geologist's delight because it holds the key to the mountain's origin. Stare at the shaded cliff cut by glacier ice, just beneath the cap that covers the dome's right flank. Two layers of deep metamorphic rocks can be discerned: a dark-colored one topping a lighter one. Both are parallel, and tilted exactly like the ice-capped surface. The giant dome is thus simply a huge anticline, folding a thick slice of deep crust. Scale not withstanding, the mechanism is the same as that which arches foreland sediments into small whale-backs. This is how a large mountain is created.

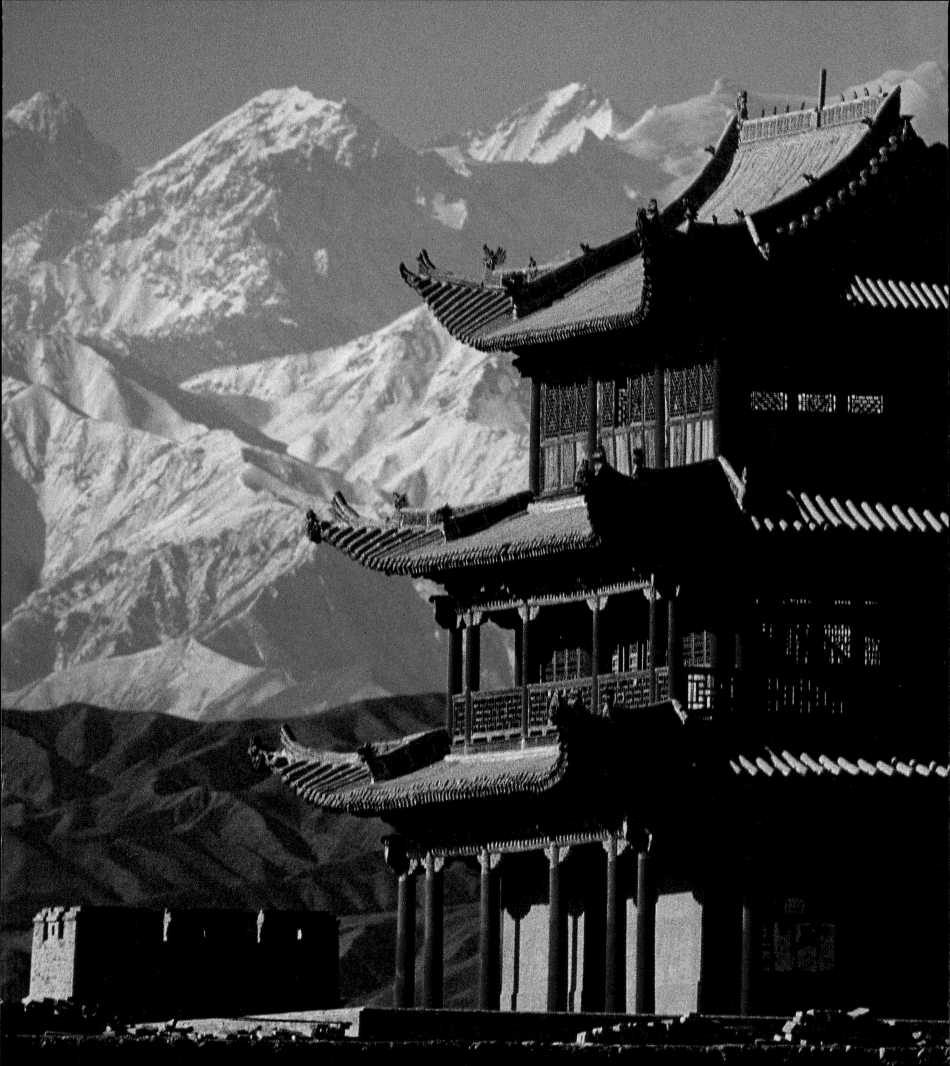

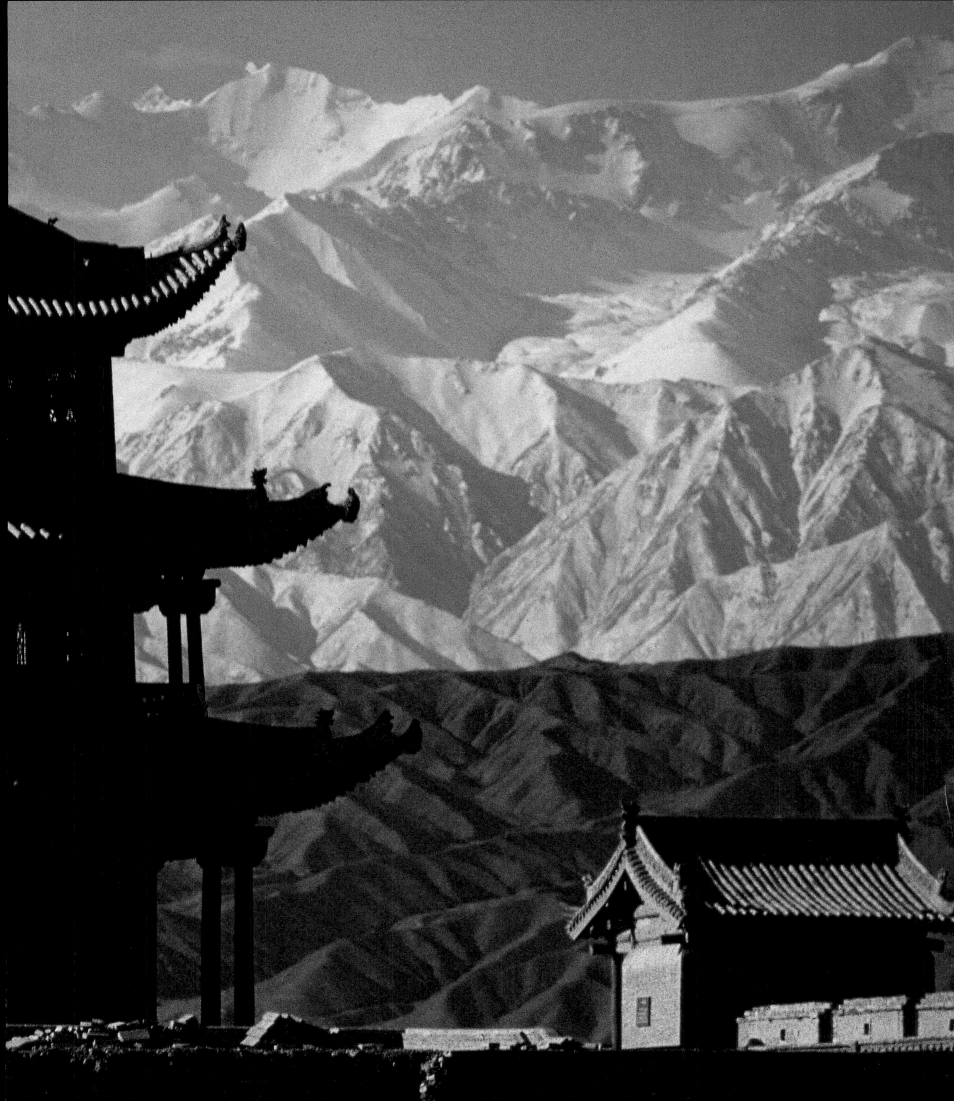

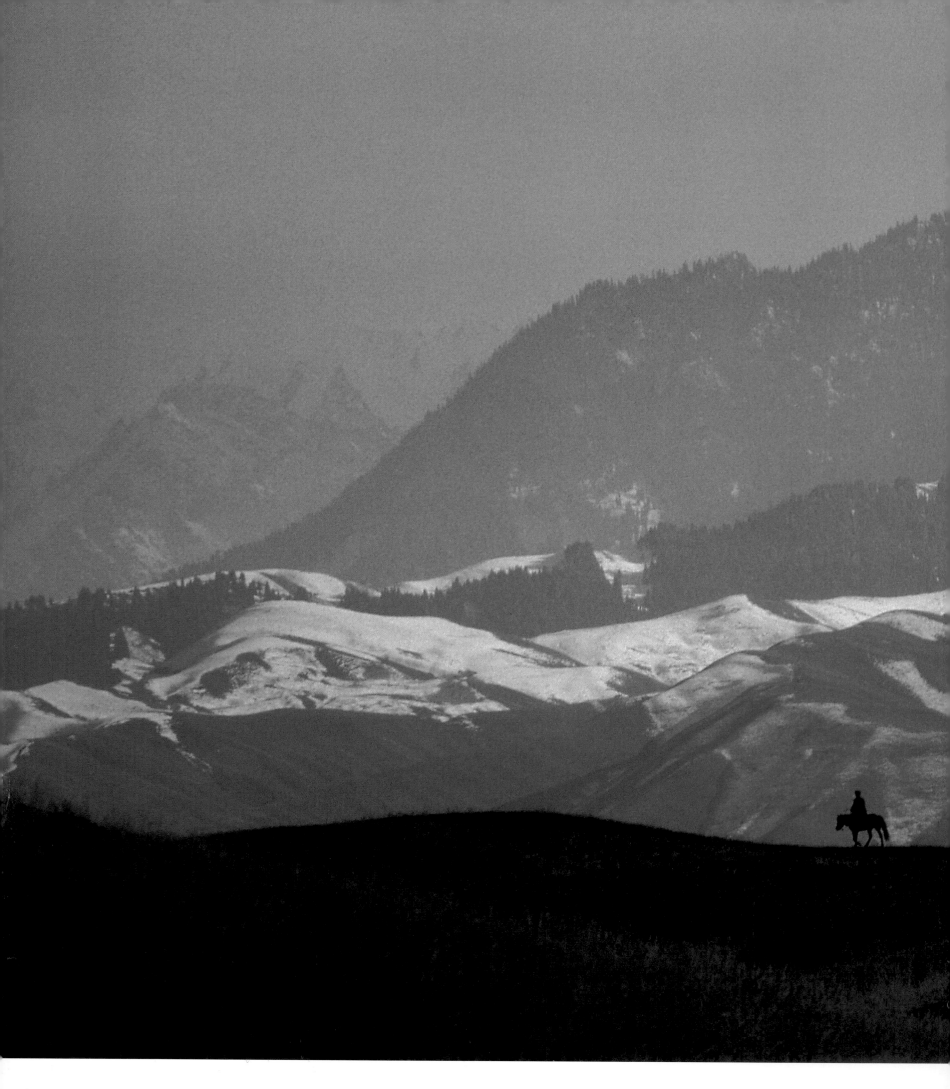

preceding pages

QILIAN SHAN, GANSU, CHINA

Tibet's northern rampart, the Qilian Shan, soars to more than 18,000 feet behind one of the watchtowers of Jiayuguan, westernmost fortress of China's Great Wall. The dark gray hill between the tower and the snow-covered mountain is a growing fold. Here the Great Wall used to protect the oases of the Gansu corridor, main passageway of the Silk Road's caravans.

76

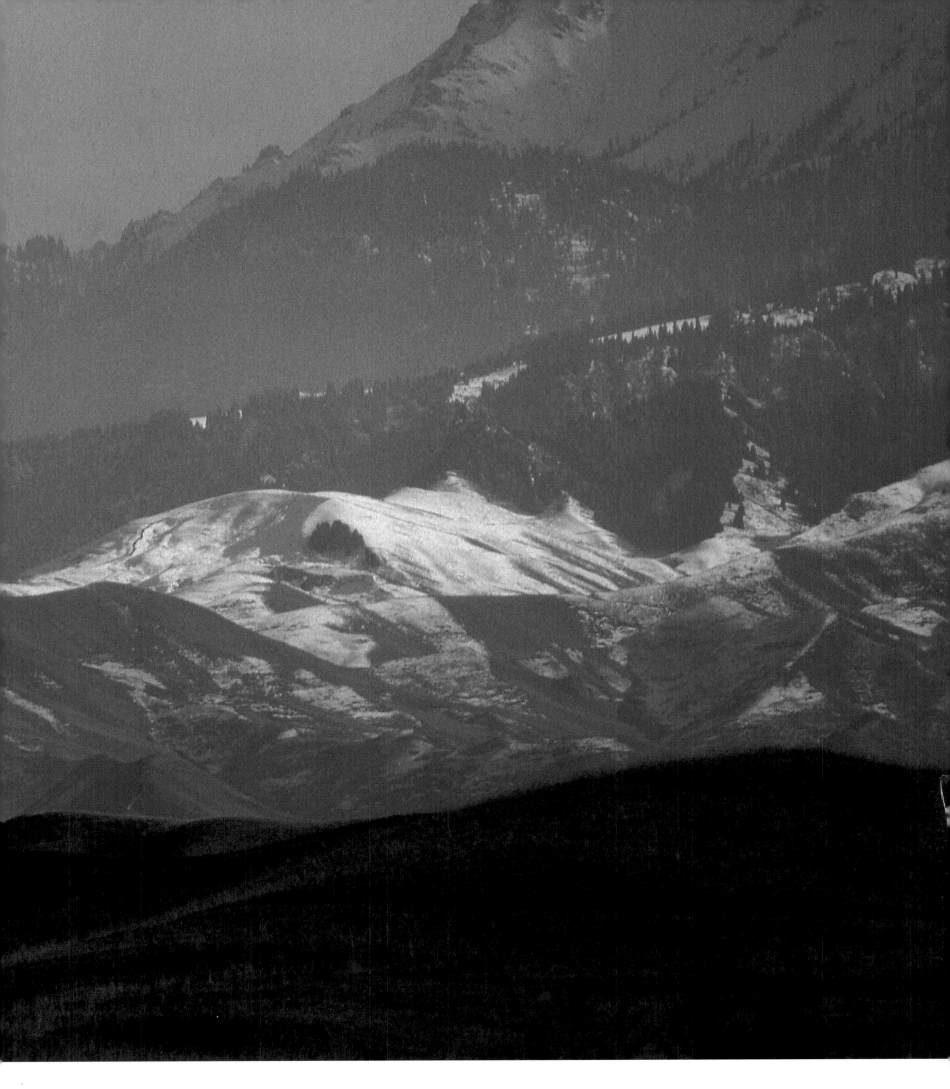

BOROHORO, XINJIANG, CHINA

The 13,000-foot-high, forest-covered flank of Borohoro, northernmost range of the Tien Shan, bounds the steppe of Dzungaria, realm of the Kazakh horsemen. The "Celestial Mountains," which are almost twice as long and one-and-a-half times higher than the Alps, are among Asia's youngest.

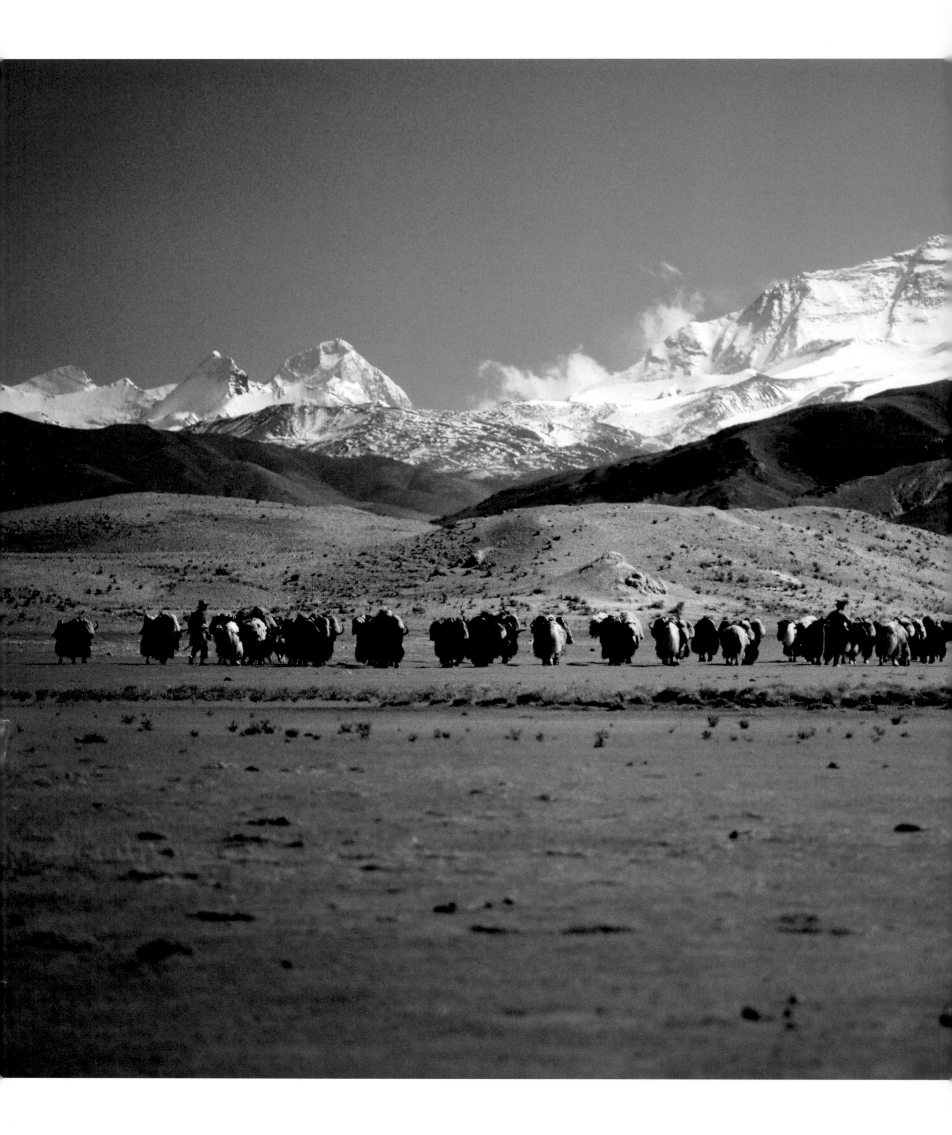

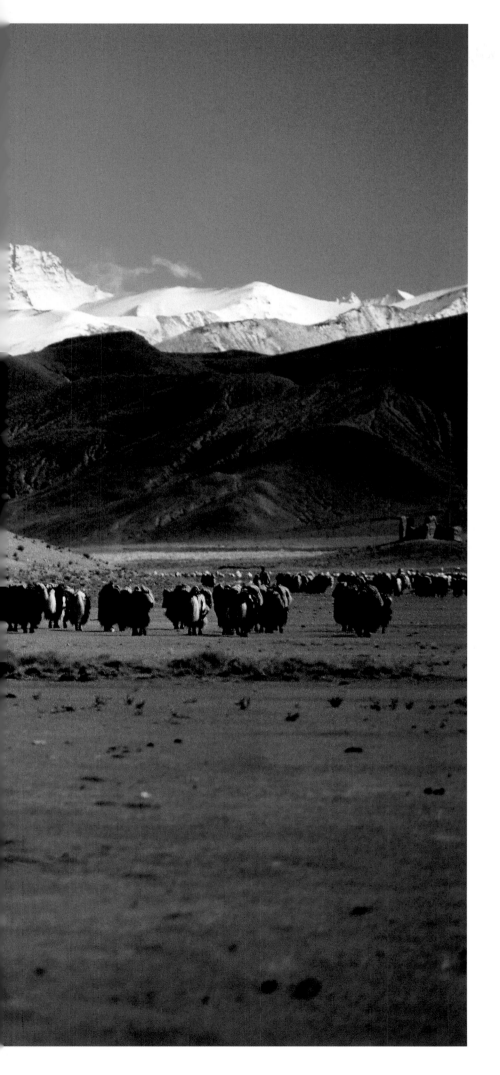

CHOMOLUNGMA, TIBET

Loaded with bundles of wool, a yak caravan approaches Chomolungma, highest Himalayan summit—also named Everest, after George Everest, director of the Indian Geological Survey at the time of the British Raj, when its height was first measured. Seen from Dingri (14,300 feet), on the Tibetan side of the range, Chomolungma's 29,000 feet are no less staggering than when viewed from the Nepalese hills. Although the altitude difference is about half, the view from here is perfectly clear. The mountain's anatomy is highlighted by ice and snow. In the cliff of the northwestern face, all visible layers are tilted towards the left of the image. They are all that remains of the northern flank of a giant fold that must have once resembled Muztagh Ata's, before being disfigured by glacial erosion. The summit pyramid and crest are made of ancient limestone formerly covered with over 30,000 feet of marine sediments, now abraded away. In the last 25 million years, the mountain's rocks were thus heaved about 60,000 feet above sea level. This dizzying ascension continues today at a rate of nearly half an inch per year, while India keeps plunging under the south flank of the range.

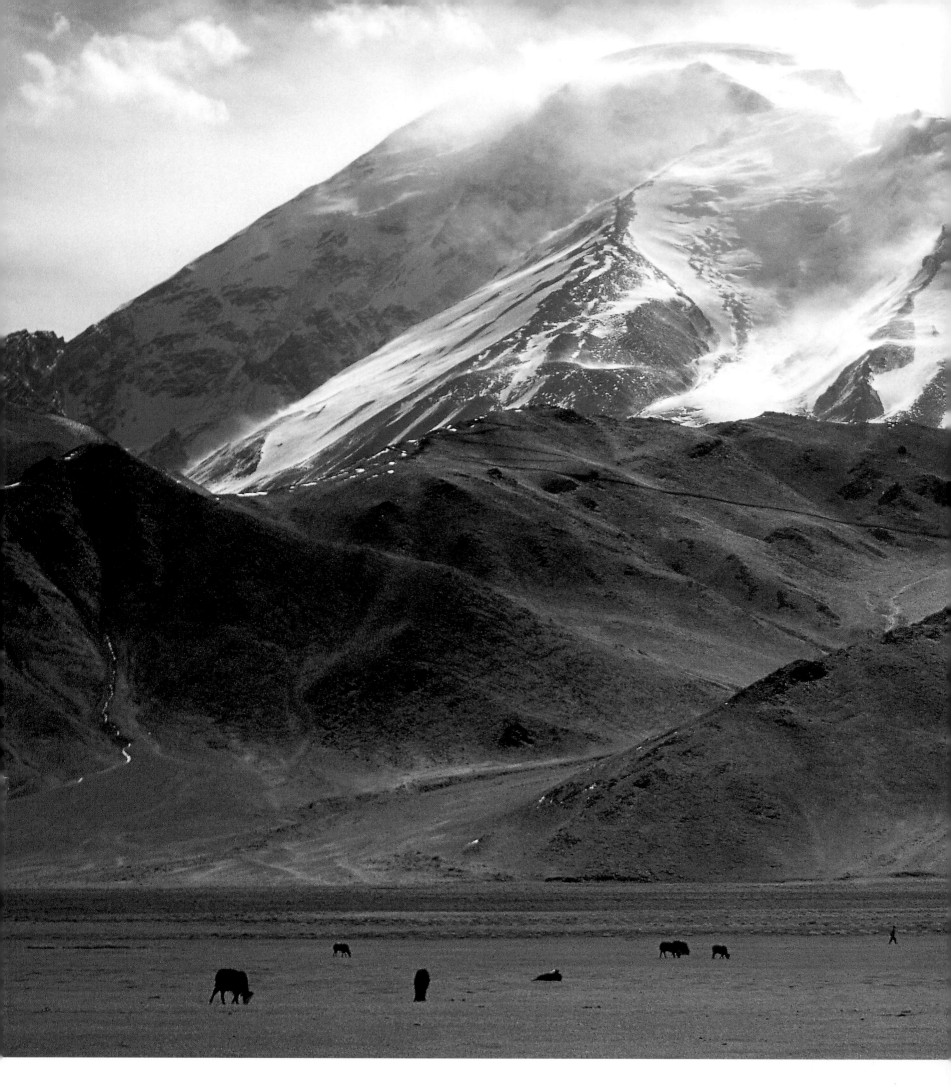

BLIZZARD ON MUZTAGH ATA, XINJIANG

Above the yaks that graze in the small Karakul basin, the Muztagh Ata's summit is veiled by powdery snow blown by a violent west wind. This powerful squall smoothes the dome shape of this giant fold, which arches up 15 miles of crust.

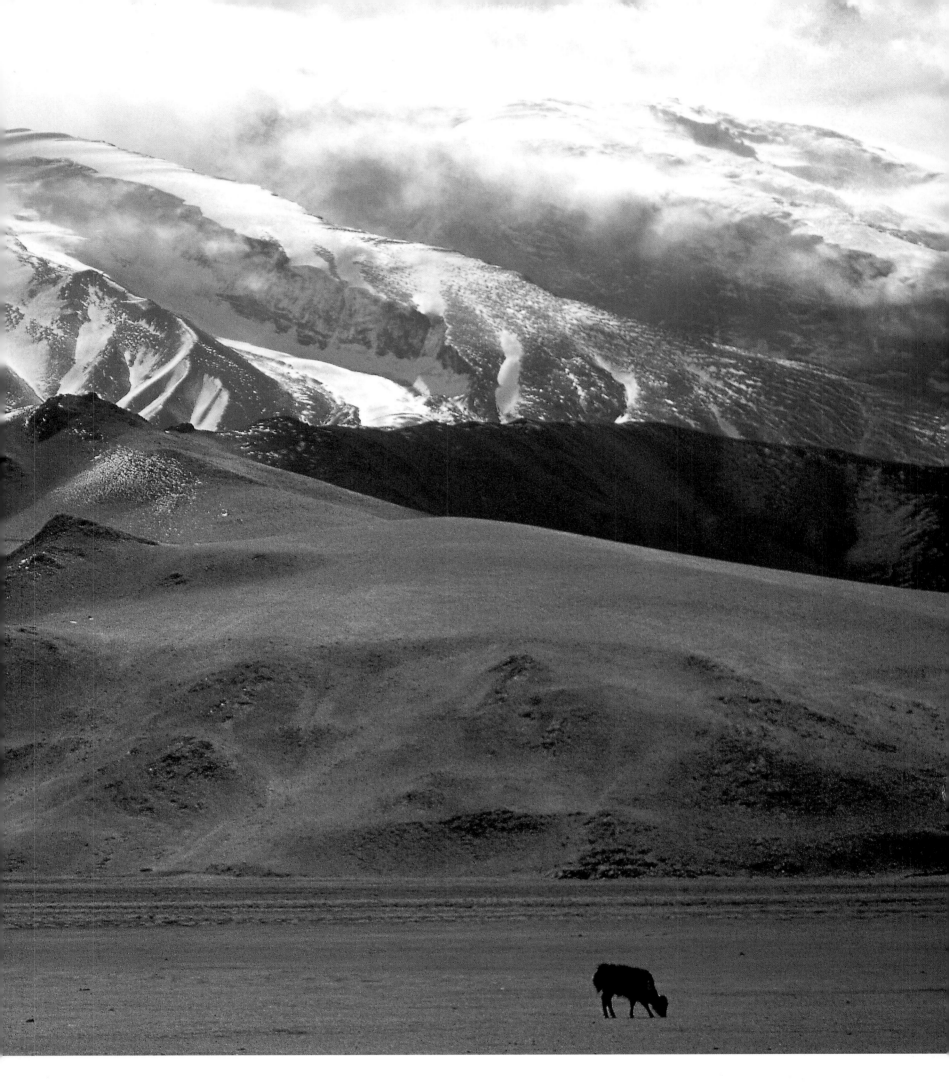

following pages

LITTLE TIBET, PAMIR, CHINA

The Pamir's two flanks are not symmetrical. The range's tallest summits, which rise to heights above 24,000 feet, tower at least 20,000 feet above the Tarim desert, but only 10,000 feet above the interior plateau—often dubbed "Little Tibet." The Taghman basin, south of the Muztagh's west-dipping gneisses, is part of it.

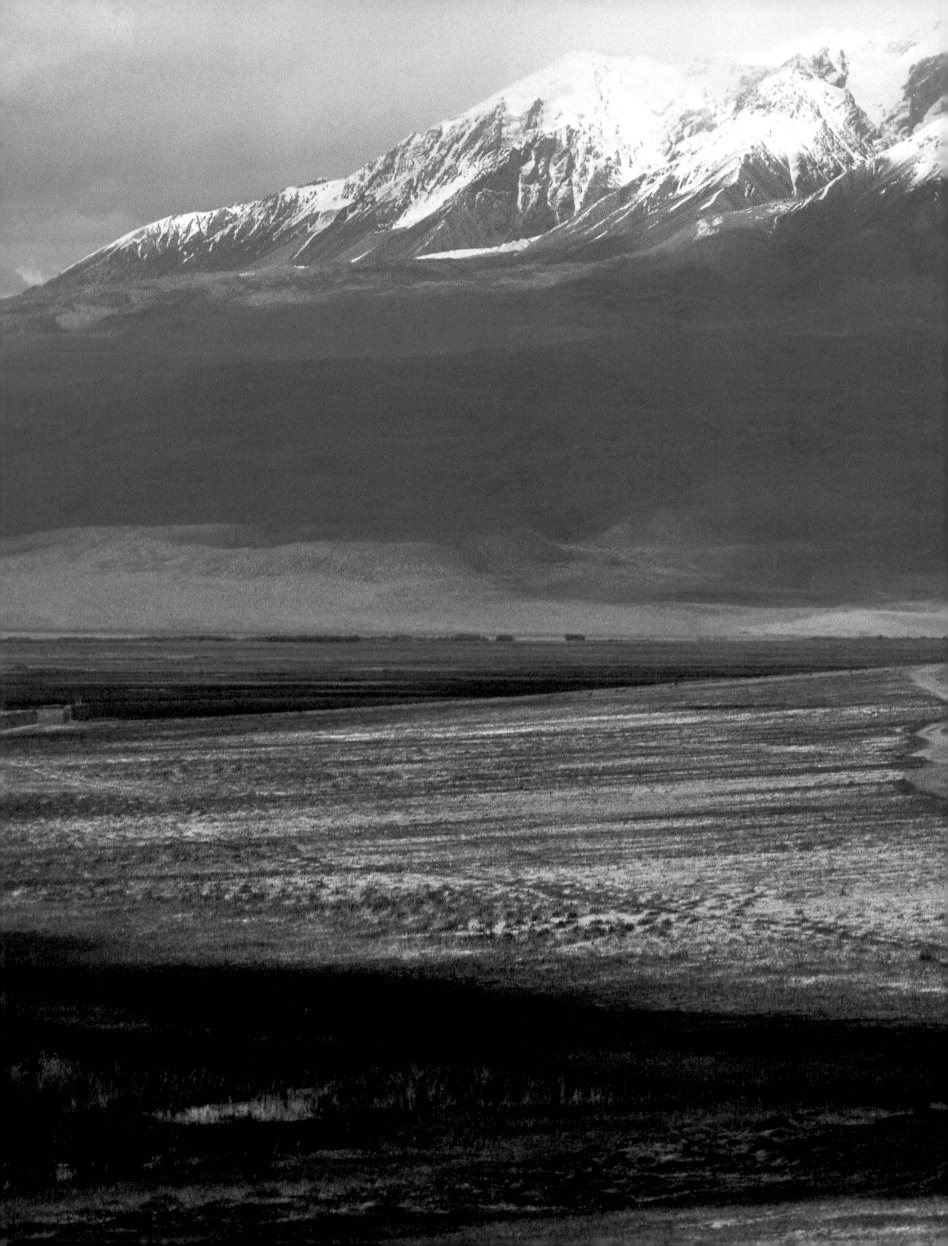

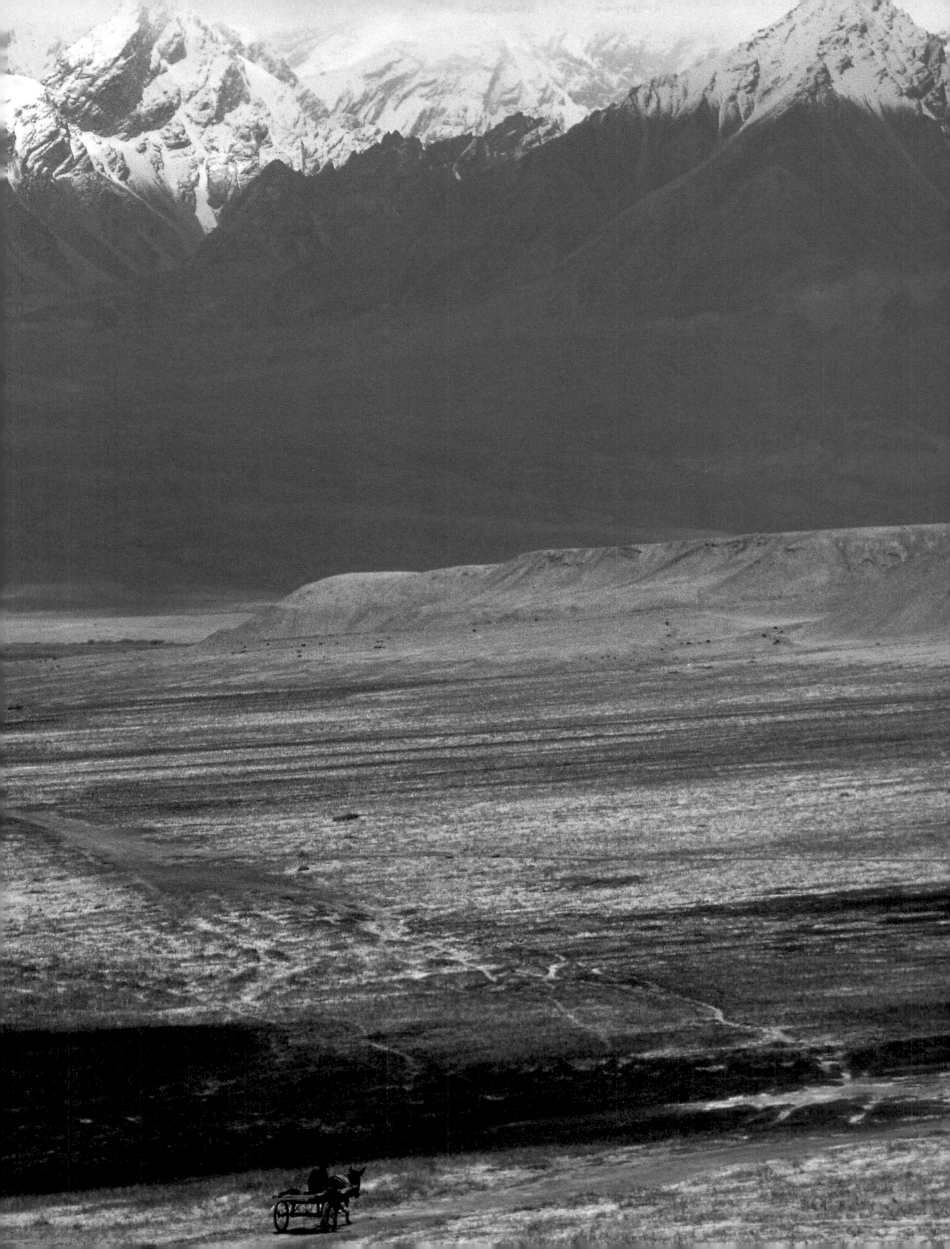

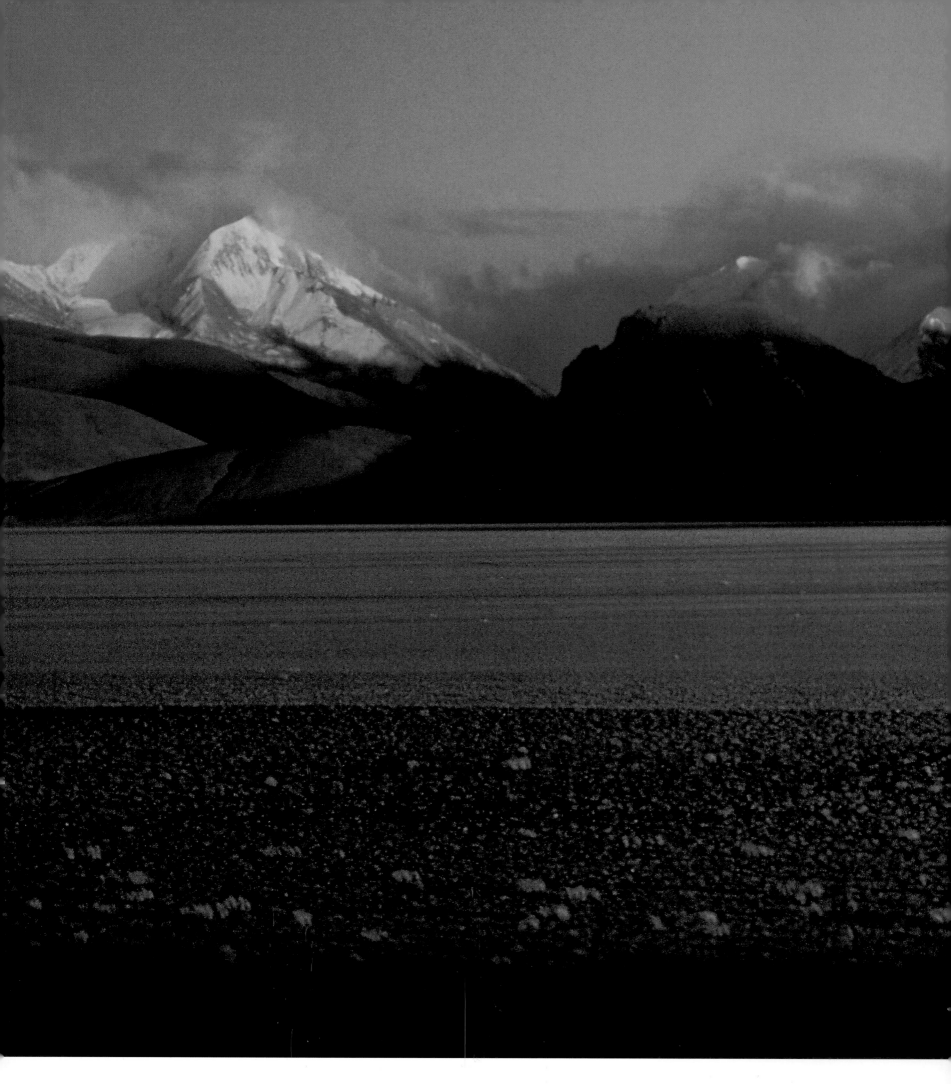

TILTED SLIVER OF CRUST, KULA KHANGRI, BHUTAN

Seen from the high Tibetan steppe, russet-hued by winter's onset, the northern flank of 24,785-foot-high Kula Khangri, Bhutan's highest peak, displays the same northward-tilting surface and ledges of metamorphic rock as Everest. Such uniform structure, which is dictated by the dip of the great thrust that heaves up the Himalayas, is observed at various advanced stages of degradation along the entire range.

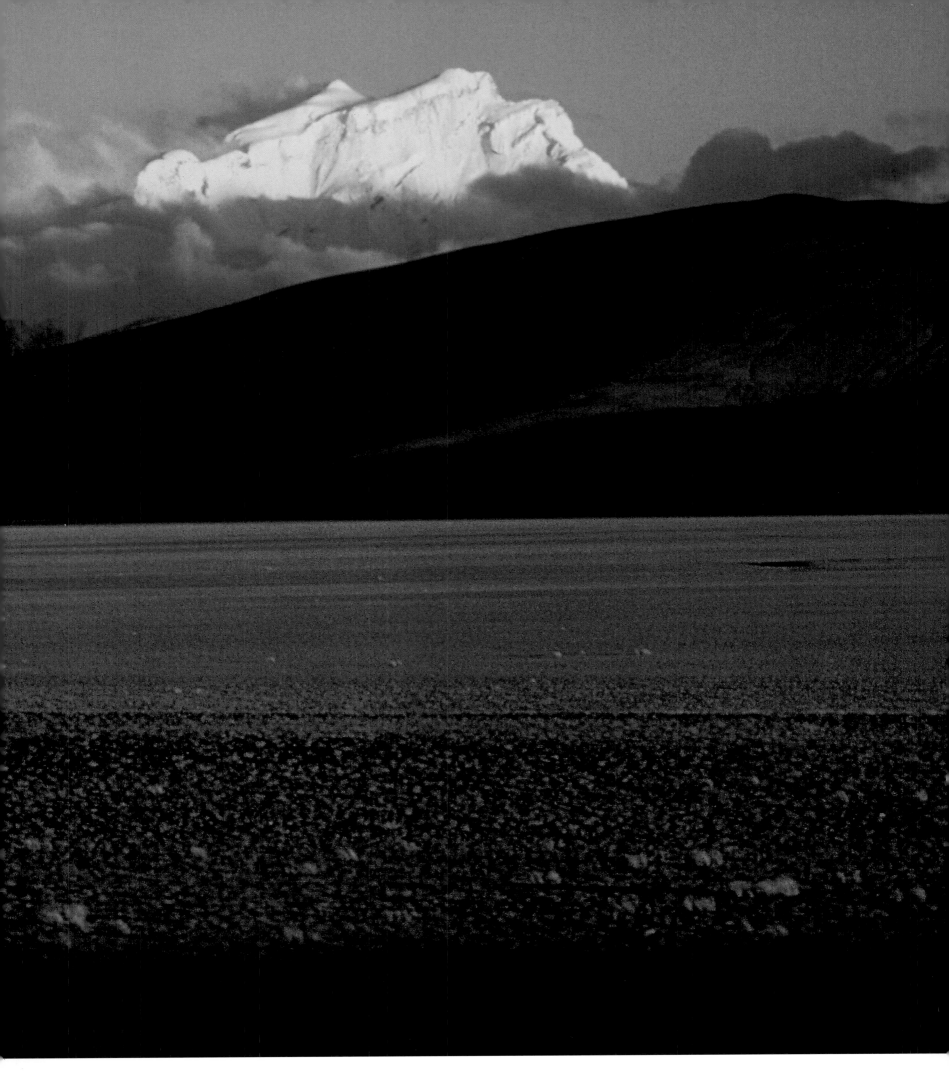

following pages

TURBULENCE, GAURISANKAR, HIMALAYA

The Himalayan summits are high enough to perturb high-velocity, upper-atmosphere winds. Here, an arabesque of condensation clouds materializes the waves caused by the rapid and turbulent surge of humid air above the 23,428-foot-high Gaurisankar.

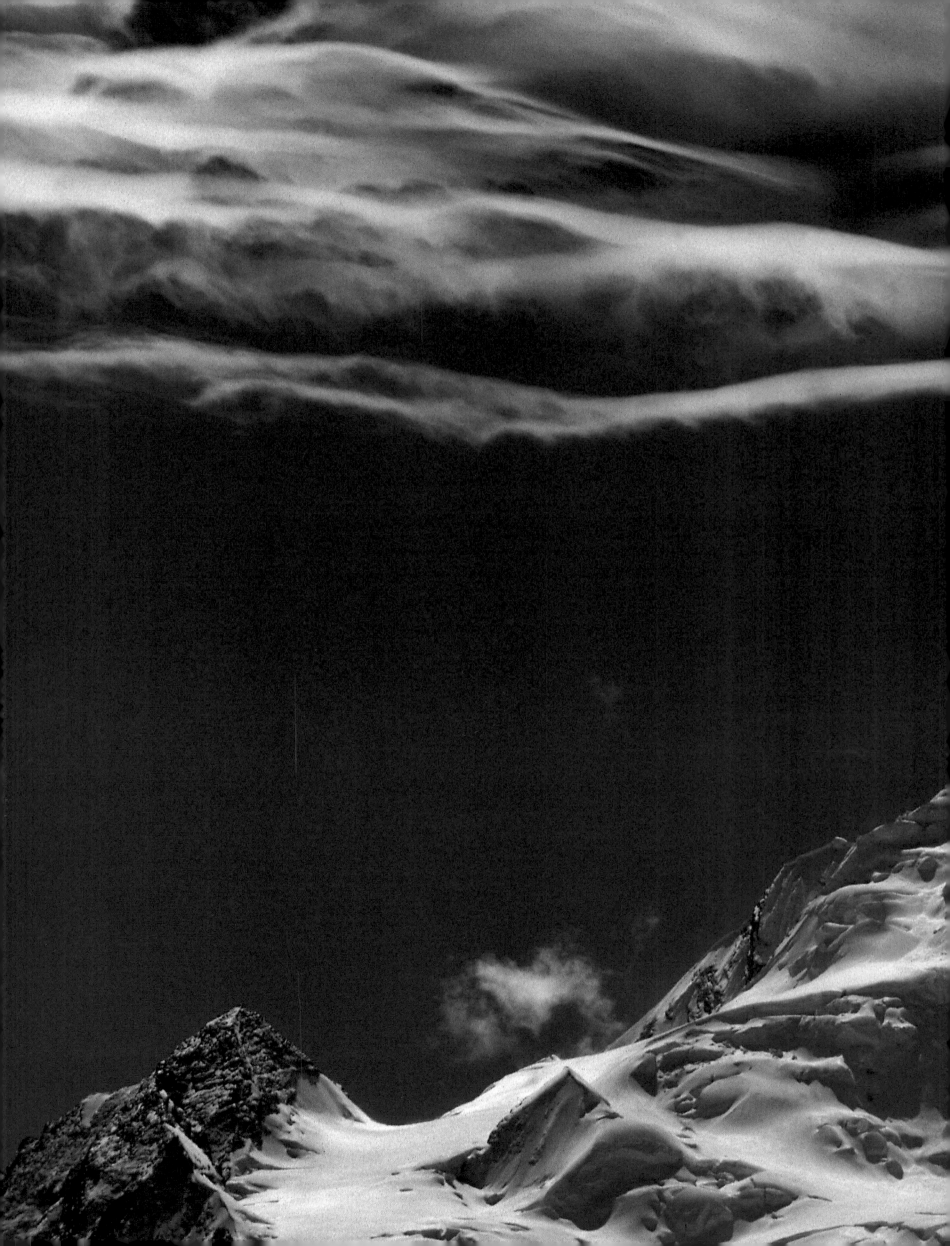

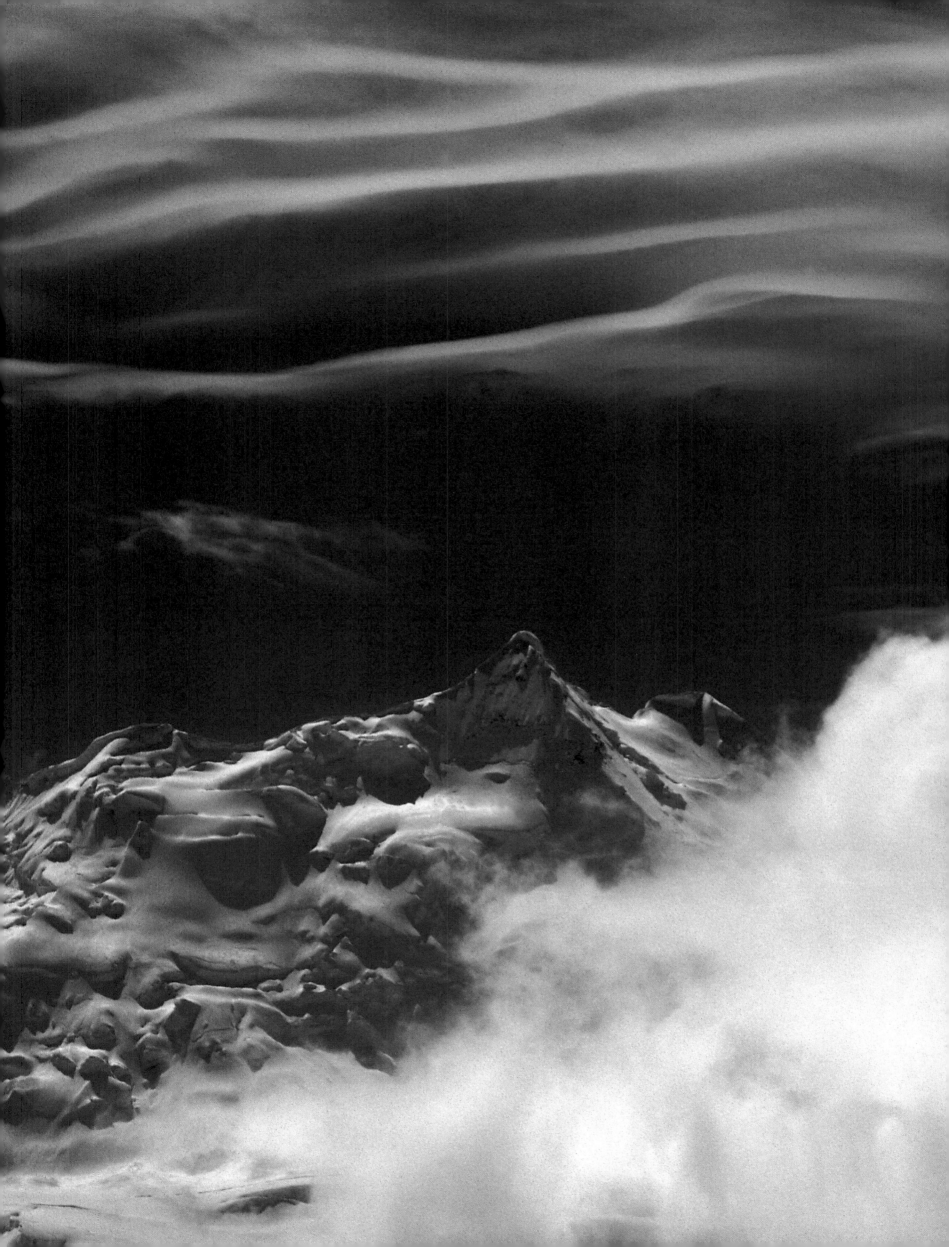

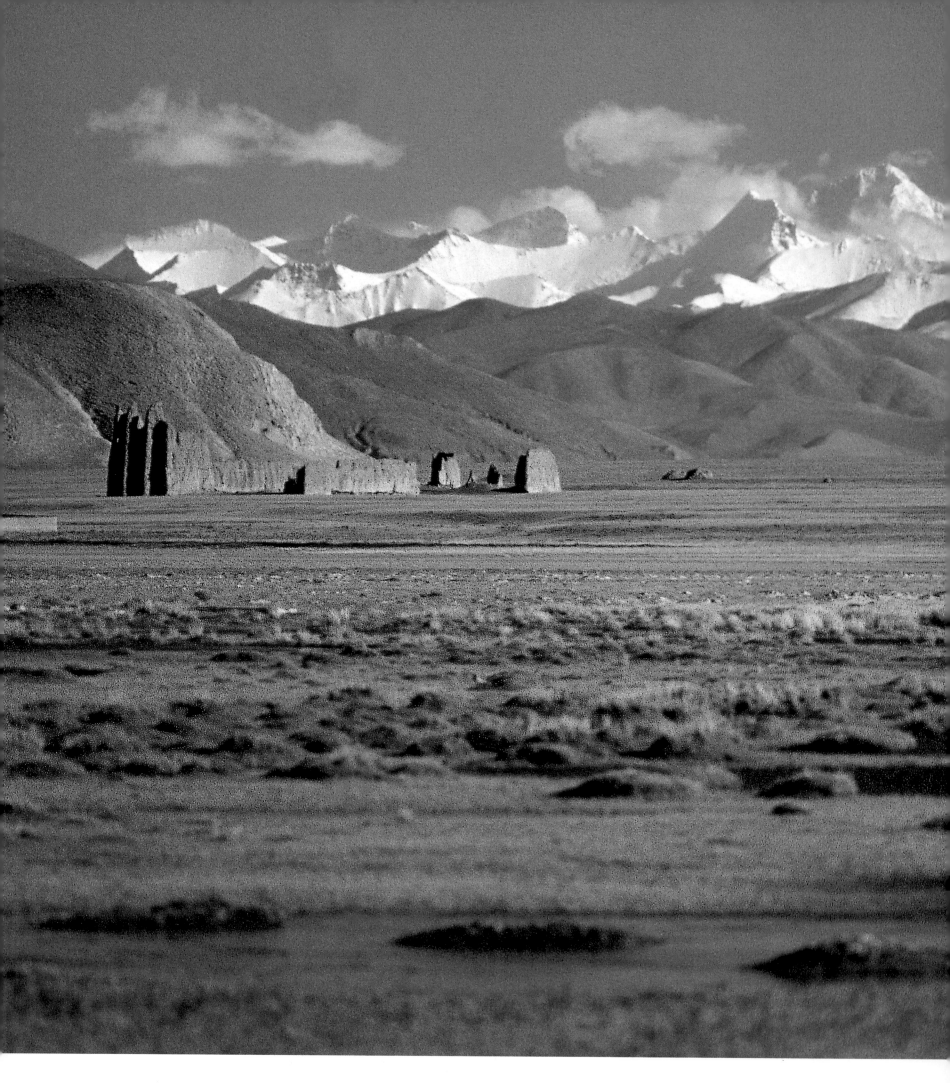

MAKALU AND CHOMOLUNGMA, TIBET

The architecture and morphology of the Himalayas are profoundly asymmetrical. To the north, no relief separates its highest summits (here Everest on the right, and Makalu, at 27,804 feet, the third tallest) from Tibet. Nothing like the Lesser Himalayas or Siwalik foothill folds. Instead, the 15,000-foot-high plateau abuts directly against the high range: hence the north side's majestic landscapes.

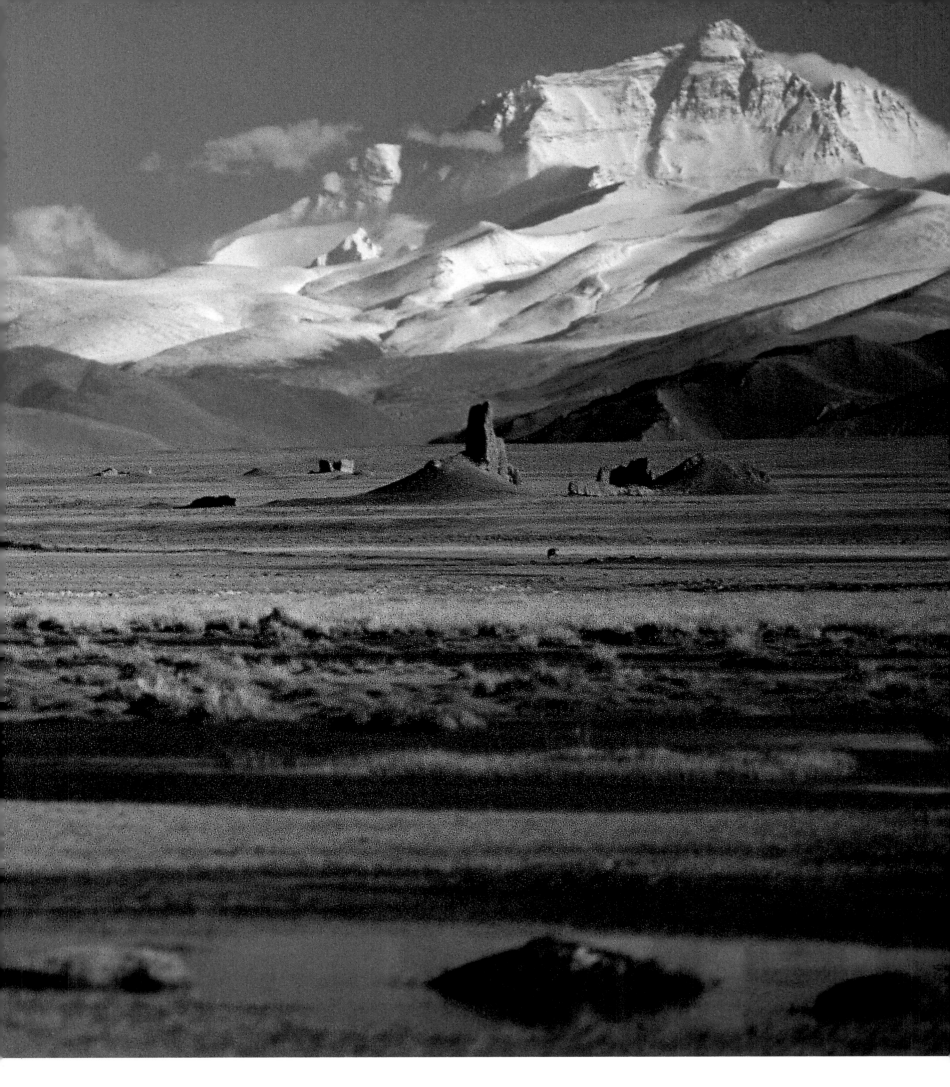

ICE AND DUNES, WEIXUEH SHAN, KUNLUN

A granite dome hollowed out by erosion, this eastern Kunlun summit is covered with an ice cap that feeds radial ice tongues, resembling octopus tentacles. One sees clearly the flow lines at the surface of the ice. The barkhan dunes below are made of sand ground away from the granite.

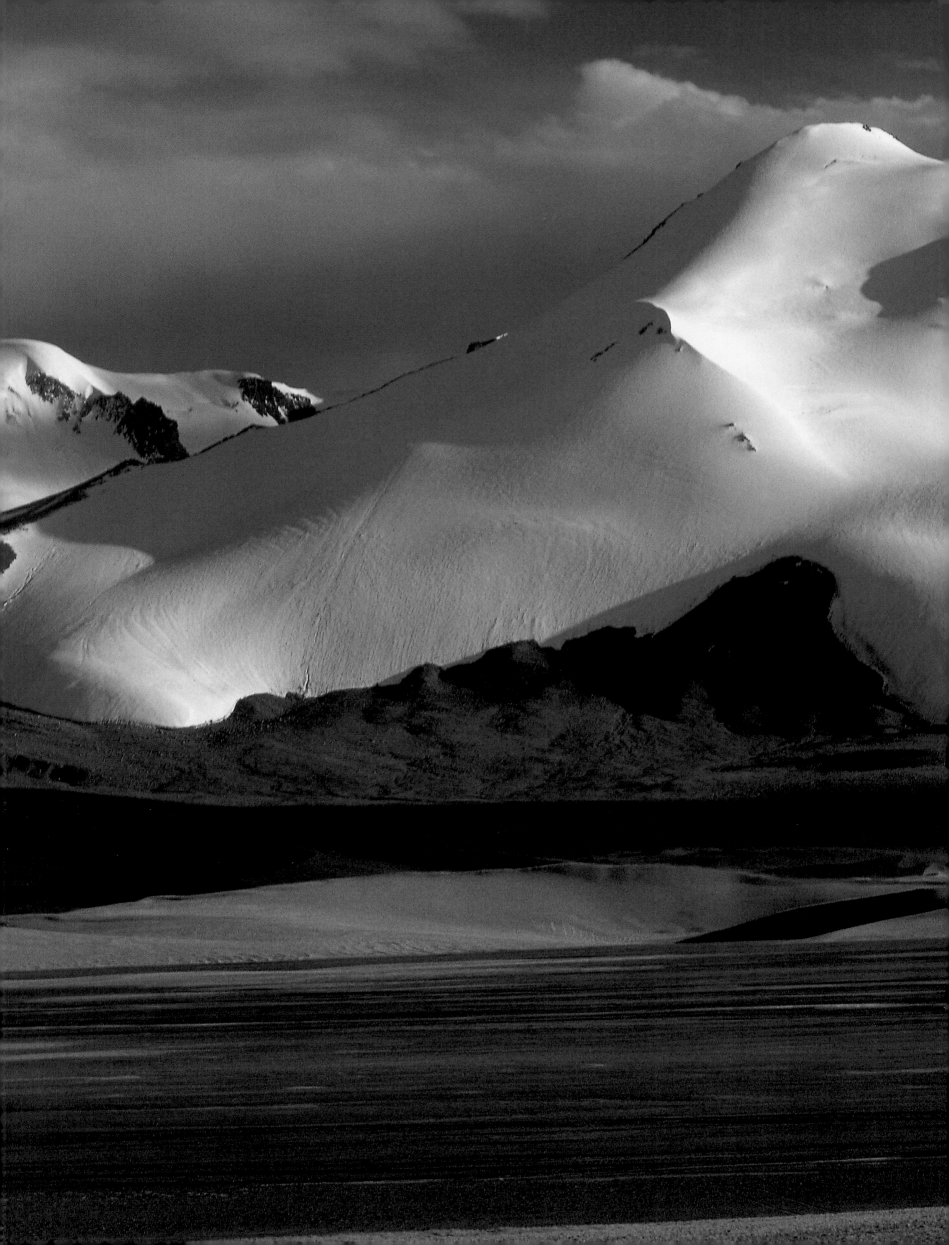

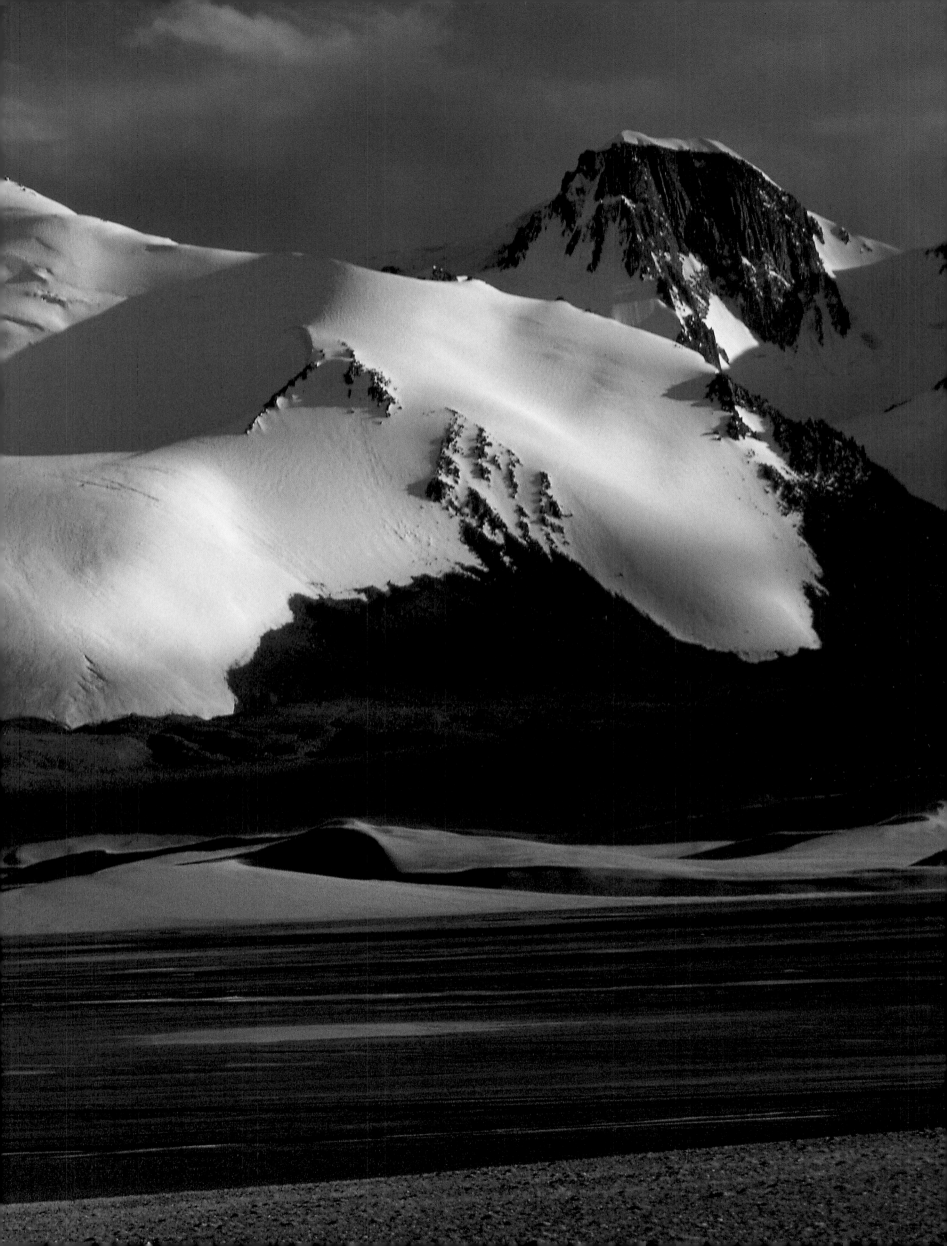

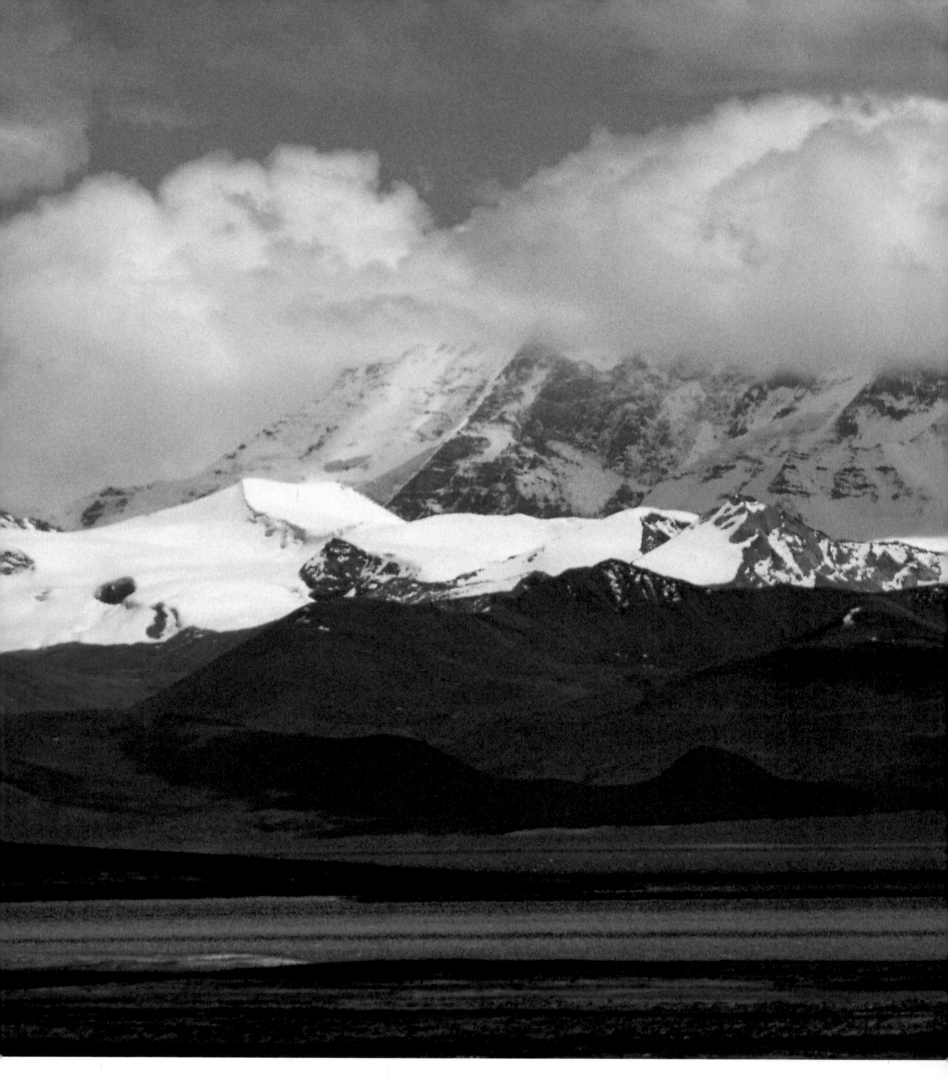

NYAINQENTANGLHA, TIBET

This complexly named range is, at 23,497 feet, the tallest mountain of the Tibet plateau proper, north of the Yarlung Zangbo suture. It dams one of the high plateau's vastest lakes: the Nam Co—also known as Tengri Nor (Lake of the Sky)—which at 15,750 feet is nearly the same height as the highest summit of the Alps, the Mont Blanc.

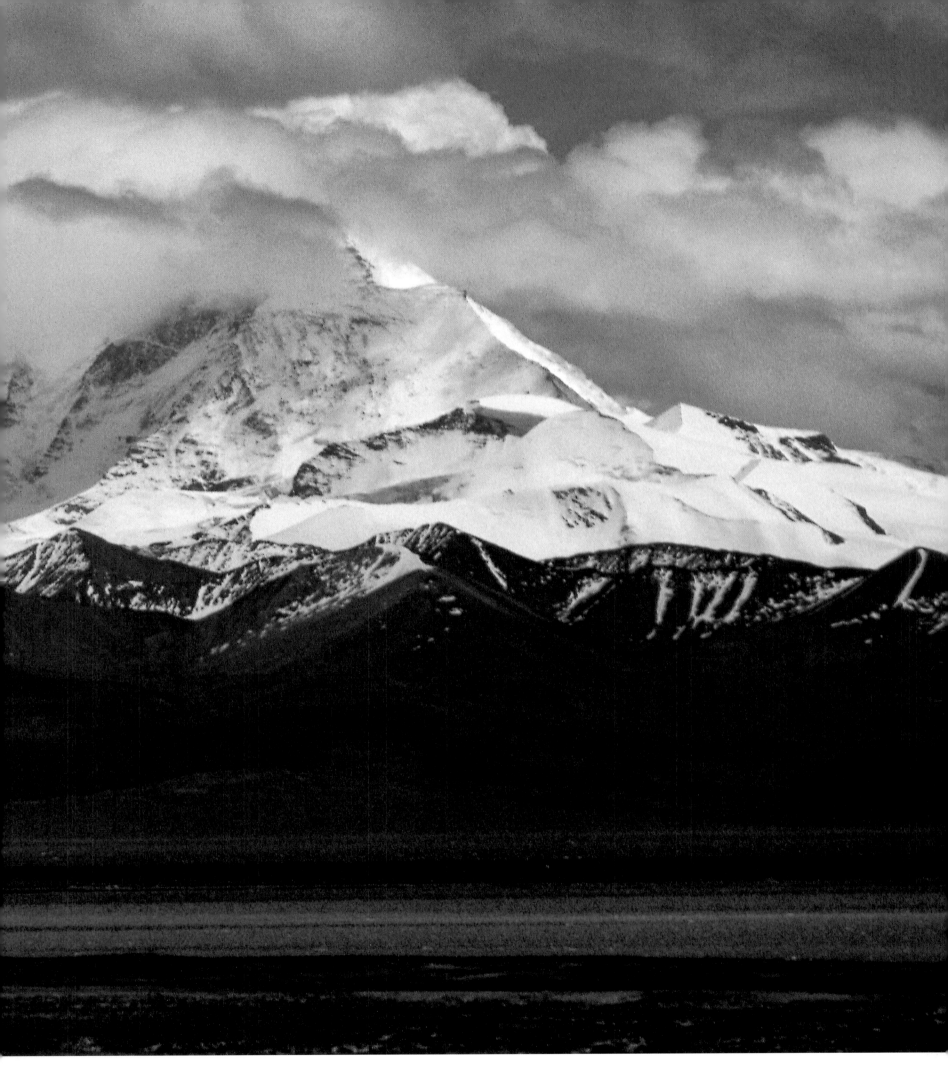

following pages

TERRACES, NEPAL

The Nepalese Lesser Himalayan slopes are cultivated up to 8,500 feet. Below 6,000 feet, rice is transplanted in permanently flooded, staired terraces fed by abundant monsoon rain. Higher up, depending on slope orientation, such sophisticated irrigation gradually gives way to less water-thirsty modes of cultivation.

MACHAPUCHARE AND ANNAPURNA, NEPAL

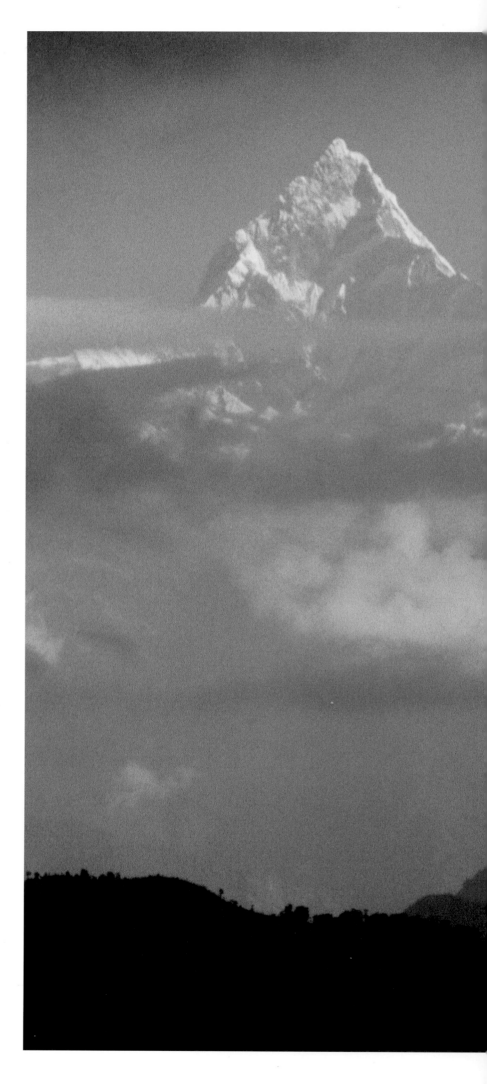

Machapuchare (22,955 feet) and Annapurna III (24,786 feet) emerge from the morning mist above Pokhara, at the west end of the Kathmandu basin. The vertiginous south faces of the Himalayan range expose gneiss and white granite studded with garnets and tourmalines, formed by the melting of the Indian crust, heated and laminated at depth by shearing on the thrust ramp that continues to force the range upwards. Nowhere else are altitude differences greater than here. They result from the combined action of two mechanisms that reach extremes: vertical rise due to the largest ongoing continental collision, and erosion driven by the Asian monsoon deluges. Indeed, under no other range does a continental crust as thick and old as that of Precambrian India plunge so rapidly. As for the Asian monsoon, its power is intensified by the very extent and height of the relief created by the collision. Each summer, Tibet pumps up the humid Indian ocean air and the resulting water discharge on the Eastern Himalayas exceeds 30 feet! No surprise then that Himalayan rivers headwaters recede at a breathtaking pace, transforming the southern side of the range into a wall.

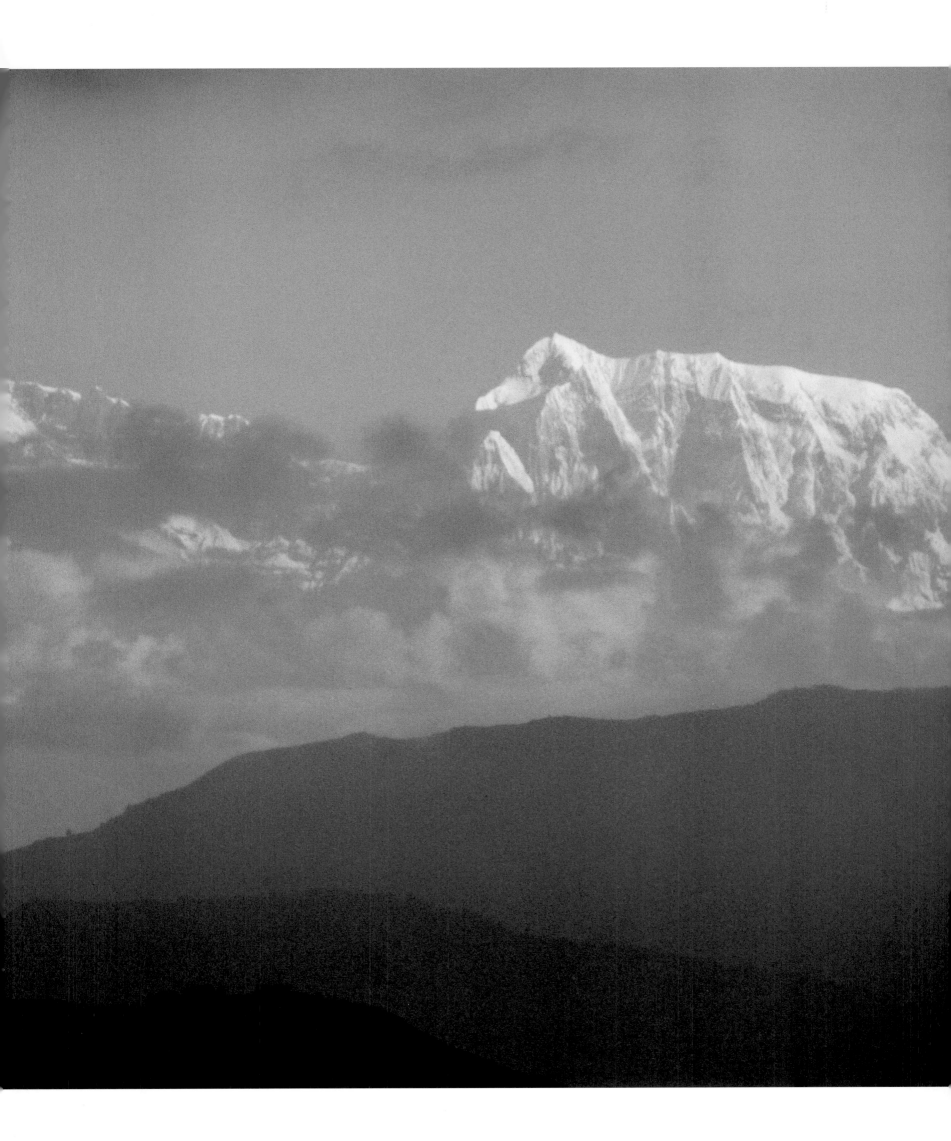

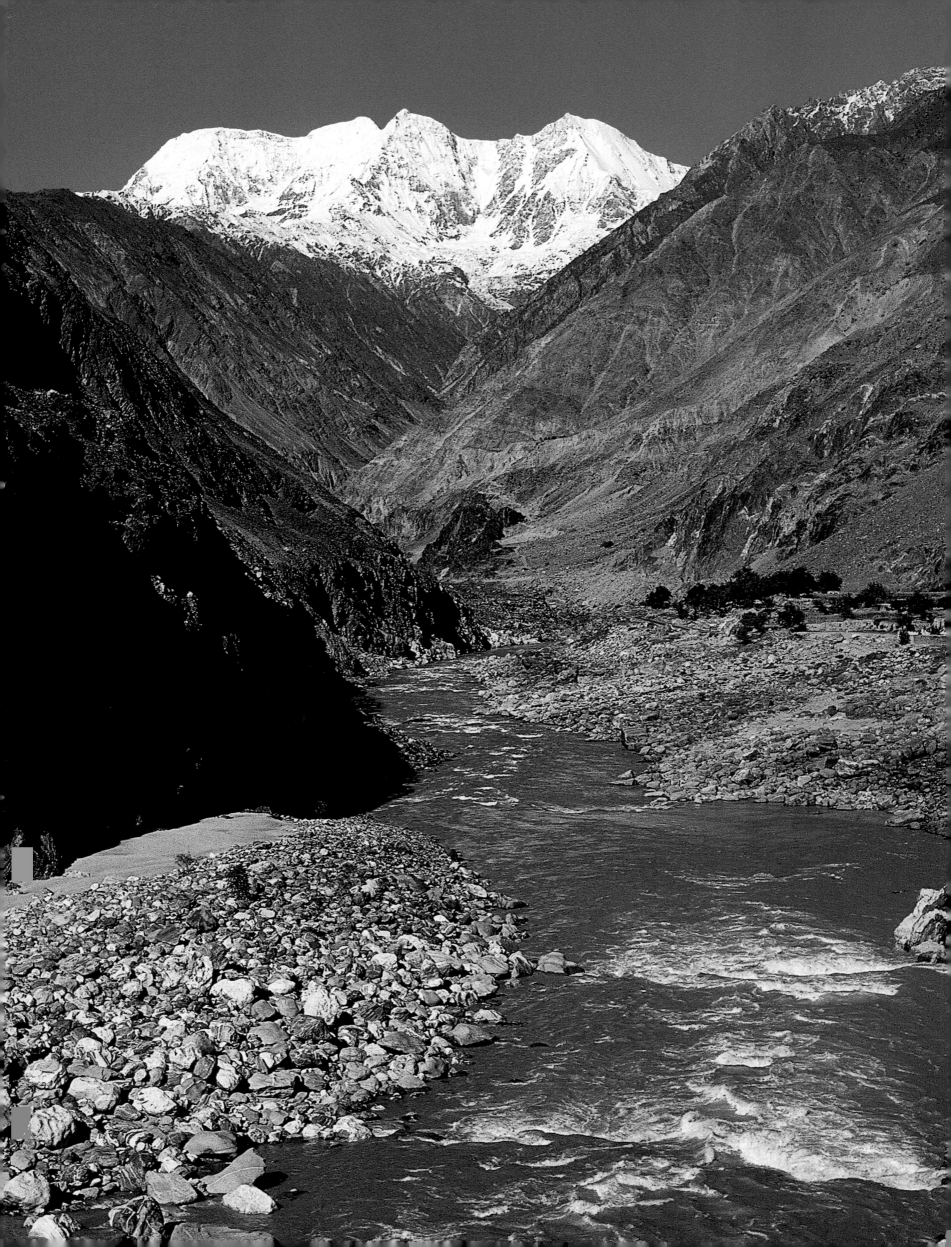

INDUS RIVER AND HARAMOSH, RONDU, PAKISTAN

The Indus crosses the Himalayan western syntaxis in a deep gorge hewn between Nanga Parbat and Haramosh, seen here towering to 24,245 feet. As it cuts down into the strongly sheared gneisses and pyroxenites of the India/Asia suture in this 160-degree bend, the river's course is but a succession of cataracts and rapids.

HIMALAYA OF ZANSKAR, INDIA

The vertical grooves on the polished rock face beneath the ice cornice were engraved by a now-vanished glacier, of which the hanging firn remains the last witness. For perhaps only a few decades more... The numerous parallel channels that scratch the mountain flank in the foreground testify to intense peri-glacial solifluction, a process in which thin debris veneers covering slopes relentlessly creep down.

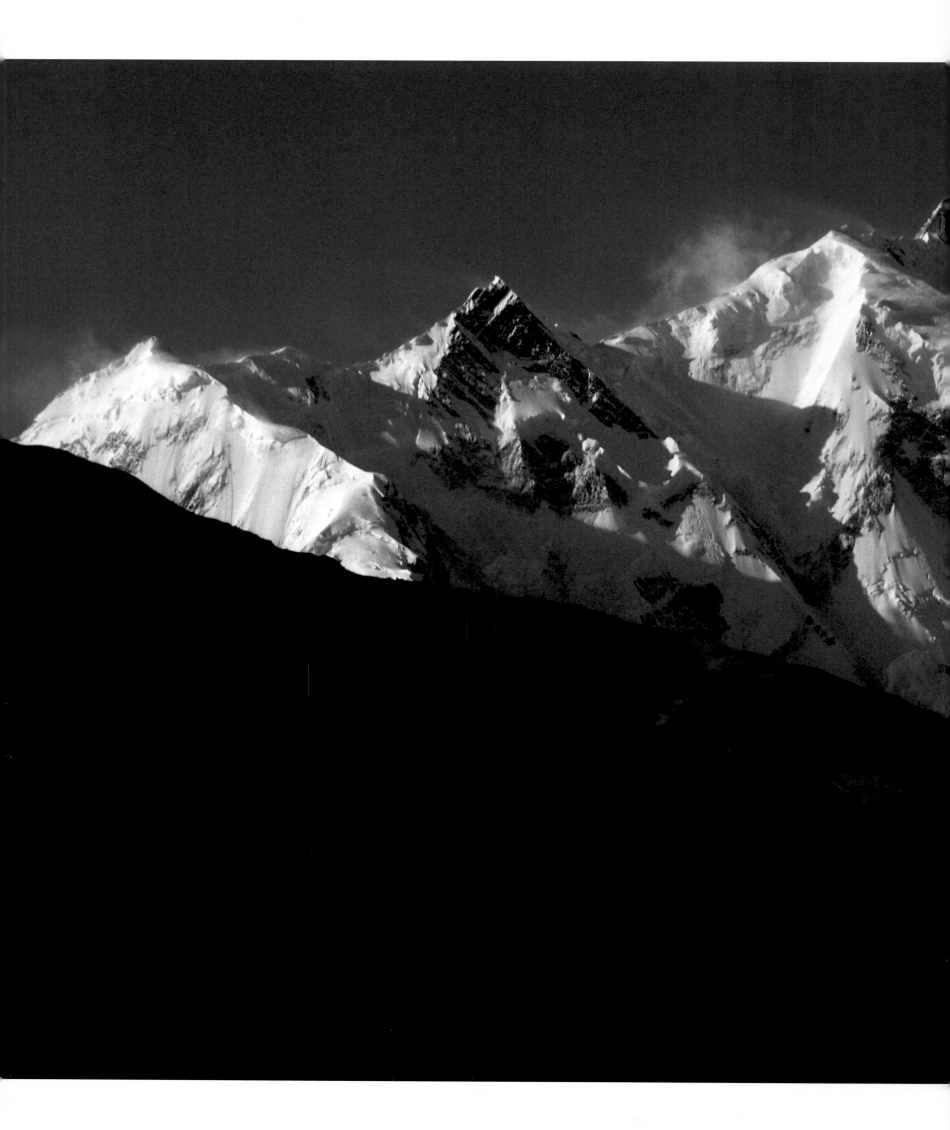

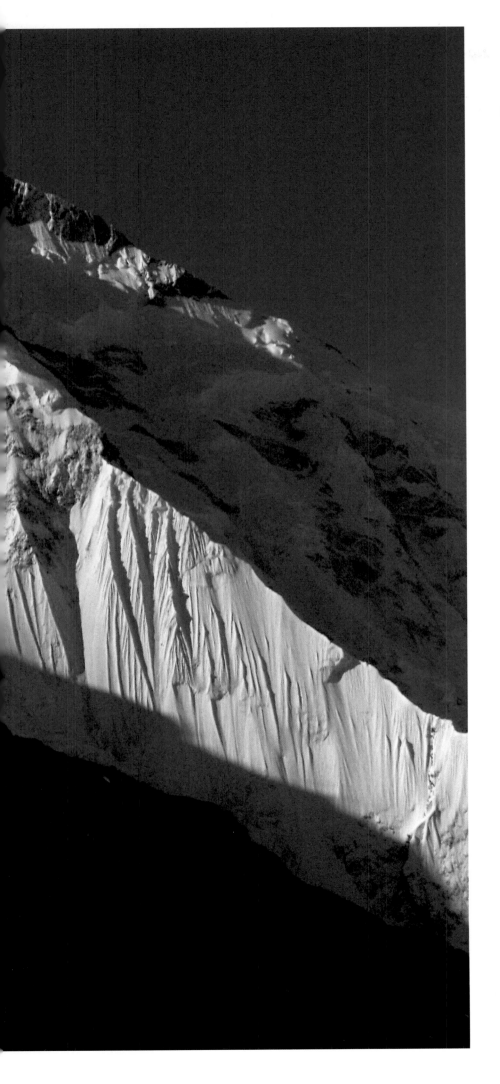

RAKAPOSHI, HUNZA, PAKISTAN

A strong northwest wind sweeps the snow from the summit cornices of Rakaposhi (25,551 feet). The ridges leading to this windswept crest, which are brightly lit by the morning sun, plunge toward the north as do the subjacent rocks. Here as elsewhere in the Himalayas, this plunge reflects that of a large thrust that dives deep into the crust. But with a crucial difference: the mountain, almost entirely crowned with Asian andesite of Cretaceous age, is not a sliver of India! Rather, it is a fragment of the volcanic arc, at the leading edge of Asia, under which Thetis' lithosphere was consumed by subduction. Dubbed "Main Mantle Thrust" (MMT), the thrust fault that heaves up the mountain in fact follows the India–Asia suture. Another big difference is that most of Pakistan's highest mountains are located north and not south of this suture. First and foremost, just north of Rakaposhi, the Karakoram range is uplifted by another north-dipping thrust—dubbed, of course, "Main Karakoram Thrust" (MKT)—following yet another suture—the Shyok suture, after the main local tributary of the Indus. Such radical differences are not surprising: the Himalayan range proper, hence its specific geological architecture, terminates just south, at Nanga Parbat (26,656 feet).

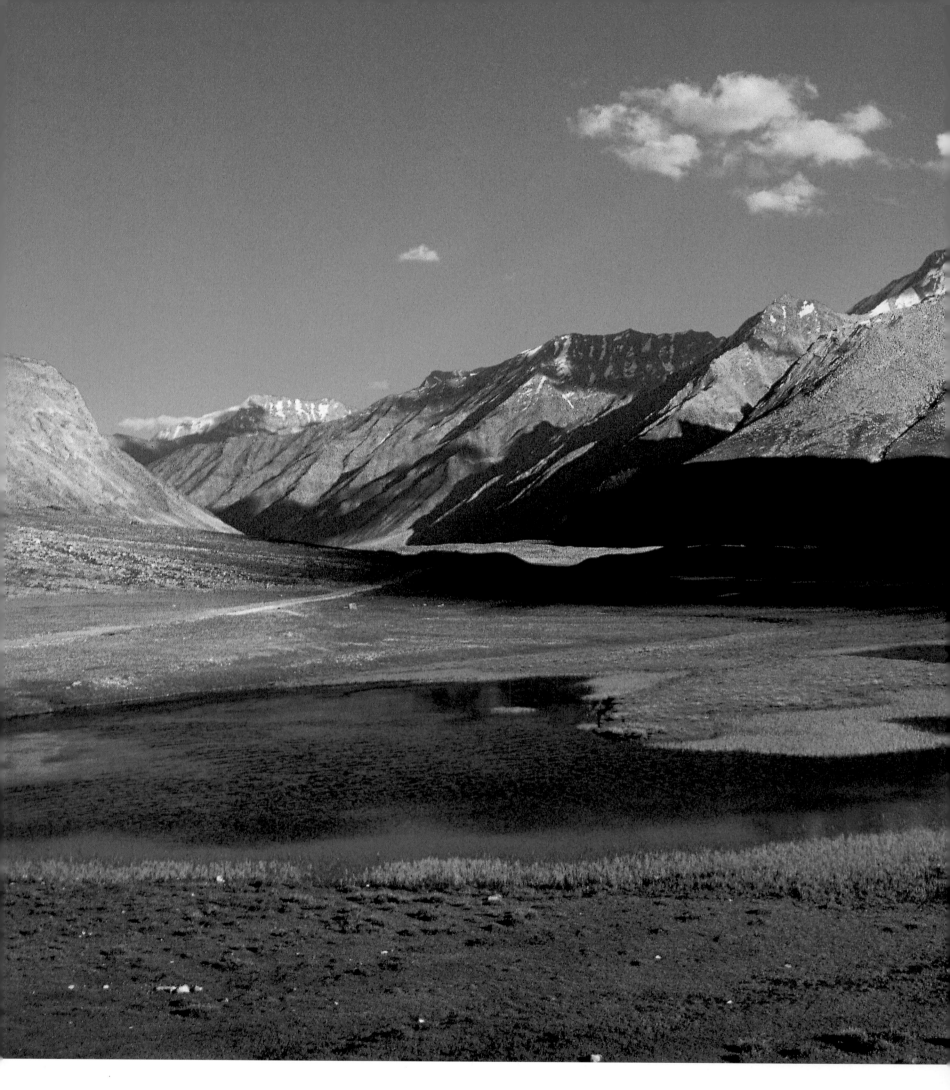

SURU VALLEY, ZANSKAR HIMALAYAS

The upper valley of the Suru river, which makes a hairpin turn at the foot of the Nun (23,251 feet) and Kun (23,408 feet) to join the Indus north of Kargil, is an abandoned, U-shaped, glacial trough.

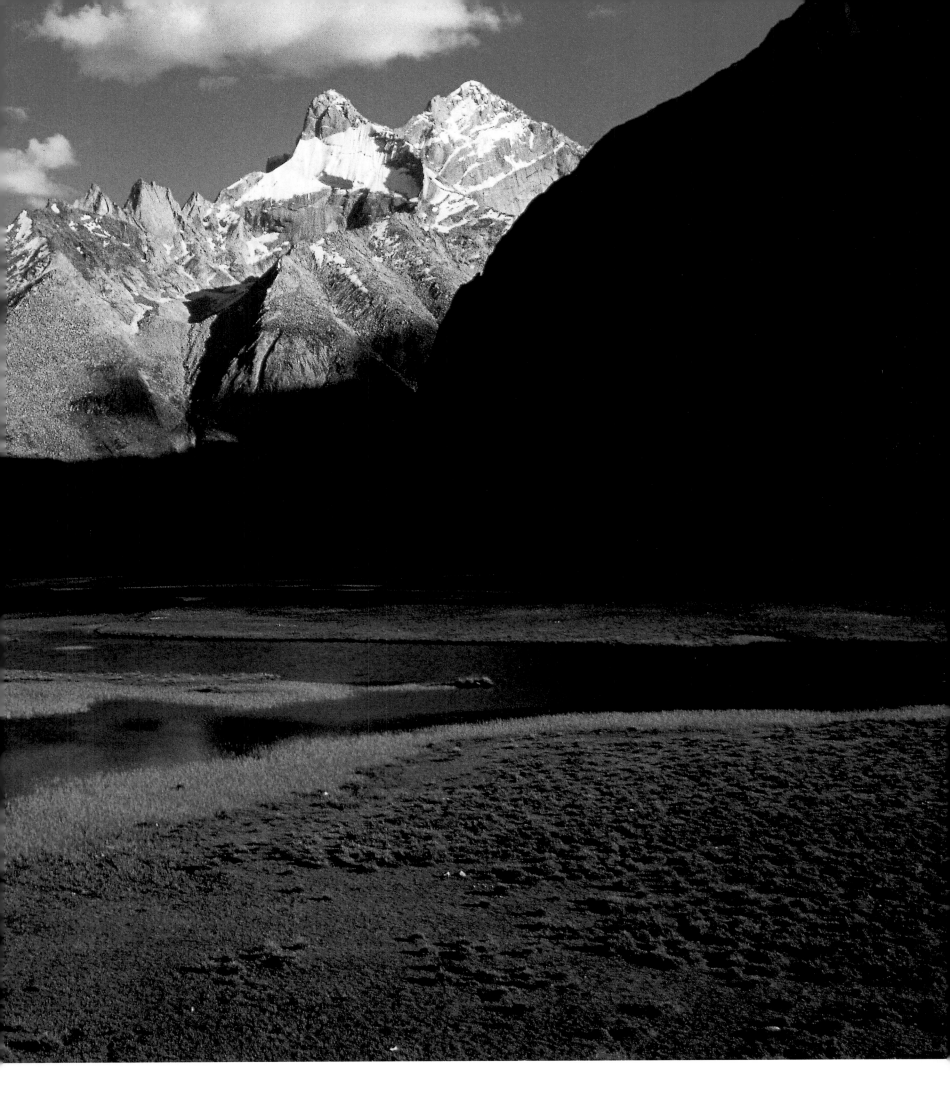

following pages

ULTAR PEAK, HUNZA, PAKISTAN

Although perched in a dominant position, the Mir of Hunza's palace, near Baltit, is dwarfed by the soaring south face of Ultar Peak, hewn ir the high Karakoram gneisses. Entrenched between summits higher than 23,000 feet, whether north or south, the Hunza valley offers one of the world's most bewildering mountain landscapes.

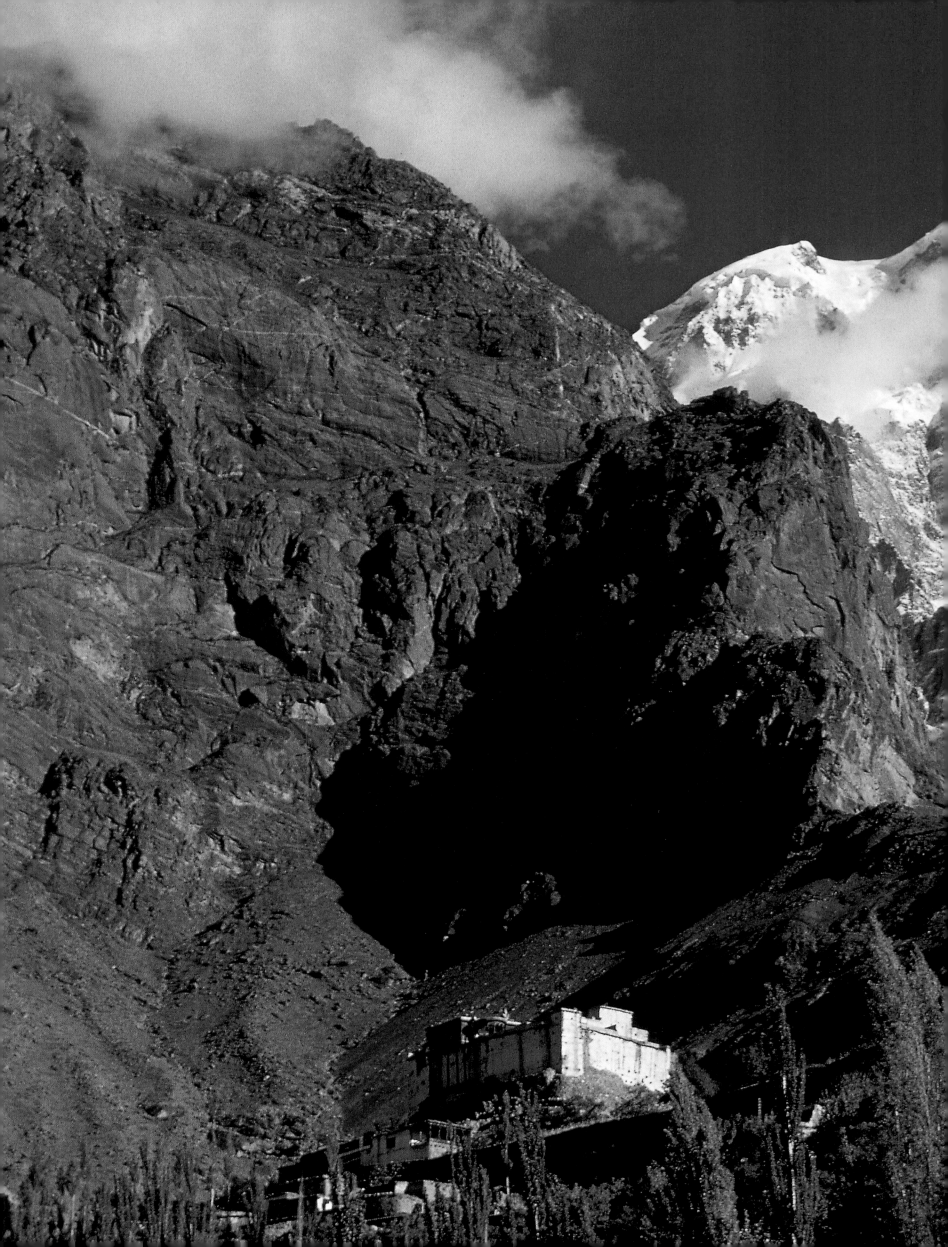

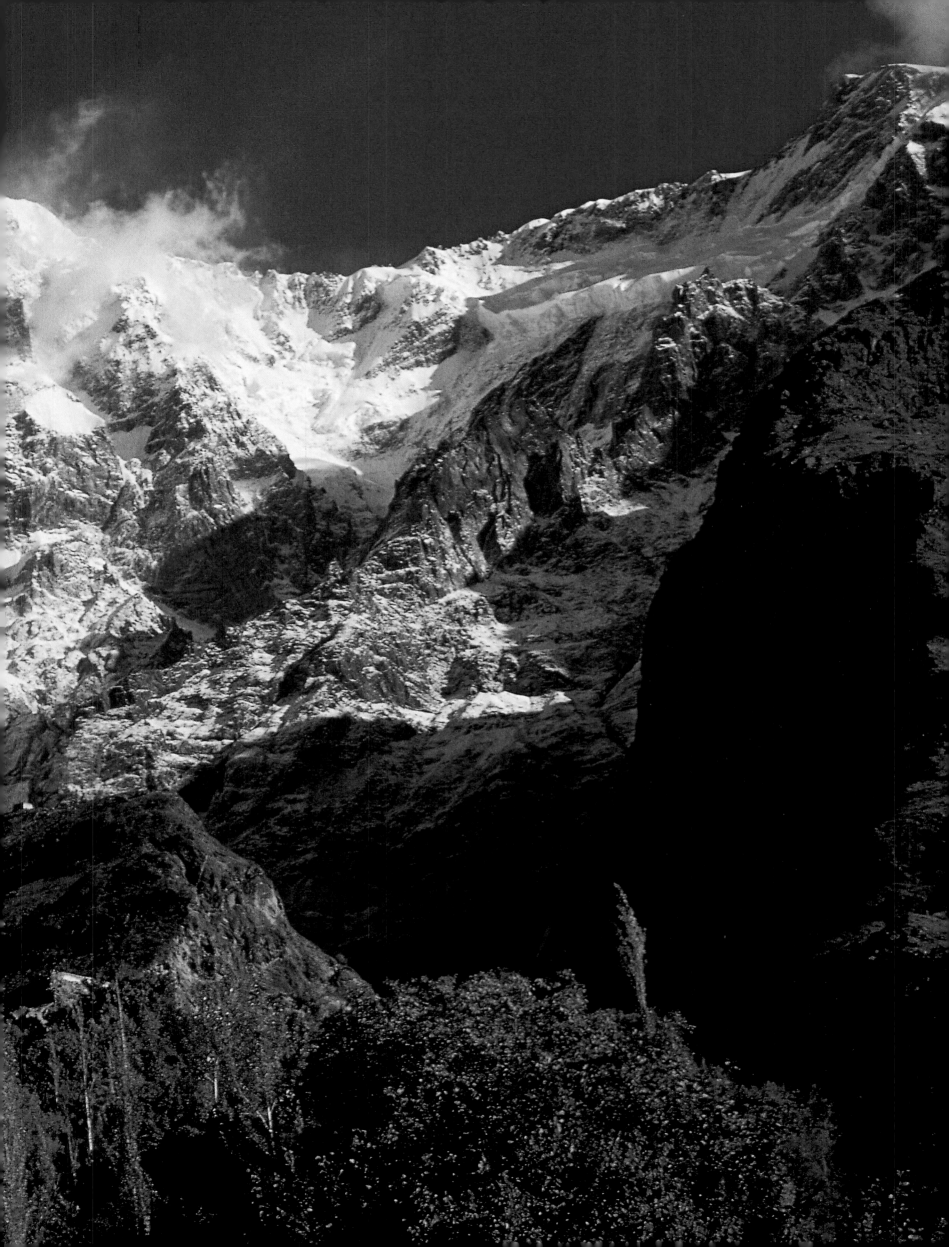

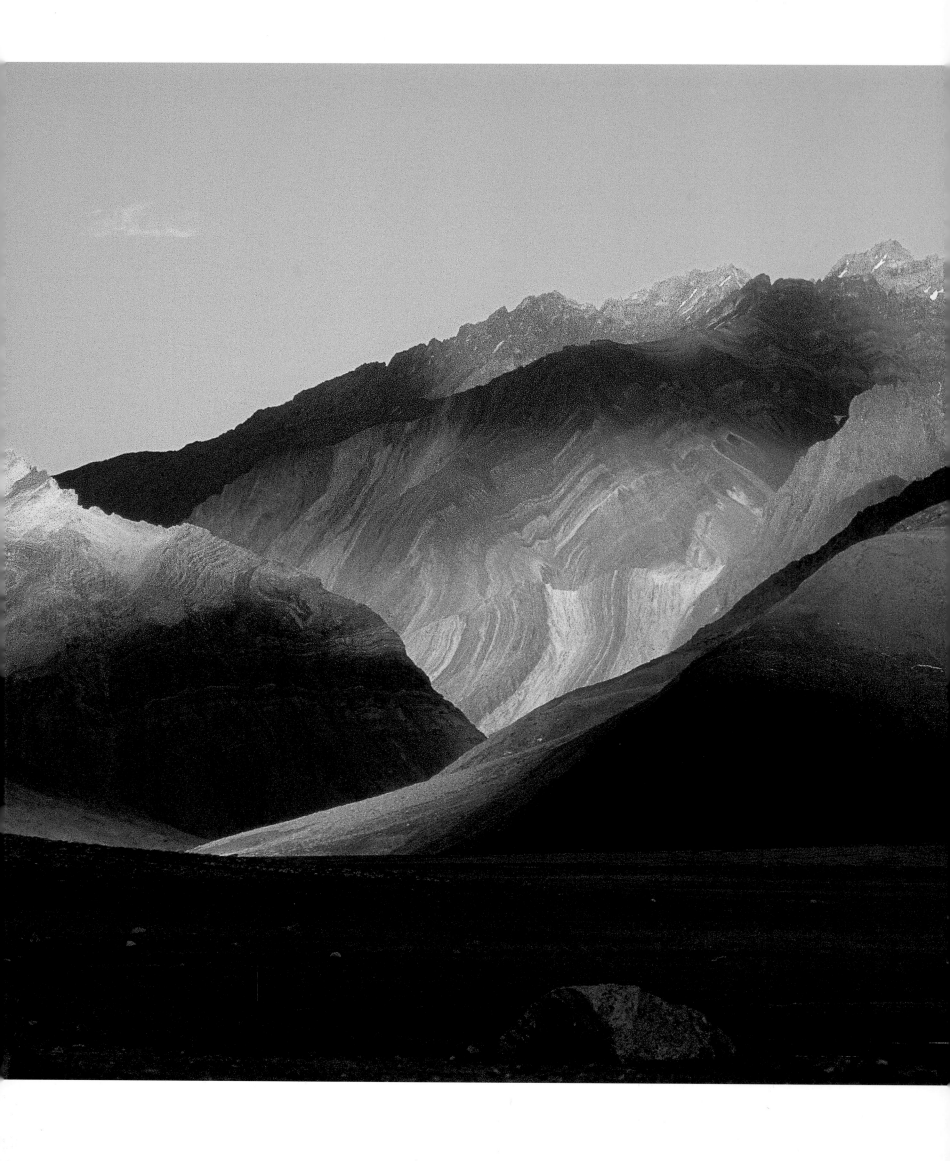

Tethisian folds,
PHOTAKSAR,
ZANSKAR, INDIA

Lit by the setting sun in the V-cut valley, the strata, which look horizontal in the foreground, are in fact tightly folded on each and every one of the spurs, all the way to the crest that blocks the horizon. The folding patterns are finely outlined by the different hues of the layers of limestone, marl, etc., whose palette ranges from dark gray to white, encompassing buff, ochre, and even pink or mauve. This thick series of marine sediments, which is better exposed in Ladakh than anywhere else in the Himalayas, is the famous Tethisian sequence, deposited on continental India's passive margin well before it met with Asia. They are among the main witnesses of the vanished ocean. It is in these layers, detached from the basement upon which they piled up peacefully for hundreds of millions of years, that the most extraordinary cascades of "small" wavelength folds in the entire Himalayan edifice are observed. Today deeply incised by Indus' tributaries, the mile-sized folds of the Zanskar thrust-sheets formed shortly after the onset of collision, approximately 50 million years ago, absorbing nearly 100 miles of the shortening between the two continents.

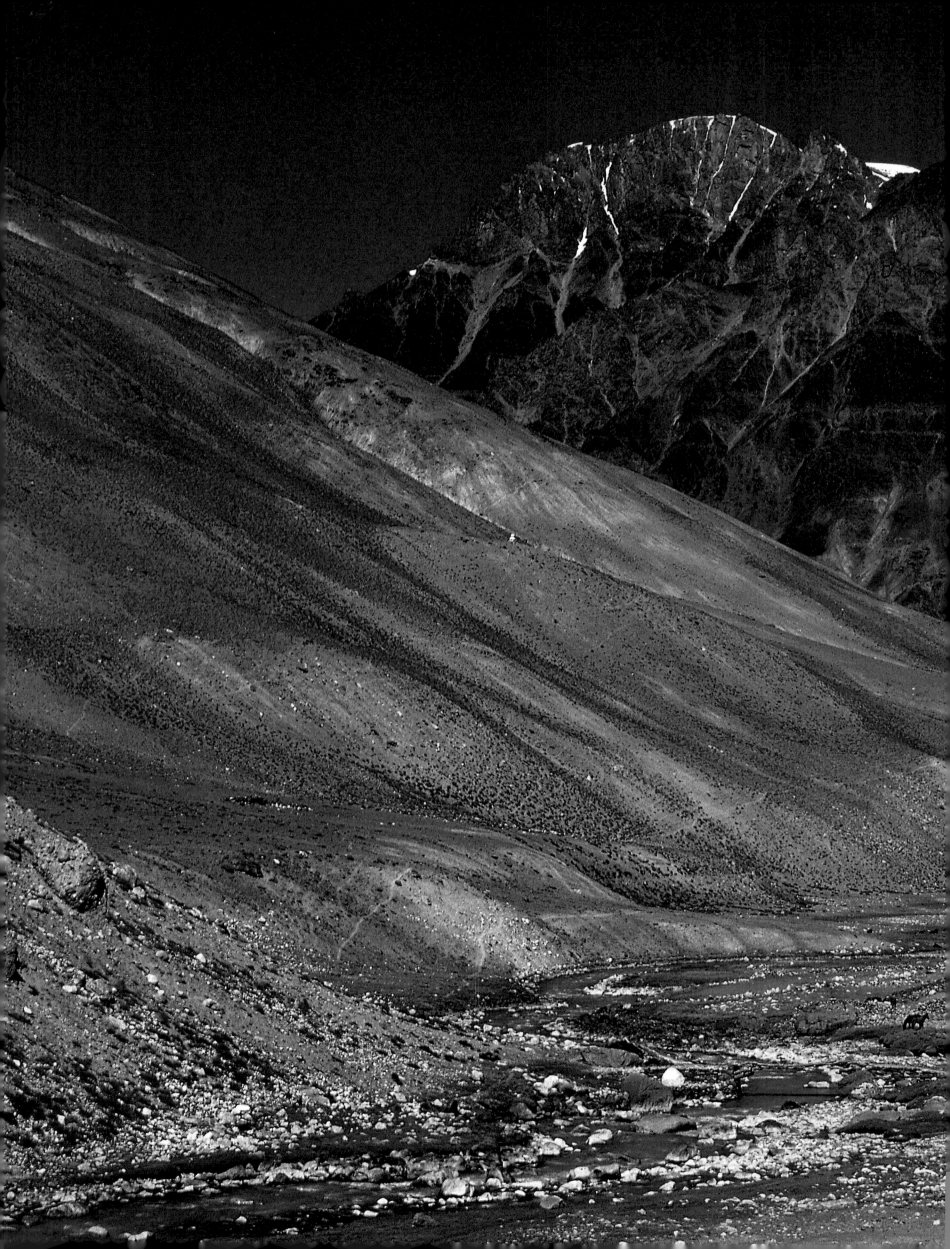

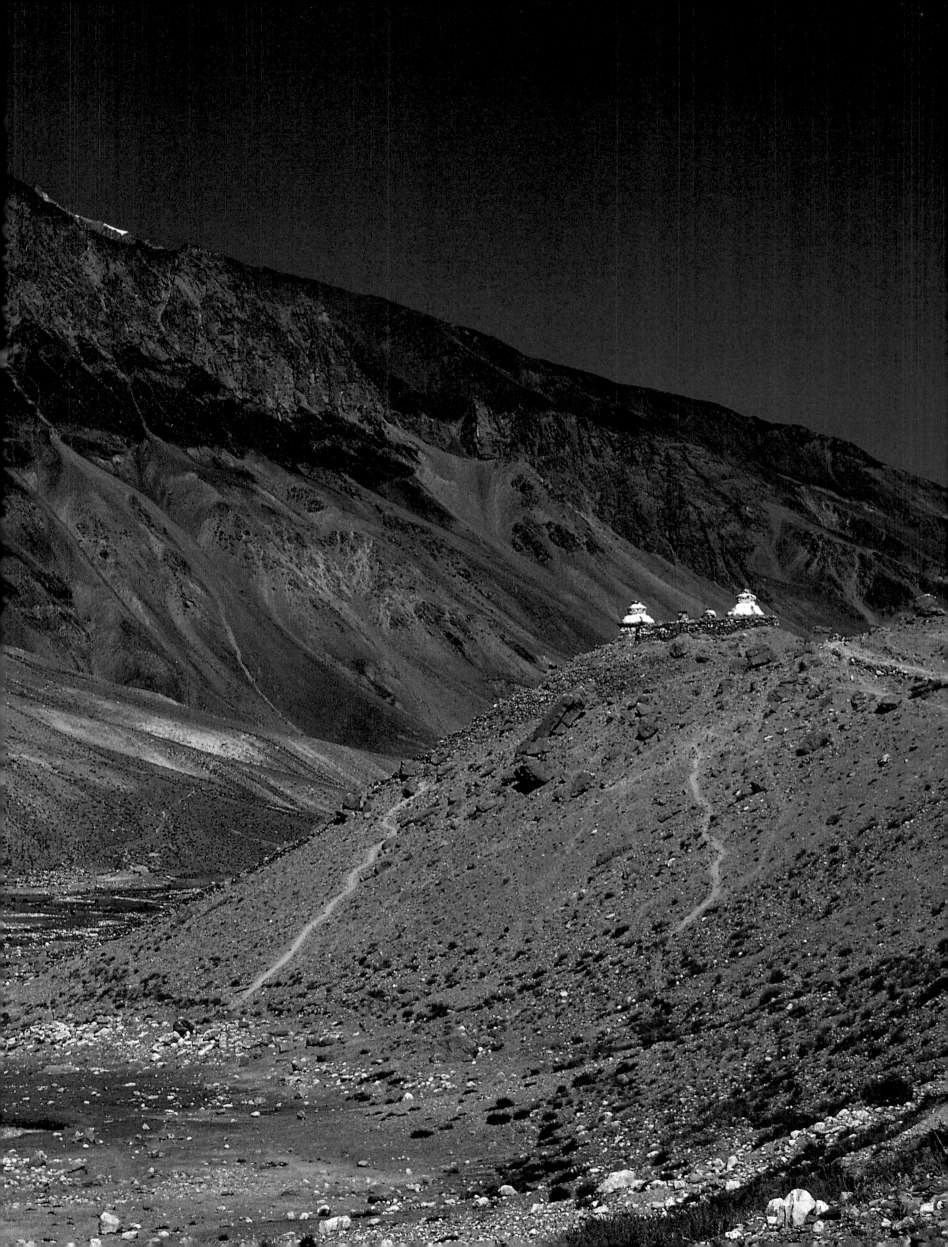

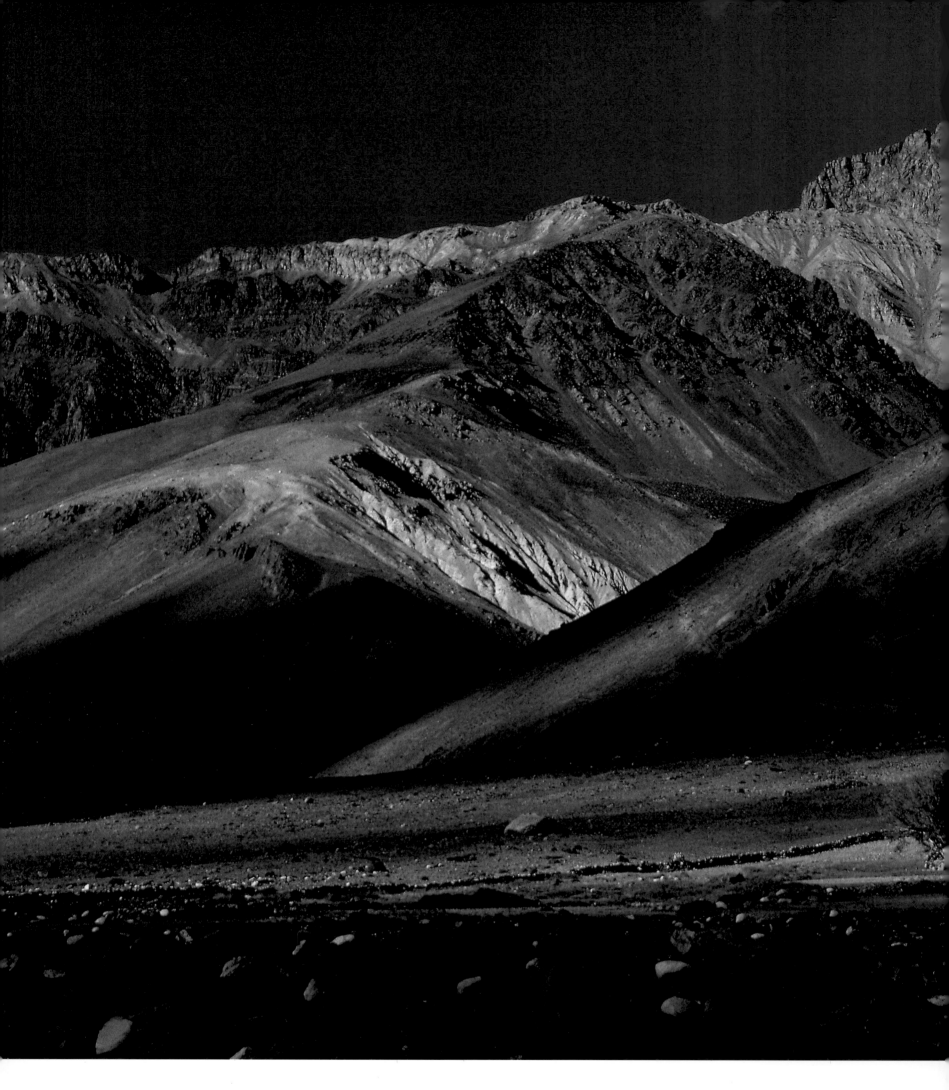

preceding pages

HIMALAYAN NAPPES, LADAKH

Ladakh, where arid valley flanks expose rocks of varied nature and color, with distinct marker horizons in magnificently stratified packages, is a heaven for geologists. Once folds and faults are mapped in three dimensions, the architecture, then the dynamics of mountain building can be reconstructed. This is how the stacking of Zanskar's thrust-sheets was deciphered.

110

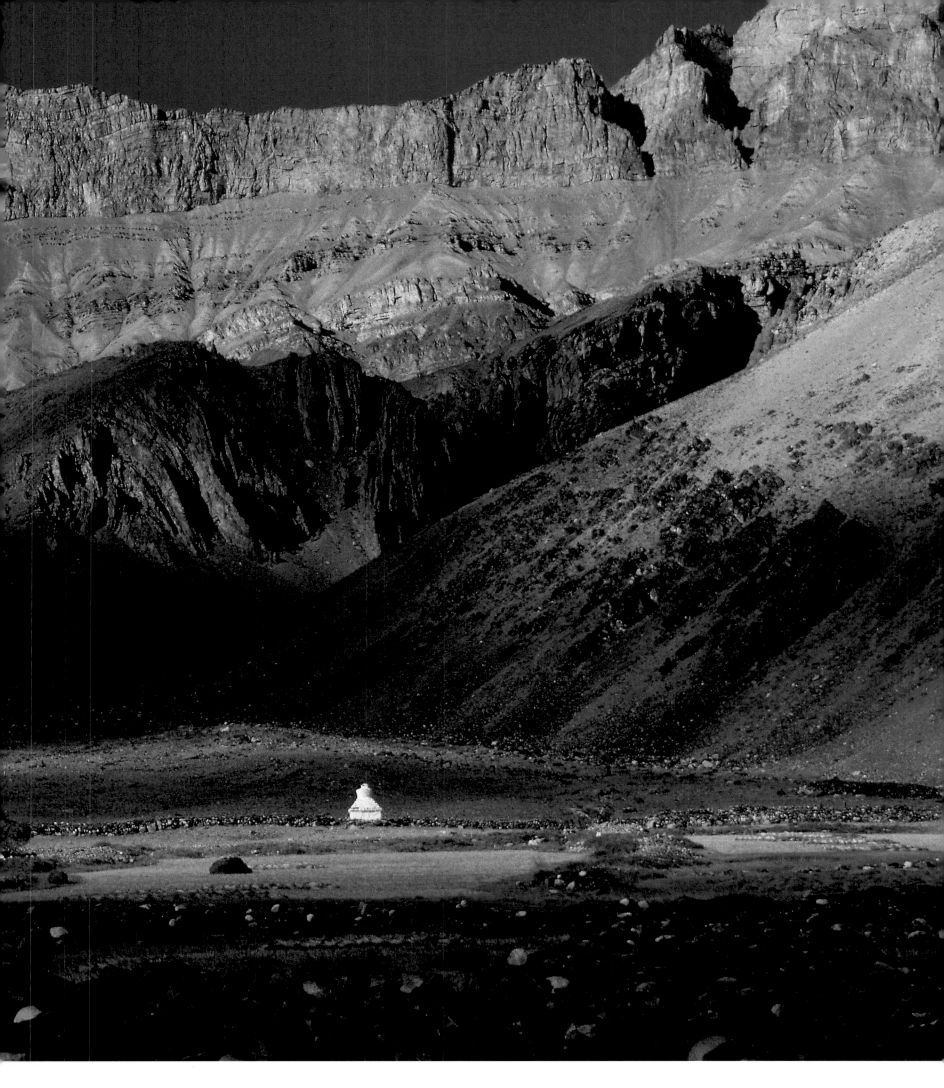

ON THE ROAD TO PADUM, LADAKH, INDIA

The summit cliff and the thinner, partly scree-covered ledges beneath are cut out of Thetisian limestone. The strata, whose natural colors range from gray to ochre, undulate only slightly under the sunlit crest. But behind the white *stupa* in the foreground, they are folded vertically.

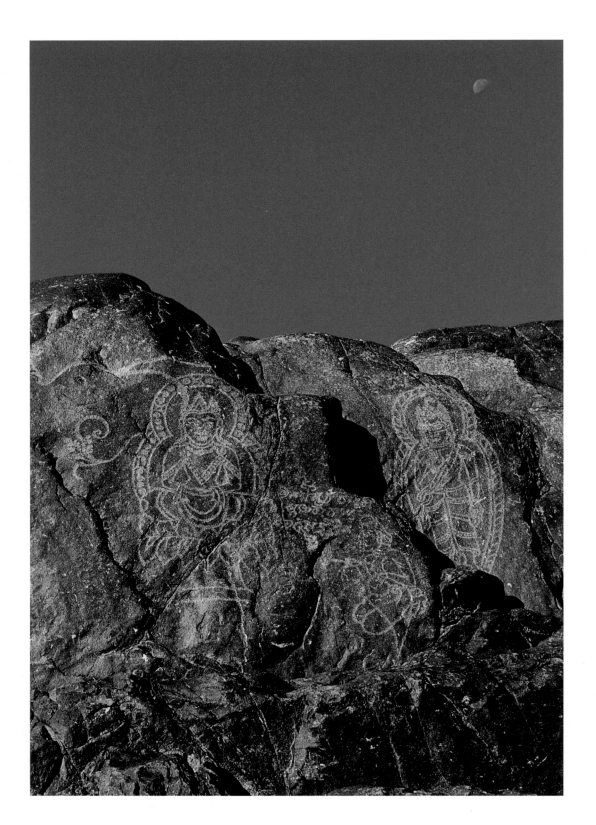

EMBLEM OF THE INDIA–ASIA SUTURE, CHILAS, PAKISTAN

Adorned with engraved Buddhas, this monolith of peridodite and dark-green gabbro, tinted orange-brown by weathering, is one of the "ultramafic" (magnesium and iron rich, as is Earth's mantle) rock splinters that mark the Indus-Yarlung Zangbo suture. Thrust on top of India at the onset of collision, these rocks belong to the Moho (crust–mantle boundary) of the Kohistan volcanic arc, under which Thetis' oceanic lithosphere was consumed before collision.

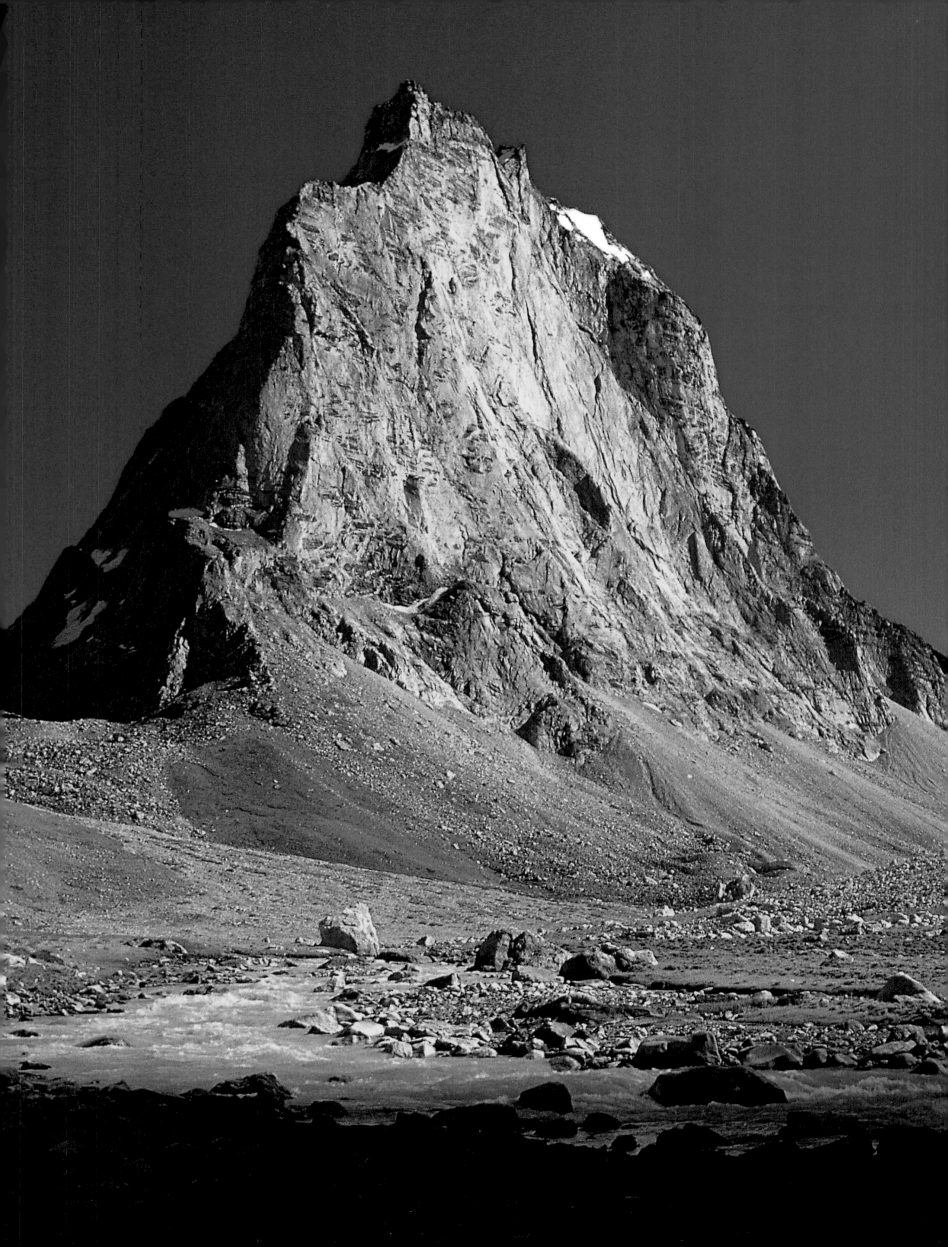

preceding pages

WHITE GRANITE, LADAKH HIMALAYA

Peppered with shiny white mica and small prisms of black tourmaline, injected then crystallized in darker host rocks about 22 million years ago, and finally cooled below 450°F two million years later—the white Gumburanjun granite is a legacy from the fusion of the under-thrust Indian continental crust.

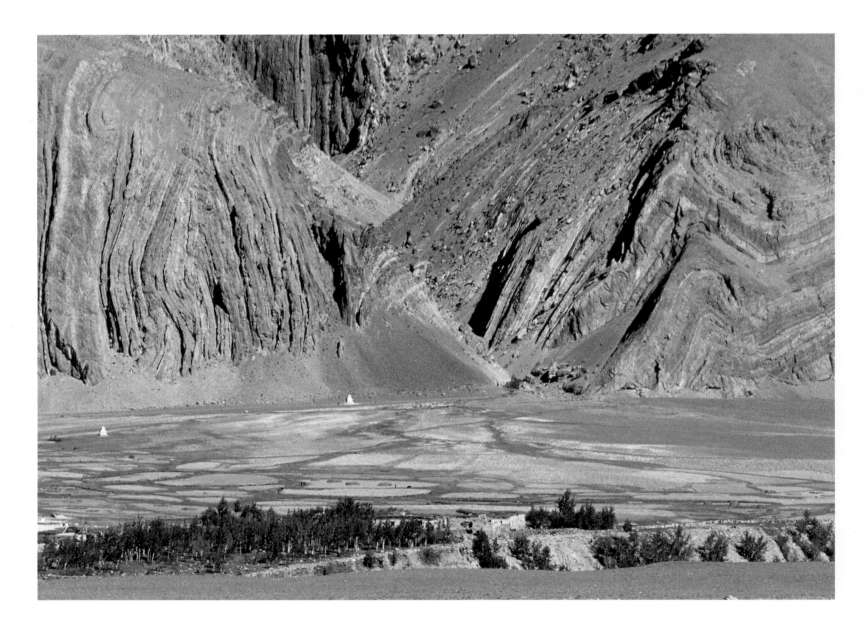

FOLDED LIMESTONE, NEAR TONGDE, ZANSKAR

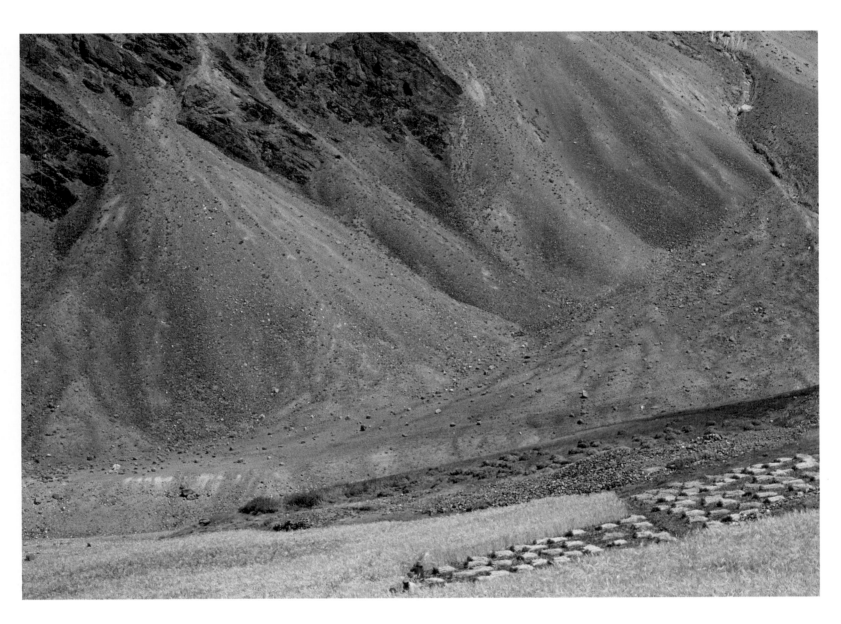

SCREE FAN, ZANSKAR

following pages

MONASTERY, INDUS VALLEY, LADAKH

Built atop a spur overlooking the Indus, this monastery is located on the Asian side of the suture. The light or gray rocks on the illuminated or shaded crests are granite and granodiorite created by Thetis' subduction. They form a large intrusive belt (locally called the "Ladakh Batholith"), stretching all the way to Lhassa, over 900 miles to the east.

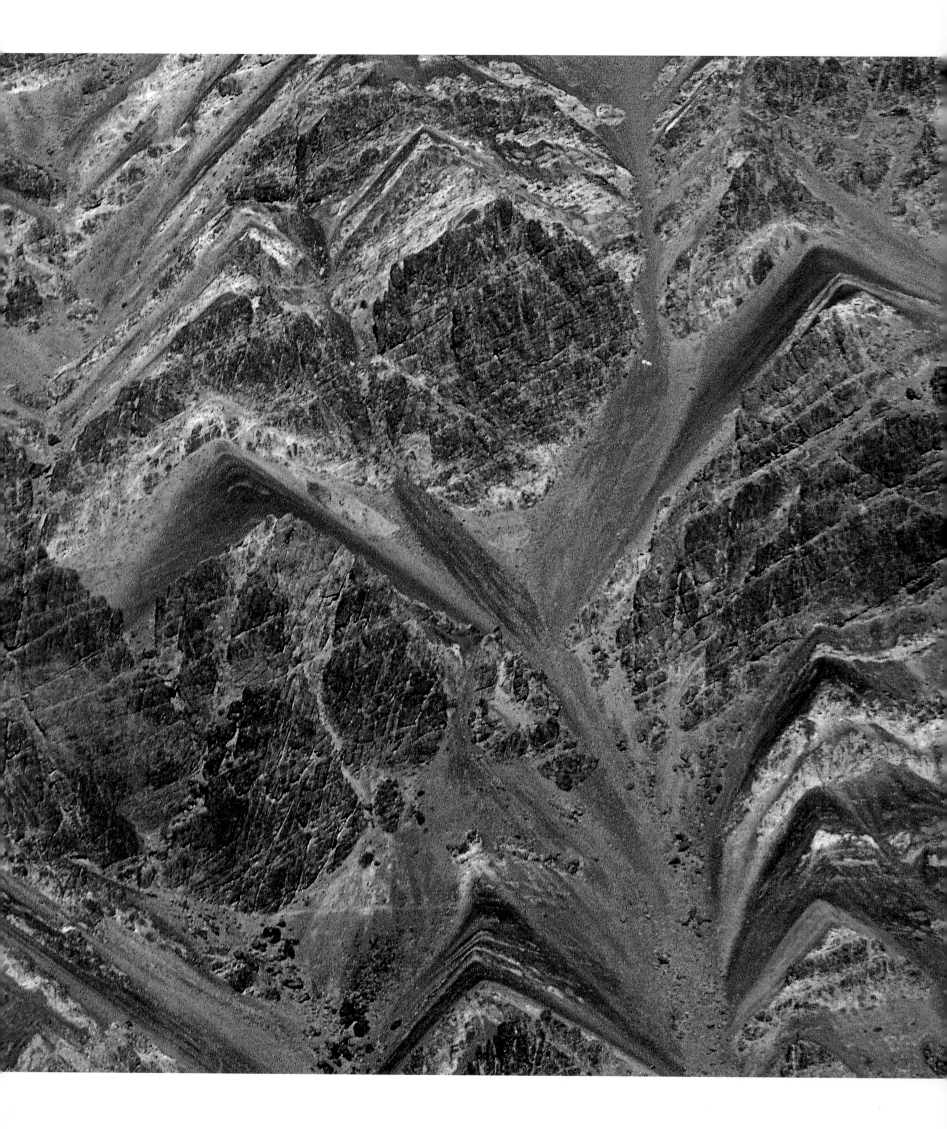

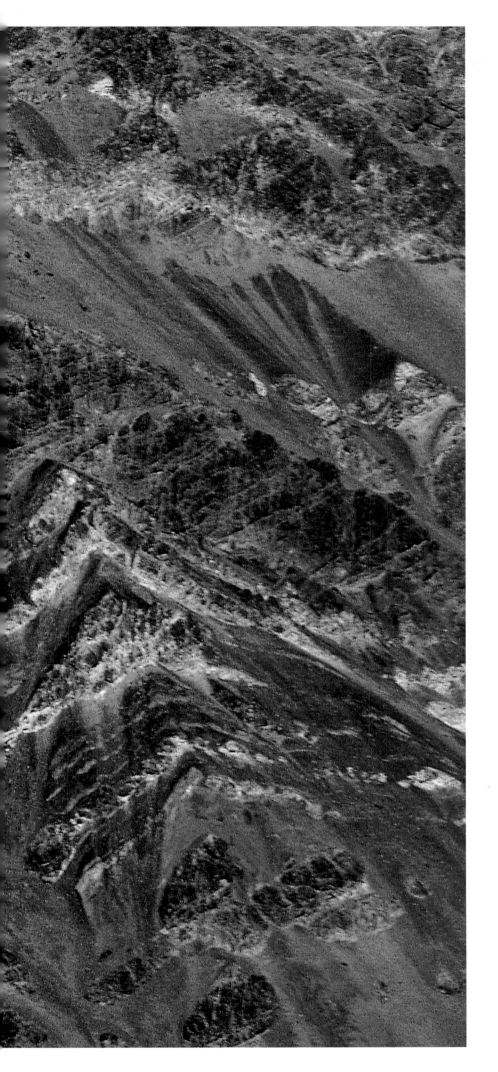

INDUS MOLASSE, DOWNSTREAM FROM KHALSI, LADAKH

Gullies rushing down into the Indus have carved upright beds of the molasse that bears the river's name into parallel chevron patterns highlighted by contrasting colors. It is simply the intersection between the ridged mountain flank and the vertical strata that produces such spectacular chevrons. Composed of stacks of variegated brick-red to wine-purple sandstones alternating with thick, green beds of conglomerates containing diverse cobbles (granite, basalt, limestone, etc.), the Indus Molasse is strongly folded throughout Ladakh. This massive accumulation of molasse follows the suture for at least 1,300 miles, from the Indus to the Yarlung Zangbo valleys, passing by Mount Kailas. An exceptional geological marker, it resulted from the huge accumulation of fluviatile deposits in the great continental trough that "replaced" the Thetis Ocean soon after collision, sealing the scar between the two continents. This "instant," between 50 and 55 million years ago at the dawn of the Eocene period, can be dated in Ladakh. At the base of the molasse, one sees the passage from the latest marine limestones, rich in fossil oysters and nummulites, to the continental deposits consolidated from Indian and Asian pebbles, sands, and muds: the agony of the sea!

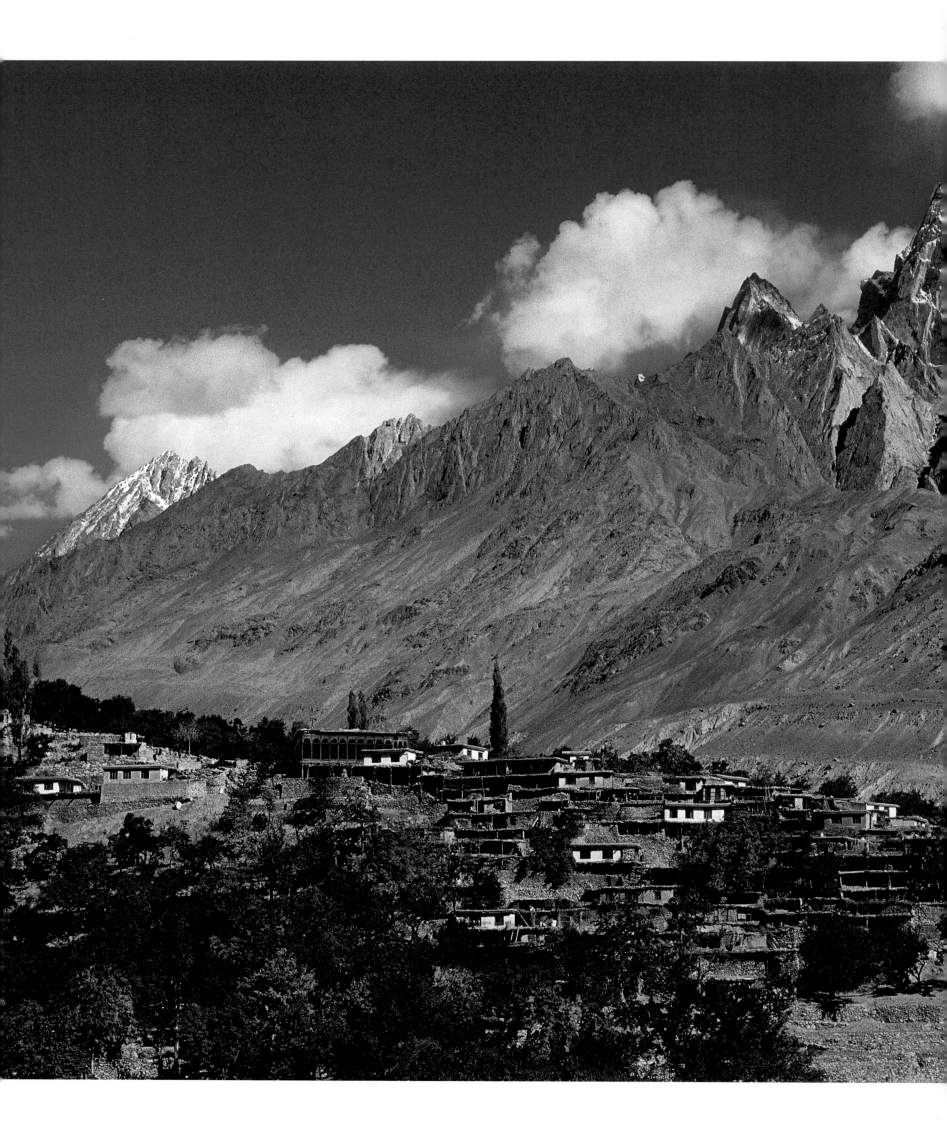

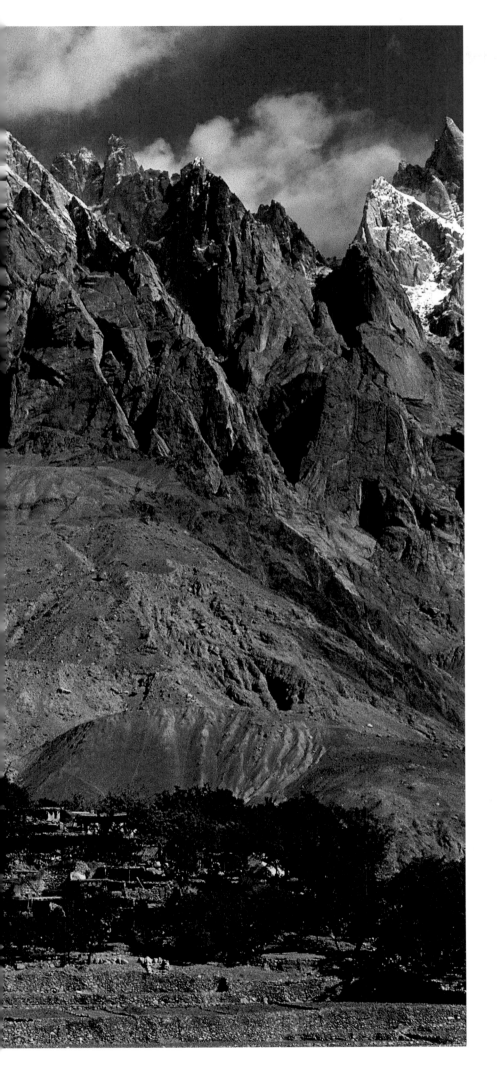

SALTORO, MACHELU, PAKISTAN

Above Machelu, the sharp-edged peaks of the Saltoro ridge, which rise to nearly 19,000 feet, are chiseled in the gneiss and granites of a large batholith, that forms the "spine" of the Karakoram, Asia's second highest mountain range. It is a belt of intrusive rocks, injected 140 and 90 million years ago along the then-active margin of the Asian continent, deformed since. The upward pointing facets and the sheer, 3,000-foot-high slabs reflect the flattening of the granites into gneiss. The Shyok suture, which skirts the slabs' base, is covered here with inset levels of lateral moraines, made of big granite boulders, which rise as a staircase behind the village. Machelu itself is built on a south-facing terminal moraine that has been transformed into stepping terraces planted with apple and apricot trees. No need to quarry blocks to build the terraces' supporting walls; the moraine boulders are enough. This enormous heap of debris was left behind about 15,000 years ago by the retreat of the Hushe glacier, a huge stream of ice fed by a ring of glacial cirques between two of Karakoram's highest summits: Masherbrum (26,659 feet) and Chogolisa (25,242 feet). The moraines contain blocks of the much younger—only 25 million years old—Baltoro leuco-granite.

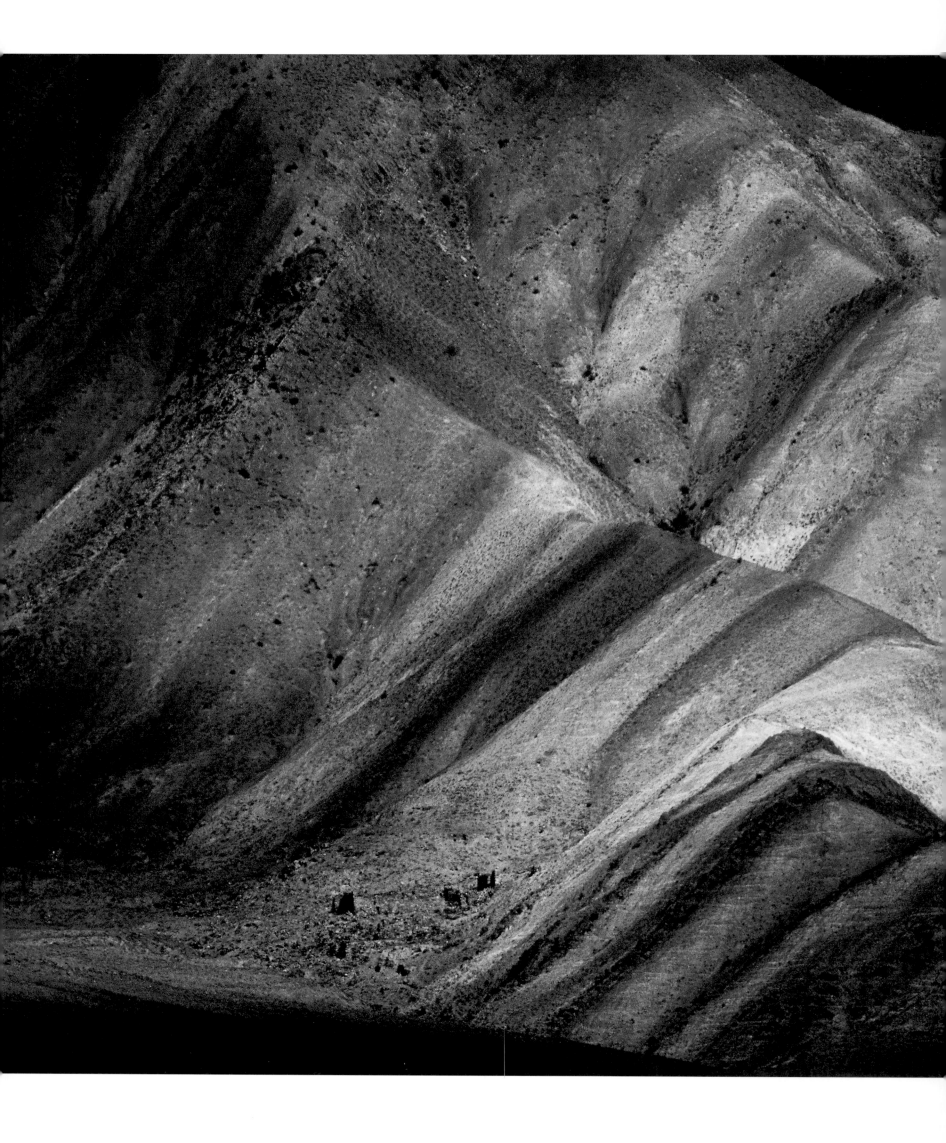

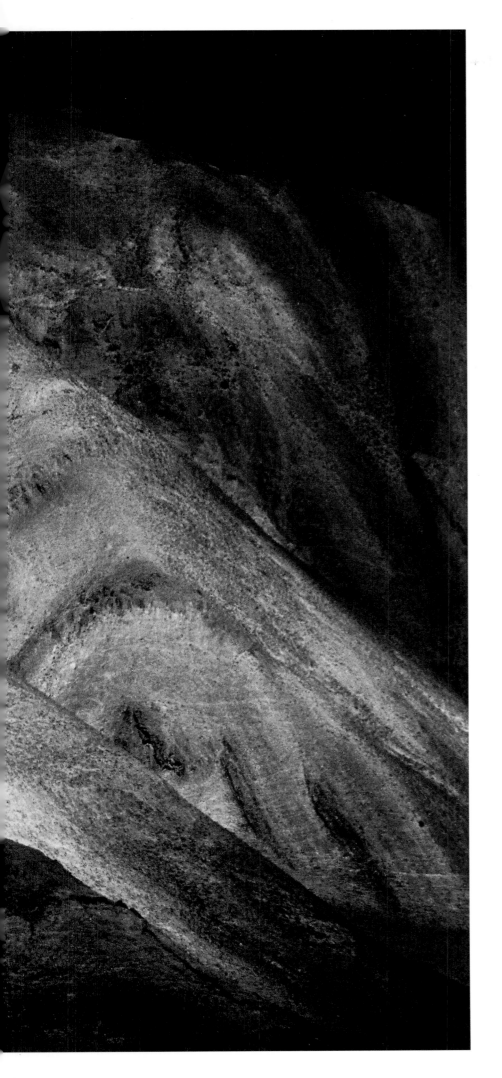

Far-travelled sandstones, TAKENA, TIBET

Just north of Lhasa, this folded series of red sandstone with intercalated limestone, holds much-sought-after evidence about Tibet's uplift and the magnitude of India's penetration into Asia since collision started. In the limestone, datable fossils such as Orbitolina show that at least the southern half of what is today the high Tibetan plateau was a coastal marine platform, at most 600 feet below sea level, only 100 million years ago. This provides strong evidence that the plateau's 16,000-foot uplift results mostly from the collision between India and Asia, the only significant tectonic event since that epoch. As for the red sandstones, the Earth's magnetic field inclination that they froze during compaction reveals that they were deposited near the equator, some 1,500 miles south of their current position! As they lay north of the suture, this yields a measure of how the collision transformed Asia's shape: India penetrated more than 1,200 miles into it, creating not only mountains and plateaus, but also pushing aside large slices of the continent, including Indochina, toward the Pacific.

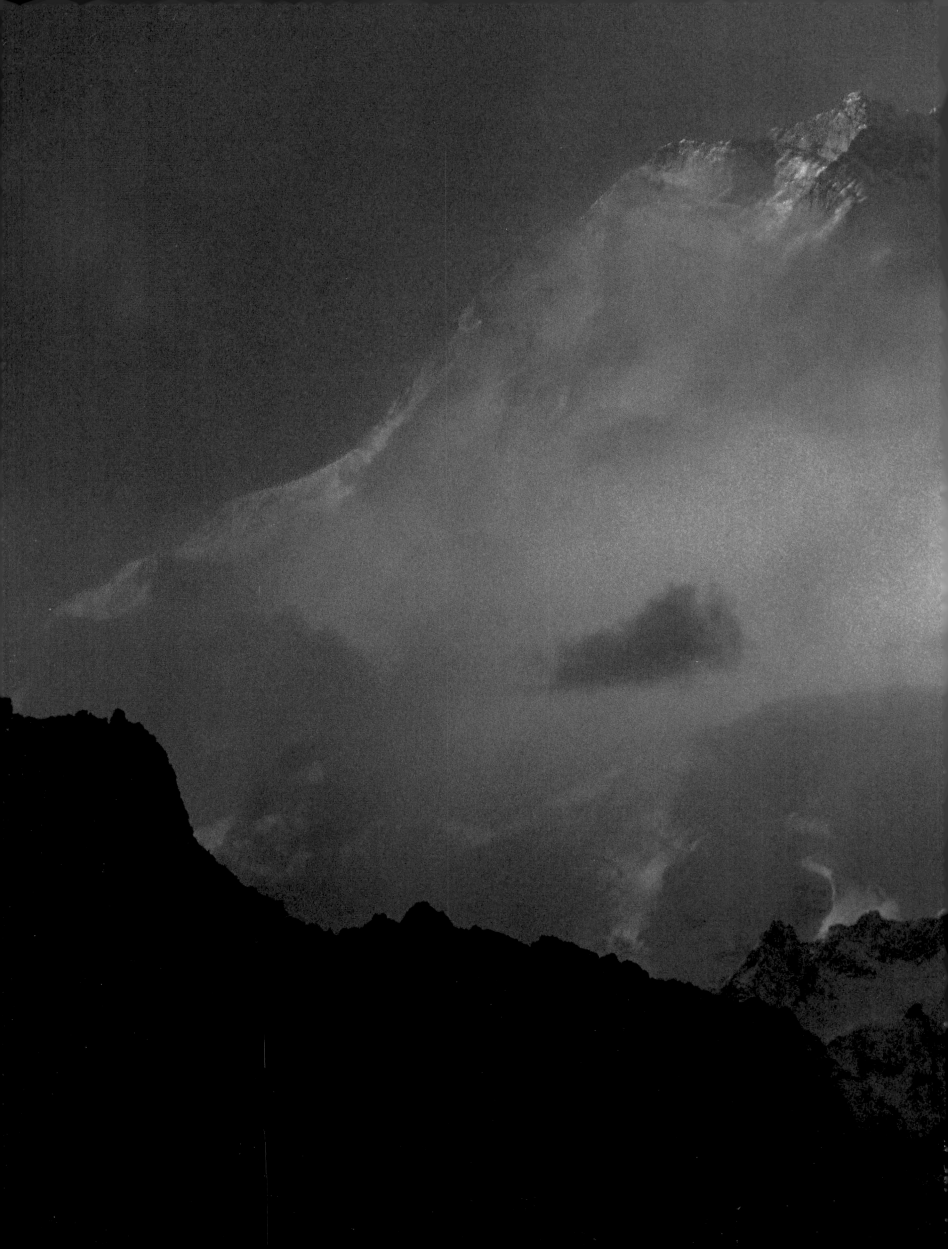

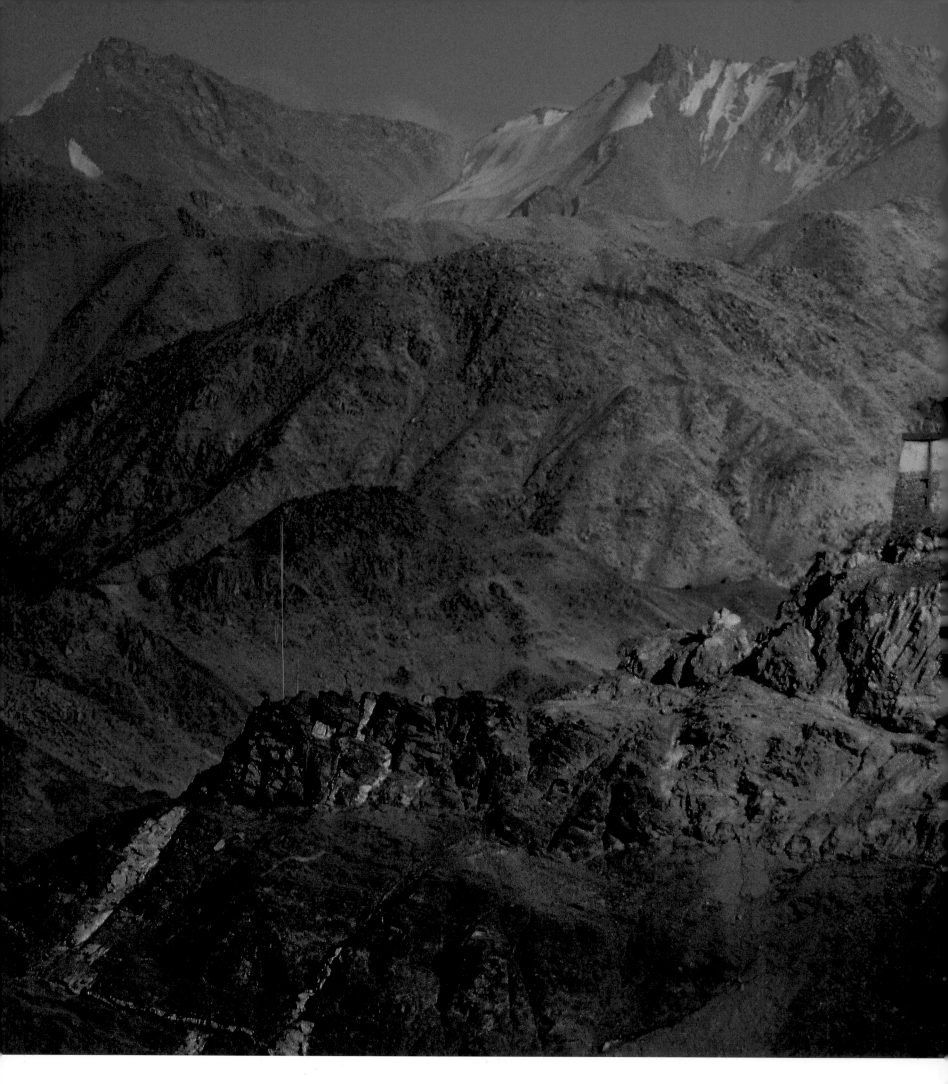

preceding pages

MASHERBRUM, KARAKORAM, PAKISTAN

At 25,660 feet, the Masherbrum, whose top remains illuminated by the setting sun while the valleys are cast in
shadow, is one of the Karakoram's giants.

128

THIKSE, LADAKH, INDIA
Like most Tibetan buildings, those of the monastic village of Thikse, which lean against a granite spur in front of a uniformly granitic landscape, have typical, inward slanting walls and trapezoidal facades.

ZANSKAR, LADAKH

On the path to the monastery.

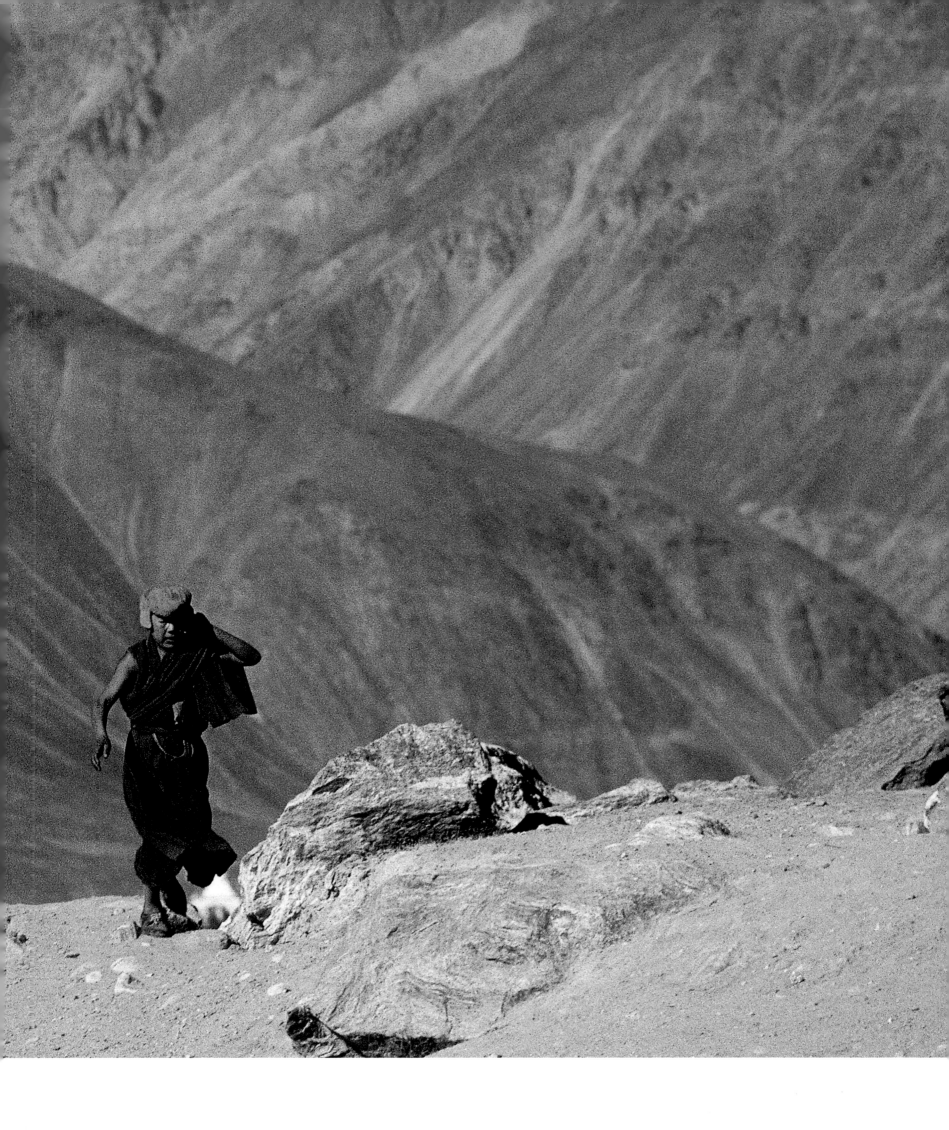

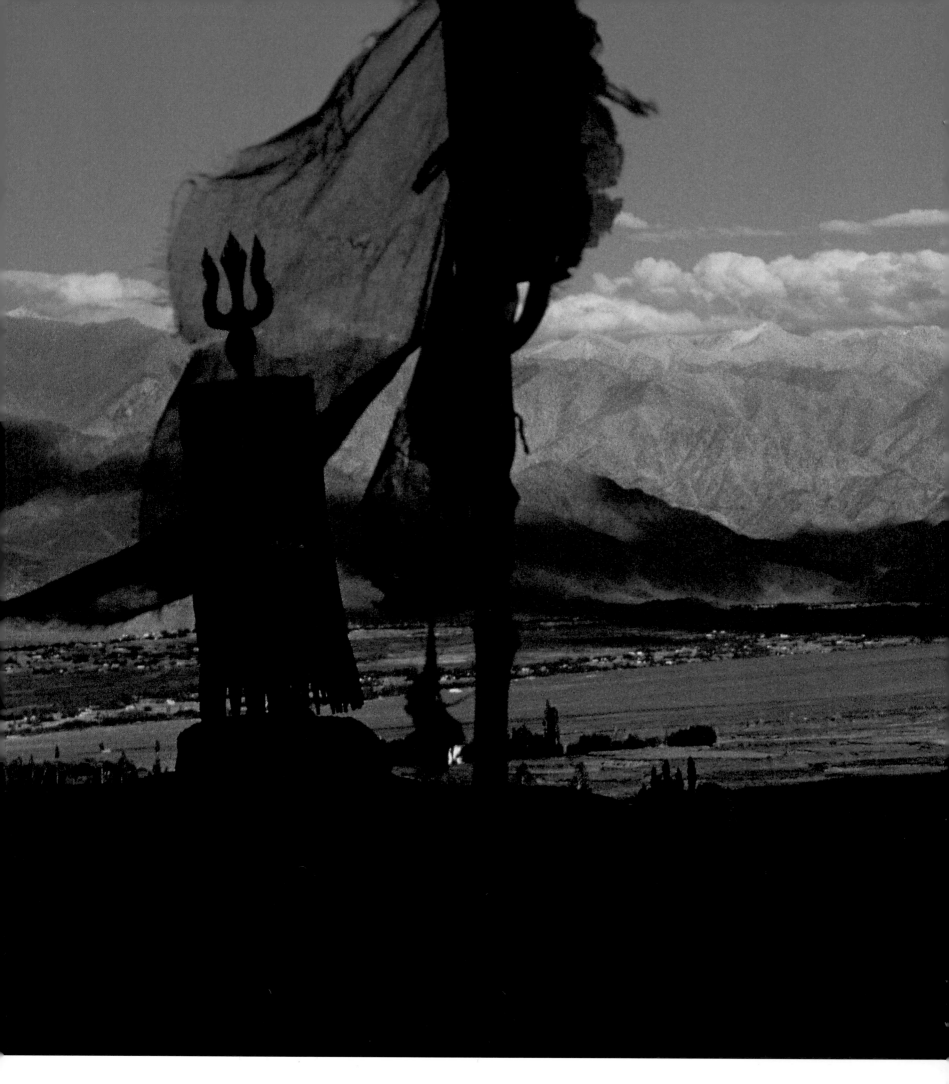

NEAR LEH, LADAKH
The Indus Valley, grave of the Thetis Ocean.

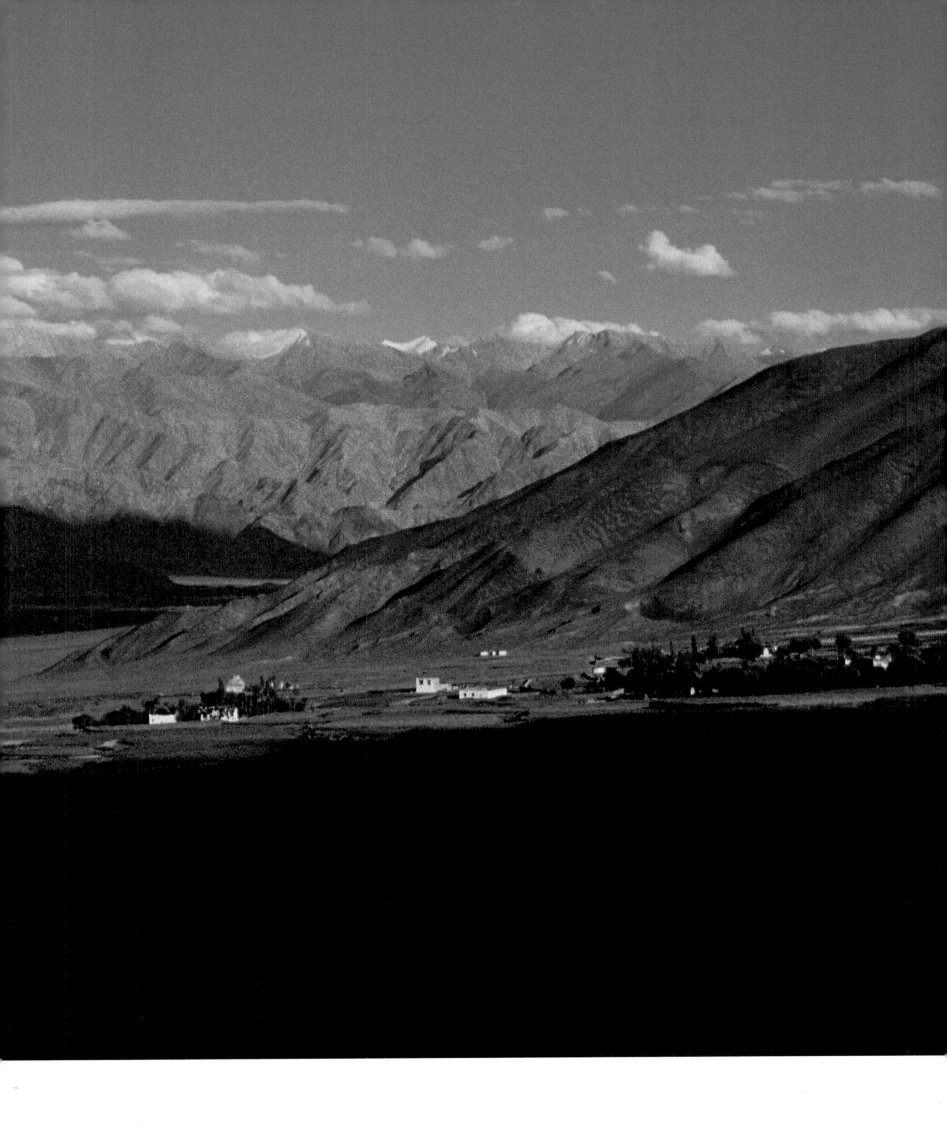

Mélanges, LHAZE, YARLUNG ZANGBO SUTURE, TIBET

A chaos of rocks mixed without order crops out on the hill flank above the riverbed and the paddies of sprouting barley. On the right side of the Tibetan woman carrying her child, the large, pinkish-white rock shaped like a leaping dolphin is a Permian limestone block. The dark green rocks below are much younger basalts, fragments of Thetis' Cretaceous oceanic crust. On the left side of the woman's silhouette, the two wine-colored patches above the basalt are silica-rich "radiolarites"—named after the abundant, tiny fossils (radiolarians) they contain—which often blanket the deep oceanic crust. Yet above them, we again see basalt shades, then a band of white limestone beneath the crest. Rightly dubbed *mélange,* such a variegated geological formation, juxtaposing rocks of different nature, age, and provenance—shallow continental plateau for the limestone, abyssal ocean for the others—is manufactured by subduction, which scrapes off, then kneads together small shards of the plunging or overhanging plate. The result, a real geological "fisherman's stew," heralds the presence of an oceanic suture.

MONK, IN LADAKH

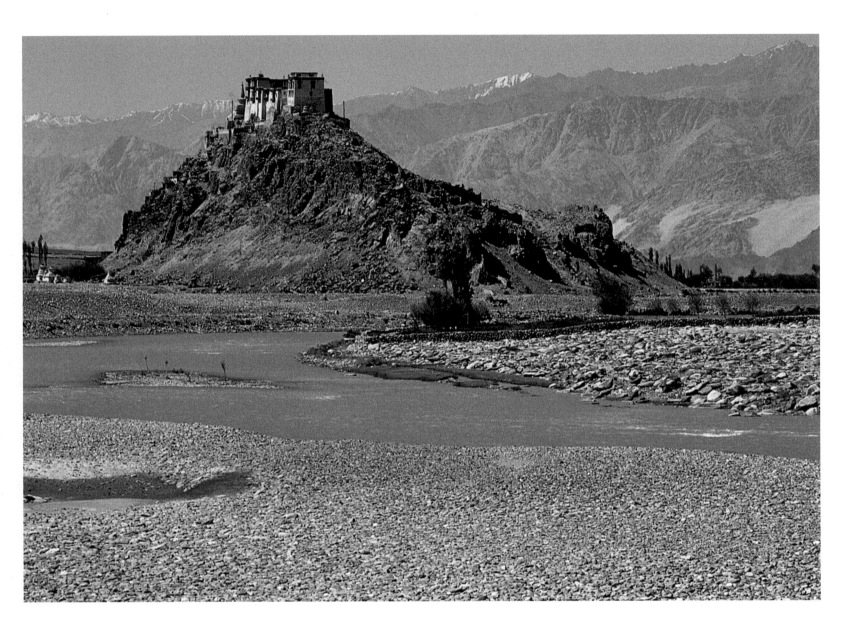

STAKNA GOMPA, GEOLOGICAL FRONTIER POST, LADAKH

Located halfway between Leh and Hemis, with the Ladakh granite batholith for a background, the Stakna monastery is built atop a pinnacle in the middle of the Indus flood plain. It stands like a milestone, marking the geological boundary between India and Asia, right above the suture, here buried beneath the Indus molasse.

preceding pages

LEH, INDUS VALLEY, LADAKH

Facing Leh, Ladakh's capital, the Indus valley widens into a vast cultivated plain. It is the site of an ancient lake dating from a time when the river was dammed downstream by glacial moraines.

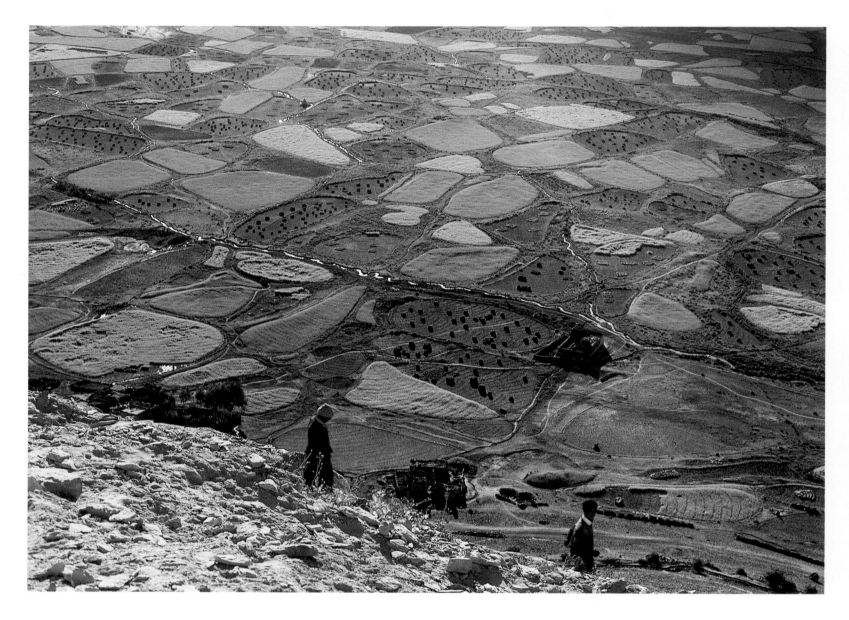

ANCIENT LAKE, NEAR PADUM, ZANSKAR

These rounded, pancake-shaped barley fields are typical of valleys that were flooded by large lakes during rapid glacier melting.

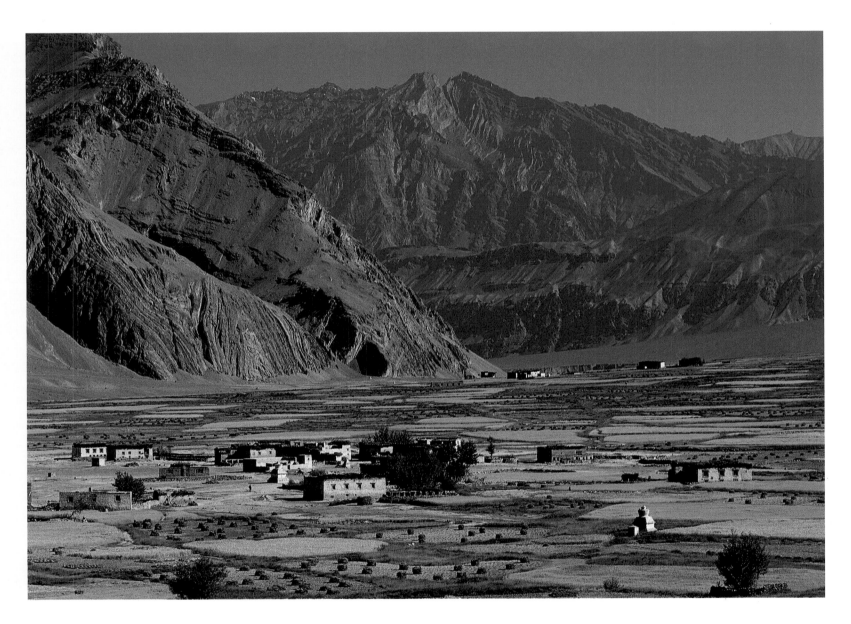

NEAR PISHU, ZANSKAR

The most fertile zones of Ladakh are the large, flat-floored, U-shaped, former glacial valleys. On one side of the valley, the cliff planed by ice exposes splendid upright folds. On the other, farther out, we see the inset ledges of two lateral moraines long abandoned by the glacier.

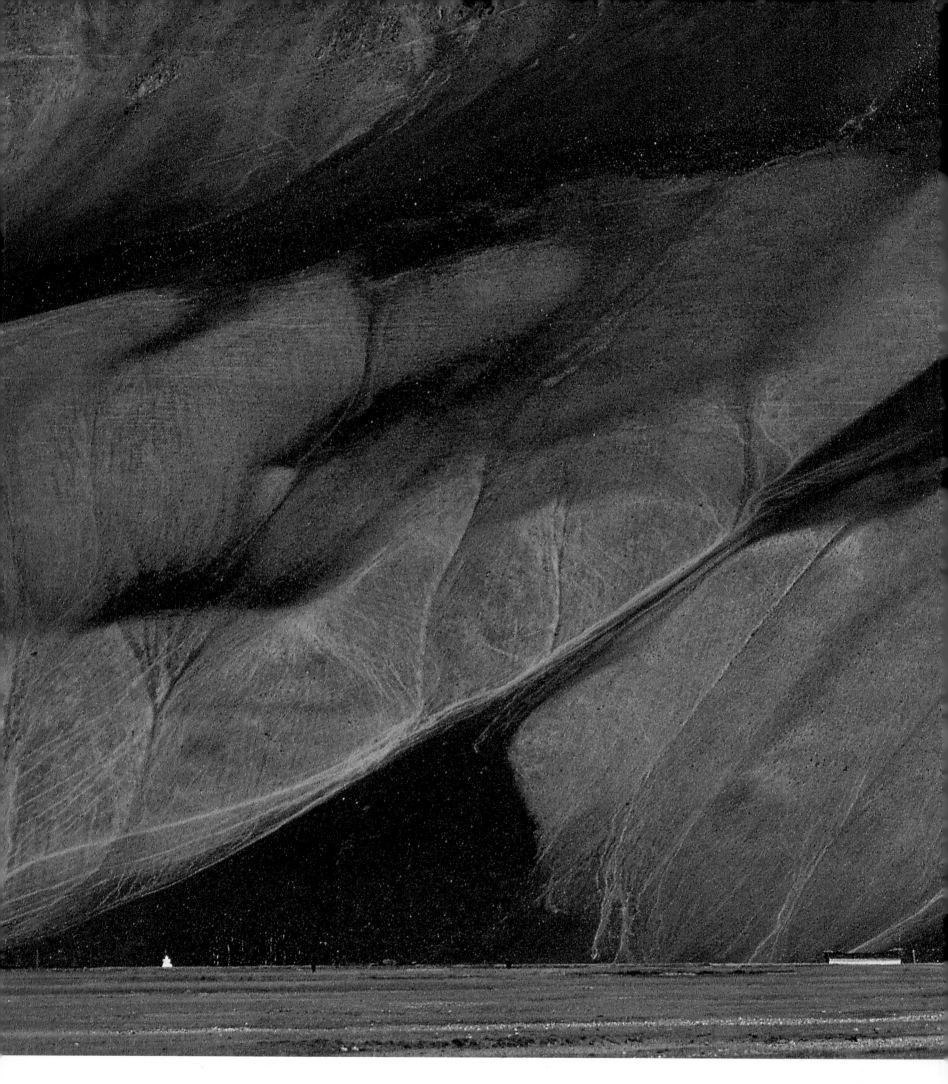

LIGHT EFFECTS ON POSTGLACIAL SLOPES, ZANSKAR

Since the glacier retreated, these gentle slopes have been smoothed by deposition of fine colluvial scree layers.
The diverse shades of gray come from the calcareous nature of these deposits. The steeper slopes are gouged
by the narrow channels of debris-flows that rush down with either violent storms or the thawing of snow.

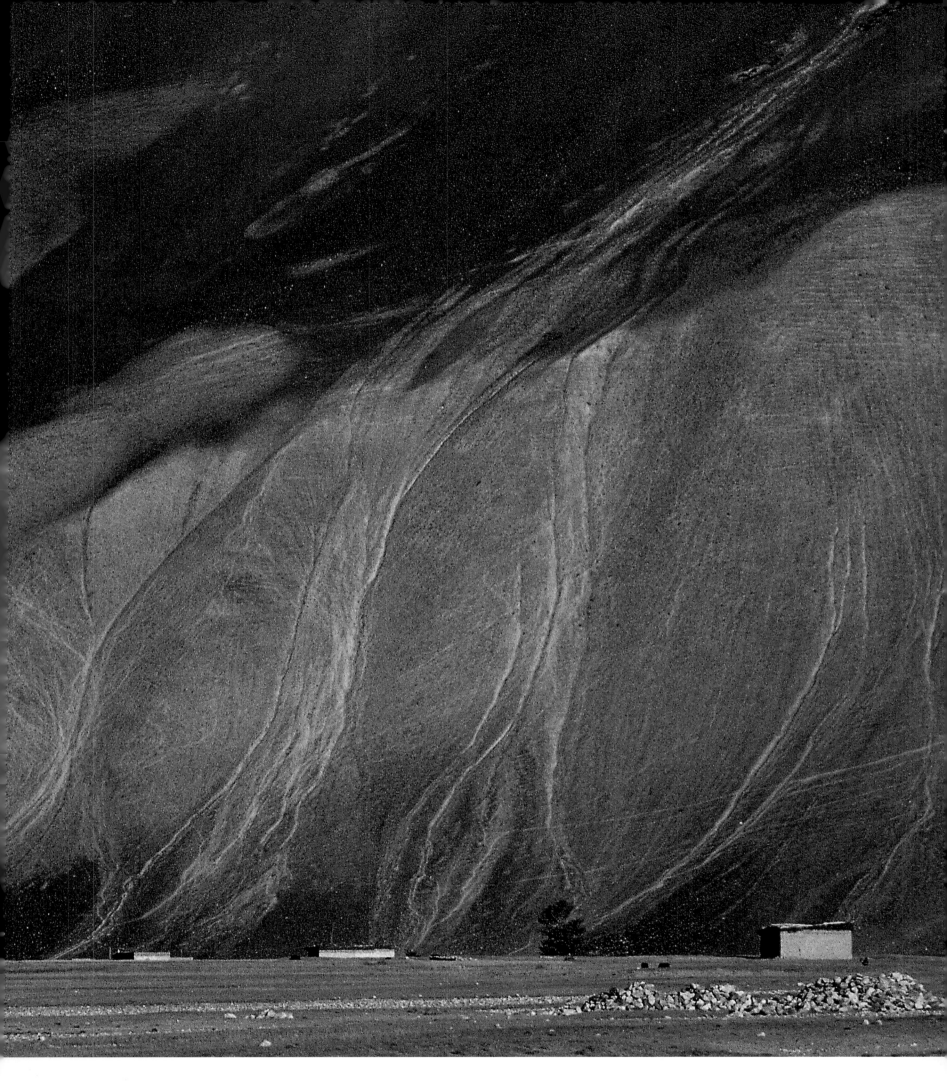

following pages

NEAR JULDO, SURU VALLEY, LADAKH

The foliated, flattened and laminated metamorphic layers that plunge uniformly towards the northeast, mark the Zanskar shear zone. This planar ramp at the base of the Thetisian thrust-sheets slipped backwards during the rise of the high Himalayan range. This provided the Gumburanjun leuco-granite with a path to rise upwards.

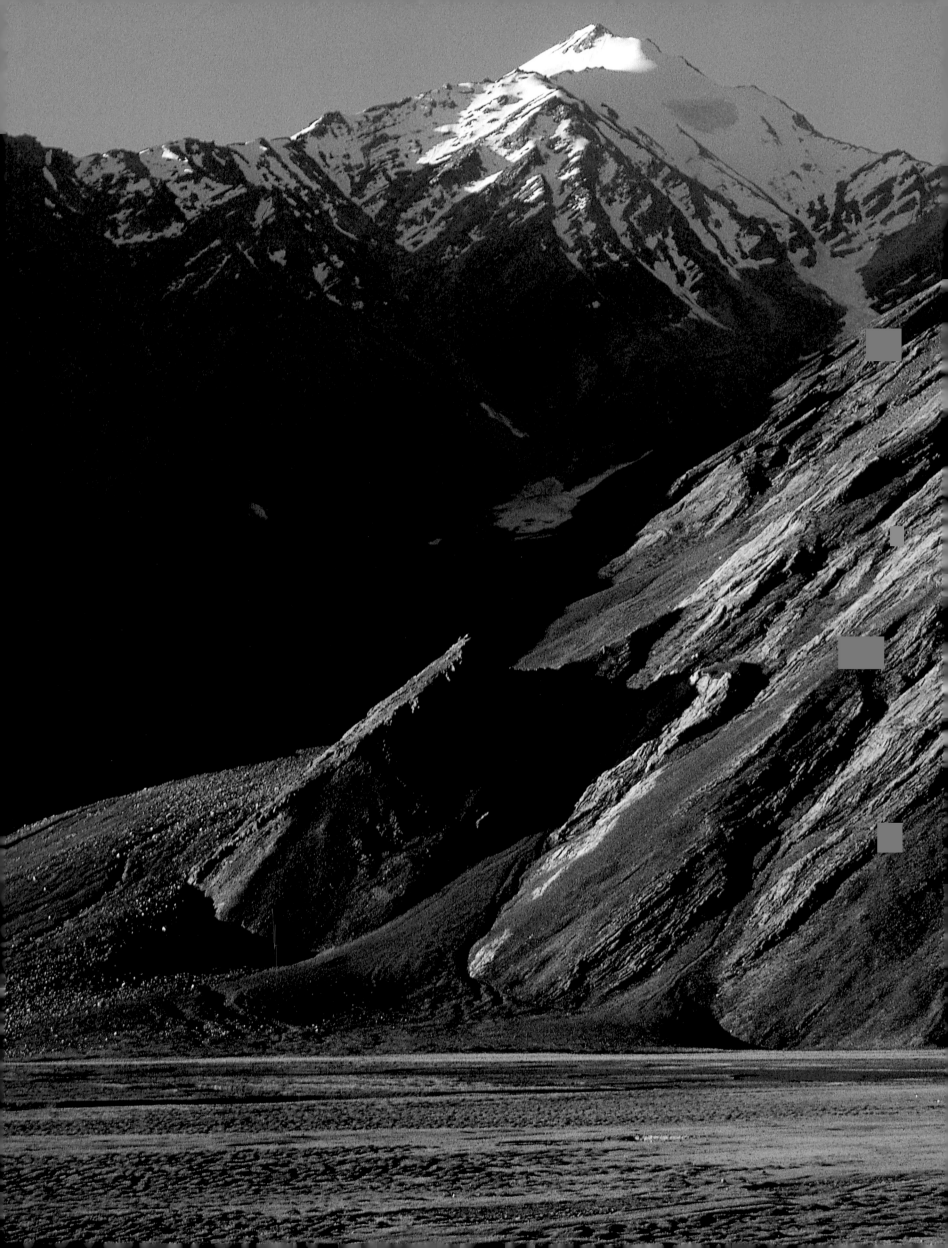

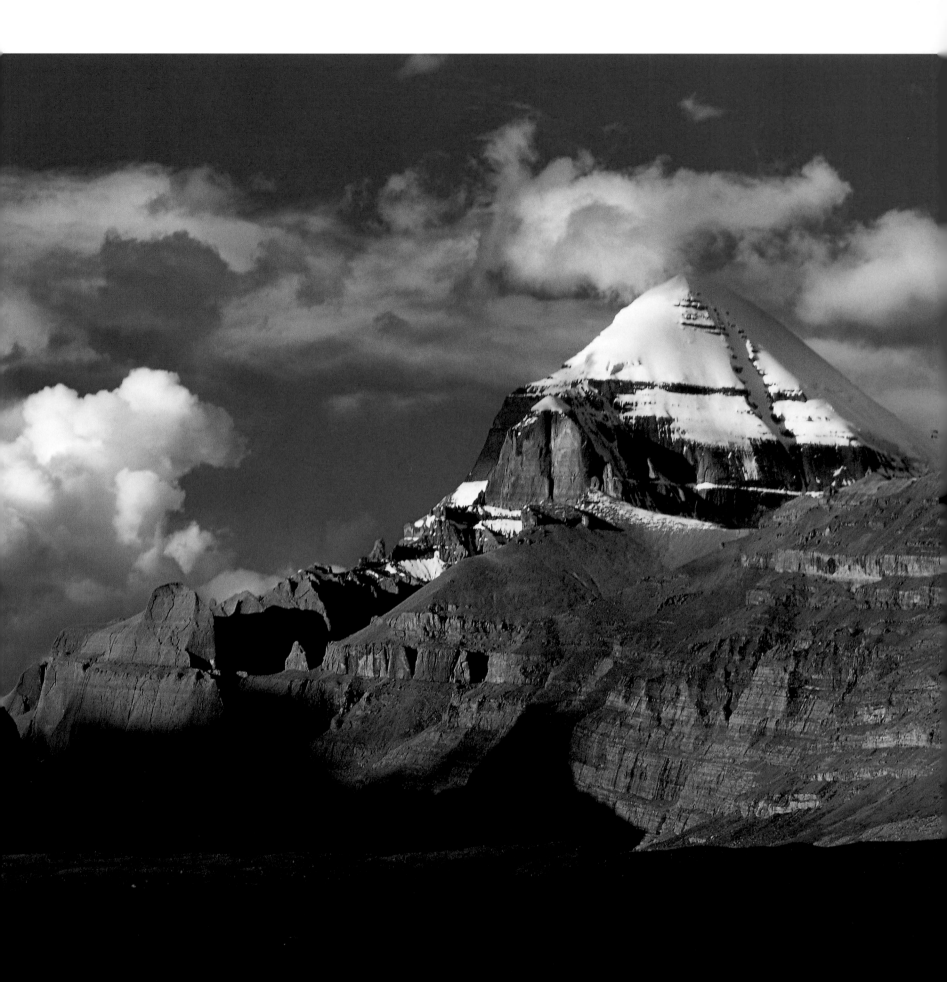

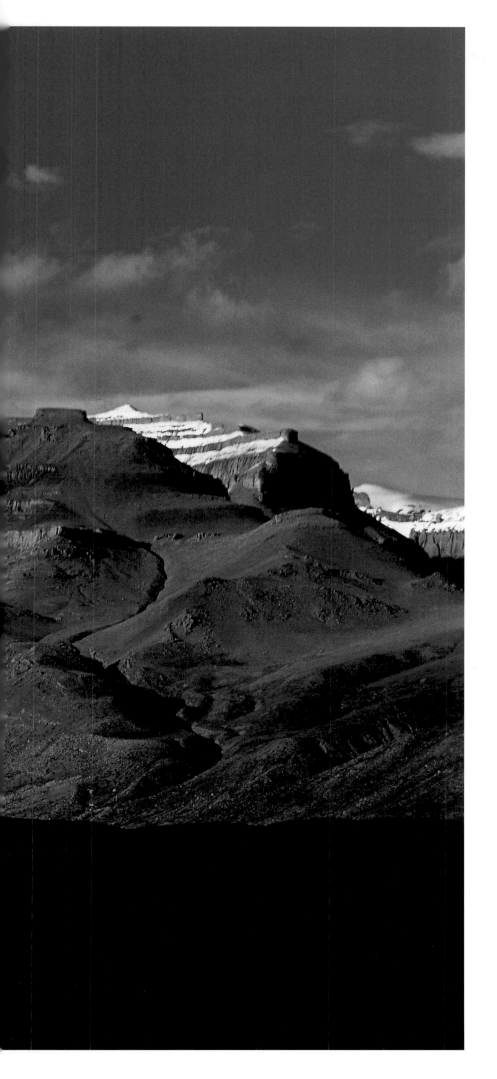

MOUNT KAILAS, TIBET

Rust-colored at the base, shaded gray up above, all the way to the snow-line, the sandstone and conglomerate beds of the Indus molasse form the bulk of Mount Kailas (Kangrinpoche, 22,027 feet), "axis" of the world, home of Siva and Parwati, most sacred of all geological pinnacles. This harmonious pyramid is one of the few summits built entirely from cemented fluvial gravel and sand, preserved in their original flatness: a monogenic mountain, raised whole, showing little sign of tectonic torment on its steep faces. Carved by a large glacier that withdrew for good 16,000 years ago, the broad, flat-floored valley, which enters the relief to the left, at the base of the rusted cliffs, is a "highway" for the Buddhist and Hindu pilgrims who start the clockwise *kora* around the mountain. A comparably wide valley brings them back on the other side. Gigantic natural *stupa*—soaring above the largest of sutures and the two lakes it harbors at the water divide between the Indus, Ganges, and Bhramaputra—Mount Kailas owes its beauty to its shape and isolation, final result of a locally well-balanced interplay of the forces that build and destroy reliefs. How can one not admire and revere such a balanced masterwork.

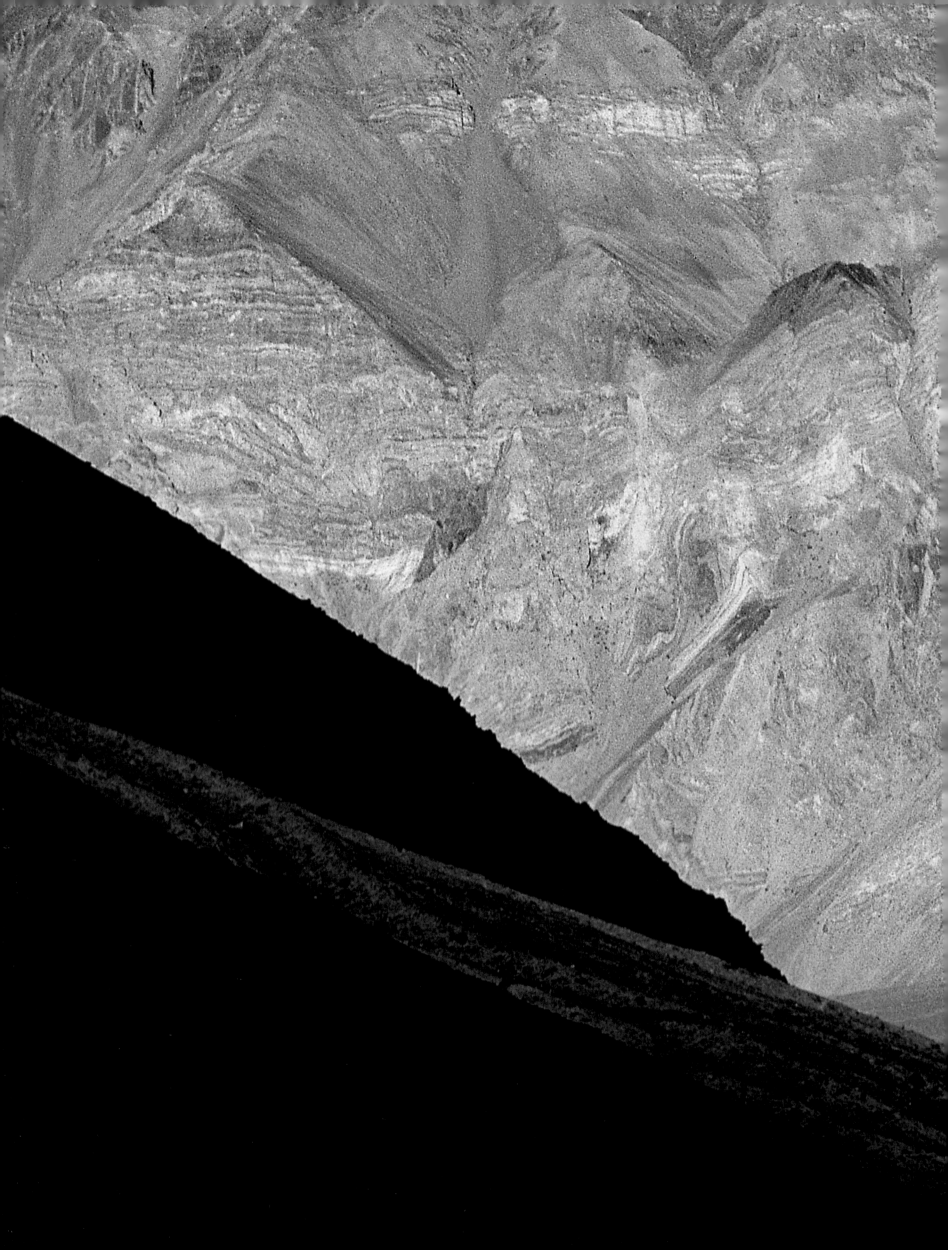

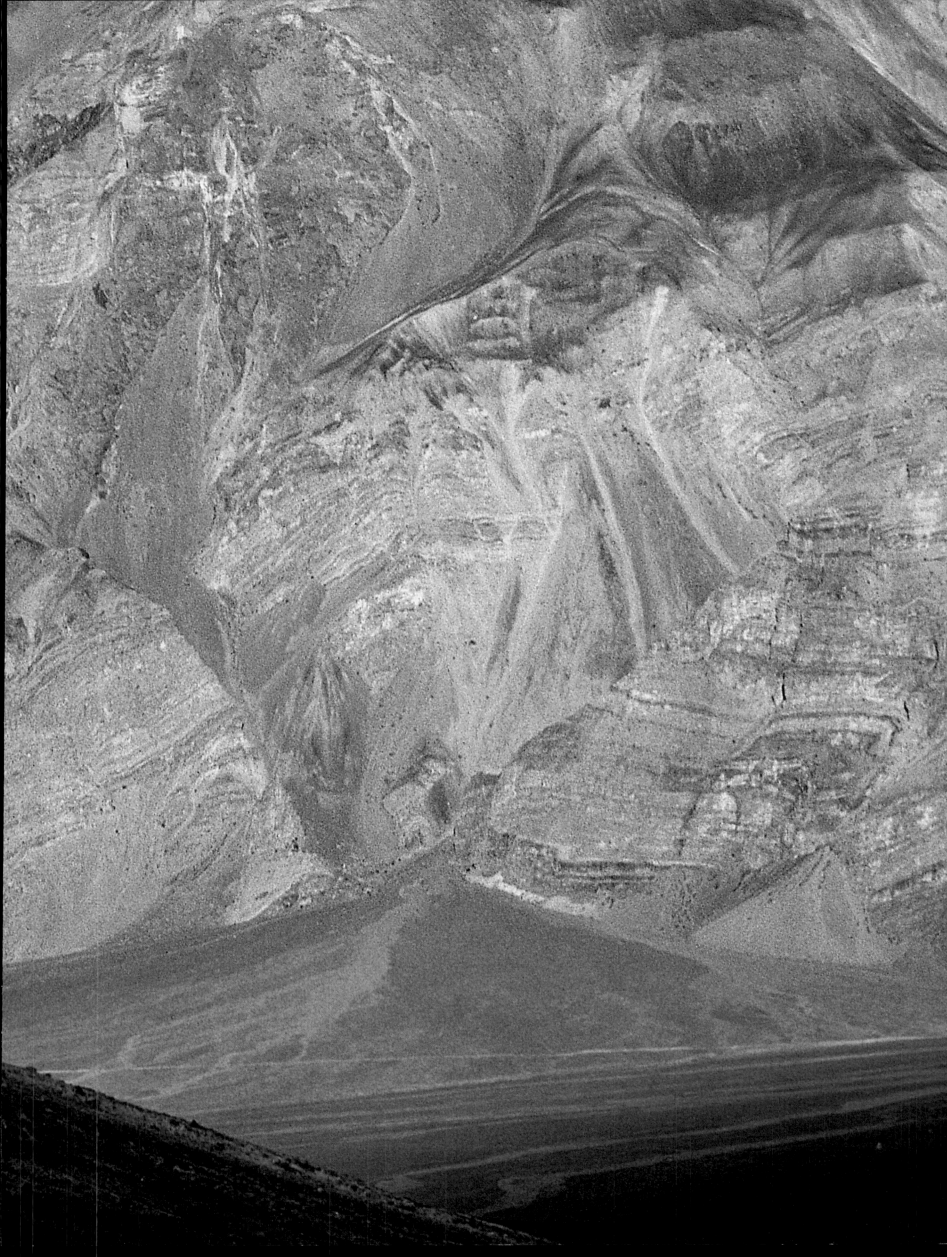

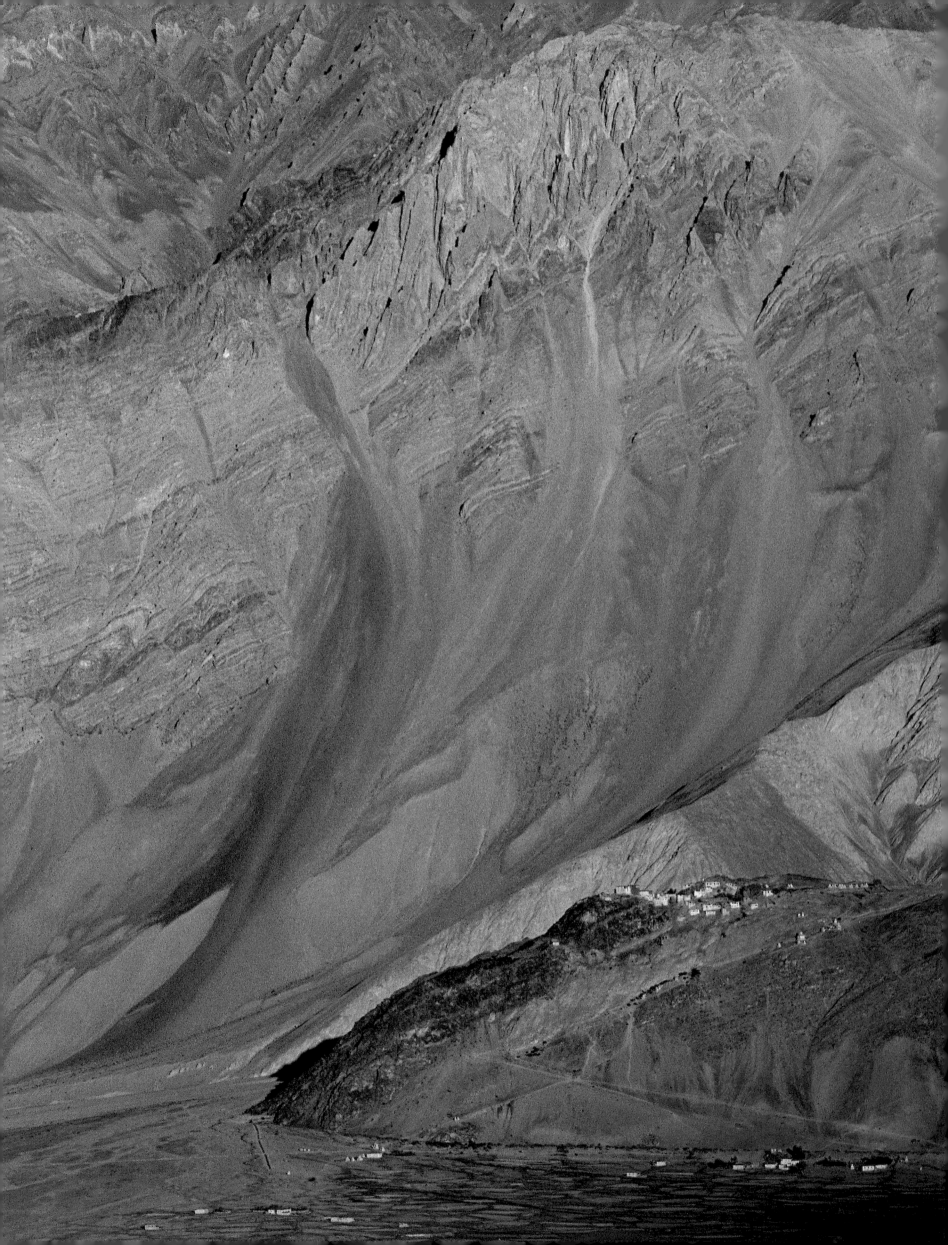

preceding pages

TETHISIAN HIMALAYAS, ZANSKAR

Folds and faults in the marine limestones of India's northern margin.

INDUS VALLEY, LADAKH

Sunset over the granites of the Ladakh batholith, on the north side of the Indus river valley.

ZANSKAR THRUST-SHEETS, LADAKH

Six thousand feet of cliff expose a small part of the formidable stack—over 12 miles thick—of tilted and folded strata that typifies Zanskar's northern Himalayan thrust sheets.

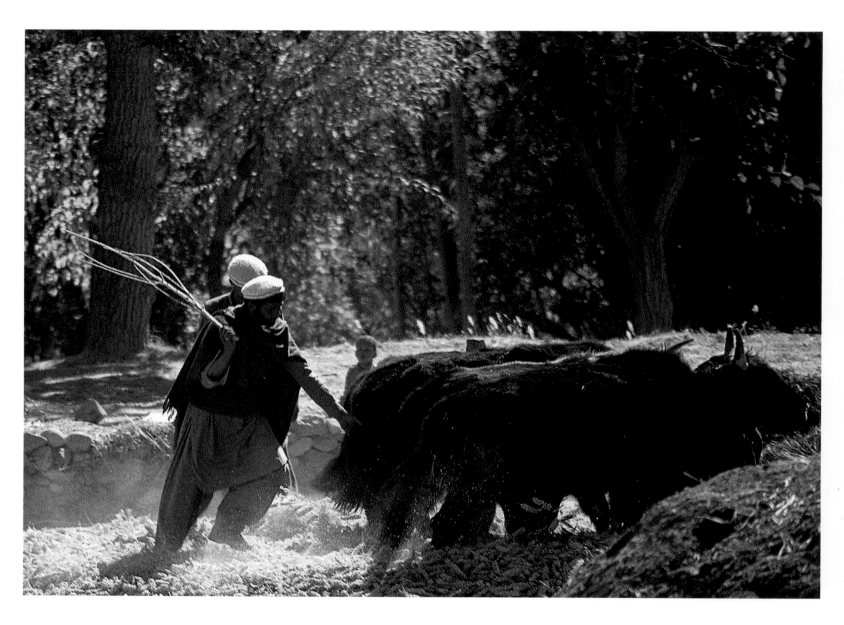

SHYOK VALLEY, PAKISTAN

Dzos—the robust result of crossing a yak with a domestic ox—go round in circles on the threshing area, treading on barley and millet. This is a high-altitude version of a technique used for ages.

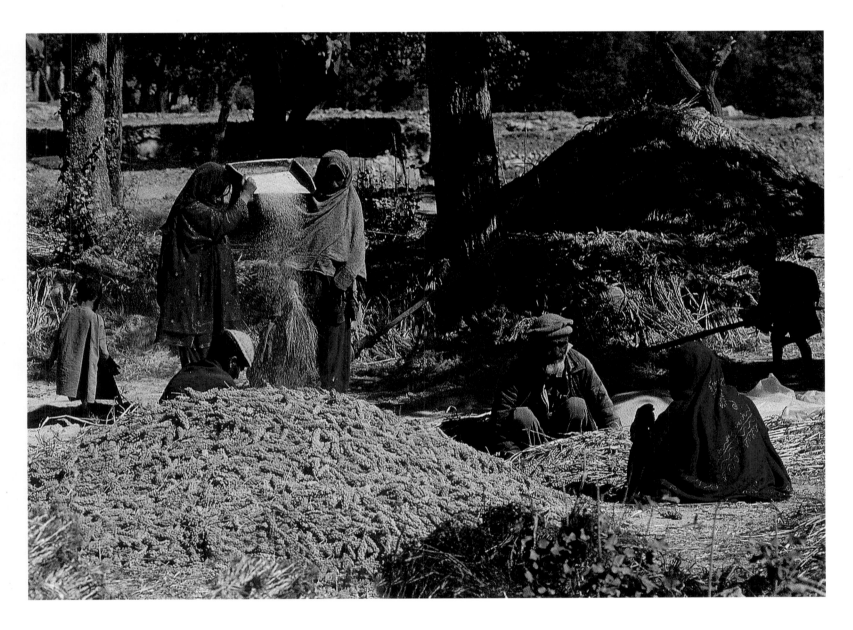

SHYOK VALLEY, PAKISTAN

In this Muslim region, veiled women still winnow millet by hand to separate the grain from the chaff.

Granite,
DREPUNG, TIBET

In mid-September, for the yogurt festival—the best yogurt in the world is to be savored ladled directly from large wooden buckets in the very heart of Tibet—lamas from the Drepung monastery are busy unfolding the large ceremonial *thangka,* decorated with a giant Buddha, a banner whose surface area approaches 10,000 square feet. By early morning, on the slopes still flowered with blue poppies and gentians, families gather to lunch, sing, and dance, in the aroma of burning juniper branches. *Chang,* a beer of fermented barley, flows like water. September marks the great comeback of the sun after the torrential summer rains, which swell the Yarlung Zangbo to overflowing. The rock amphitheater in which the festival takes place is a gift of plate tectonics: an accumulation of cyclopean granite blocks, some still in unstable equilibrium. Most of the lamaseries in the vicinity of Lhasa are erected on granite slopes. Granite is also the cut stone from which they are built, as one might expect along the north side of the Gangdise belt— the huge granite batholith continuing that in Ladakh, and also a product of Thetis' subduction beneath Asia's margin, before India's arrival shifted the site of deep fusion towards the north, then south of the suture.

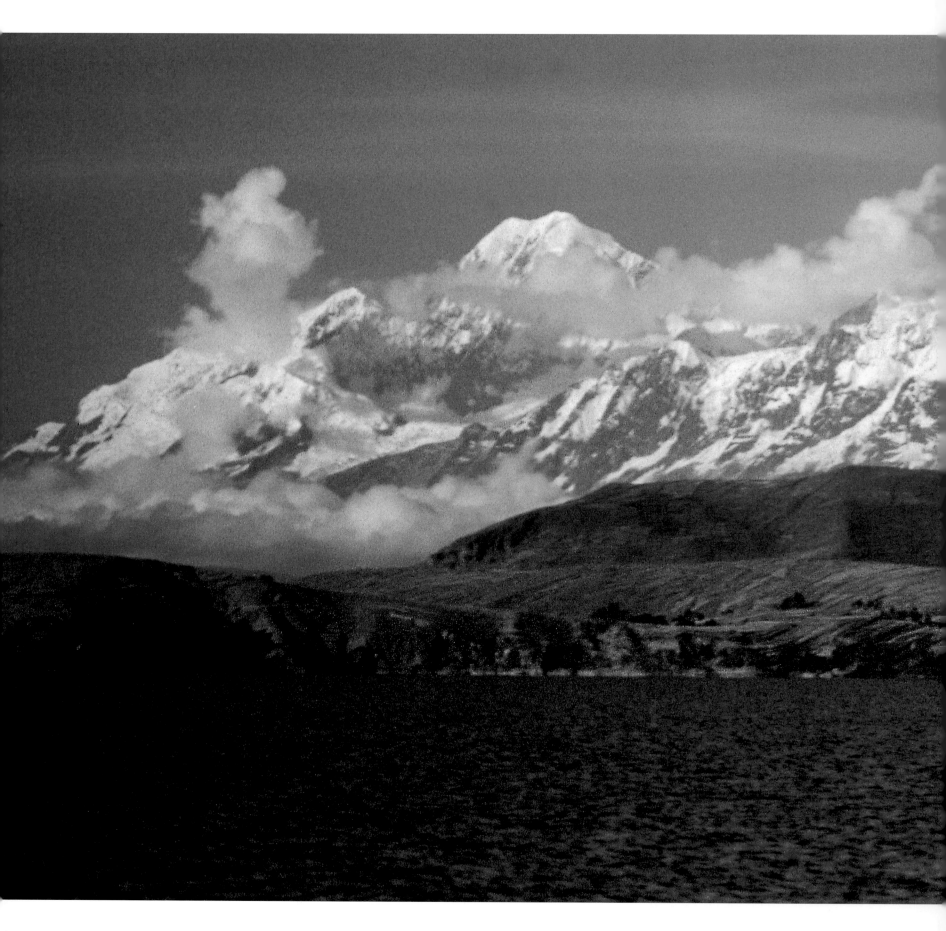

ILLAMPU AND ANCOHUMA, BOLIVIA

The Illampu (20,872 feet) on the left, and Ancohuma (21,096 feet) on the right, two of Cordillera Real's highest summits, tower above Lake Titicaca, already 12,506 feet high.

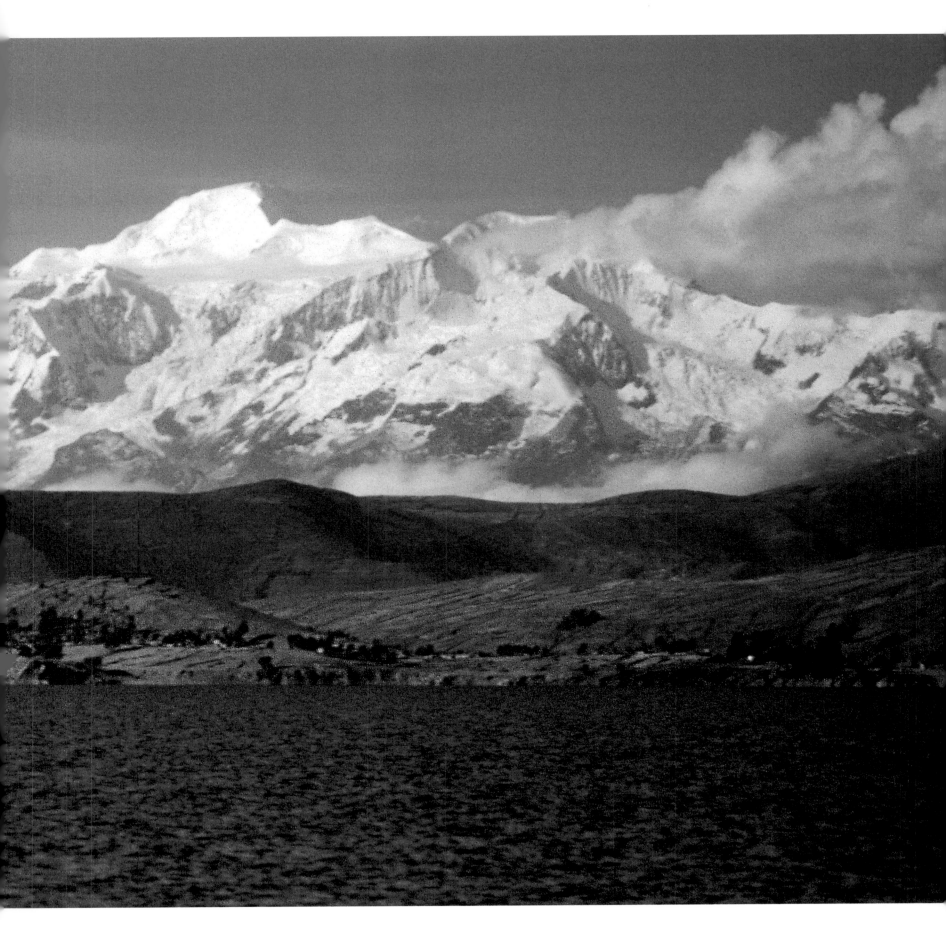

following pages
CORDILLERAN SUMMITS, SOUTH OF CUZCO, PERU

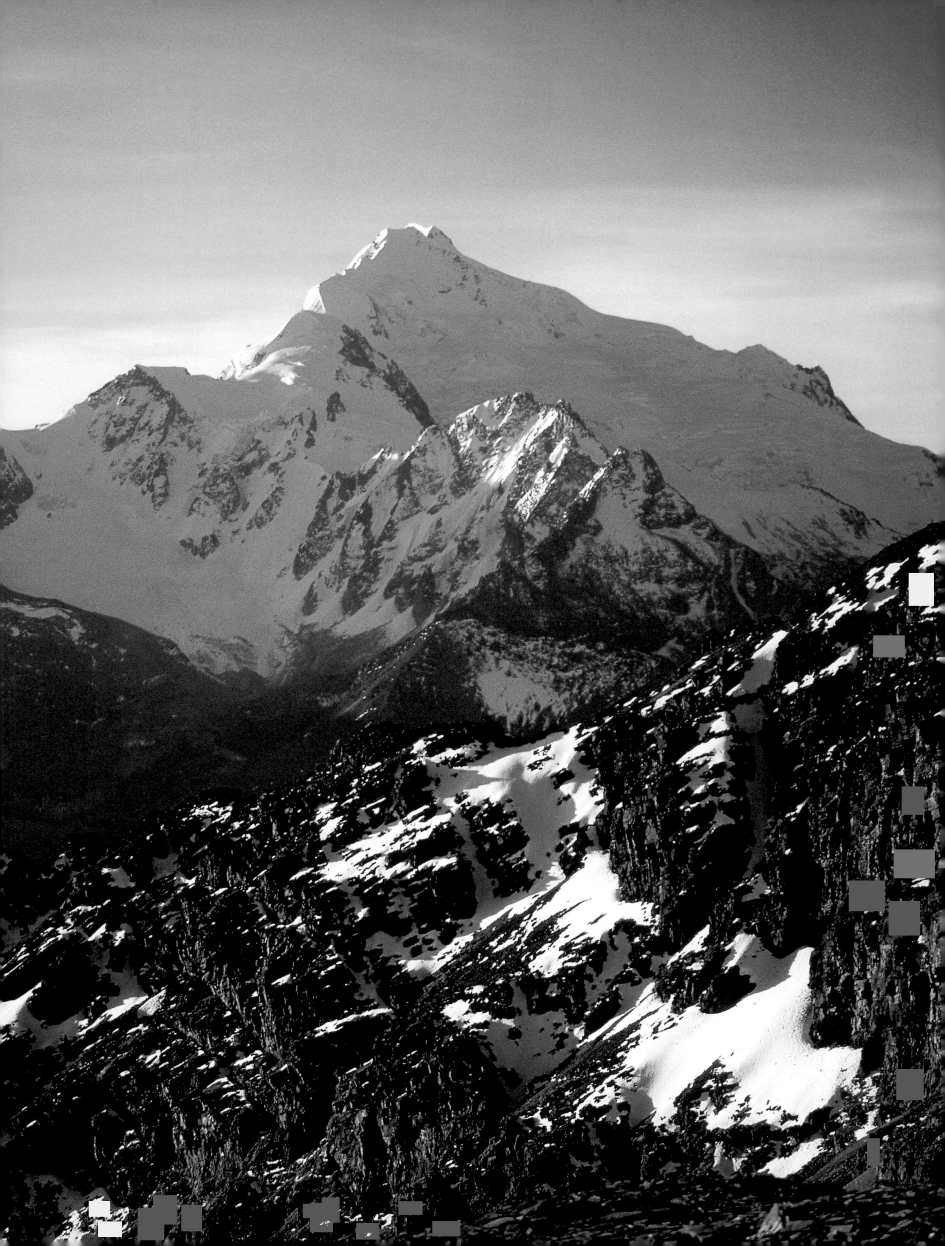

HUAYNA POTOSI, BOLIVIA

This granite peak, which soars above 19,700 feet, is one of the non-volcanic summits of the Bolivian cordillera.

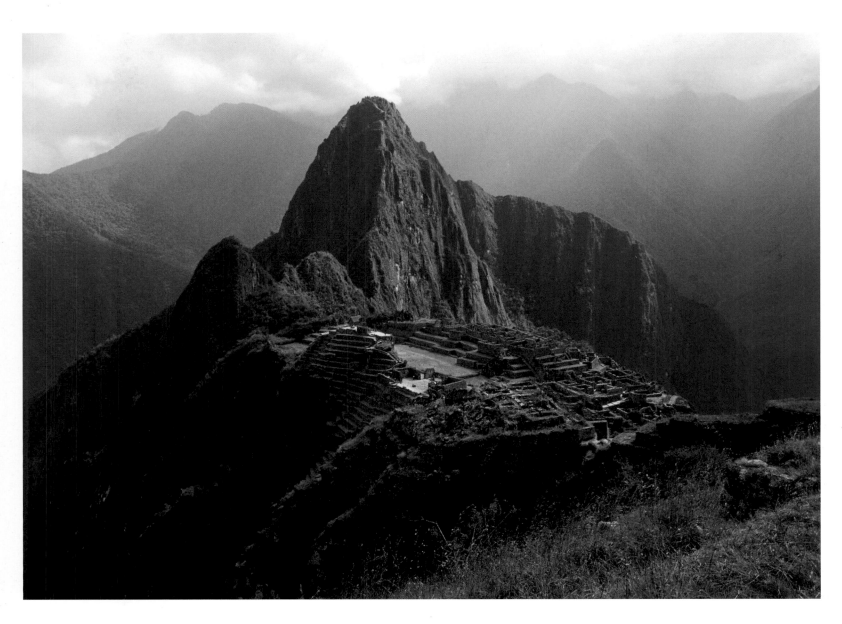

MACHU PICCHU, PERU

Leaning against a granite pinnacle on the Selva side of the Peruvian Andes, in the Amazon upper catchment, the Inca citadel of Machu Picchu defies the ages. It is built of blocks irregularly rigged together to resist earthquakes.

following pages

SUB-ANDEAN FOLDS, SELVA, BOLIVIA

Separated by fog-bound valleys, the dark ridges densely covered with tropical rainforest are the parallel folds of the Sub-Andean chain, at the foot of the Altiplano. They resemble those that surge in the forelands of most collision belts.

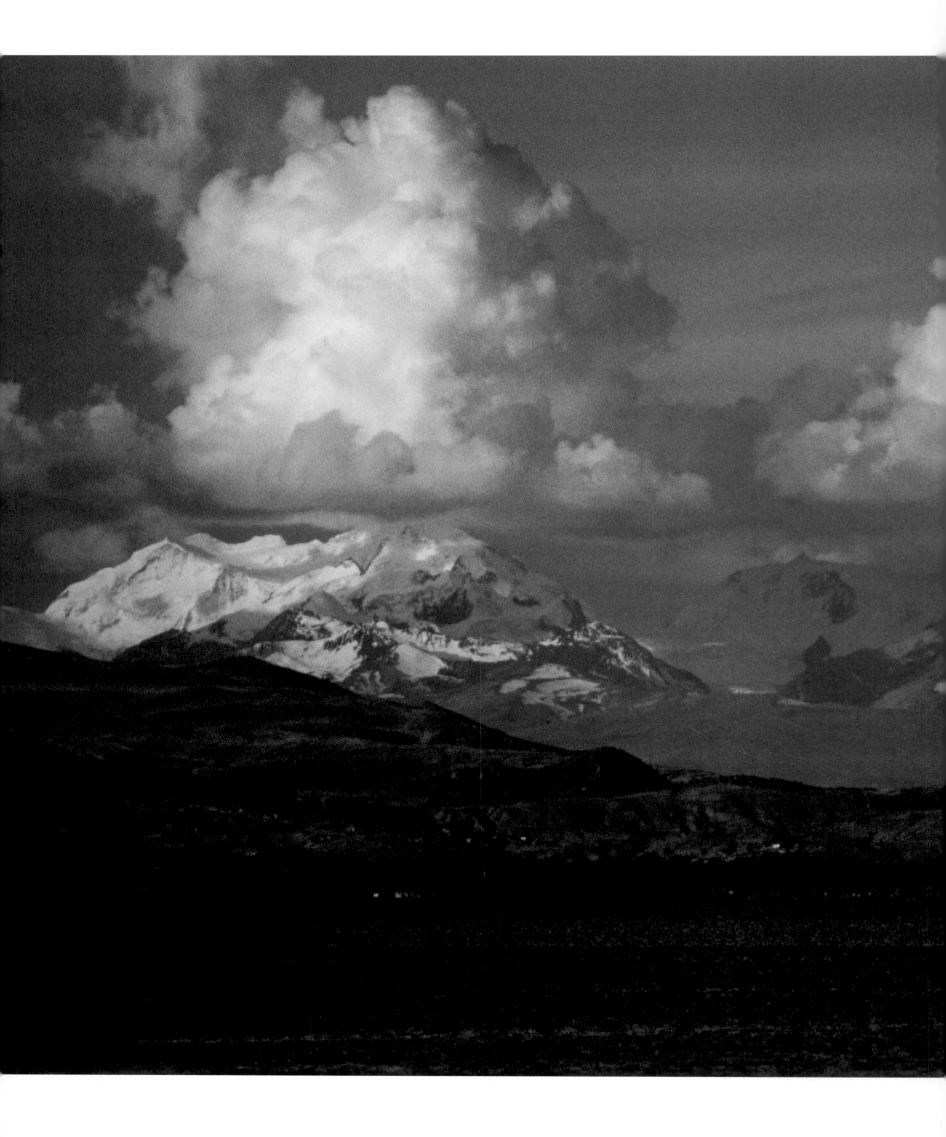

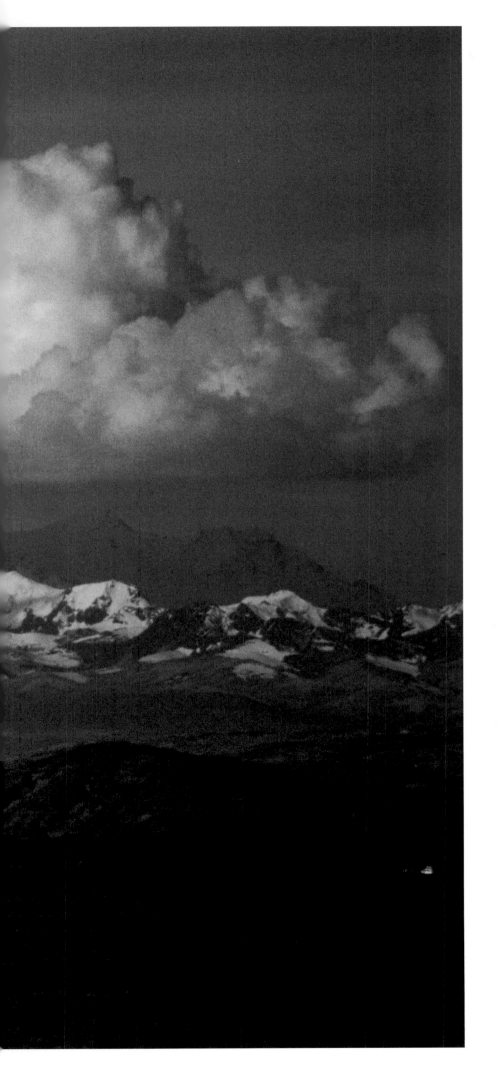

CORDILLERA REAL, BOLIVIA

Not all the mountains of the Andes are volcanoes. Most of the peaks of Cordillera Real, east of lake Titicaca, for instance, are not. Here, beyond the Island of the Moon, the ice above 19,000 feet covers uplifted ancient basement infiltrated with granites. For a while, one of the highest summits of this Bolivian cordillera was believed to exceed 22,960 feet, which would have ranked it as South America's highest point. Today, we know that this distinction belongs to Aconcagua (22,840 feet), 1,200 miles farther south, in Chile. But if there is one Andean range whose origin and architecture resemble most those of the Himalayas, queen of all collision mountains, it is the Cordillera Real: a flake of continental crust uplifted by a large thrust fault dipping under the Altiplano, the local high plateau. The exhumation has been going on, unabatedly, for more than thirty million years. To the east, at the foot of the cordillera, the required shortening is absorbed by folding in the Sub-Andean chain, down to the Amazonian Selva. Thus, like India beneath southern Tibet, the Amazonian basement plunges beneath the eastern edge of the Altiplano. The origin of the forces causing such hidden subduction in the heart of the South American continent, however, remains controversial.

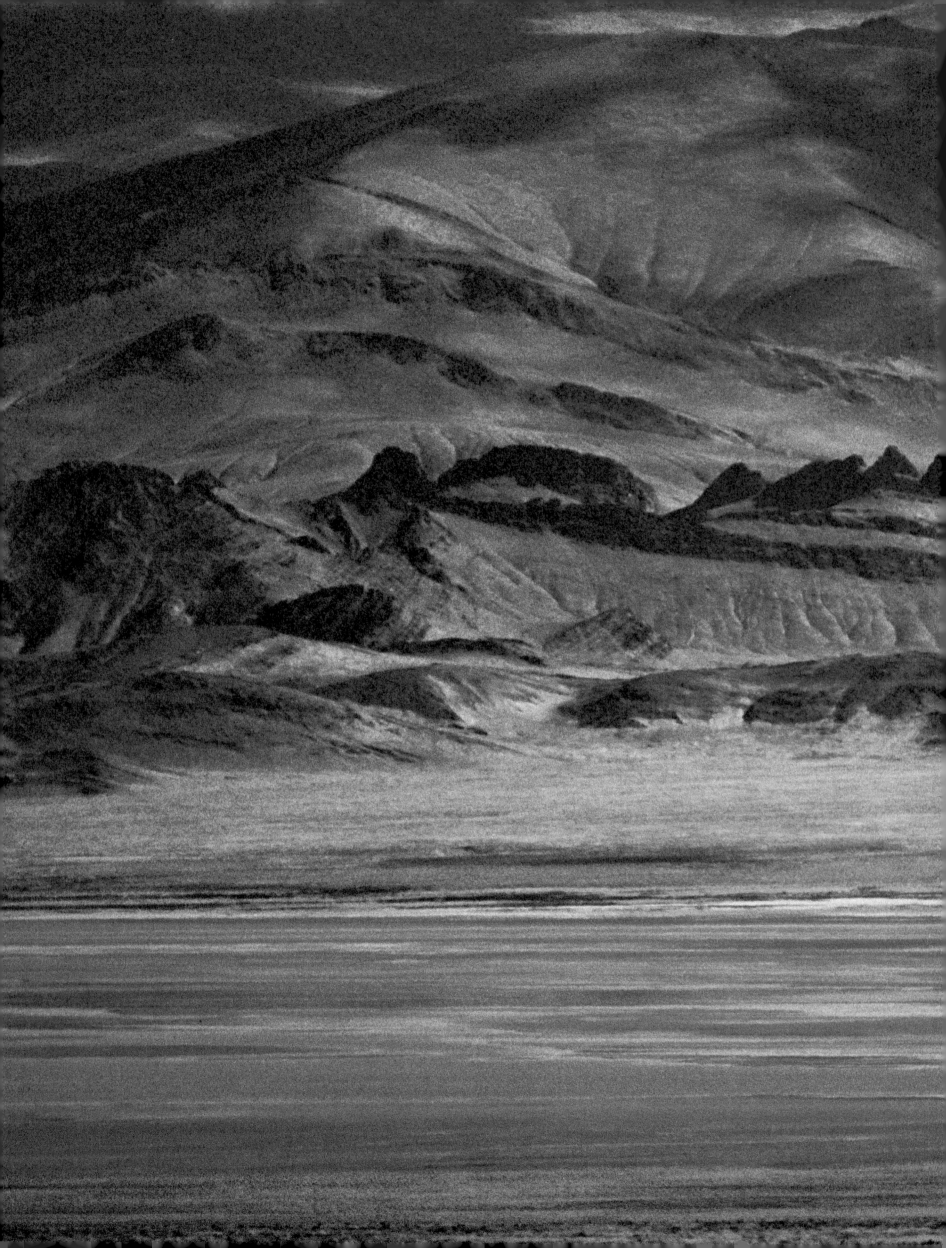

FALSE
MOUNTAINS

"FALSE" MOUNTAINS REVISITED

THERE IS NO DOUBT that most large mountain ranges originate as a result of continental collision. But let's come back to the "common" oceanic subduction zones and their strings of "false" mountains, perhaps unduly neglected. They might be worth a third look.

It is true that the landscape of these coastal zones is usually marked by a jungle of volcanic constructs, juxtaposed and overlapping—superficial ornaments plastered on the surface by the rising of silica-rich magmas melted at great depths. Thick, viscous magma flows sluggishly, making for highly explosive, dangerous eruptions. They create tall, pointed cones, with steep concave slopes: the exact opposite of the broad domes characteristic of basaltic shield volcanoes. In Sumatra or Java, they are the only reliefs of consequence, the only mountains, in fact. In the Cascades of Oregon, they are the only permanently snow-capped summits. In Japan, too, they are the most common. The same is true for the Andes, which have lent their name to the archetypal lava of subduction: andesite.

Indeed, from Chile to Colombia, andesites and sister lavas, or deeper chemically equivalent igneous rocks (granites and granodiorites) make up most of the Andes, a typical mountain chain created by subduction zone volcanism. The Andes are home to the highest volcanoes in the world. Extinct or active, some rise well above 20,000 feet and are crowned with glaciers. The perfection of their form and the majesty of their alignments have fascinated generations of scholars and naturalists. Charles Marie de la Condamine, along with his colleagues Pierre Bouguer, Antoine Laurent de Jussieu, and Jean Godin, for instance, commissioned by the French Academy of Sciences in 1735 to measure the length of a degree of the meridian at the Equator spent many years in Quito, between the Pichincha, Cotopaxi, and Illiniza volcanoes. Travelling there a century later, Milanese explorer-physician Gaetano Osculati sketched some of the volcanoes, leaving behind charcoal drawings remarkable for their startling realism. And let's not forget the two greats: Charles Darwin and Alexander von Humboldt.

For the latter, who was most fond of the great Ecuadorian "avenue of volcanoes," nothing in the world was more worthy of admiration than the Cotopaxi. It is true that seen from the right angle, the classic silhouette of this active volcano—which last erupted in 1904 and is, at 19,347 feet, just seven feet higher than Kilimanjaro—is an ideal model of the genre. Humboldt never tired of contemplating it. "The shape of the Cotopaxi," he wrote, "is the most beautiful and symmetrical of all the colossal peaks in the high Andes. It is a perfect cone..." Once, while climbing the ice-capped Mount Chimborazo, an even higher but extinct volcano at 20,702 feet—whose form slightly recalls that of the Muztagh Ata—Humboldt recorded his observations on the mountain's flora until he could climb no more. His passion took him up to 16,880 feet! While it may be true, from a tectonic point of view, that these volcanic mountains are "fake" ornaments pasted to the earth's surface, there is no question that they have allure and beauty aplenty to rival any of the genuine ones.

THE RANGE THAT KEEPS ITS SECRETS

Darwin was fascinated by other aspects of landscapes. Known universally for his work on evolution, he was also an exceptional geologist, a geormorphological visionary, and one of the first to ponder—with an astonishingly modern perspicacity—the connections between earthquakes and the uplift of relief. This is partly because he spent more time in the Chilean stretch of the Andes, and the circumstances there

were particularly favorable to such insights. At 11:30 AM on the morning of February 20, 1835, he experienced the two long minutes of the great Concepción earthquake, south of Santiago. In his memoir *The Voyage of the* Beagle, he noted that, "the most remarkable effect of this earthquake was the permanent elevation of the land; it would probably be far more correct to speak of it as the cause." Indeed, after the tremor, about 30 miles south of Concepción, along the shores of Santa Maria Island, "Captain Fitz Roy found beds of putrid mussel-shells, *still adhering to the rocks*, ten feet above high-water mark." Darwin immediately connected this observation with ancient fossilized seashells he had discovered 1,000 to 1,300 feet above sea level in many places along the coast. He also linked it to the existence of uplifted beaches ascending like a series of steps parallel to the shoreline. "It is hardly possible to doubt," he concluded, "that this great elevation has been effected by successive small uprisings, such as that which accompanied or caused the earthquake of this year." Such certitude stemmed naturally from his conviction that "the present is the key to the past" as upheld by Charles Lyell, his mentor and future protector.

A month later, when he traveled across the Andes between Santiago and Argentina, Darwin pursued these reflections on a much larger scale. There he found a double cordillera, a not uncommon feature, crowned with three of South America's highest summits: Aconcagua (22,841 feet), Tupungato (22,309 feet), and Mercedario (22,211 feet). Whether following the Rio Maipu valley, or other valleys, the road gradually climbed along the orchard-covered surface of thick fluvial terraces, from the coastal piedmont to an altitude of 10,000 feet. These terraces were deeply incised by present-day torrents. Darwin realized that the elevation of these ancient riverbeds, thousands of feet above the torrents, implied a huge amount of uplift relative to the level of the sea. He wrote, "No one fact in the geology of South America interested me more than these terraces of rudely-stratified shingle ... I am convinced that [they] were accumulated, during the gradual elevation of the Cordillera." So there we are—Darwin "sees" the great Andean range emerge incrementally

from the sea *en masse*. His observations of deeper rocks, in the following part of his journey towards Mendoza, confirmed this intuition. The first cordillera he crossed consisted chiefly of thousands of meters of purple porphyry, submarine volcanic tuffs capped with red sandstones and conglomerates, and, especially, gypsum and limestones, rich in fossilized marine shells. In the second, great masses of pink granite had infiltrated white granites and sandstones cooked into quartzite. He noted that this second cordillera's crown of conglomerates was inclined 45 degrees toward the Pacific, and that certain pebbles were derived from the limestone of the first cordillera. From these observations, he drew two conclusions: the first cordillera rose at least 14,000 feet above sea level before the second came into existence; and the second, which today is actually a little higher, rose at a later period.

In broad terms, Darwin's insights were correct. After only two months of exploration, he was the first to connect a sudden seismic-induced slip of several feet with thousands of feet of gradual mountain uplift. Giving free rein to his youthful enthusiasm, he went as far as proclaiming: "Nothing, not even the wind that blows, is so unstable as the level of the crust of this earth." Admittedly, this was going a bit too far; but he was working without one essential geological yardstick, one that would elude geologists until more than a century later: an absolute time scale.

Who could stand here and not be reminded of Central Asia? The Andes? Phony volcanic mountains? Mountains whose foundations were raised three to four miles above sea level by the accumulated effect of thousands of large earthquakes? Let's be serious! We are back to the realm of tectonics. The Andean cordillera is not quite as "false" as we made them out to be. It is simply a range that knows how to keep its secrets.

COUPLING OR A LOST CONTINENT?

What might make the Andean crust rise? What might shorten it? Indeed, on the Pacific Ocean side, no other continent is in sight. No collision. Nothing but a subduction zone.

Yet, many Andean peaks, even among the highest, are not volcanic. They face the Nazca plate, which is diving beneath South America at the extremely rapid rate of about 30 feet per century. Between Santiago in Chile and Trujillo in Peru, for almost 2,000 miles, rise nearly all the 20,000-foot summits and even the rare ones approaching 22,000 feet or more. They top the cordilleras bordering the two sides of the orogen (from the Greek *oros,* meaning "relief"), towering over either the Pacific Ocean or the pampas and the Amazon basin. In addition to the cordillera Darwin crossed near Santiago, the two highest are the Cordillera Blanca, north of Lima, which is crowned by the Huascaran (22,204 feet), and the Cordillera Real near La Paz, whose summits (Ancohuma, 21,200 feet, and Illampu, 20,877 feet) block the horizon to the northeast of Lake Titicaca. And there's more. The eastern foreland of the Andes is home to many young mountains. In Argentina, the Sierras Pampeanas surge up from the low peneplain between Mendoza and Cordoba. In Bolivia, at the base of the eastern cordillera, the Sub-Andean fold belt ripples the Amazonian Selva. Scale notwithstanding, we could be in Mongolia or at the foot of the Tian Shan.

What is the source of forces powerful enough to shorten the crust and cause the uplift of these high peaks, which continue to clone themselves farther and farther into the interior of the South American continent, more than 500 miles from the subduction zone? One fashionable explanation is that it might be the Nazca plate that's pushing. A young oceanic plate born in the Eocene (again!), it would dive only reluctantly, not having cooled enough to be sufficiently dense. A situation halfway between an easy subduction and a clean collision. Instead of sliding easily, the interface between the two plates would stick. Geophysicists speak of "strong plate coupling." The resulting friction of the subducting plate transmits a push to the overriding plate, which shortens in the process.

But is this really the only plausible scenario? Stepping back, we can see that the morphology, geology, and, therefore, history of the Andes vary greatly from north to south. They are narrow in Colombia and in Chile, but bulge out in the cen-

ter, broadening out to more than 300 miles across the Altiplano, which is basically a small Tibet. Two suture zones, one north of Ecuador and the other in Patagonia, offer irrefutable evidence of past collisions, albeit local. It is clear that the Andes are not a *single* range, but several different ranges. Why is it that the Sub-Andean fold belt of Bolivia is most developed precisely where the Andes are at their widest? And why does the Arica Bend, this 60-degree elbow of the Pacific coastline at the Peruvian–Chilean border, face the Altiplano? Is it a simple coincidence or an indent left by the collision of a small continent subsequently swallowed up without a trace, suture and birthmarks included? An island-continent formerly carried by the Nazca plate? For those who believe that only continental collision can build high mountains, it is a tempting hypothesis—or at least, a mystery worthy of investigation.

COLLAGES AND THE GENTLE GROWTH OF CONTINENTS

What of the mountain ranges along the west coast of North America? The Rockies? Mount Logan in Canada and Denali in Alaska both hover around 20,000 feet without being volcanoes. These are real mountains. But, with the exception of these two peaks, the continent's highest, and a couple of summits in California along the San Andreas Fault, they are a bit old and at an advanced stage of evolution. They are in the process of being broken up by more recent tectonic processes and movements that are radically different from those that formed them. Now, the action is orchestrated by the horizontal slide of the Pacific plate, which ends plunging northward under Alaska.

The claim to fame of the mountains of North America's far west is that they are emblematic of another variation of mountain building, still on the theme of subduction, of course. They are "collages" of small crustal blocks. Some are clearly continental in origin, others less so. They became welded or "accreted" to the old heart of North America long ago, well before the demise of the dinosaurs. We can tell that these

"exotic" blocks came here from somewhere else. Particular geological traits give away their origins and identities, like stamps in a passport. They are known as "terranes," an unfortunately vague, generic term dictated by common usage. At least their family names and the story of their journeys— though still not completely unravelled—inspire the imagination. Between Nevada and Alaska, for example, we can meet terranes called "Stikine," "Alexander," and "Wrangellia." All are aliens from afar. For Alexander, the long journey might have begun in Australia.

The mechanism of orogenic collage is rather simple and does not trigger massive disruption. Because the terranes are small, their impact and subsequent accretions do not stop the conveyor belt of subduction beneath the continental margin. Imagine a grate across a canal. All the debris that water transports—dead leaves, branches, or other floating detritus— accumulates in a heap in front of the grate. This heap will keep growing as long as the current does not weaken. Likewise with orogenic collages: everything transported by the diving oceanic plate while it is plunging—fragments of volcanic island arcs, microcontinents, oceanic plateaus—accumulates and becomes integrated into the continental edge. In the last three billion years, this process has contributed to the progressive growth by accretion of many continents around their ancient cores.

Salt lake, Tibet

A storm rages on the vast, flat expanse of central Tibet, at an altitude of 16,400 feet. Like hundreds of others in the heart of the plateau, the lake in the foreground, which stores the local water runoff, is a salt-water lake.

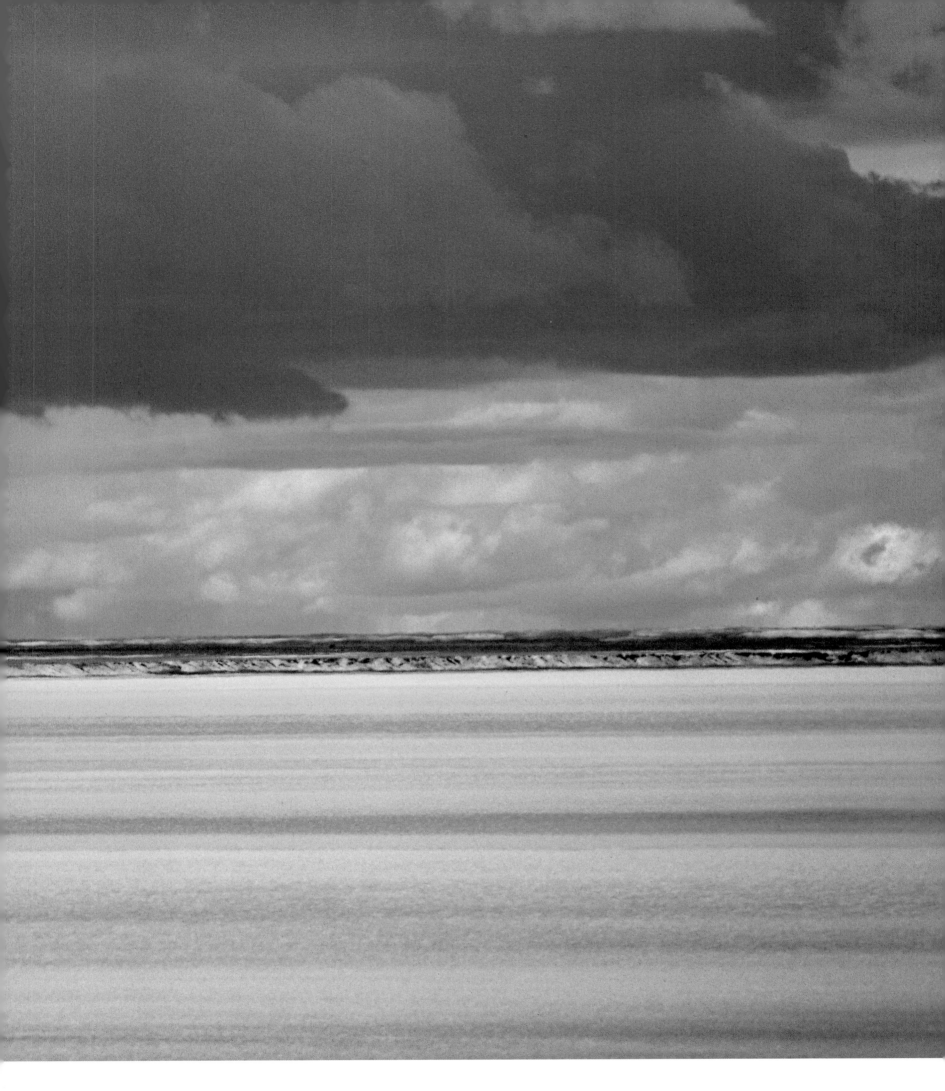

following pages
VARIEGATED SANDSTONE, GUIDE, QINGHAI
A spectacular accumulation of diversely colored fluvial sandstones, still poorly consolidated but already warped, marks the place where the Yellow River escapes from the Guide basin into a deep gorge around the Laji range. The uplift of the mountain obstructs river flow, forcing the sediments it carries to pile up upstream.

173

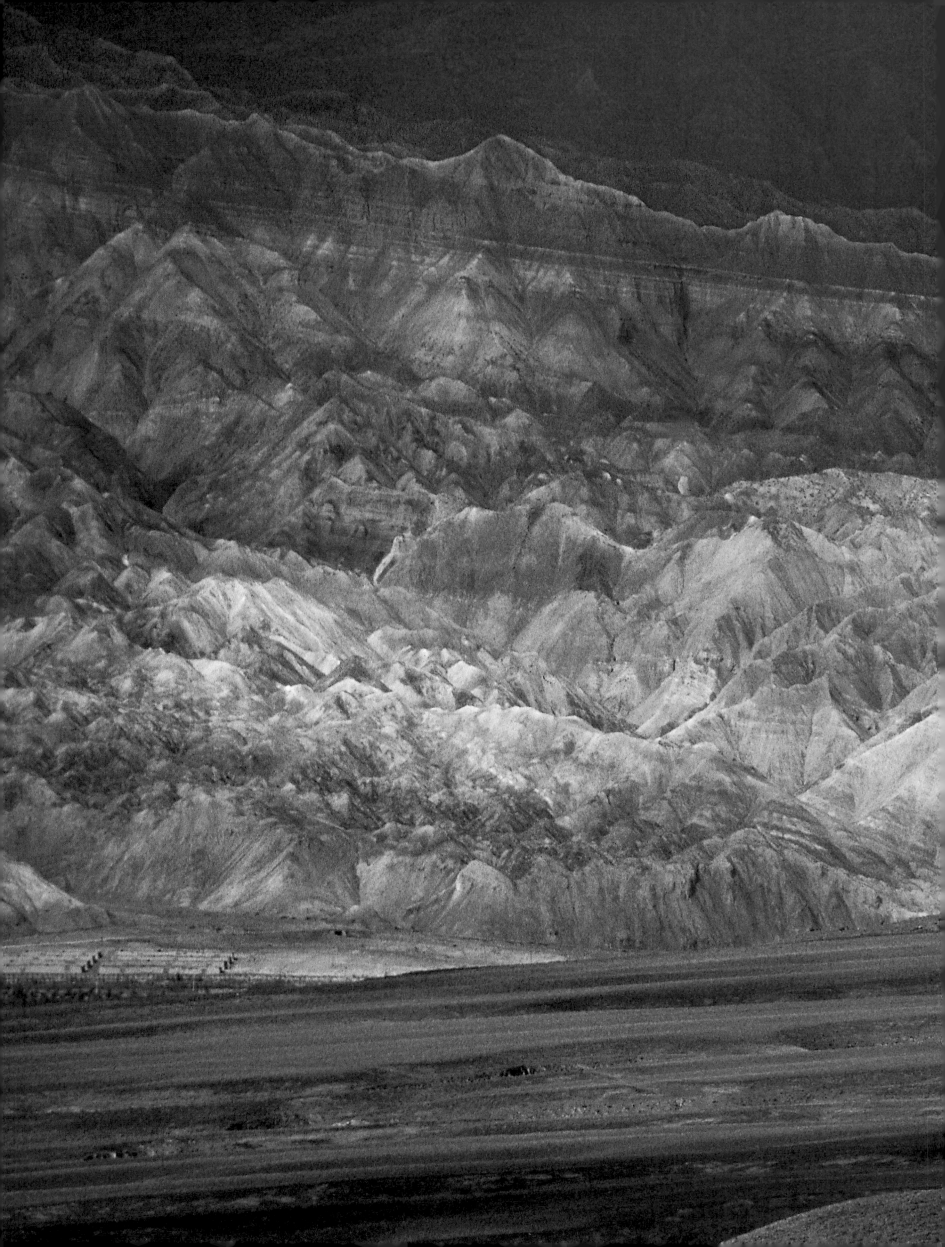

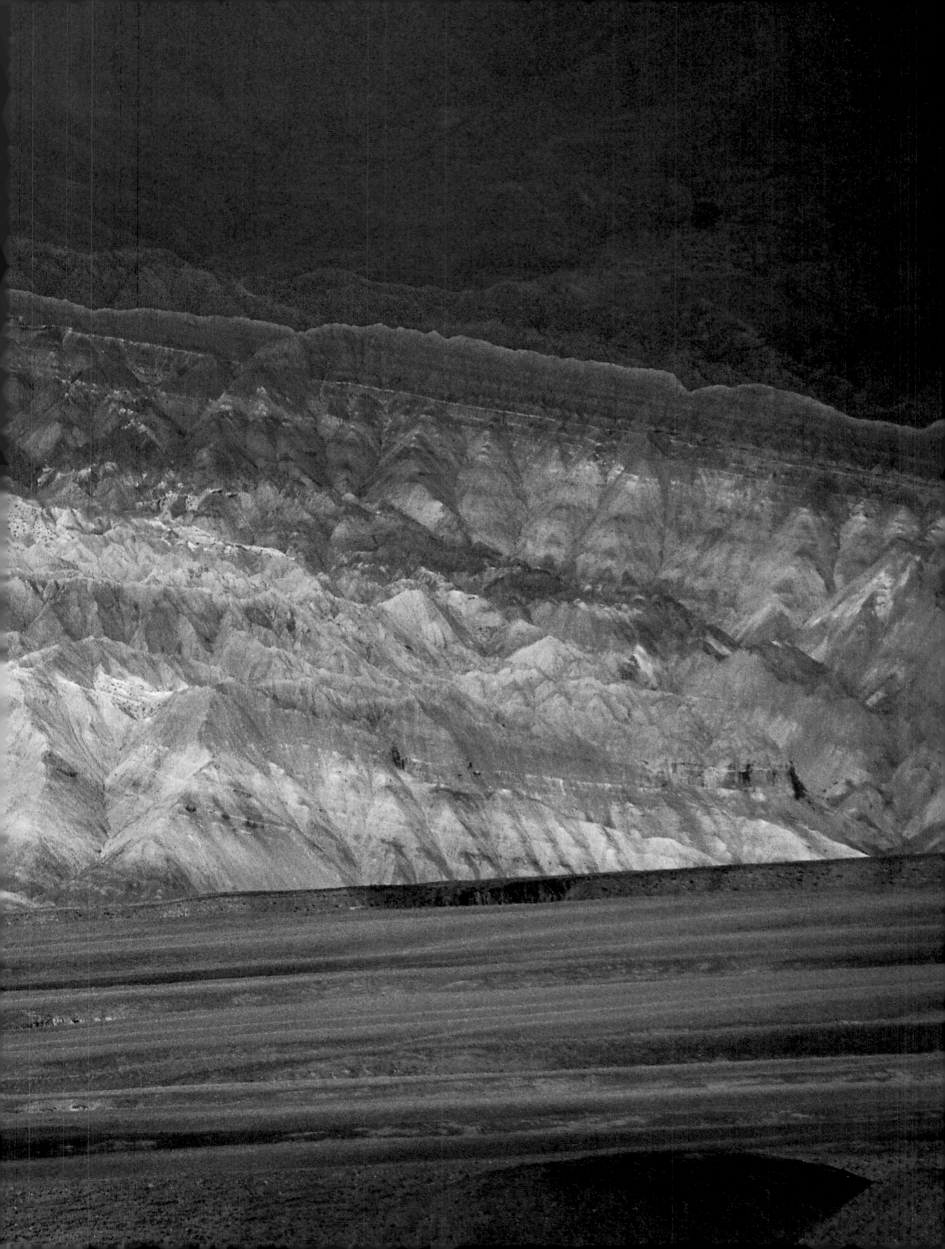

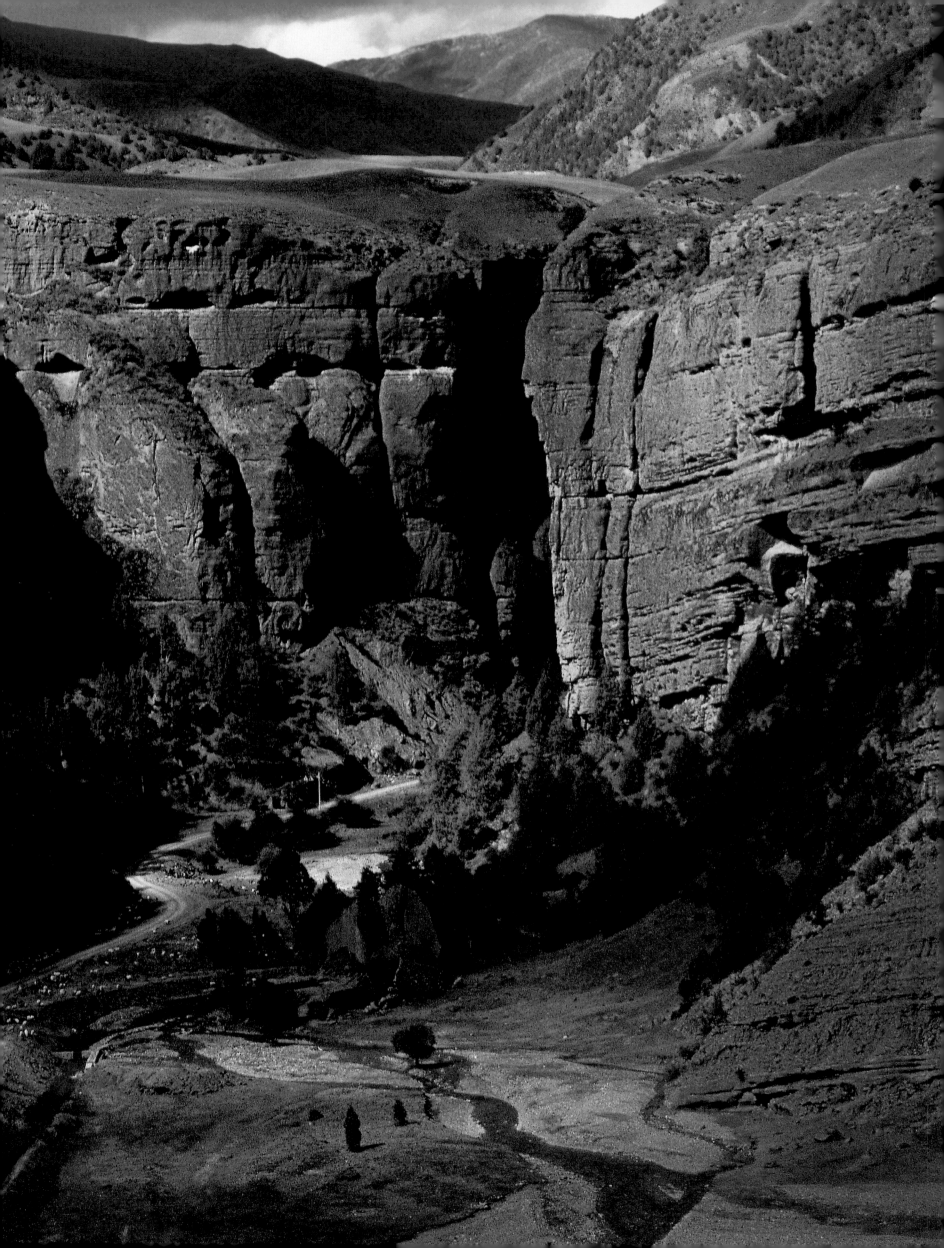

RUSTY SANDSTONE, QINGHAI

A small stream cuts a vertical-walled canyon in weathered sandstones that fill a valley that was formerly much deeper. Such infill is characteristic of Qinghai's high valleys. Flooding by river deposits, followed by renewed incision occur in tune with power changes of the Yellow River, the main fluvial outlet of this part of the plateau.

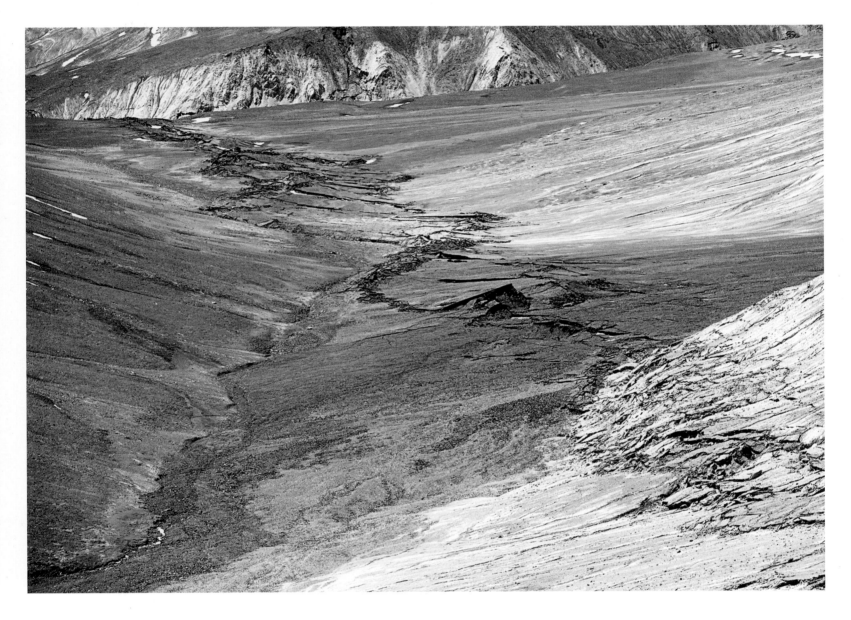

KUNLUN FAULT, QINGHAI

Tearing the high steppe for a length of more than 200 miles, the surface rupture of the November 14, 2001, earthquake propagated along the entire length of the Kusai segment of the Kunlun Fault in less than two minutes, at a velocity of nearly two miles per second! This fault and that earthquake reflect the most important facet of current Tibetan tectonics: the highest part of the plateau south of the Kunlun range no longer thickens, but slides eastwards, being pushed sideways by the penetration of India into Asia.

HOT SPRINGS, TANGGULA, TIBET

Against a background of glacial ice caps flowing lazily down smooth mountainsides, the Wen Quan fissure spits its hot waters, like a small dragon. The dissolved carbonates they contain precipitate out and crystallize, building a crest of yellow and white travertine bit by bit. Oriented north–south, the crest and the fissure result from the east–west extension that has started to "demolish" the high plateau.

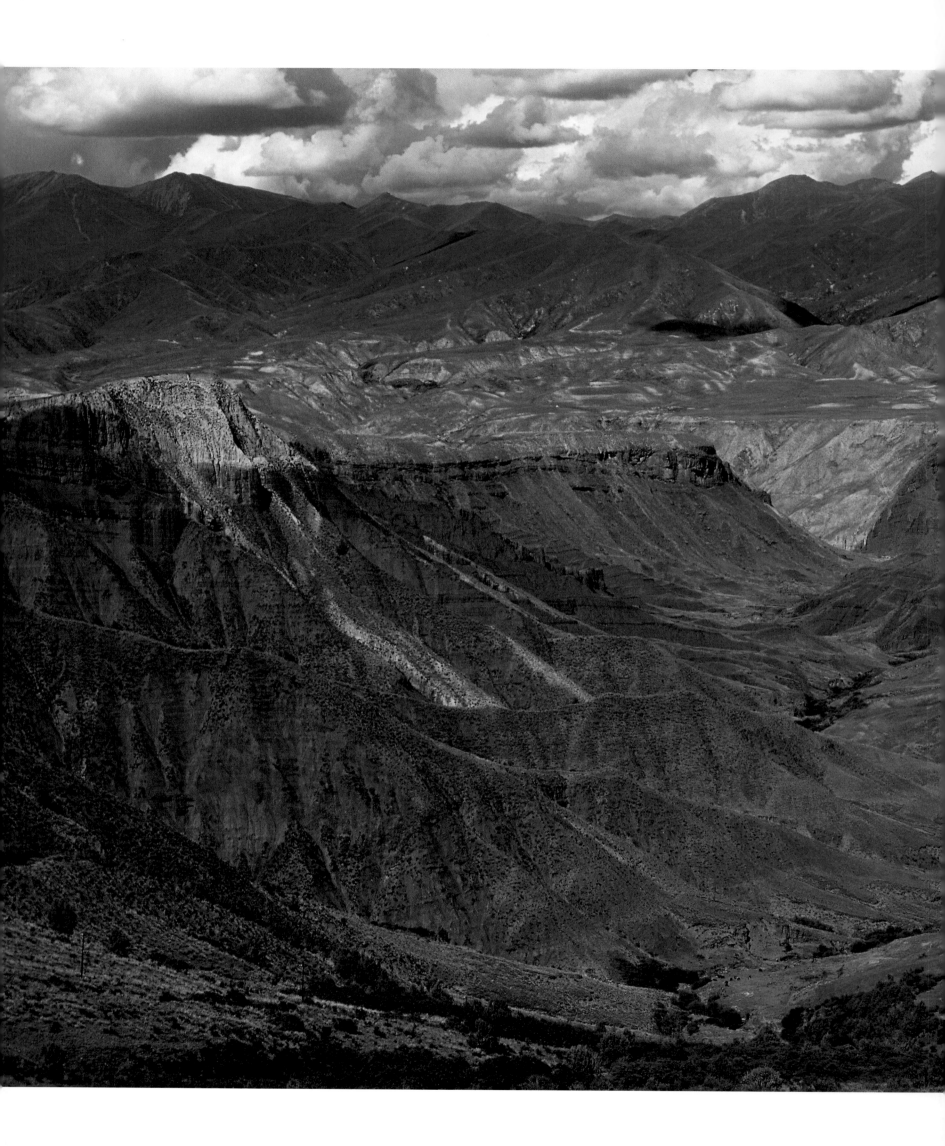

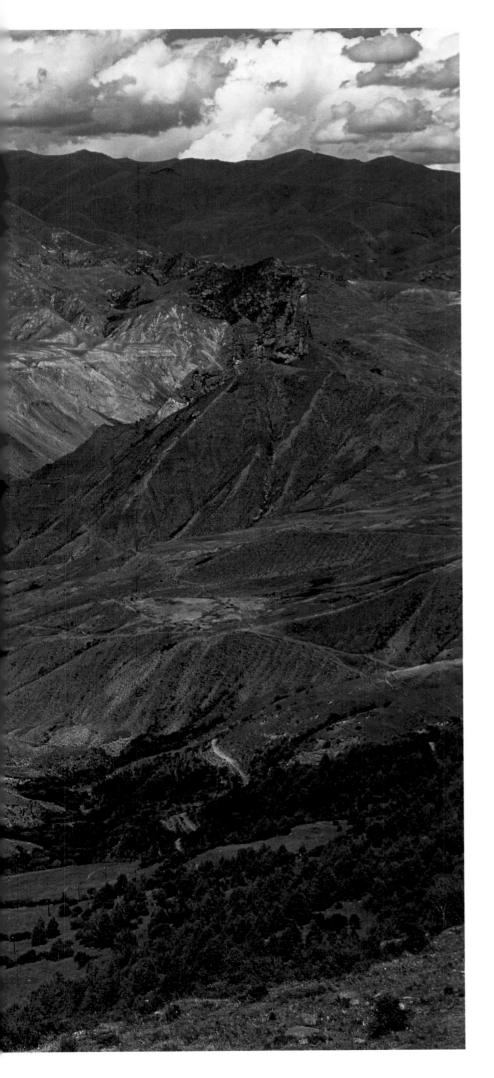

Red sandstone,
QINGHAI, CHINA

The Kunlun Range marks the northern limit of Tibet—a boundless "plain" whose elevation rarely falls below 14,700 feet, and whose stupendous flatness remains the subject of considerable debate. For some, the reason for such flatness might be found 15 miles beneath the surface, in a nearly liquid, lower crust: the roof of the world could be viewed as a geological "waterbed." For others, the cause of this anomaly lies much closer to the surface, in the first three to six miles of crust. In this canyon dug by a tributary of the Yellow River, one of the few to cross Kunlun's barrier, we see evidence in favor of a superficial mechanism. The canyon's cliffs expose hundreds of meters of almost horizontal red sandstone strata, capped by a yellow layer, itself covered with grassland. This is the roof of a basin that gradually filled with sediments when ancient rivers flowing from the south, impeded by the uplift of the mountain range in the background, were too weak to force their way across. Result: a high plain of interior deposits, similar to those observed in coastal deltas, but here near the summit of the mountains. The Tibetan plateau surface is flat insofar as it was born flat, through this mechanism of sedimentary infilling and leveling: much of it is a mosaic of basins rather than an assemblage of mountain ranges.

Eolian sculptures,
QAIDAM BASIN, QINGHAI

This tightly packed battalion of small, asymmetrical ridge-crests (*yardang* in Persian) that look as they are all aiming at the same target, are one of the strangest yet most typical landscapes of the Qaidam. A vast desert at the northeast corner of Tibet, Qaidam is both higher than the Pre-Alps, but nearly as flat as the Flemish plain. From east to west, the basin's altitude (about 8,900 ft) remains constant for nearly 250 miles. It is the floor of a lake, dry for now. *Yardangs* are carved out of light-beige lacustrine mud, full of gypsum crystals. Deposited "just yesterday," such muds are still tender enough to be easily sculpted by the prevailing northwest winds. We can "see" these forceful winds blowing, both from the *yardangs'* round, blunted heads facing them, and from the thinly striped *yardang* tails on the lee-side, whose barely tilted mud strata have been smoothed by eolian polish. In the distance, shrouded in bluish fog, we discern one of the ranges that ring the basin: a "captive," closed-in basin which, like a bathtub, can only fill with water, salt, and other river-born debris. This mechanism, seen here at work, governs the leveling-off of such high plateaus as Tibet and the Altiplano.

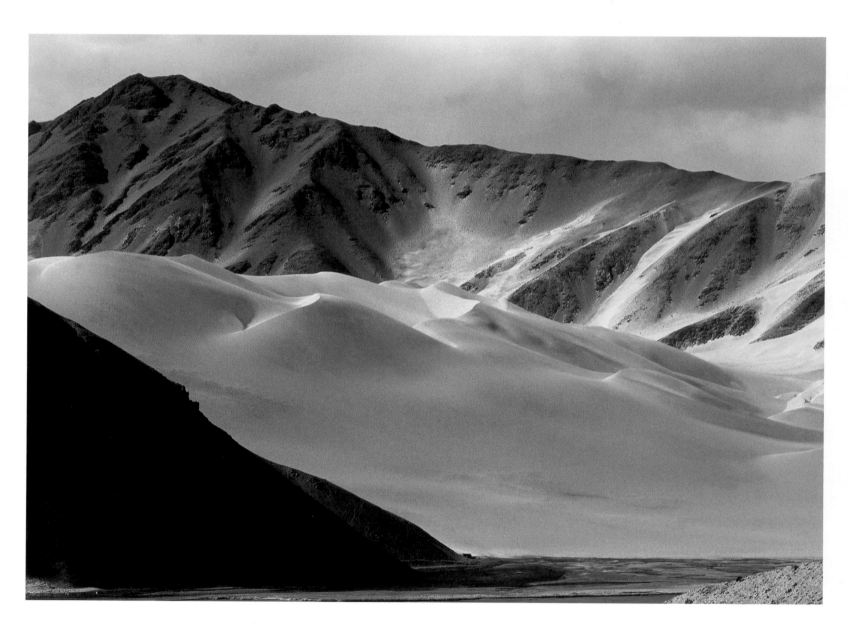

DUNES, PAMIR, XINJIANG

Little Tibet's rivers also struggle to find an escape down and across the Pamir range. These giant dunes (12,800 feet high) are built with sand deposited in a vast lake when the Bulong Kol fault, which raises Kongur Shan, dammed the Gez River.

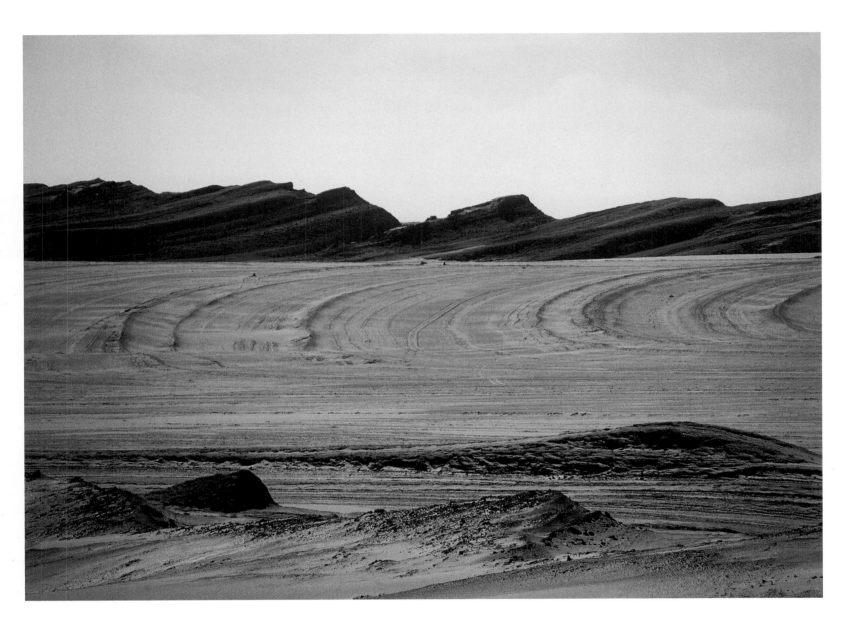

Folded lacustrine deposits, Tafeng Shan, Qaidam, Qinghai

Near the "great wind" mountain, ellipses drawn by slender beds of lacustrine marl recall the rings of Saturn seen at an angle. They outline the ongoing folding of the very young deposits of the Qaidam.

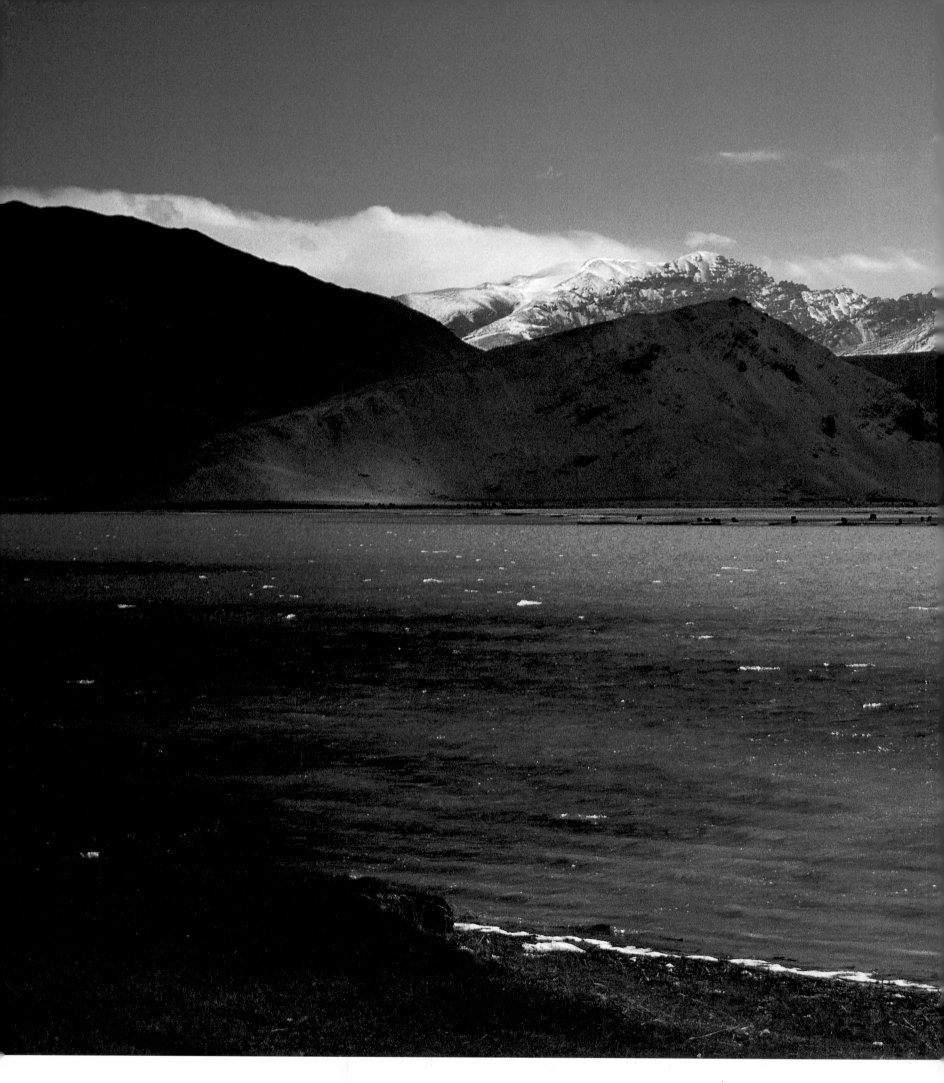

KARAKUL, PAMIR, XINJIANG

Without regard to its Turkic name, the glacial Karakul Lake (Black Lake) displays its gorgeous turquoise waters
at the foot of Muztagh Ata.

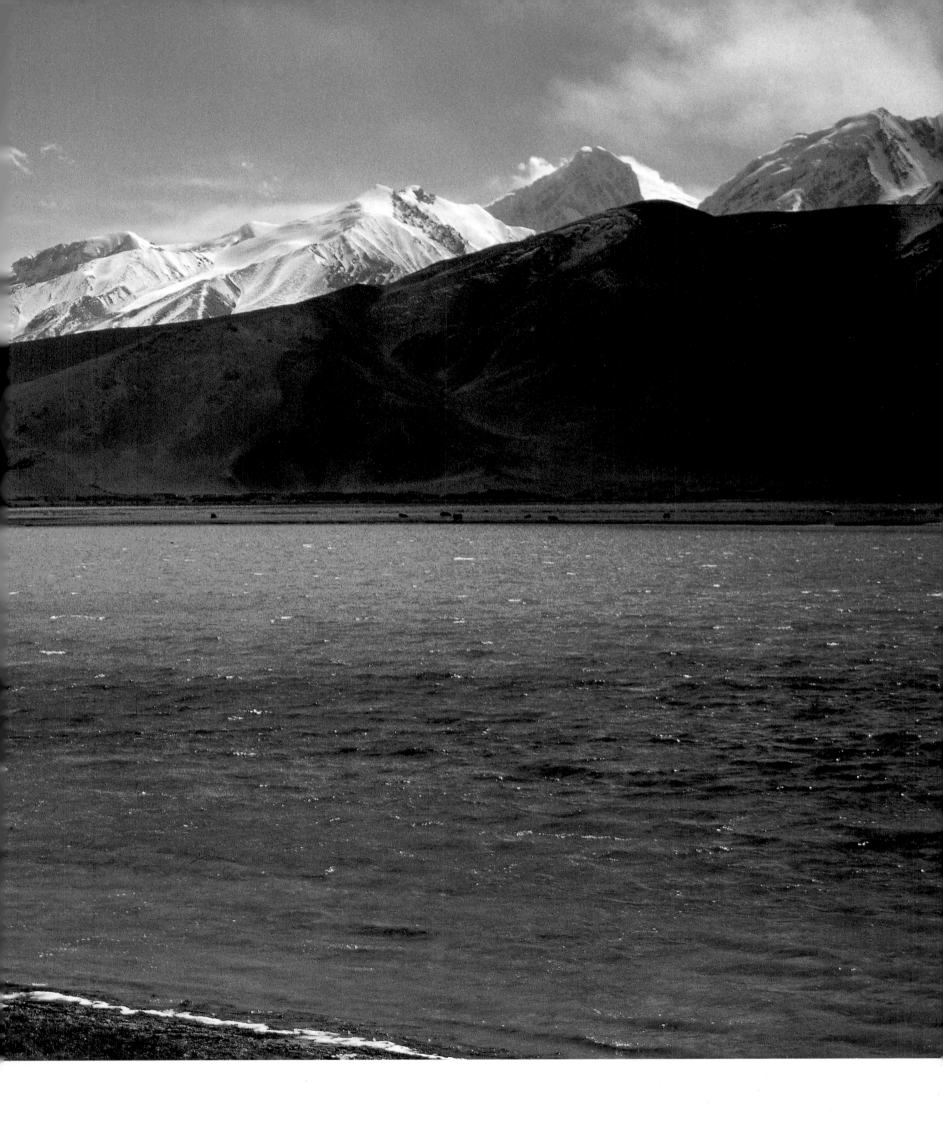

HUANG HE, MADOI, QINGHAI

The Yellow River is born from countless springs in the marshes surrounding the Gyaring and Ngoring lakes on the high Tibetan steppe. Unlike most rivers, whose headwaters are raging alpine torrents, these meander lazily—at 15,000 feet!

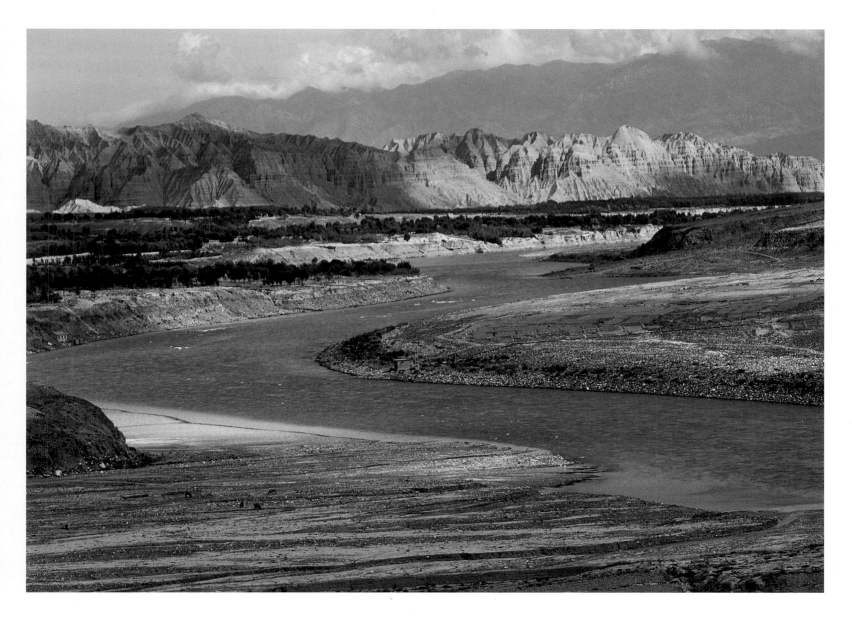

HUANG HE, GUIDE BASIN, GANSU

In between the six rising ranges that it must cross to escape Tibet, the Yellow River snakes across basins where it brought and dumped thousands of meters of gravel and sand during just the Quaternary period. Here, near Guide, the sun illuminates piles of these gray, flat deposits, already turned into ruins by erosion.

Extreme lakes, QIANTANG, TIBET

At 16,500 feet above sea level, the lakes of the Qiangtang platform are the world's highest. Water cannot escape from this part of Tibet. Everywhere, it stands in vast "puddles," most often salty or brackish, which gradually dry out as the climate warms up. Hence, the small islands we see emerging in the center of the lake are covered with bright layers of limestone and gypsum, deposited only a few thousand years ago. These deposits, where submerged, also give shallow waters their turquoise color. We could be contemplating a salt marsh at the edge of a tropical lagoon next to the ocean. There are no palm trees, however, and considering the altitude, it would be natural if the white brightness were that of ice or snow-patches. This is a most disconcerting landscape, a complete contradiction of what one imagines Earth's highest mountains to look like. It is in fact one of the flattest of landscapes, with less than 3,000 feet of relief over an area of nearly 200,000 square miles. Why? This vast region of inland drainage is cut off from the rest of the world. Here the waters know nothing of the ocean's existence. The Indus and Yangtze rivers, which remain a good distance away, have yet to communicate this information. Consequence: erosion is paralyzed! And will remain so for a long time.

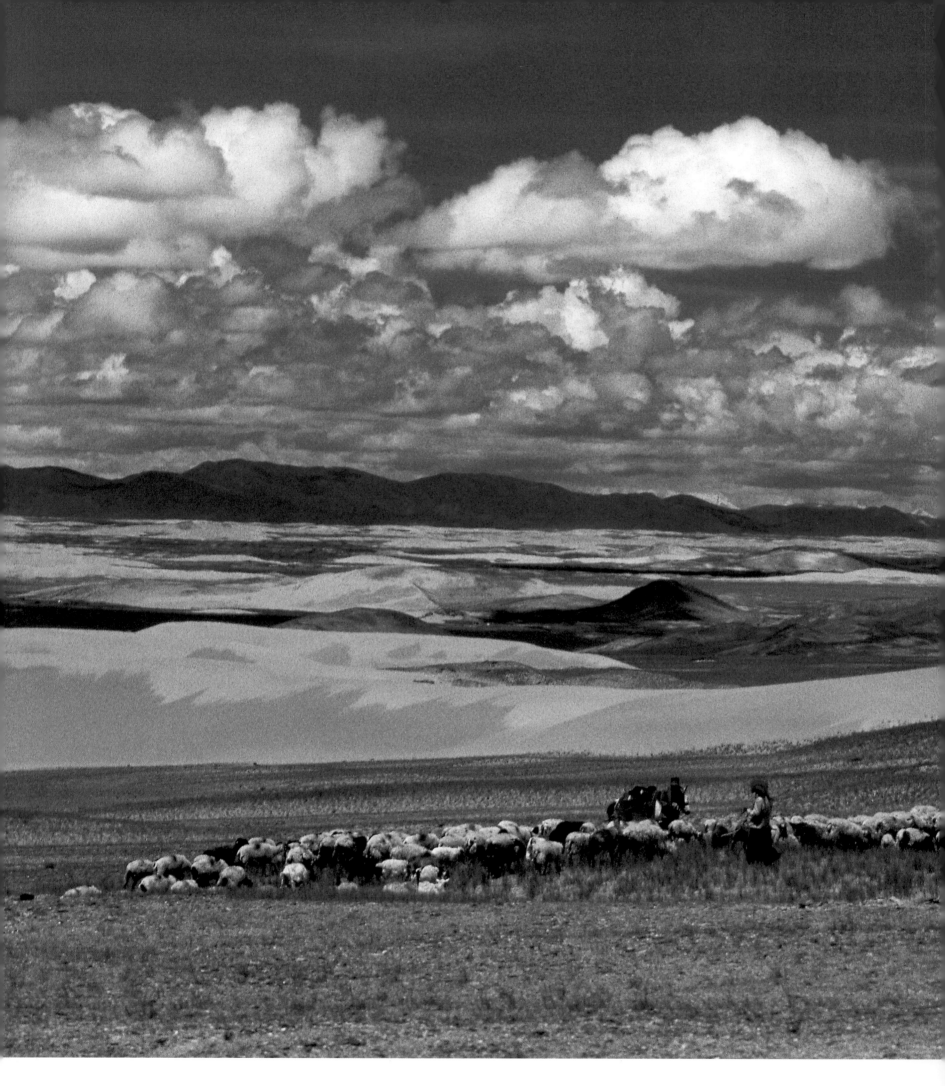

HERDER, NEAR ZHONGBA, TIBET

Located in the direct pluvial shadow of the Himalayas, the upstream valley of the Yarlung Zangbo receives less rainfall than the rest of Tibet, particularly in the east. Though sparse, the grass nourished by the summer monsoon suffices to feed herds of goat and sheep, however. As elsewhere on the plateau, the dunes here mark the site of a former lake, evidence that the river was dammed in the past.

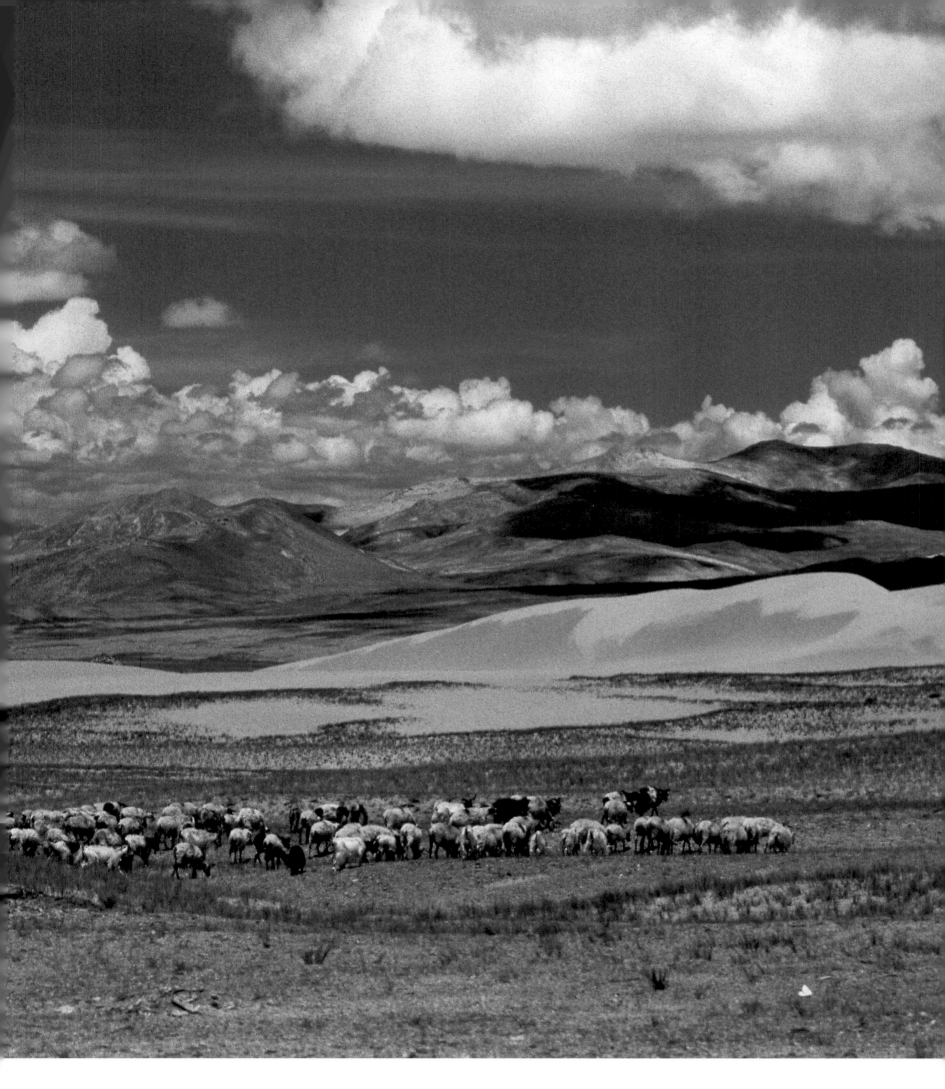

following pages

PINK LAKE, NEAR GERZE, TIBET

Like some salars on the Chilean Altiplano, certain Tibetan lakes take on a salmon pink color. The folded
sandstones in the background are among the oldest in Tibet. They were deposited during the beginning of collision.

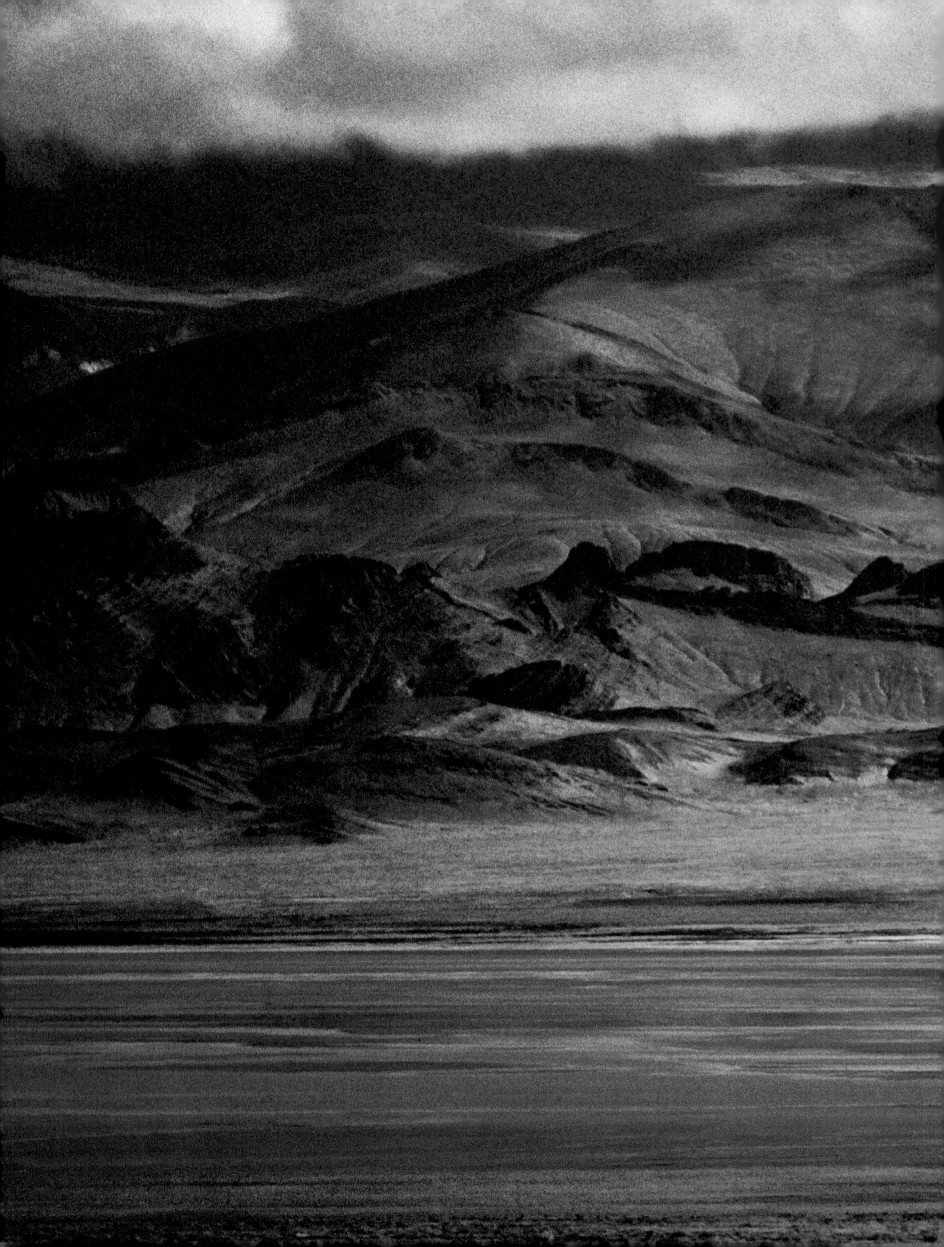

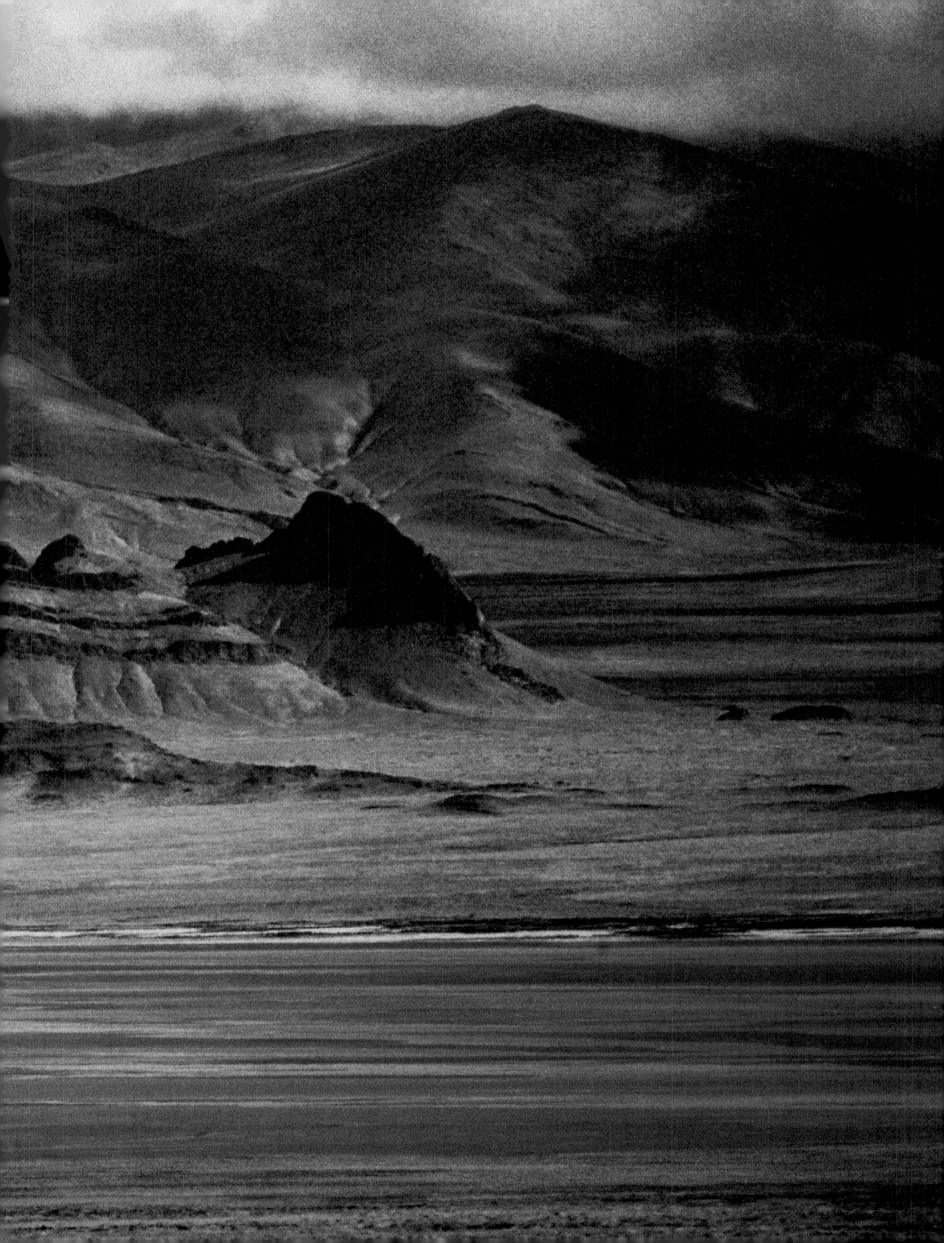

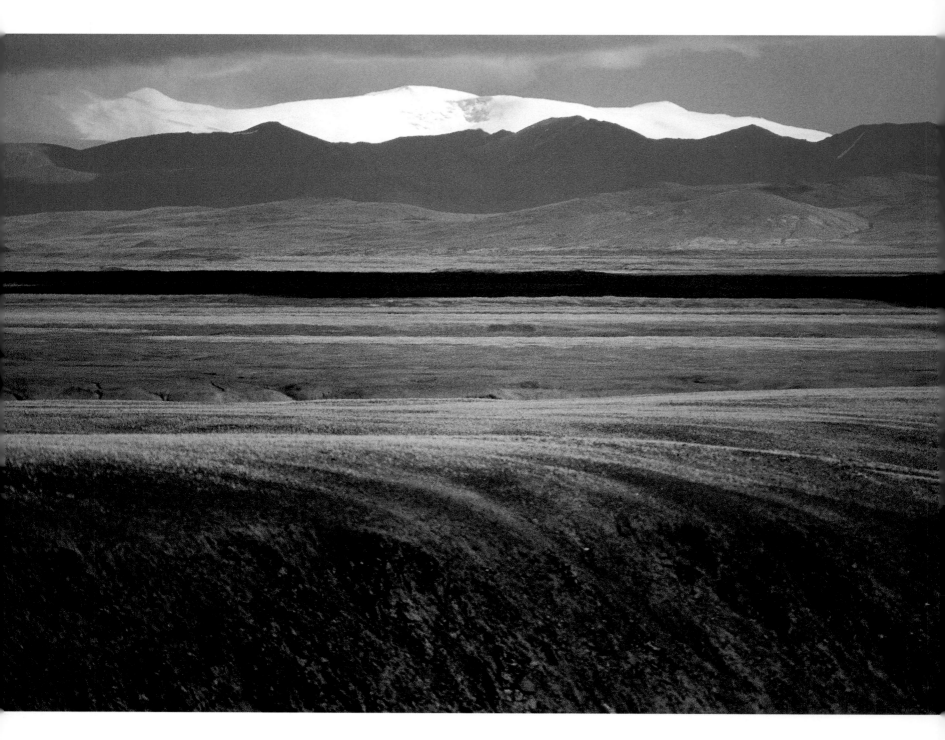

GYPSUM SANDSTONE, HOHXIL SHAN, QINGHAI

This basin of red sandstone peppered with desert roses, south of the Kunlun, was a precursor of the Qaidam. Approximately 30 million years ago, during the Oligocene, gypsum, silt, and sand were being deposited here in large inland lakes.

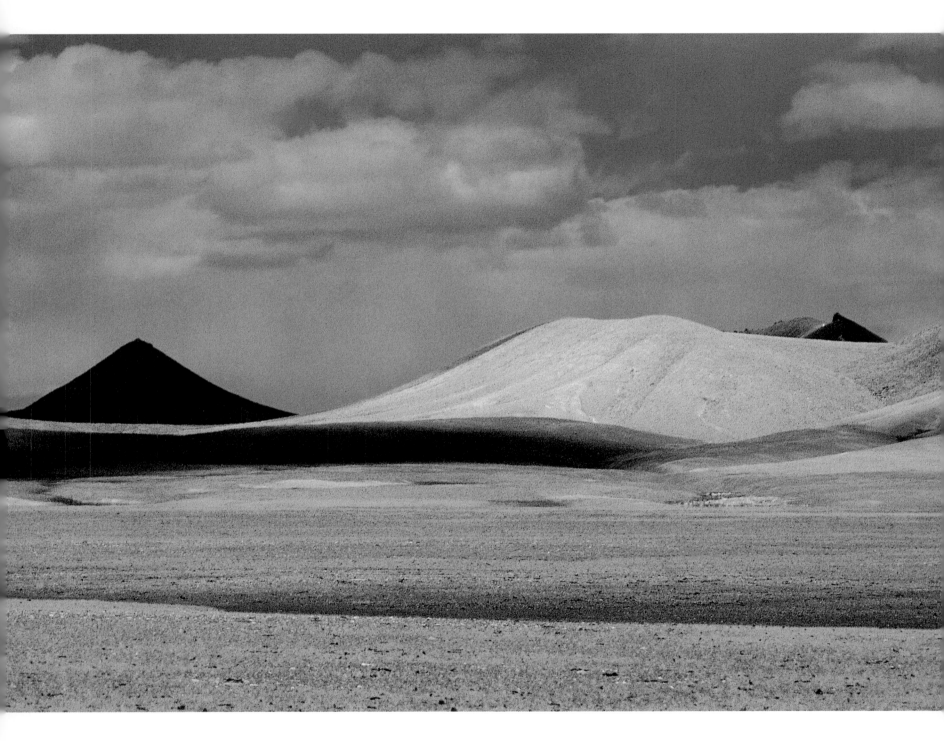

Volcanoes, Kunlun, Qinghai

These small pyramidal constructs are brand new volcanoes, less than 15,000 years old. They are built of rhyolites, pink lavas rich in feldspar and quartz, the superficial, effusive, equivalent of granites that crystallize at greater depths in the crust.

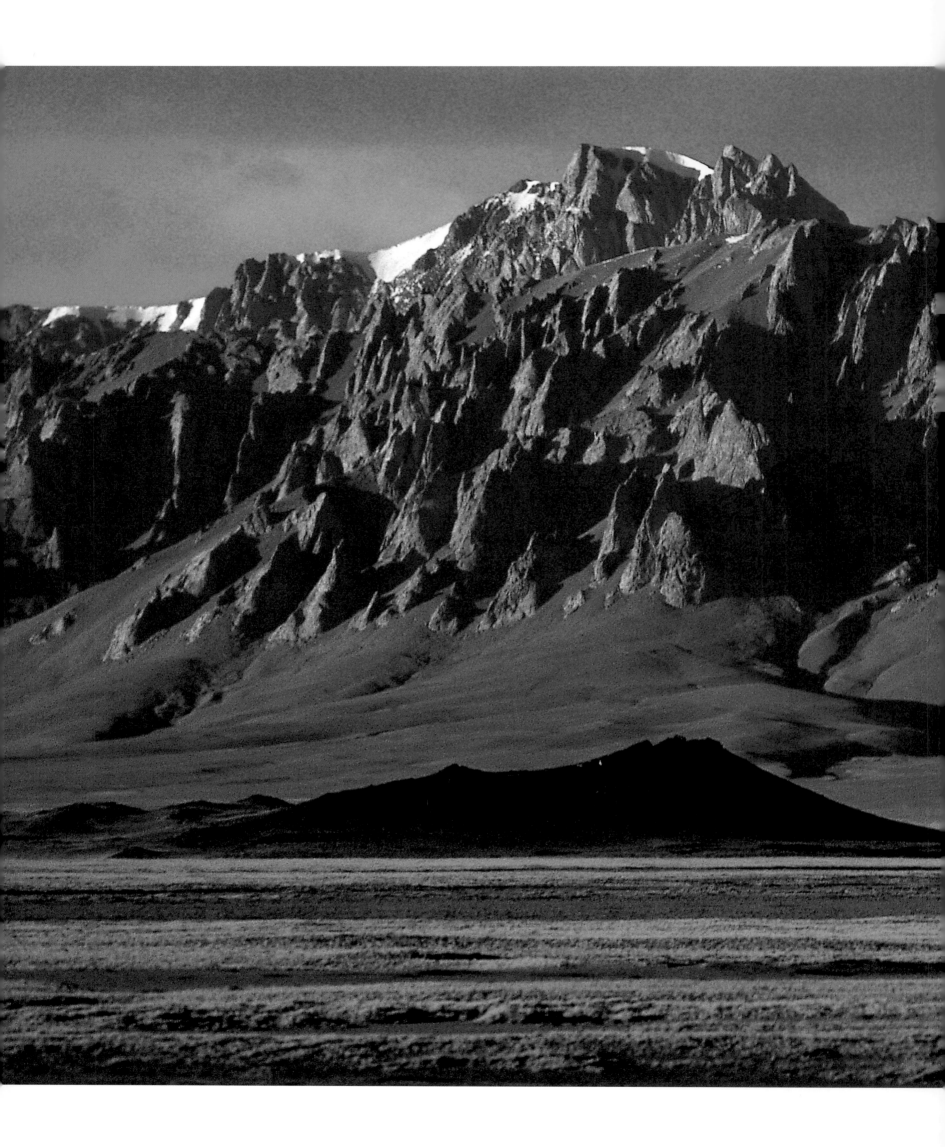

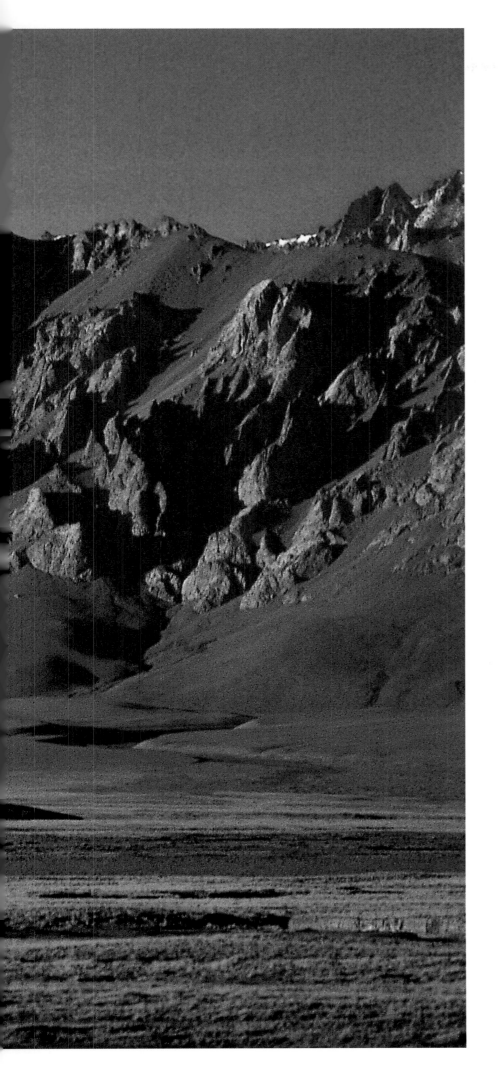

HORNITO, LAKE JINGYU, TIBET

Black cone pasted onto the golden, 15,800-foot-high meadows in front of the limestone wall of Arkatagh—southernmost range of the eastern Kunlun—this small volcano is so young that it did not witness the last glacial maximum, 20,000 years ago. Young and rare, some active, northern Tibet's volcanoes challenge theories that claim to explain intraplate volcanism. South of the ranges that bound the plateau, they are stranded along the two great faults that guide Tibet's current expulsion toward the Pacific. While close to these faults—Altyn Tagh and Kunlun—they show little connection with surface geology. Their lavas, which resemble those common in the Andes, are found capping any pre-existing rock whatsoever, be it Tertiary red sandstone or Paleozoic schist. Only deep, hidden subduction seems to be able to account for such unusual volcanism in the very heart of the continent. A situation somewhat similar to that in Sumatra, where andesitic volcanoes skirt a large strike-slip fault on the inner side of a thickened wedge of stacked crustal slivers—dubbed accretionary prism—under which the mantle dives. Here, however, rather than oceanic lithosphere, it is the ancient Tarim and Qaidam cratons that plunge, stealthily and slowly.

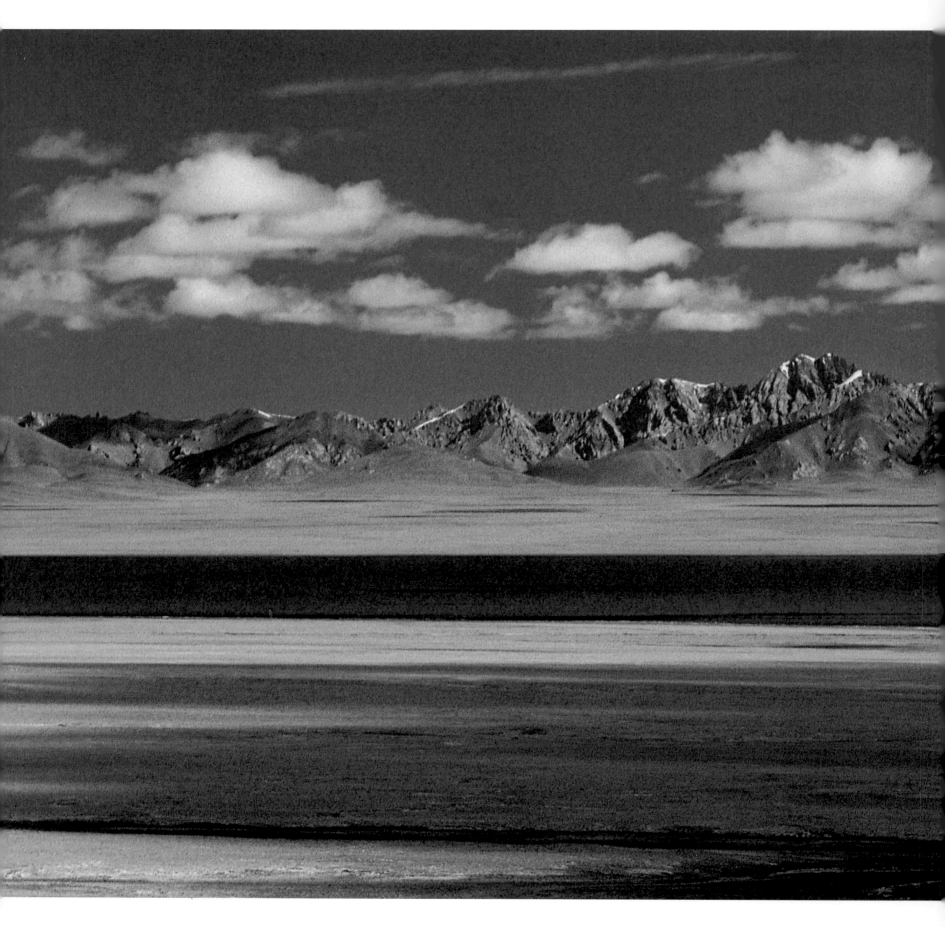

preceding pages

EQUUS HEMIONUS (KYANG), QINGHAI

Kyangs live in herds of 10 to 30 heads. Closely related to the domestic ass above the withers and to the horse everywhere else, particularly with regards to their elegance and speed, they are the most numerous of the high plateau's large wild mammals.

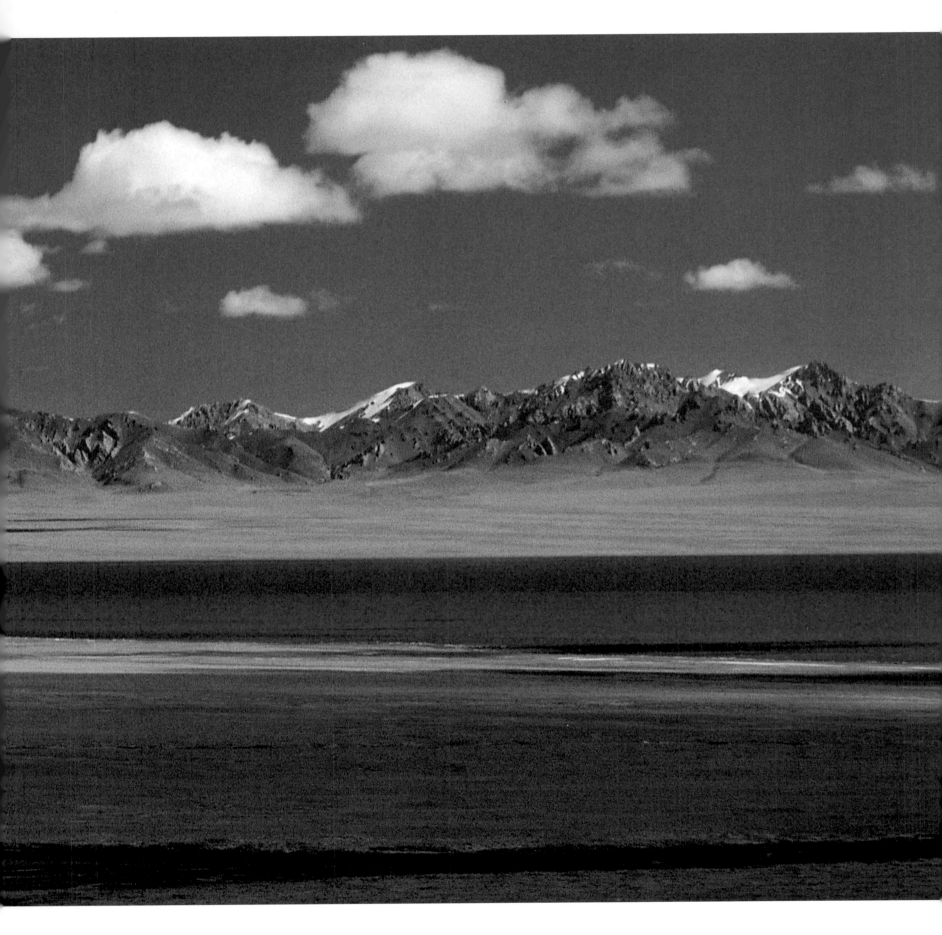

LAKE JINGYU, QINGHAI

The landscape around the shores of Lake Jingyu, south of the Arkatagh, illustrates the pristine virginity of northern Tibet. To this day, this part of the high plateau is inhabited only by wild yak, kyangs, antelope, ibex, bears, and griffon or bearded vultures.

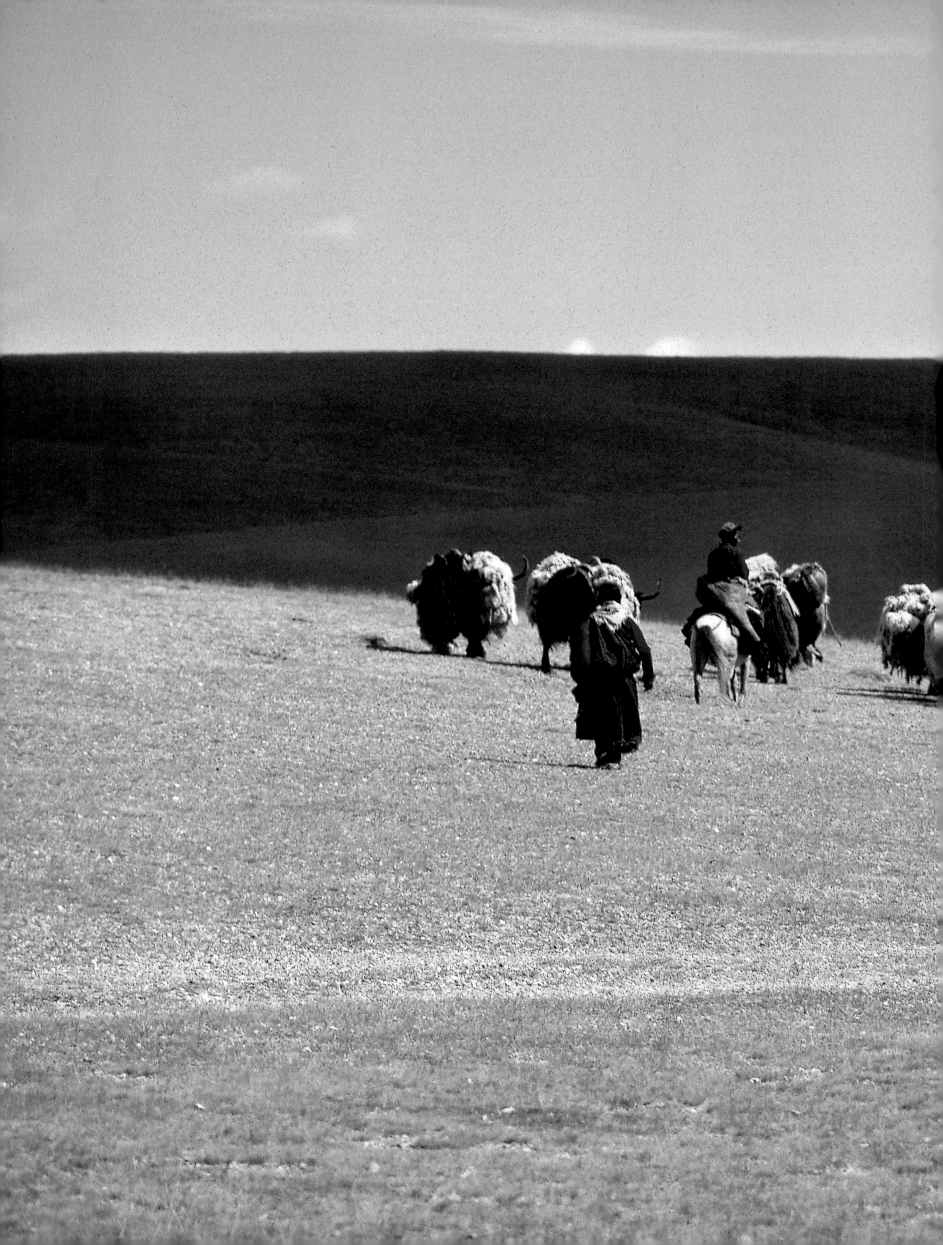

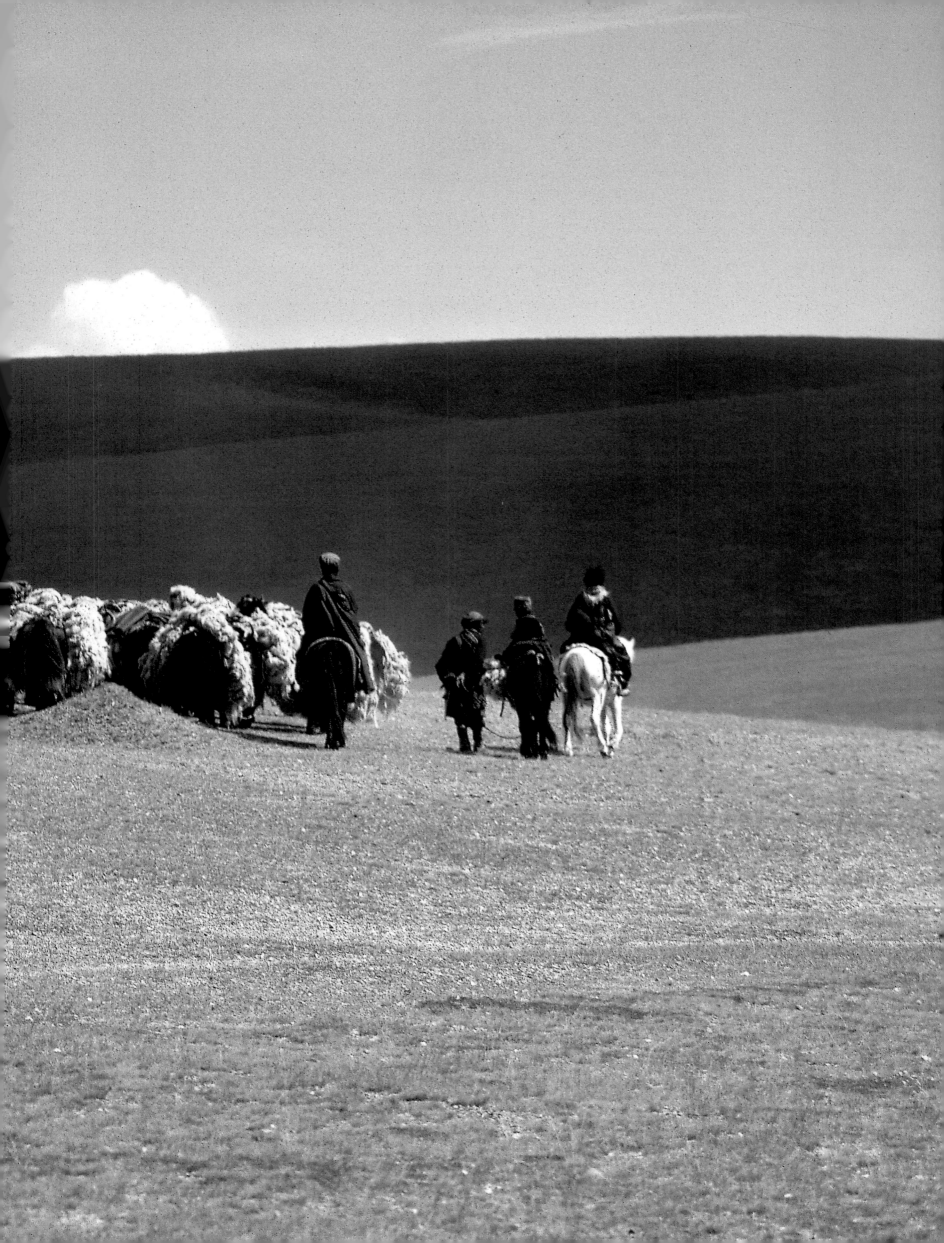

preceding pages
CARAVAN, NEAR NAGCHU, TIBET
The central Tibetan plateau is so high that only yaks, here loaded with wool bundles, are up to carrying heavy loads.

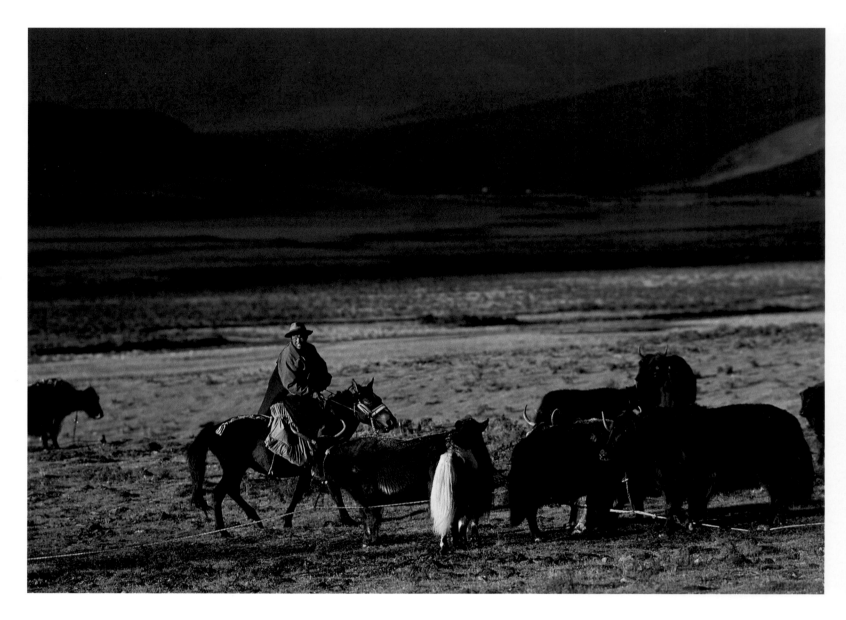

GOLOK HERDSMAN, ANYEMAQIN, QINGHAI
It is yak-milking time. At summer's end, herdsmen use most of their milk to make yogurt, the best in the world.

ALPINE FLOWERS, MAQEN, QINGHAI
In August, meadows south of the Kunlun Mountains are covered with gentians and giant edelweiss.

BLACK TENTS (*MAIKHANS*), DAMXUNG, TIBET

The dark, yak-wool tents are firmly secured to the ground in anticipation of a night of storms and wind.
The baskets that serve to collect yak dung for the campfire are on the ground, and the yaks, away grazing.

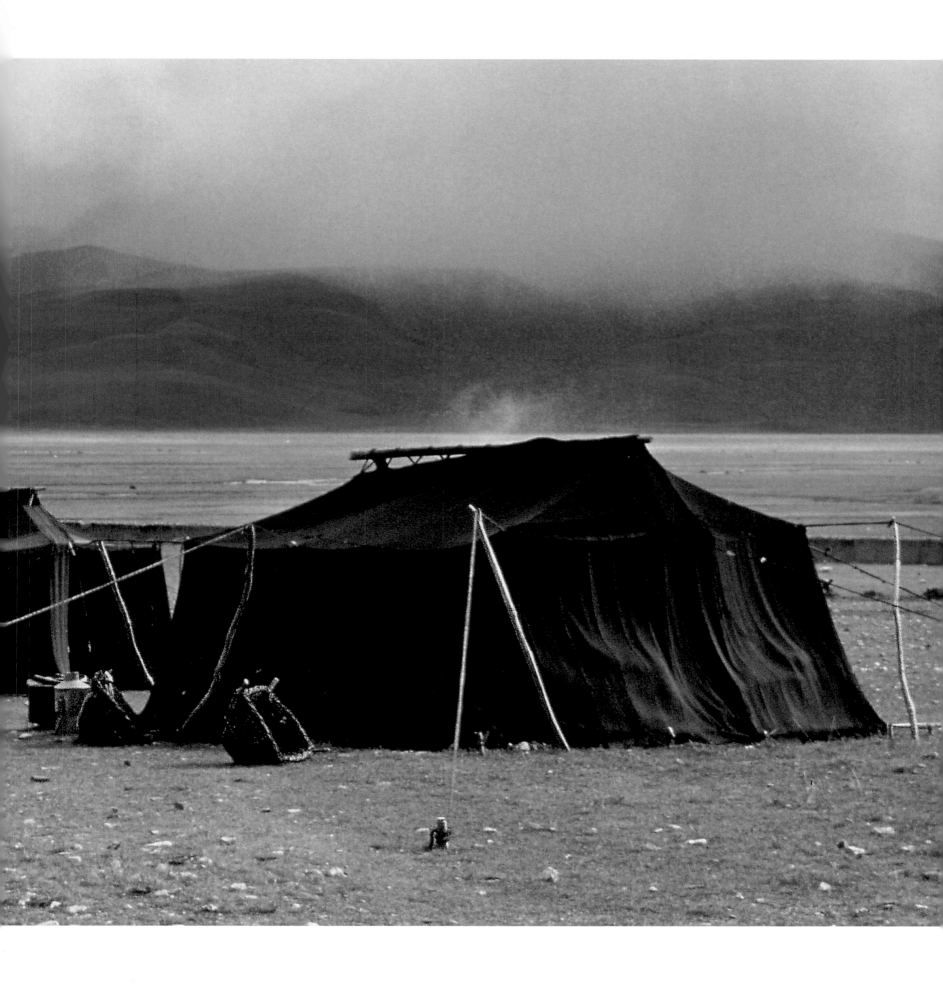

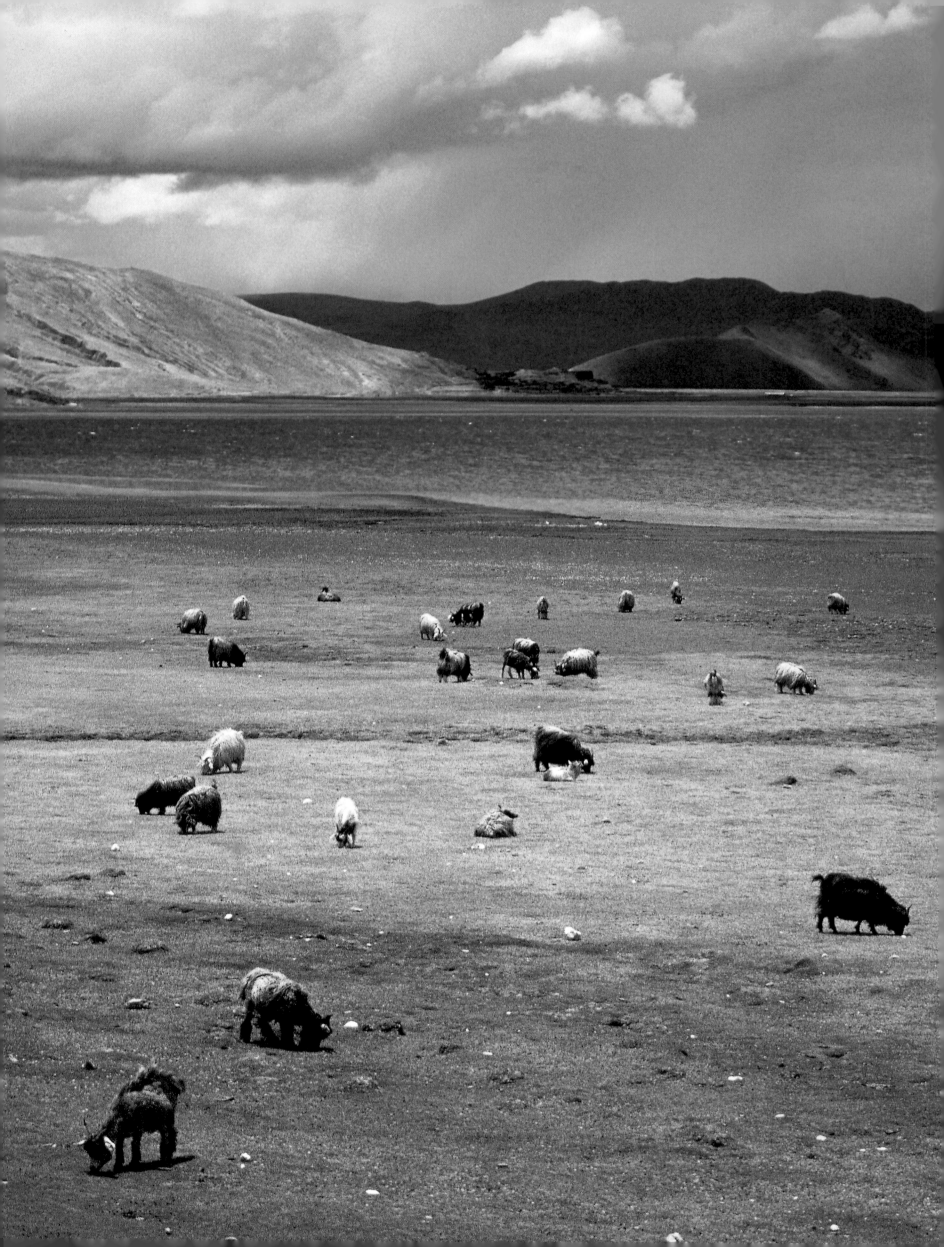

NEAR NAGARZE, TIBET
Goats grazing on the shore of Lake Yamdrok.

LAKE KARAKUL, PAMIR, XINJIANG
Yaks on a peninsula.

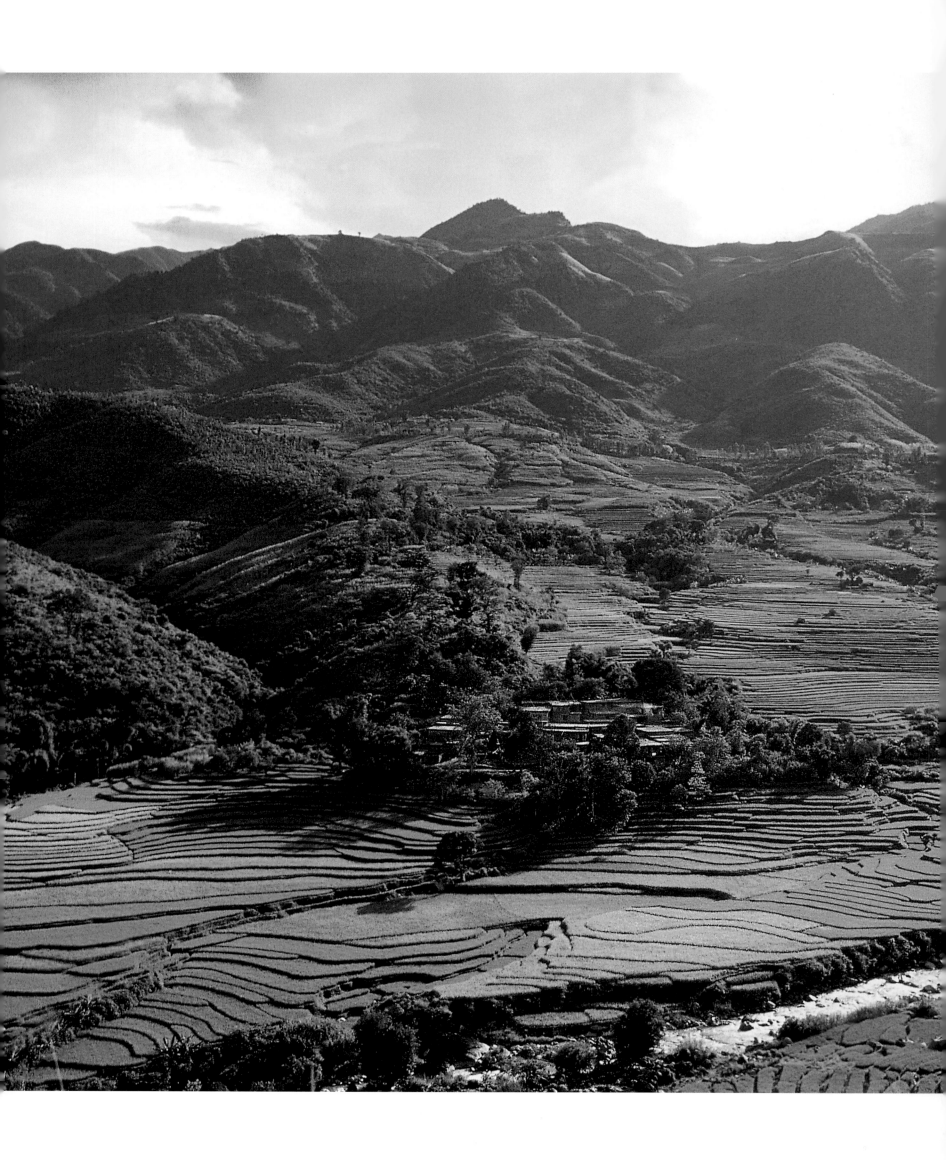

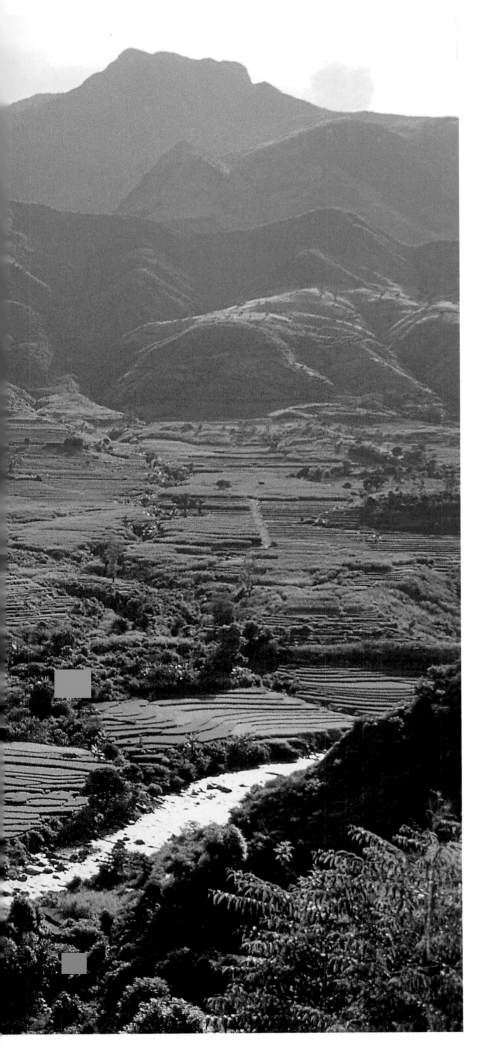

AILAO SHAN, YUNNAN, CHINA

Myriads of terraced paddy fields climb from the Red River on the flank of the Ailao Shan. Carved and maintained for centuries the small steps defining their edges closely follow topographic contour lines. Green rice grows dense and thick in the water-soaked paddies. The steps only end where the steep gneiss slabs that form the backbone of this "small" mountain make terracing higher up impossible. The architecture of the Ailao Shan is radically different from that of other mountain ranges. No stacking of crustal slivers here, as everywhere else. Its maximum altitude is modest: a little over 10,000 feet, barely 3,000 feet above the Yunnan plateau, which it slices in half. Its small width, barely 15 miles, is dwarfed by that of the Alps and the Himalayas—200 miles or so. Undoubtedly, it is not a "real" mountain range. Yet, it has been the site of bewildering movement given its size: a displacement parallel rather than perpendicular to its trend. It is along this small crest and along its northern and southern extensions that Indochina was pushed 500 miles southeast by India's collision with Asia! Starting from southern Tibet, this narrow, thousand-mile-long metamorphic belt runs across all of Yunnan and north Vietnam to plunge under the Red River delta, before continuing into the South China Sea.

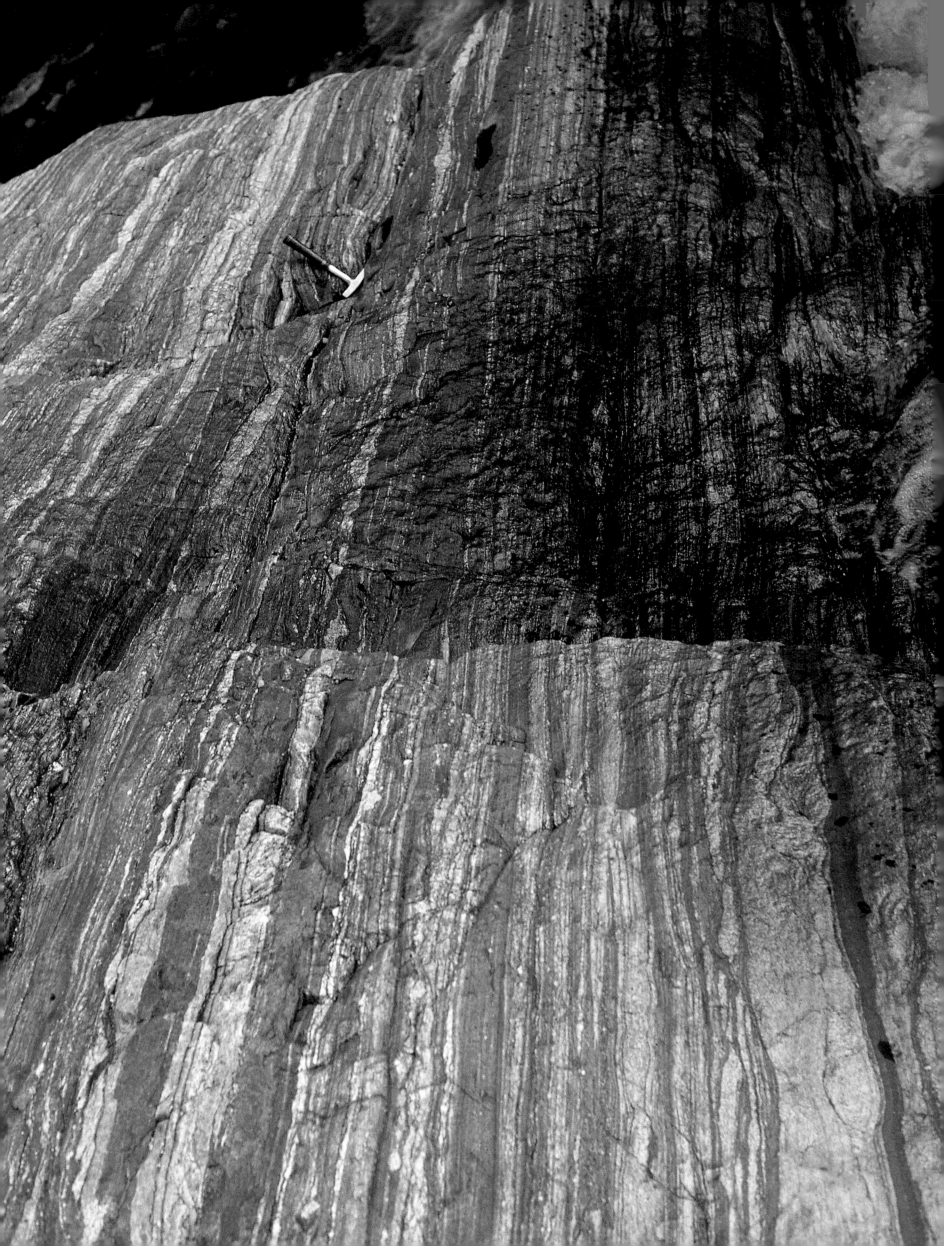

VERTICAL GNEISS, AILAO SHAN, YUNNAN

Laminated 10 miles deep by the horizontal sliding between Indochina and China, these rocks, initially sediments, were heated, flattened, stretched, and recrystallized at 1100°F, under a pressure 7,000 times greater than that of the atmosphere. Transformed into gneisses 20 to 30 million years ago, they mark, for hundreds of miles, the greatest shear zone of Asia outside the Himalayas.

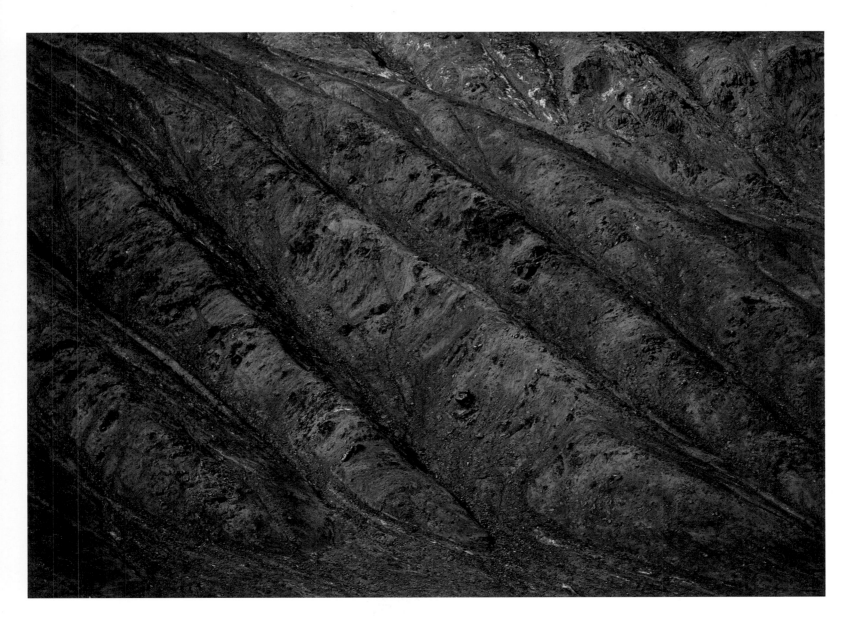

KUM TAGH, XINJIANG

Folded, gypsum-rich red sandstones.

following pages

TERRACED RICE PADDIES, AILAO SHAN, YUNNAN

Flooded up to an altitude of 6,000 feet, the stair of terraced paddies that covers the north flank of the Ailao Shan, near Yuanyang, is one of the most staggering in all of China.

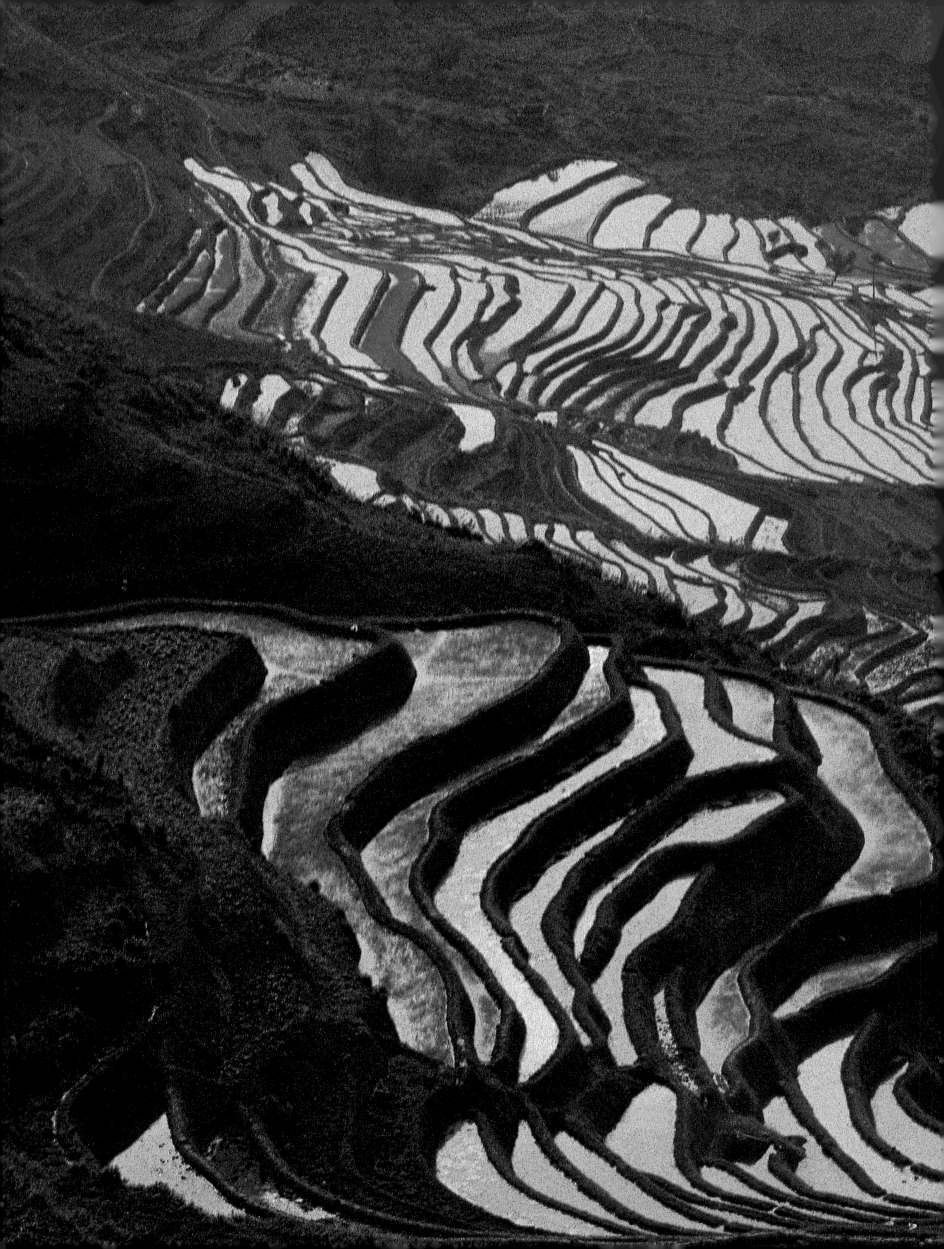

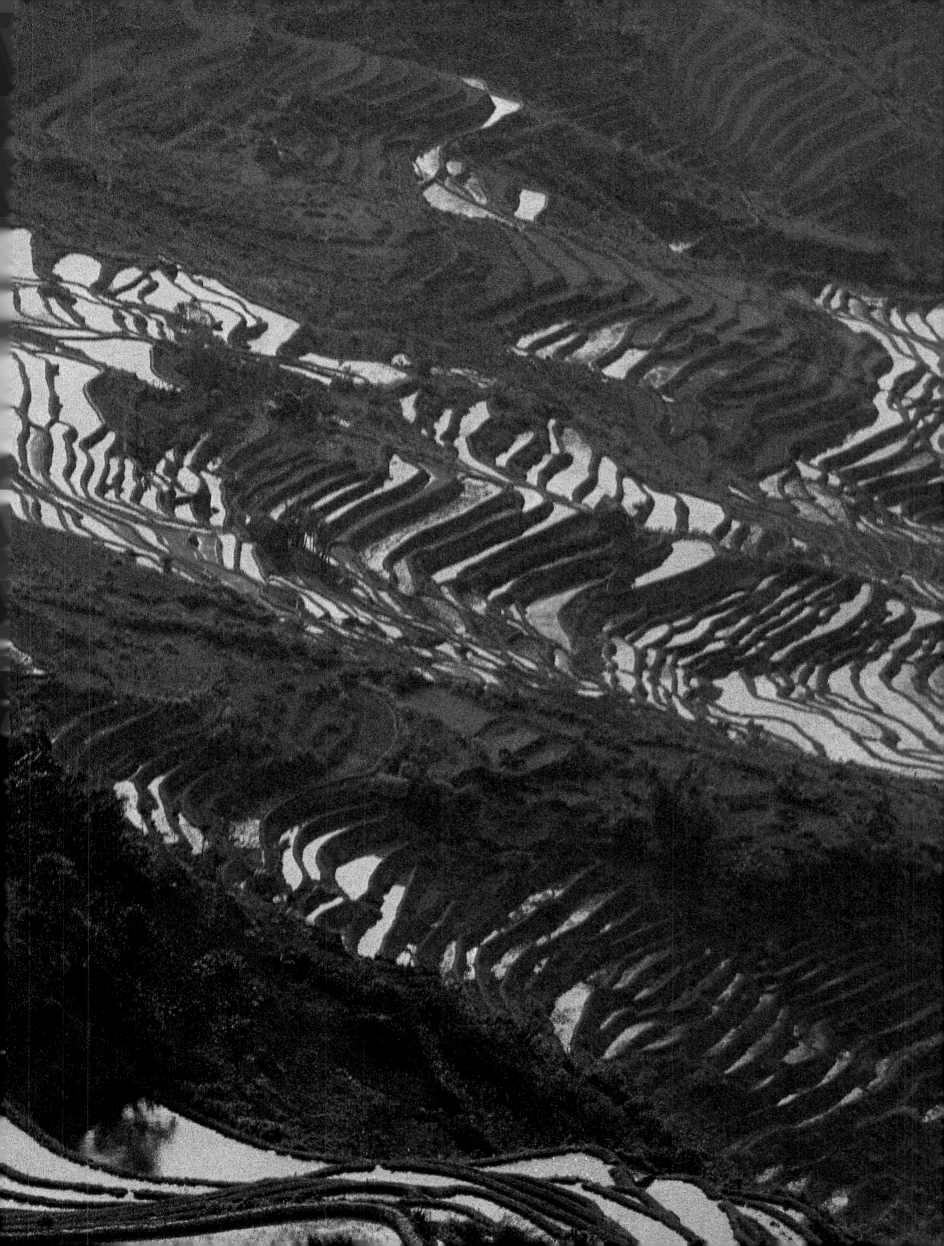

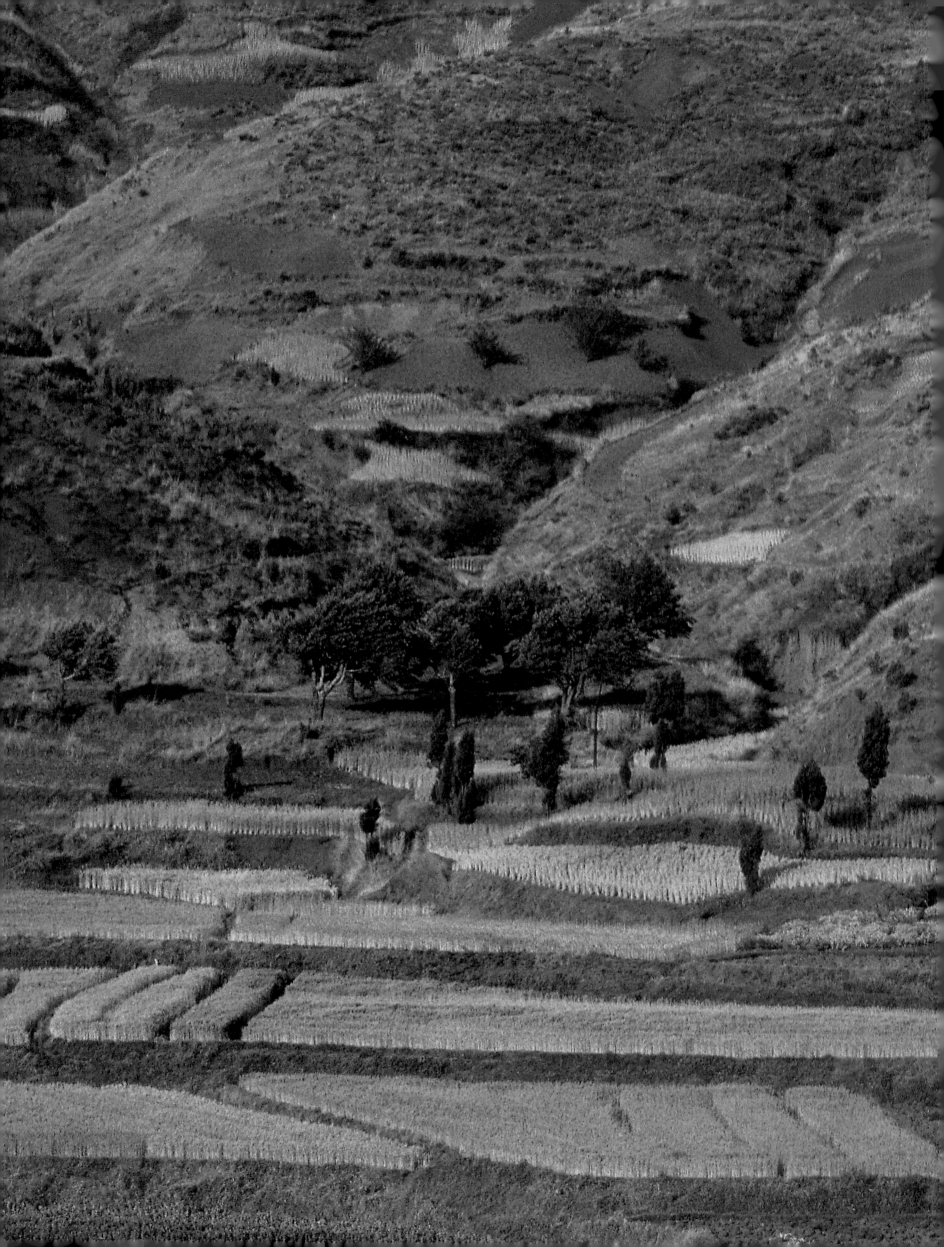

"SOUTH OF THE CLOUDS," CHINA

About 6,500 feet high, but close to the Tropic of Cancer, the plateau of Yunnan (South of the Clouds) enjoys an almost Mediterranean climate. Though moderately high on the Asian scale, this plateau was born of the very first shortening and thickening of the crust caused by the collision, during the Eocene epoch. Today eroded and thus lower than then, it probably rose in tune with southern Tibet, with which it is contiguous. Could it be an old Tibet remnant?

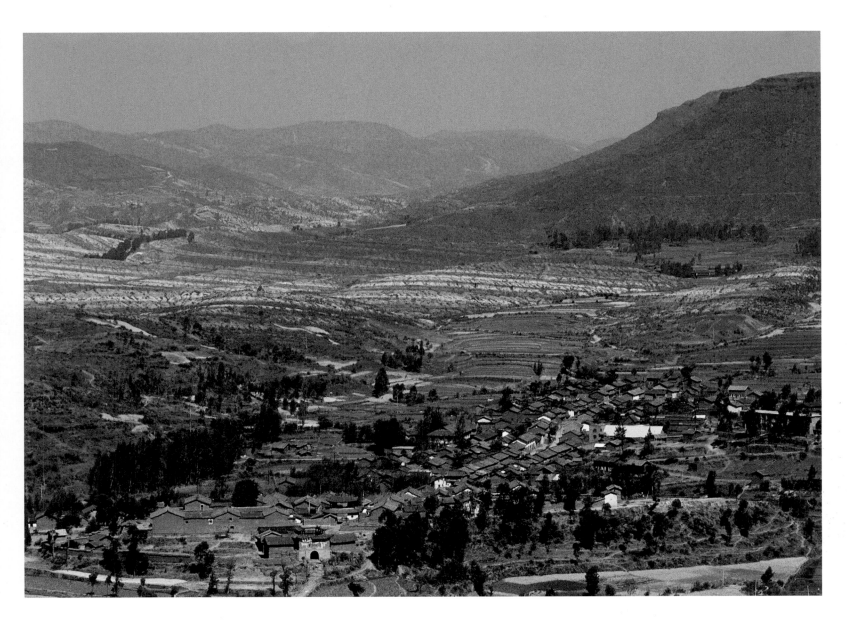

RED BASIN, NEAR LUFENG, YUNNAN

The red and white sandstones behind the walled village closely resemble those of Takena, near Lhassa. Like the latter, they are of Lower Cretaceous age and strongly folded.

FISHERMAN, LAKE INLE, BURMA

A geological extension of Yunnan, western Burma is a mountainous area called the Shan Plateau. As between Kunming and Dali, lakes fill the fairly high, isolated basins that subsist between the mountains. Lake Inle, about 3,000 feet high, where people live on the water, is the most famous example.

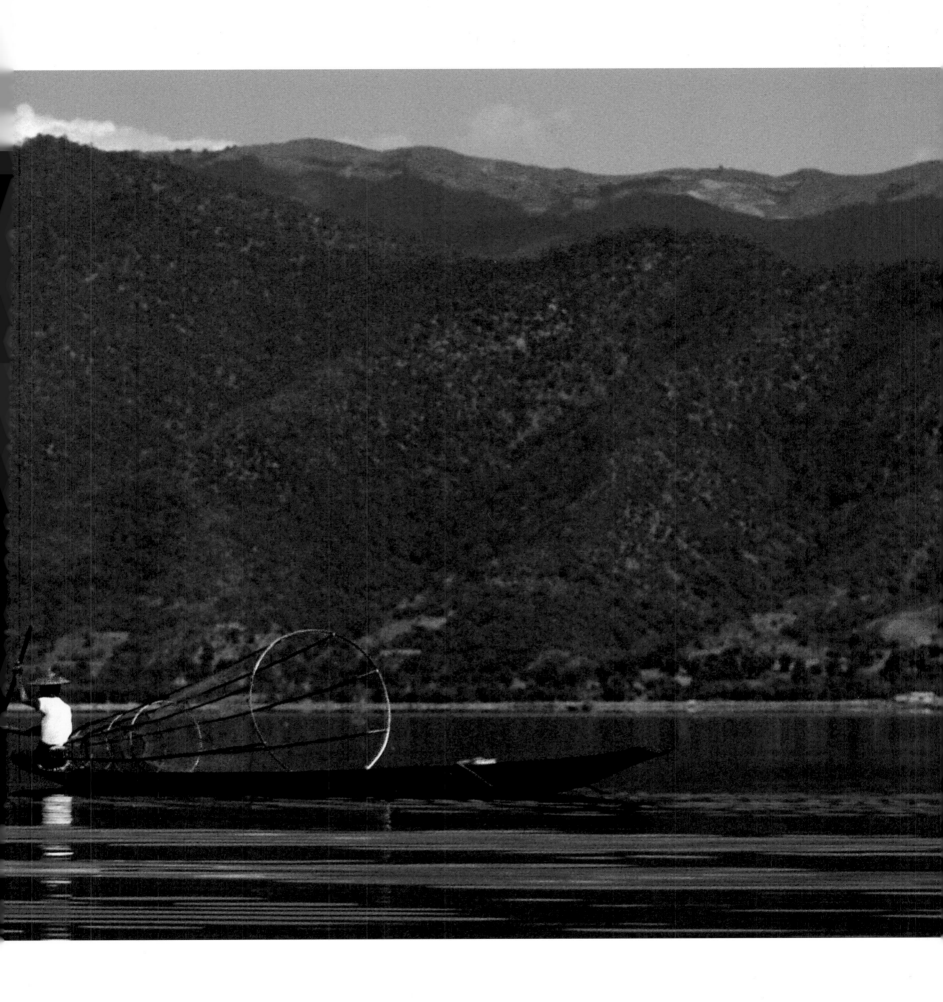

SILUSTANI, ALTIPLANO, PERU

The landscapes of the Altiplano strongly resemble
those of Tibet: sandstone, lakes, steppes, and
marshes.

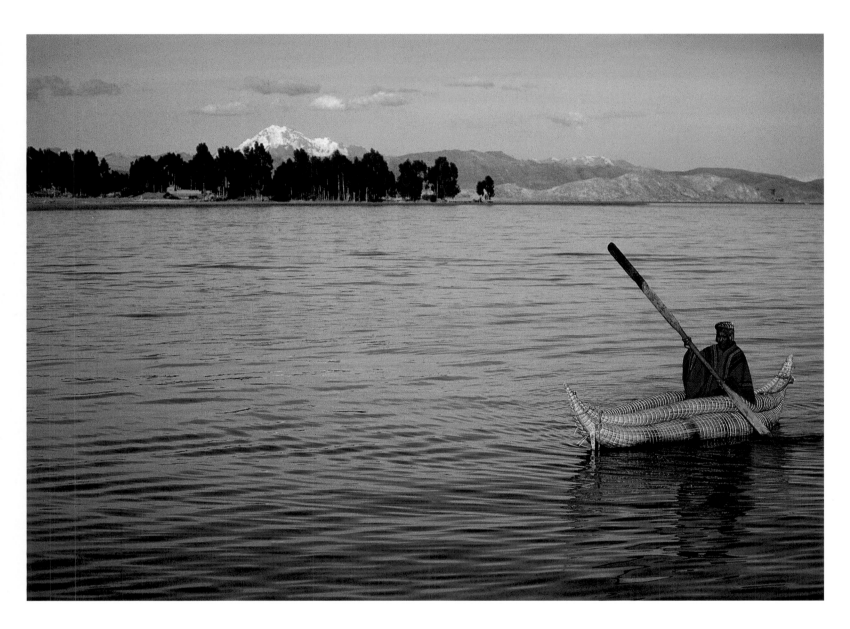

LAKE TITICACA, ALTIPLANO, BOLIVIA

Straddling the Peru-Bolivia border, Lake Titicaca is the largest high-altitude lake (3,220 square miles at an elevation of 12,505 feet). Its origin is the same as that of the Tibetan lakes: water cannot escape from the Andean Altiplano, which is ringed by Cordilleras. To the south, such inland drainage has formed Lake Poopo and the vast Coipasa and Uyuni salt marshes (salars). Towards the east or west, nothing flows out, neither to the Amazon and Paraguay, nor to the Pacific.

following pages

BALCONY ON THE ALTIPLANO, CHACALTAYA, BOLIVIA

Perilously balanced, this small cabin overlooks the escarpment that marks the edge of the Bolivian Altiplano, on the Amazonian side of the Andes.

pages 226–227

CHIMBORAZO, ECUADOR

Chimborazo, an extinct volcano, is the Ecuadorian Andes' highest summit. Like the Muztagh Ata, father of the Khirghiz nomads, it is the father, or *taita*, of the people who live at its foot. Astonishingly, its form and structure also recall Muztagh Ata. But the inclined layers of andesite that wrap its flanks have not been folded. They simply flowed and piled up on already steep slopes. The tilt observed today has been present from the start.

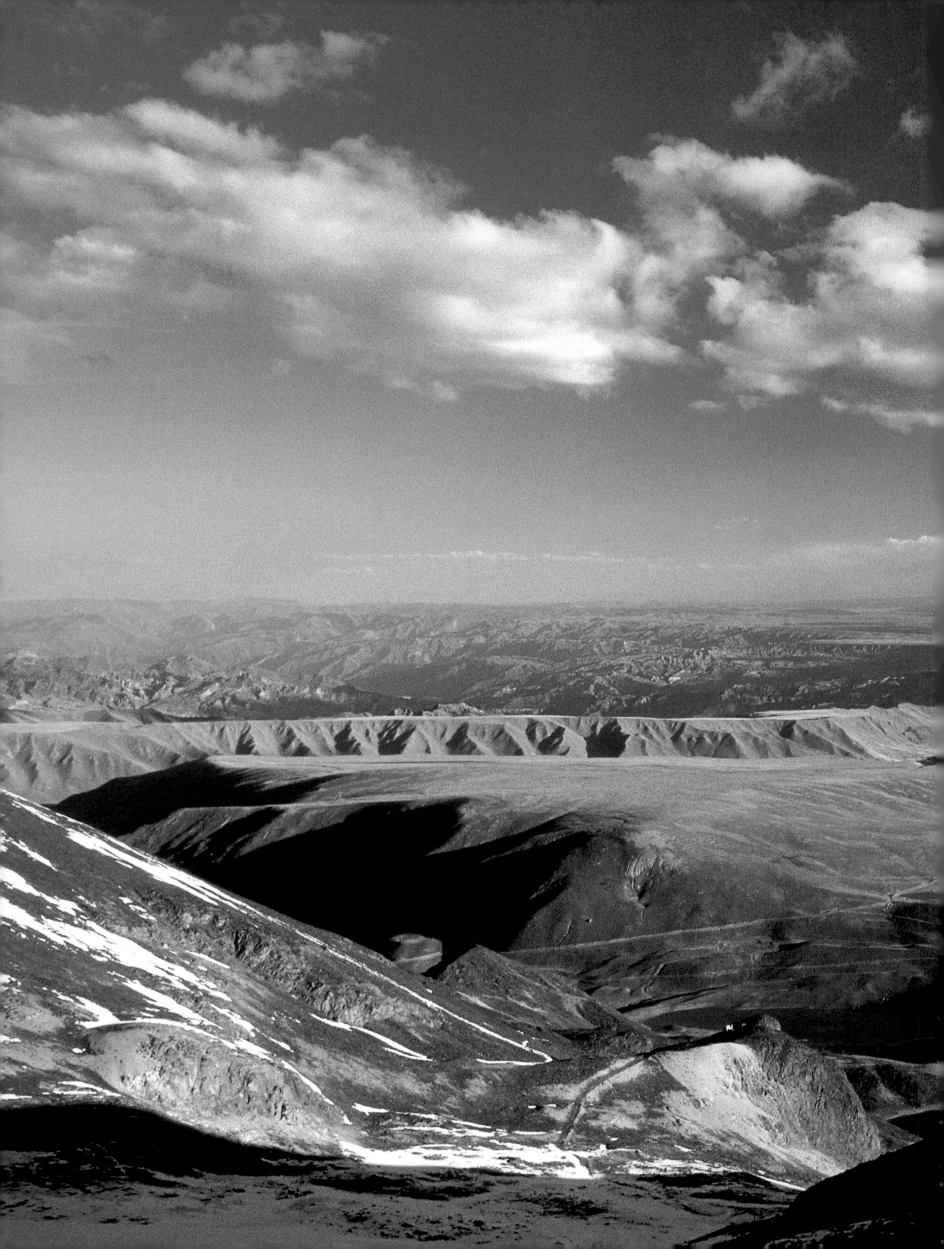

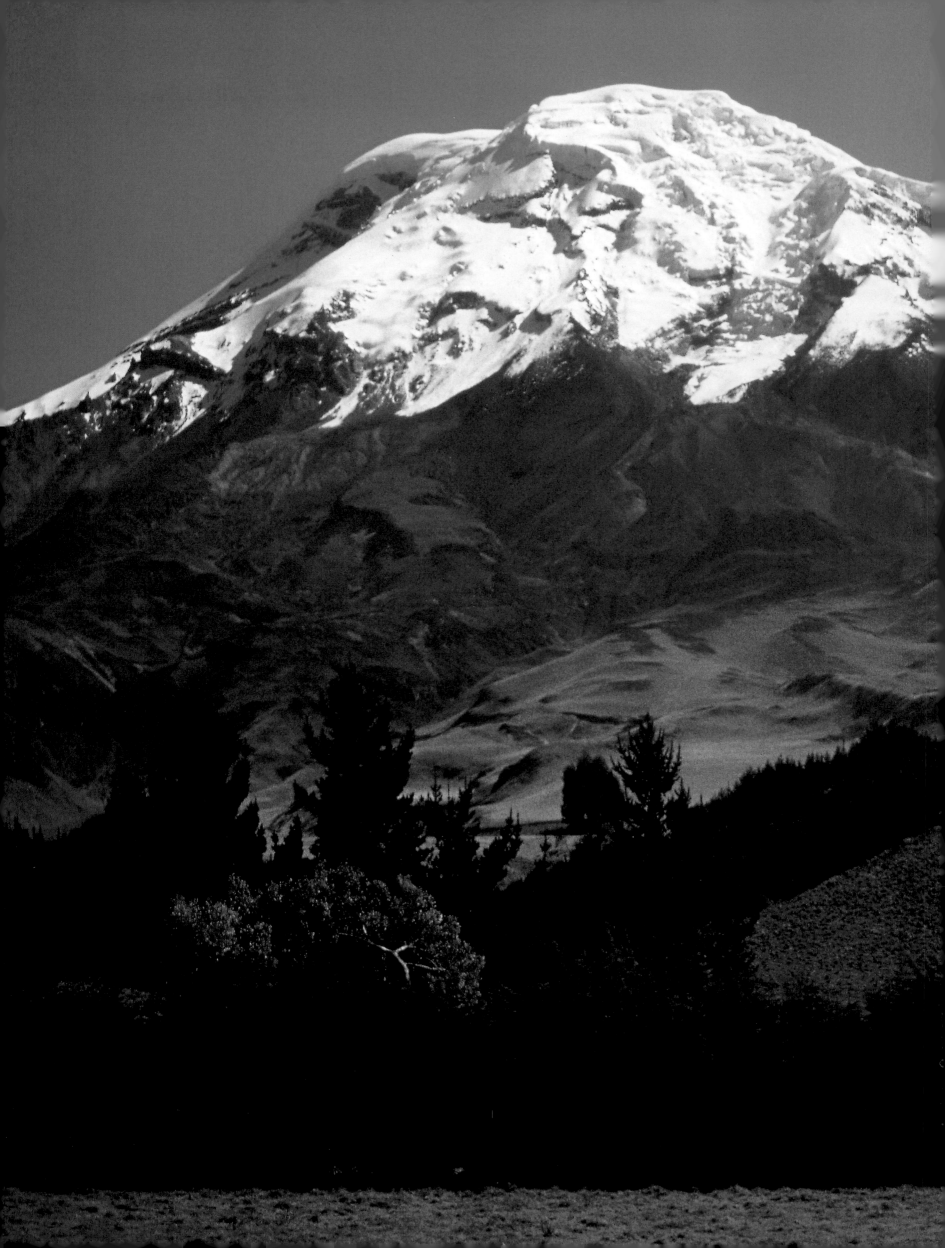

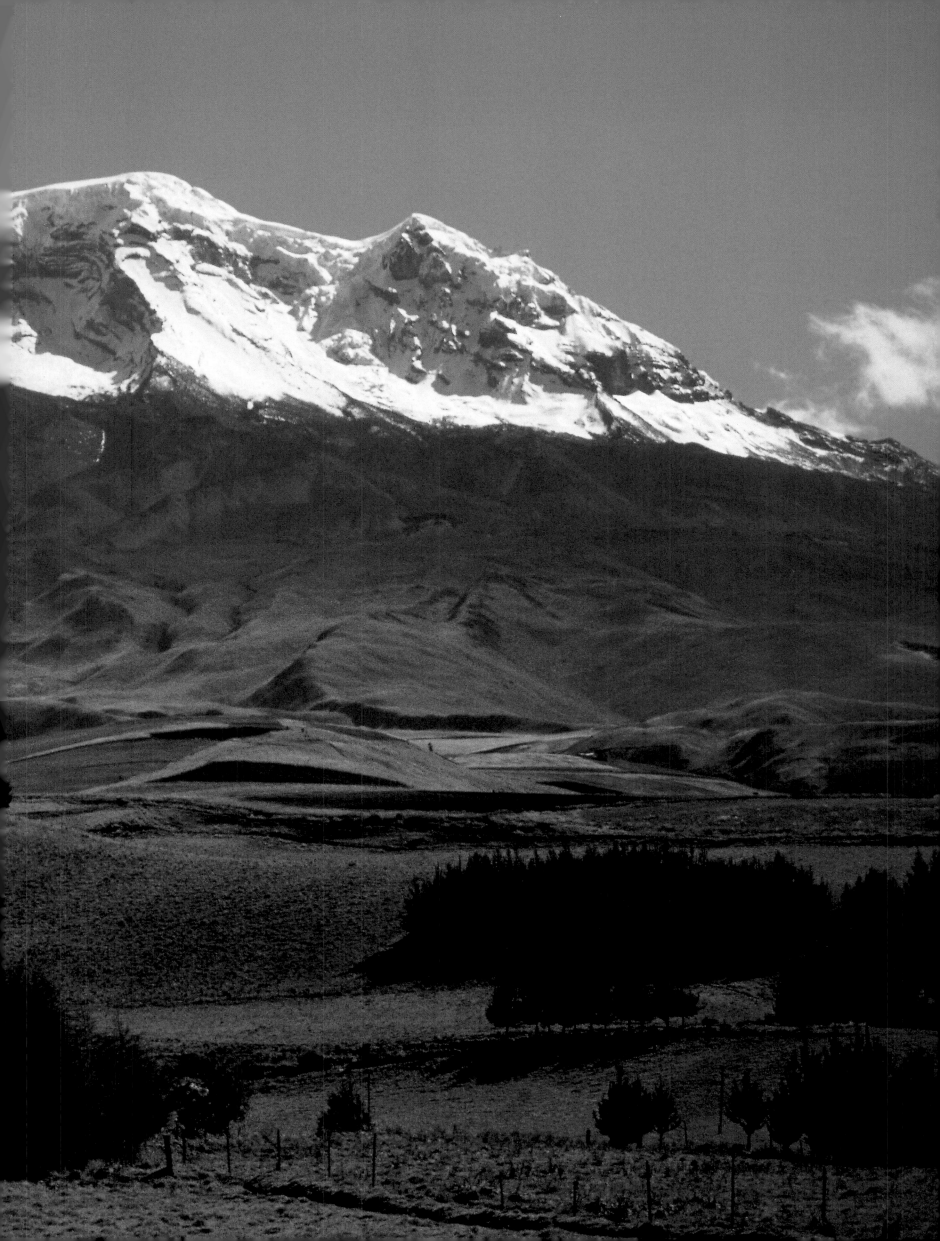

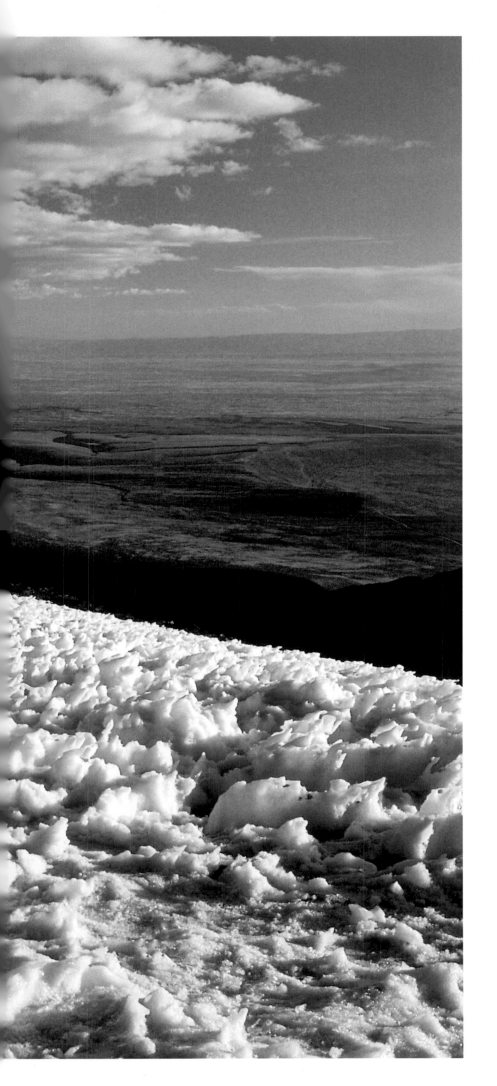

ALTIPLANO, BOLIVIA

The surfaces bathed in golden evening light, behind the snow-dusted spur are extraordinarily flat. They are approximately 12,500 feet high. The few deep canyons, already in the shade, that separate these flat surfaces, are cut by torrents that meet downstream to form the longest of Amazon's tributaries, the Rio Beni, which becomes Rio Madeira as it crosses from Bolivia into Brazil. The cliffs and cirques that bound the canyons slowly recede, devouring the flat surfaces, which give way to a chaos of crumbling ruins, or "badlands," visible in the distance on the left of the image. We look here at the abrupt, eastern edge of the Altiplano, near La Paz. Though only half as wide and about 6,500 feet lower than Tibet, the Altiplano likely formed in a comparable way: by infilling of basins dammed by cordilleras. As attested by the outstanding uniformity of its surface, flat because of depositional origin. However, its integrity is already under threat. Vanguards of regressive erosion, the Rio Beni's tributaries, passing through breaches separating the Illimani from the other peaks of Cordillera Real, are leading the attack that will ultimately destroy this high plateau, the second highest in the world.

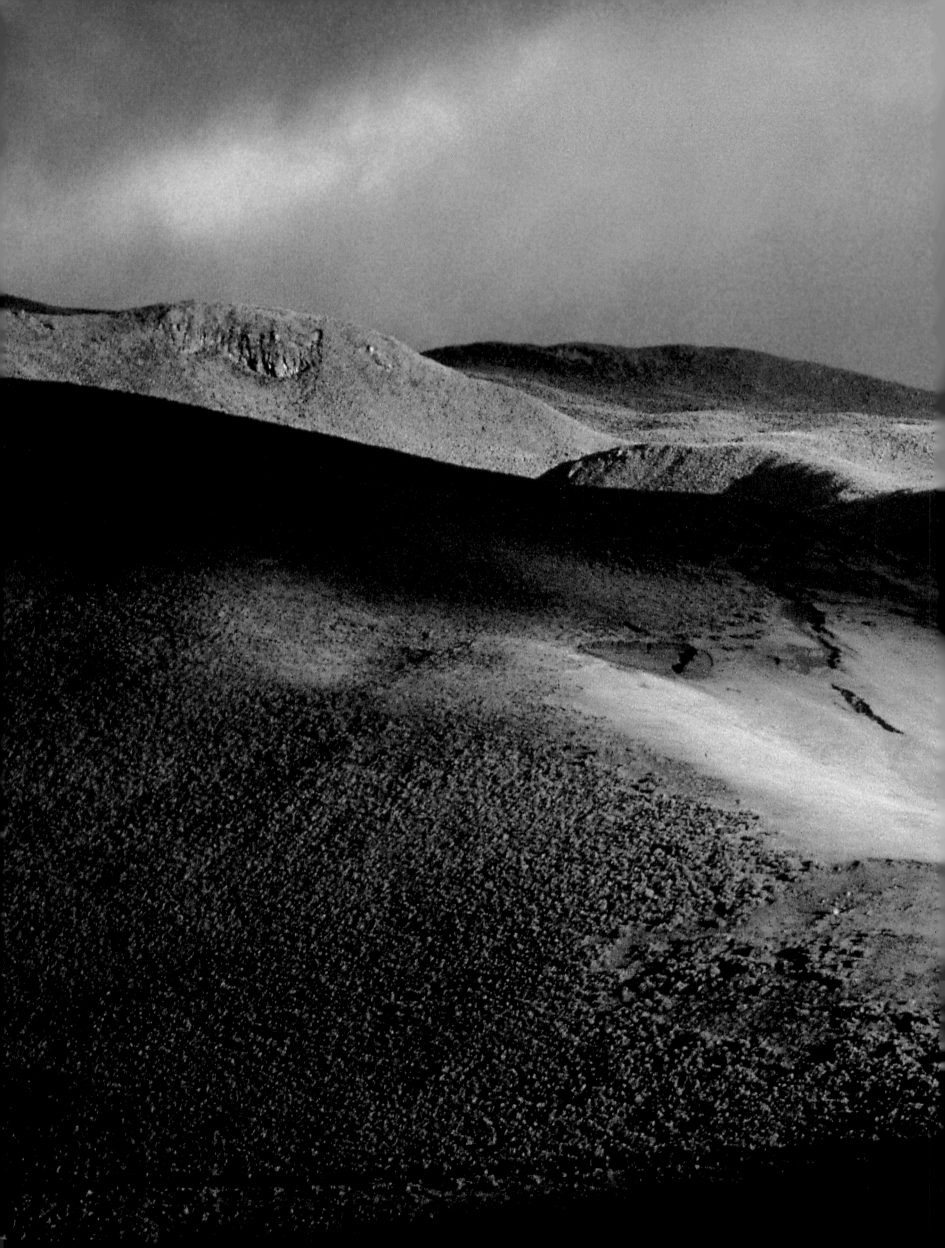

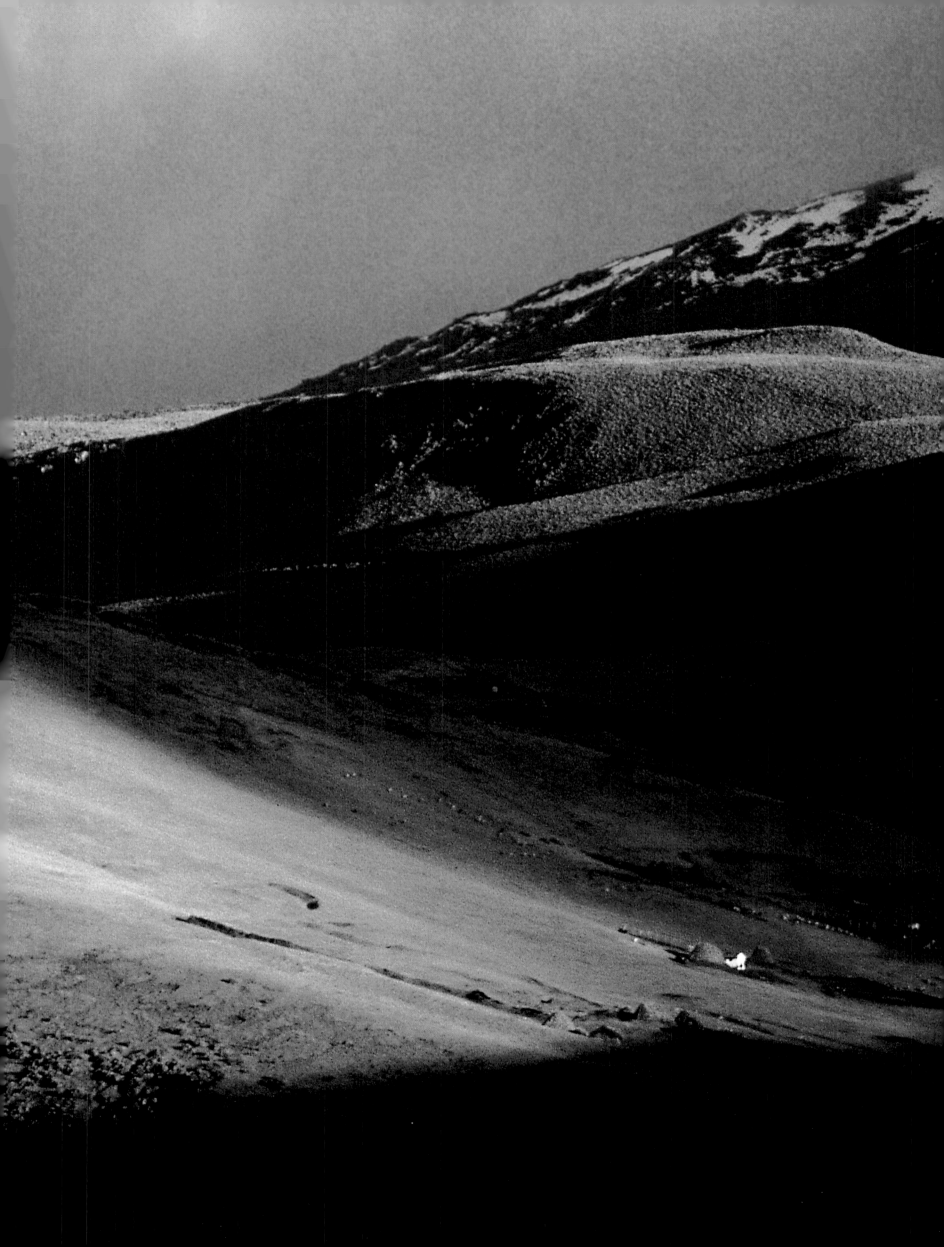

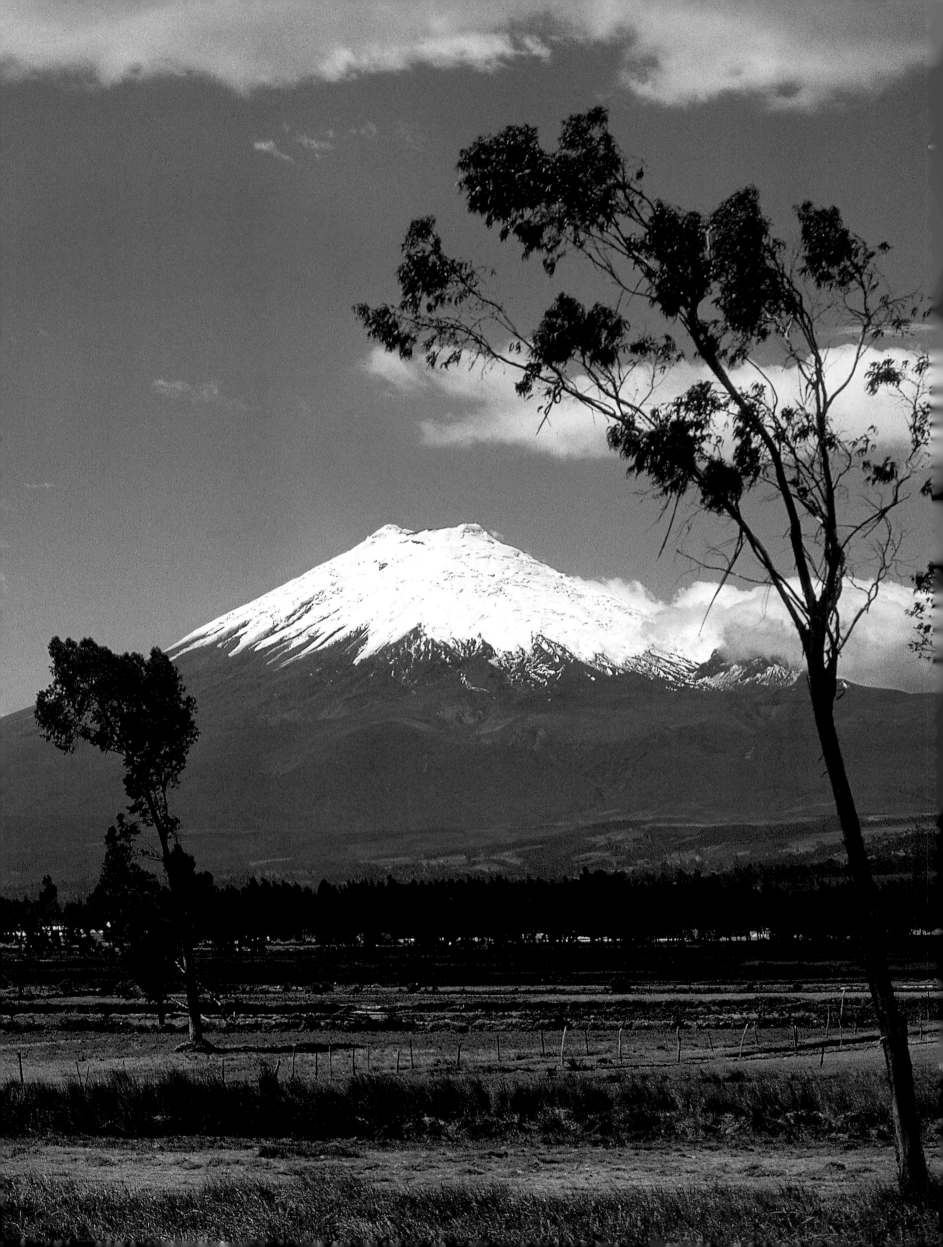

preceding pages
PÁRAMO, CHIMBORAZO, ECUADOR

A late sunbeam finds it way through the layer of clouds that enshrouds the old volcano's summit and shines on the highest pastures of Páramo.

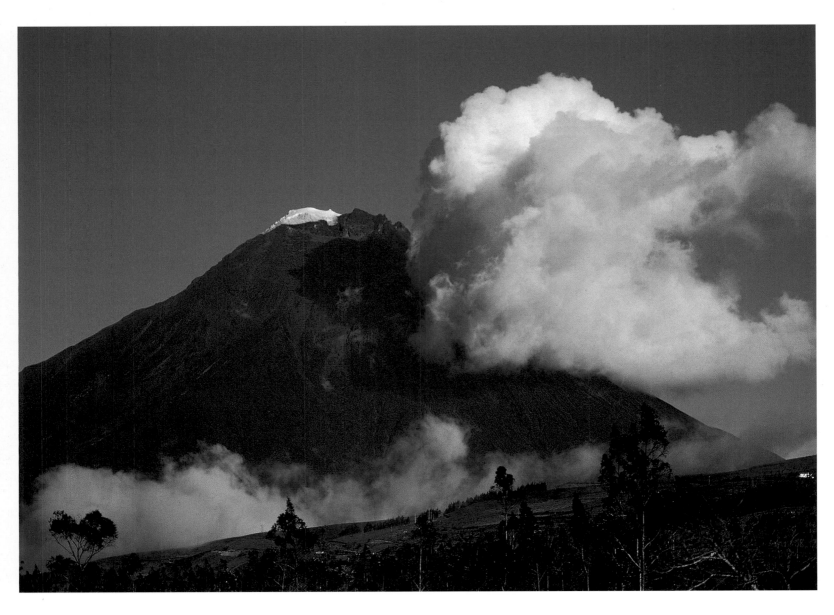

TUNGURAHUA, ECUADOR

Facing Chimborazo on the Amazonian side of the cordillera, this active volcano, whose top exceeds the 16,400-foot mark by only 52 feet, is high enough to support an ice cap on one edge of its crater. Unless it gets beheaded by a cataclysmic blast, it will grow to resemble Cotopaxi 200,000 years from now.

COTOPAXI, ECUADOR

With its ice-capped summit crater at 19,437 feet, and its perfectly conical shape, much admired by Alexander von Humboldt, the highest active volcano in Ecuador is unquestionably one of the world's most magnificent mountains.

preceding pages

CHECKERBOARD FIELDS, CHIMBORAZO, ECUADOR

The abundant rainfall, the equatorial sun, and the rich volcanic soil are all favorable conditions for the cultivation of potato, quinoa, and barley even at high altitudes.

PLOWED VOLCANIC SOILS, ECUADOR

Native to the Andes, the potato is queen of the mountain crops. There are hundreds of species, with some wild ones growing as high as 16,500 feet above sea level!

ILLINIZA, ECUADOR

Rising up out of the morning clouds, the jagged peak of the Illiniza soars to 17,267 feet. Like Chimborazo, it belongs to the western Cordillera of the "avenue of volcanoes."

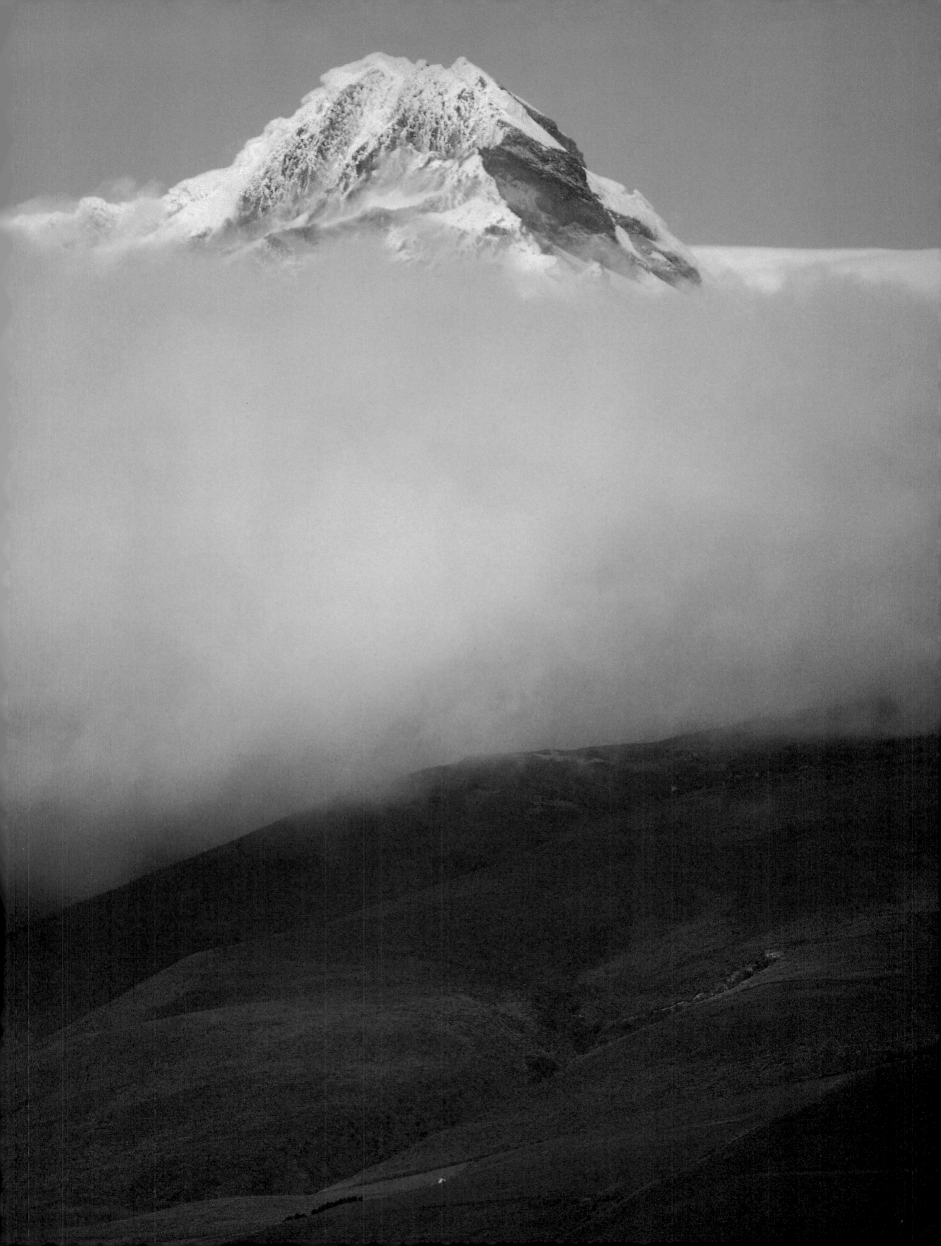

Volcanic deposits,
SARAGURO, ECUADOR

Volcanic rocks take on warm colors, especially when altered by hydrothermal fluids. In the Ecuadorian Andes, volcanoes and their products, which flood reliefs and overwhelm landscapes, yield white, orange, pink or red outcrops, and tabular ledges within valleys. Subduction volcanoes are powerful and dangerous. Unlike basalt, their acidic, silica-rich lavas flow sluggishly and freeze rapidly. Too viscous to spread out very far, in general, they merely build a dome in the summit crater: a plug that slowly swells, and whose steadily steepening flanks continuously collapse into small avalanches of incandescent debris, as relentlessly occurs, for instance, at the summit of Java's Merapi, until the dome explodes from the inevitable pressure buildup in the clogged conduit. Pyroclastic flows (emulsions of lava and gas) then surge down the slopes at more than 100 miles an hour. They can reach out to cover hills and fill valleys tens of miles away, finally freezing into rocks called ignimbrites, from the Latin for "fire-rain rocks," whose splintery structure is the tell-tale sign of a violent origin. Many of the pink tuffs that cover "false" subduction-zone mountains are ignimbrites.

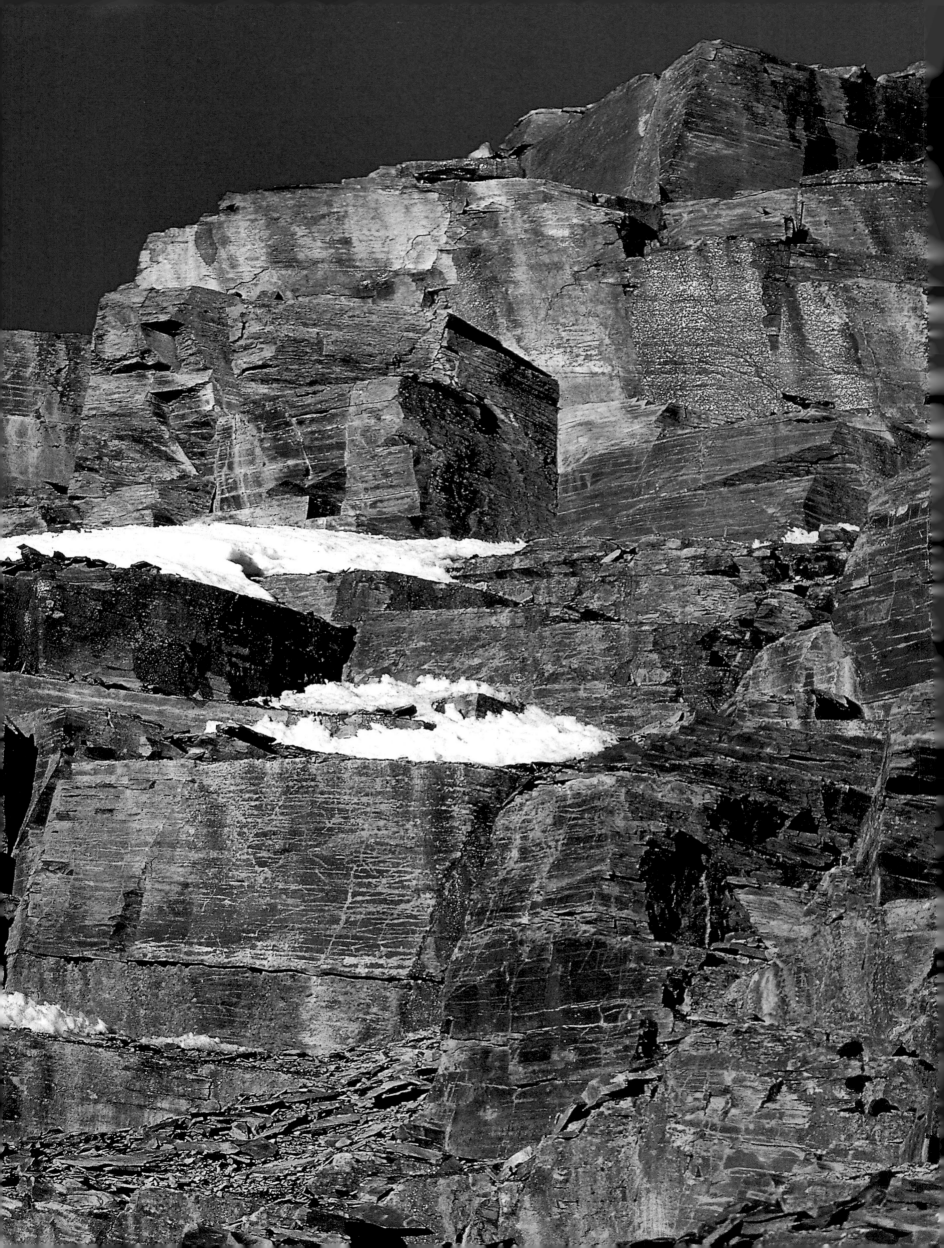

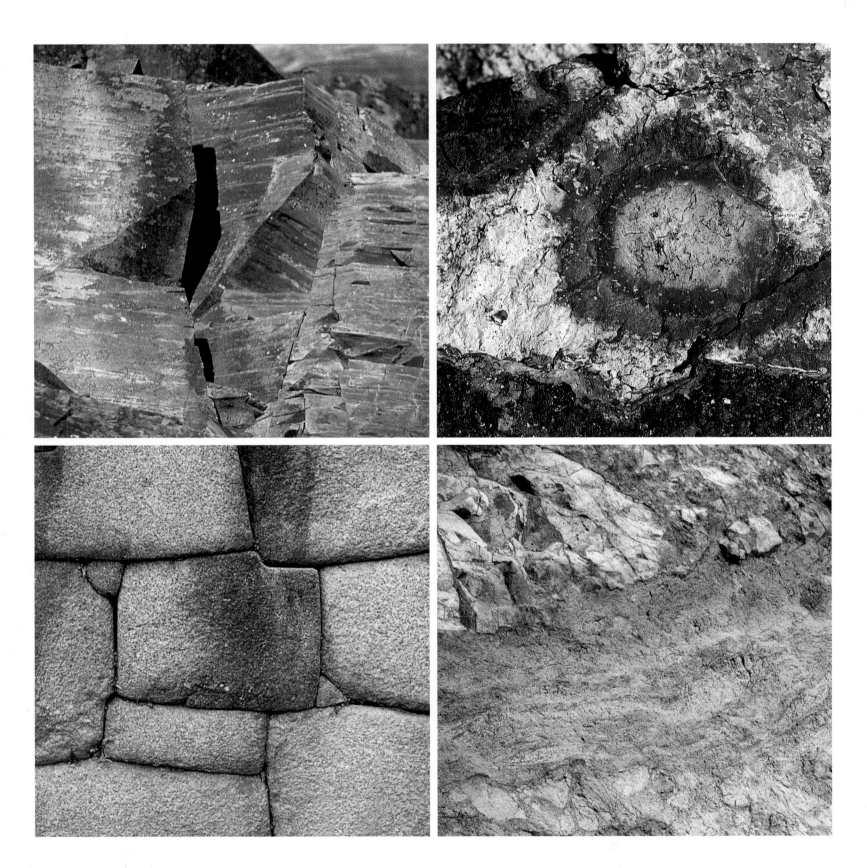

IGNIMBRITES, BOLIVIA
Welded at high
temperature, ignimbrites,
which solidify from rapid
cooling of an emulsion of
drops of silica-rich lava,
are very hard rocks that
form vertical cliffs,
naturally cut into
dihedrons or prisms.

clockwise from top left
ANDEAN ROCKS

Welded ignimbrite, Bolivia.

Oxidation rings in volcanic tuff, Ecuador.

Ash-fall tuffs rich in copper, Ecuador.

Earthquake-proof assemblage of granite blocks,
Saxahuaman, Peru.

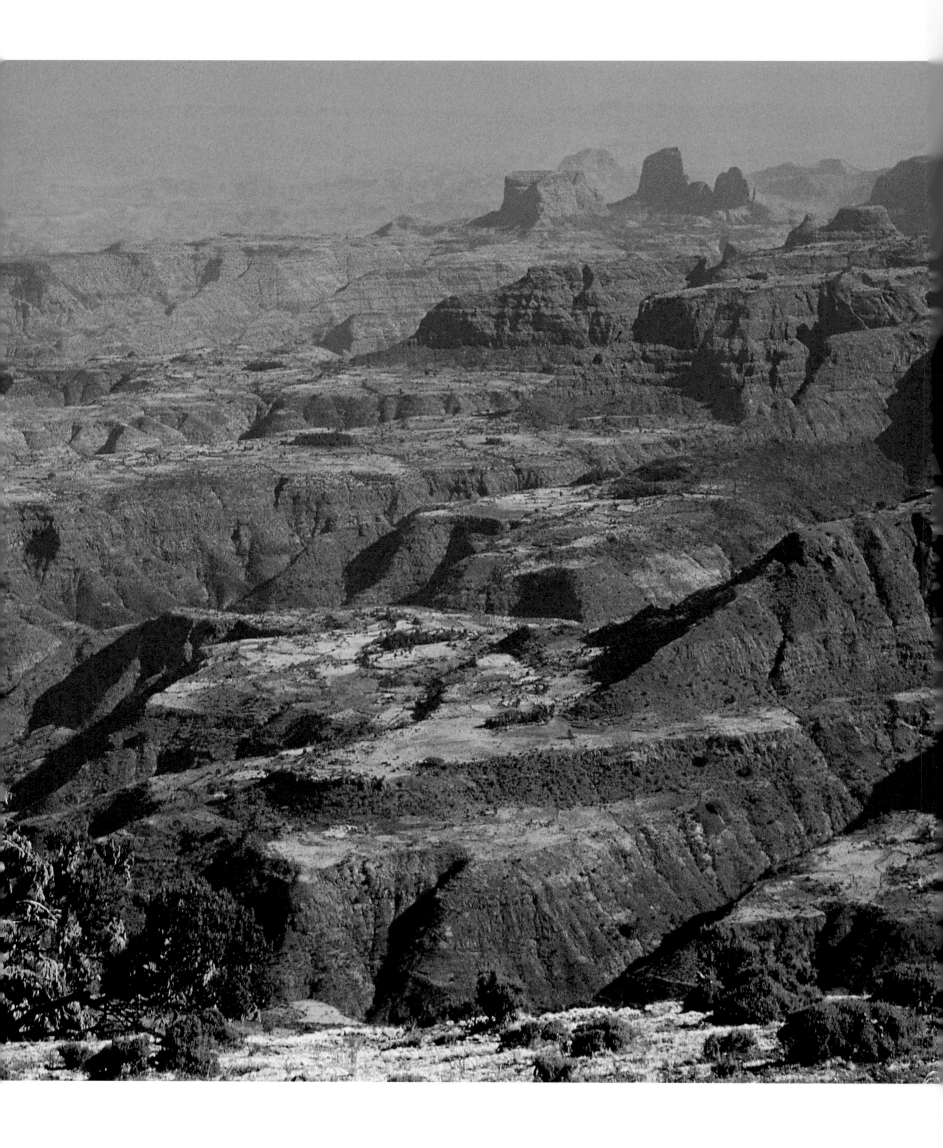

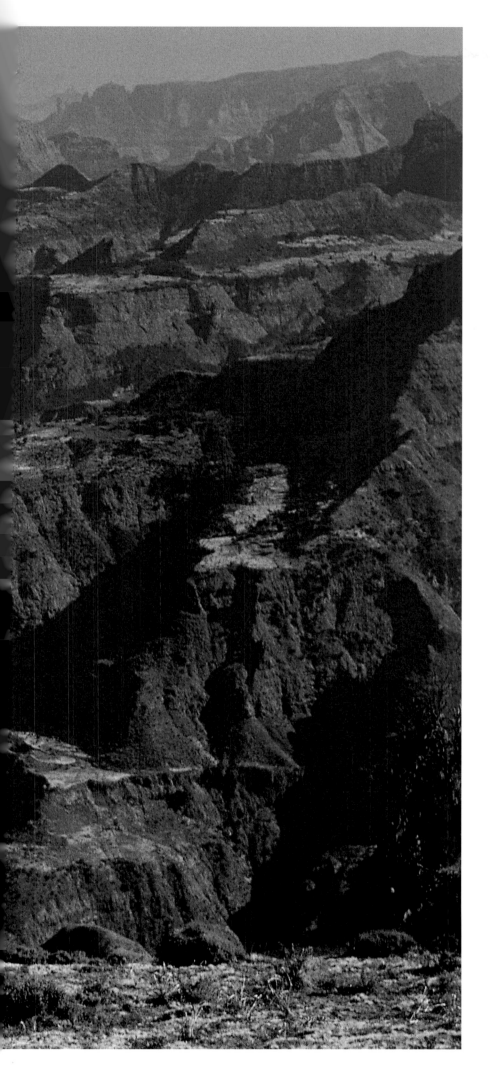

SEMIEN, ETHIOPIA

From the summit of Lima Limo's steep cliff, we contemplate the northwest side of the Semien, Roof of Africa, which rises above 15,100 feet. A massive basaltic pile, the Ethiopian high-plateau is a typical example of a "false" mountain. Yet, it is a landscape of vertical cliffs, precipitous escarpments, vertiginous slopes, and acute pinnacles. This equatorial mountain massif, abundantly watered during two rainy seasons, feeds one of the two Niles: the Blue. Born of equatorial rainfall, the Nile flood is so powerful that it crosses 1,500 miles of desert before fertilizing Lower Egypt. A yearly providential flood, now tamed by large dams, it was worshipped for millennia because of the mystery of its origin. It is at the edges of the plateau that the reliefs are most reminiscent of Dante's inferno. To the east, next to the large faults along which the Semien vault's keystone collapsed to create the Afar Depression and the Red Sea Rift. And to the west, along the edges of the ramified notches incised by the Nile and its tributaries. At Lima Limo, this natural dissection exposes the stairs—*traps*—formed by a succession of basalt flows emplaced in record time: thousands of meters in just one million years. This colossal eruption was generated by the impact on the base of the lithosphere of a "jet" or plume of hot mantle, rising from Earth's core/mantle boundary, about 1,800 miles below the surface.

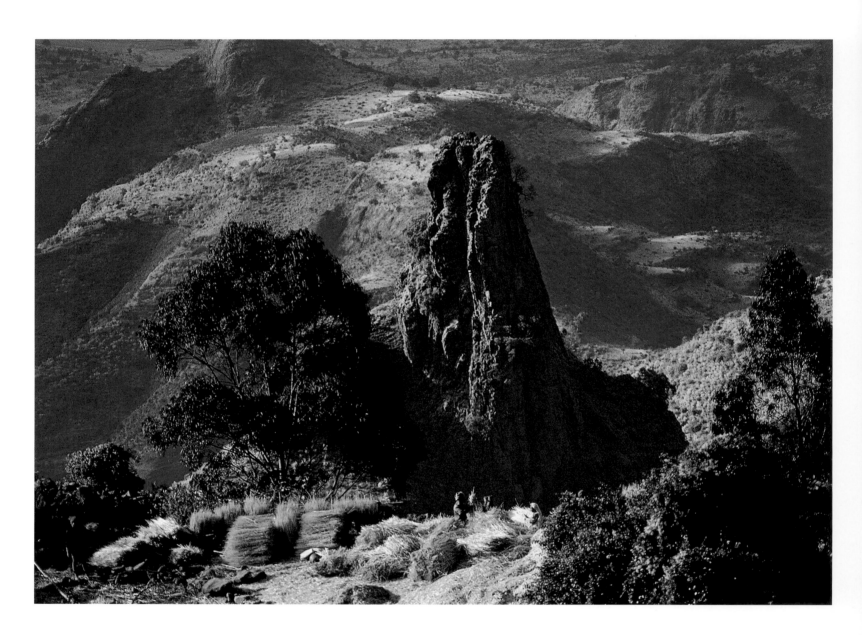

BASALT PINNACLE, ETHIOPIA

Vertical "pillars," isolated by erosion, punctuate the monotonous flatness of the Ethiopian basalt pile. These "necks" of frozen lava are the chimneys that once fed the flows.

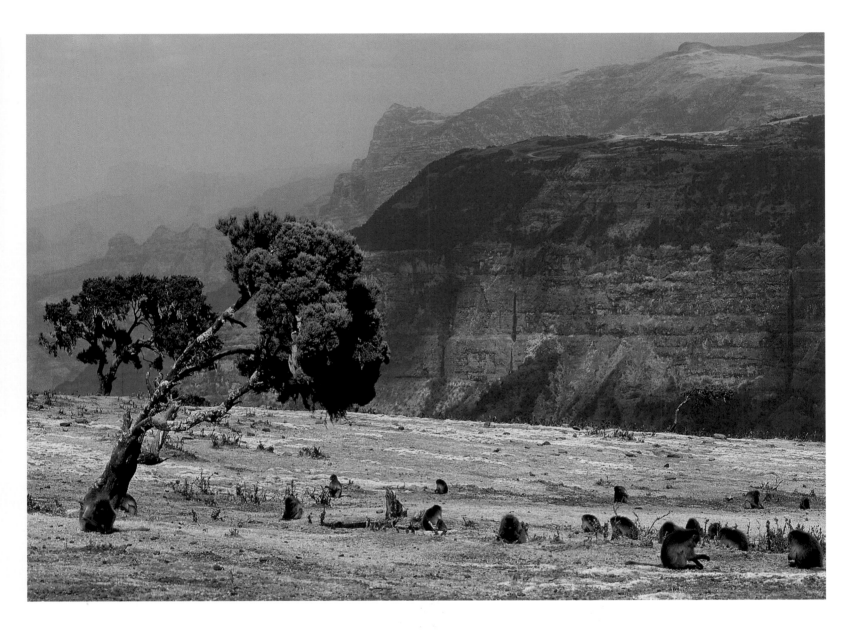

GELADA BABOONS, LIMA LIMO, ETHIOPIA

With their thick fur, the Gelada baboons can withstand the frigid cold that one finds above 10,000 feet, even near the equator. The summit of the Semien escarpment is one of their favorite refuges.

following pages

INTRUSIONS, NEAR KASSALA, SUDAN

Erosion has stripped bare these columns and domes of subvolcanic granite, intruded where the Ethiopian hotspot swell meets with the Red Sea Rift. We literally see them rise in the crust, like the heads of large "bubbles" of molten rock, frozen while in full ascent: an upward rise driven by their hot temperature, and consequently, their relative lightness.

GIANT CHIMNEY, SEMIEN, ETHIOPIA

The diameter of this basaltic neck, though already split in two, gives an idea of the fantastic volume of hot, liquid basalt (2000°F) belched out during the eruptive paroxysm.

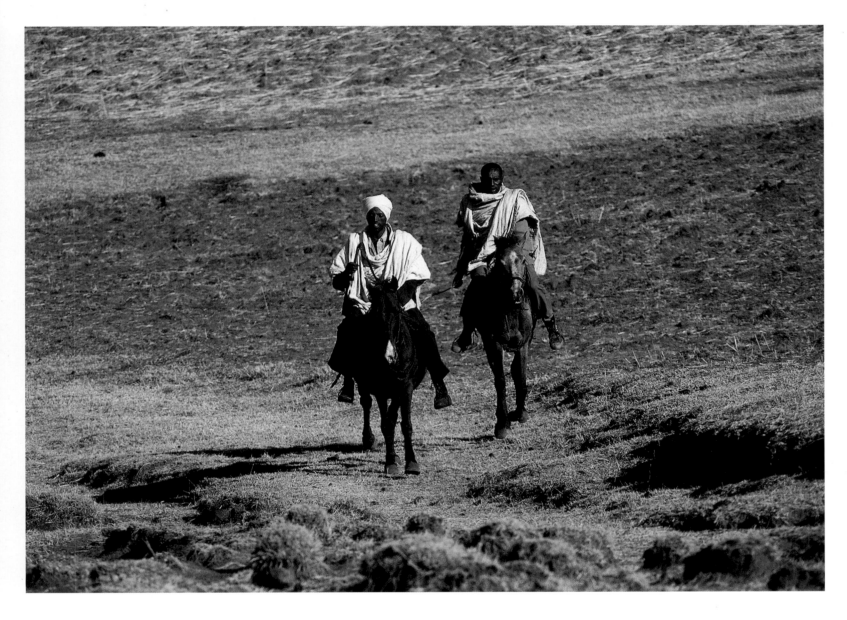

HORSEMEN, SEMIEN PLATEAU, ETHIOPIA

As in all the world's steppes, the horse is the fastest and best-adapted mode of transport.

following pages

BASALT PLATEAU, ETHIOPIA

Fertile flats are rare in the high cliffs bordering the Semien Mountains on the Sudan side. This one marks a volcanic pause, a period of calm that was long enough for weathering to generate soil, before the relentless eruptive outpour, which rapidly built the uniform pile of basalt flows visible in the background, resumed.

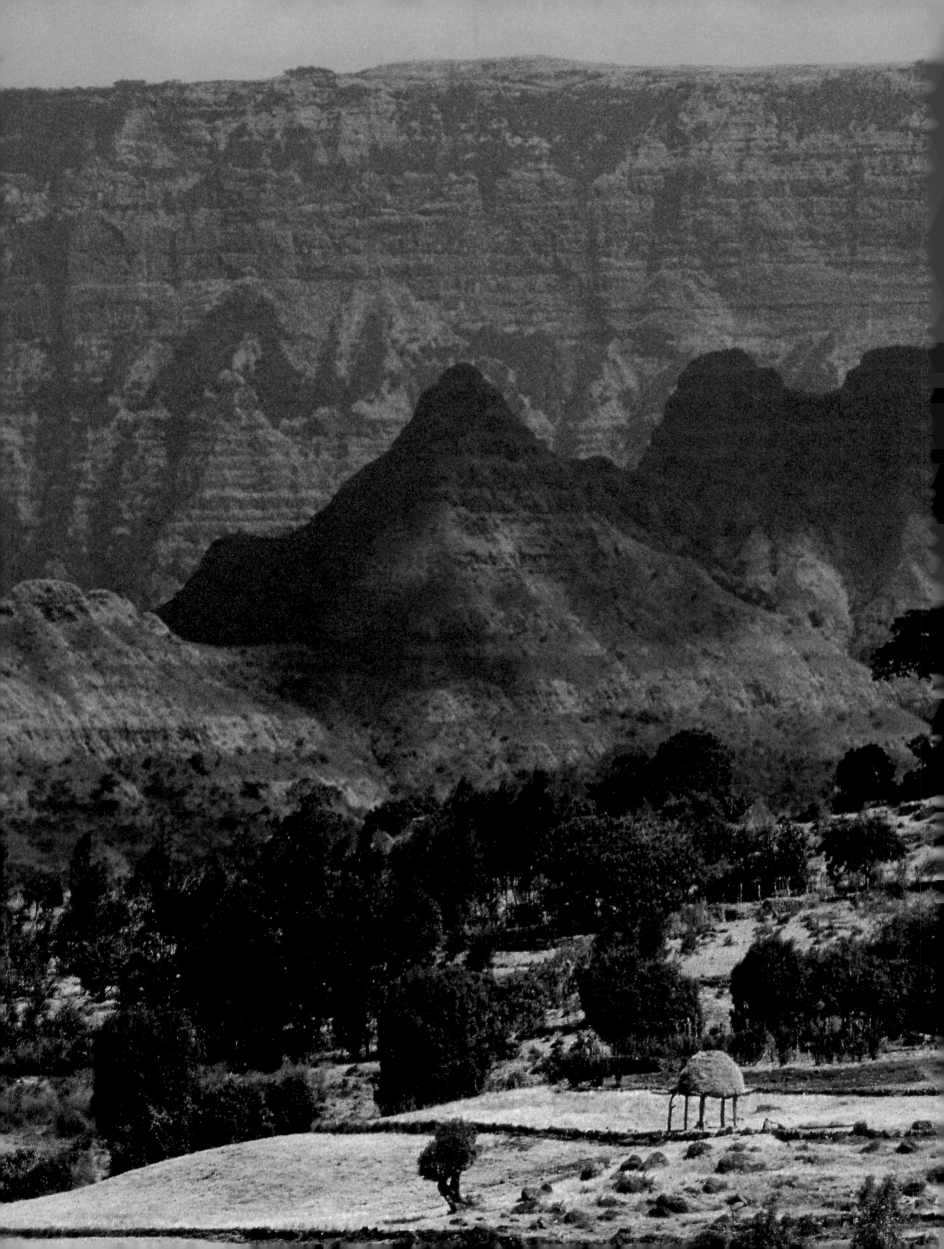

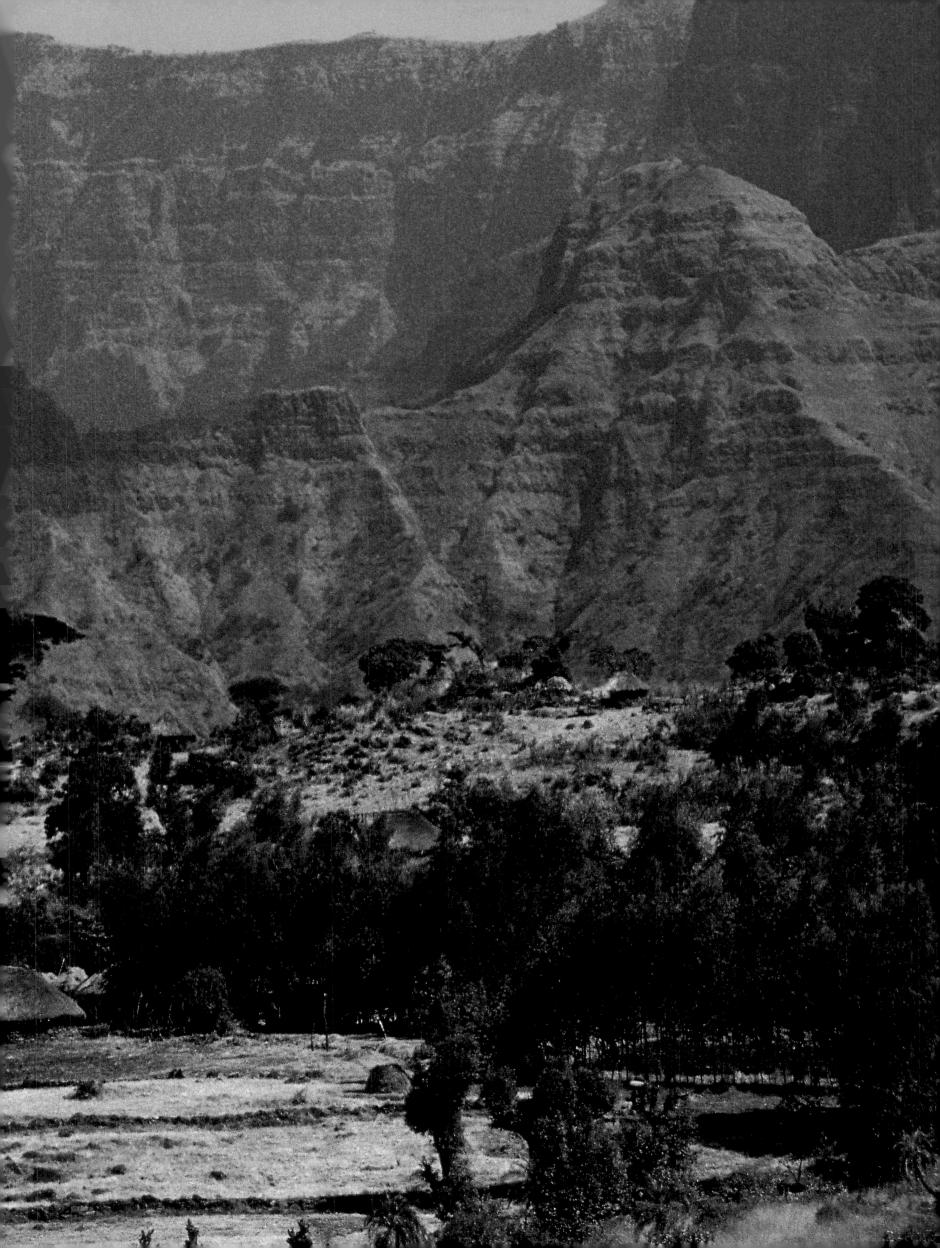

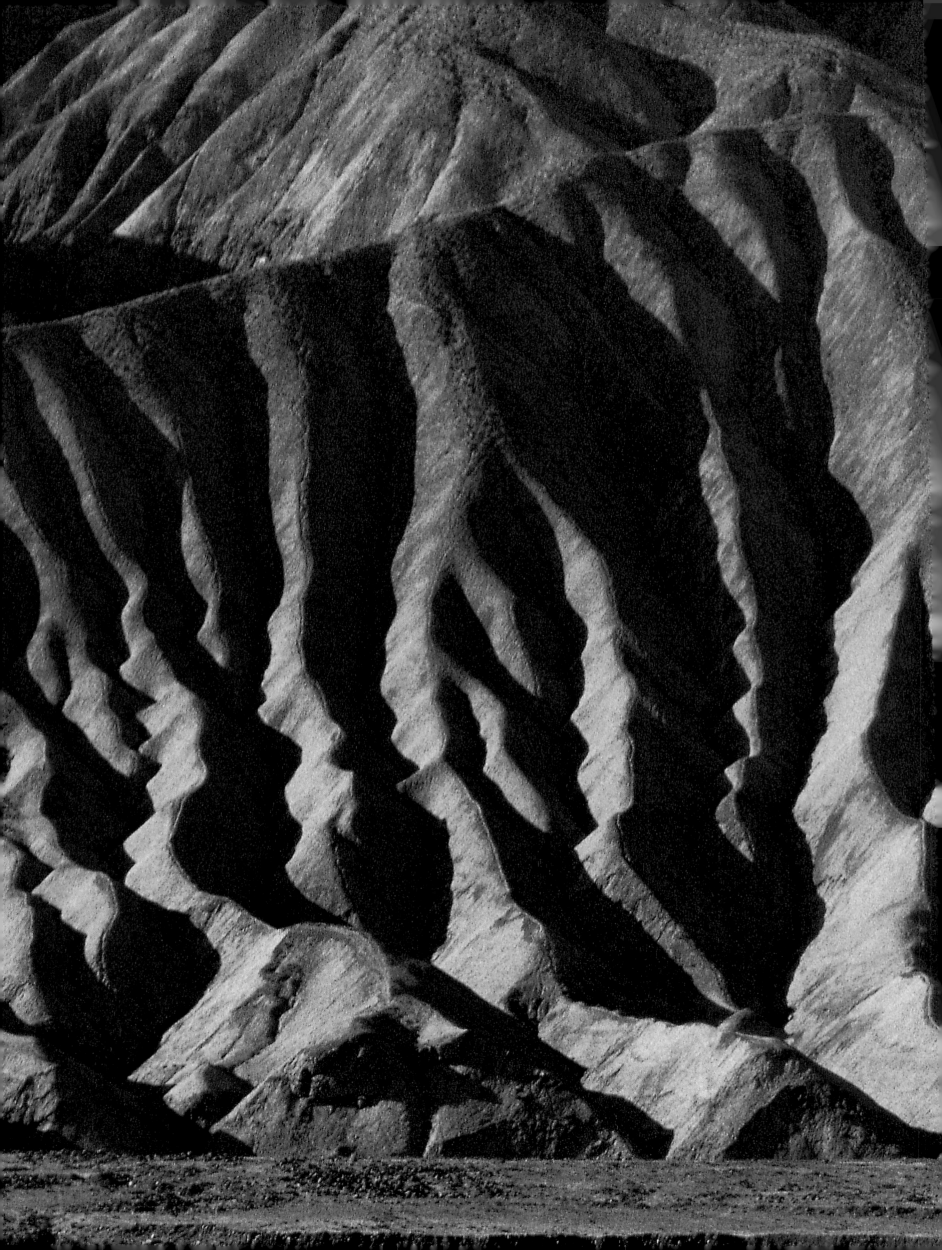

THE DEATH
OF
MOUNTAINS

THE TWO DEATHS OF MOUNTAINS

EVERY MOUNTAIN EVENTUALLY DIES. In the end, all that remains of their proud summits are the folded and tortured metamorphic rocks found beneath the timeworn flatness of the peneplains. These are the very rocks whose richly complex structures lured generations of eminent geologists into thinking that in earlier times the earth's upheavals and reliefs were much more spectacular than they are today. A lack of understanding enabled this idea to endure, feeding relentless controversies among different schools from the seventeenth to the twentieth century.

This mistaken view of "spectacular" paleotectonics and "uneventful" neotectonics has been hard to shake. It became almost a dogma, for instance, within some Russian circles, among others. Even well after the plate tectonic revolution, we've had to fight tooth and nail to combat this stubborn idea. To some of our Chinese colleagues, this way of thinking was almost self-evident, since Confucius and the primacy of ancestors are still held in great esteem. This has resulted in a remarkable paradox: in the country that possesses the greatest number of active faults and the majority of young mountains, most of the geologists prefer to focus their study on the oldest and deepest rocks—the most "noble" in the sense derived from the veneration of ancestors. With one notable exception, however: the small group of geologists to whom Mao Zedong assigned the task of predicting earthquakes in the aftermath of the 7.0- to 7.5-magnitude shocks, which in 1966 devastated the populated region of Xingtai, south of Beijing.

We know now that tectonic upheavals in ancient times were not more vigorous than those of today. This is because we have taken advantage of being able to observe, measure, and understand present-day "action," rather than speculate about frozen structures entombed in peneplains.

How, then, do mountains die? They face two possible ends, each reflecting the power of the two forces that destroy reliefs. The first is gravity and the second, a derivative of the first, erosion—an internal degeneration, and an external decline.

THE SLOW DISINTEGRATION OF LARGE MOUNTAINS

A mountain that grows too high can theoretically reach a point where it ends up crumbling under its own weight. As in the case of the cyclist starting his descent, stored gravitational energy can generate driving forces. Such forces will cause summits to fall and mountains' roots to rise. However, the potential energy can only be consumed if the mountain loses its internal rigidity. This happens when the thickened crust heats up and, as a result, softens. The mountain's "skeleton" is then no longer able to maintain its structural integrity. Gravity—the supreme regulator—immediately exploits this weakness. Everything sags and stretches. The relief is dismembered and flattened, a bit like a huge iceberg that, in breaking up, gives birth to a floating expanse of small ice rafts. "Normal" faulting at the surface and ductile flow of the deep crust preside over the relief's disintegration. The malleable crust flattens because it is squeezed, as if in a vice, between the weight of the mountain pushing down and the buoyancy of its root pushing it up, due to Archimedes' force.

Normal faults and thrust faults slip in opposite directions. The former cause horizontal extension while the latter cause the horizontal shortening that drives the uplift of mountain ranges. Though found on high plateaus and at the top of some mountains, normal faults mostly bound grabens and rifts—structures that characterize places where plates pull apart from each other.

This kind of degeneration by flattening is often referred to as "orogenic collapse." A wave of enthusiasm triggered by the discovery of normal faults at altitudes over 13,000 feet—mainly north of the Himalayas and in the central Andes—led many geologists to think that orogenic collapse was a widespread mechanism and the ultimate fate of all mountains. Some even went as far as to proclaim that mountain ranges averaging barely 5,000 feet high, such as the Italian Apennines, were collapsing.

In fact, it is a rather rare phenomenon, mostly restricted to very broad, high plateaus. For instance, there are numerous young, active normal faults cutting across the surface of the Tibetan plateau and the Andean altiplano. This is proof that both are currently stretching, but the deformation is small. There has been at most 2 to 3 percent of east–west extension across all of southern Tibet in the last 4 million years, resulting in eight small half-graben troughs—half because they are more often bounded by only one normal fault instead of two. Some make it easier to cross the Himalayas—the Thakkola graben, for example, a deep valley that cuts across the range in the ancient kingdom of Mustang. On the whole, South Tibet, which is 1,000 miles across, has been stretched by no more than 30 miles in a direction more or less perpendicular to the movement of the Indian plate. It is of course tempting to think that the "roof of the world" is now starting to crumble and collapse, punished for having challenged almighty gravity by exceeding the limit of altitude by too much and for too long. However, no one has yet been able to measure the least reduction in altitude or a thinning of the crust.

The same cannot be said of the Basin and Range (Great Basin) between the Colorado plateau and the Sierra Nevada. This geological region, which includes the Rocky Mountains, is approximately 500 miles wide and can be interpreted as an ancient Tibet. The area, as its name indicates, displays an alternating pattern of elongated basins and parallel mountain ranges, 12 to 18 miles wide and roughly oriented north–south. The basins are grabens, bounded by still-active normal faults, whose floors are entrenched 6,000 feet below the ranges that separate them. Lots of extension then. What's more, there has been widespread volcanism—proof of heat—and today, the crust has returned to almost normal thickness. In short, nearly all the evidence points to a plateau originally twice as high, half as wide, and with a crust twice as thick, that would have started collapsing tens of millions of years ago. It is thus possible that high plateaus are indeed condemned to die of this fatal condition. This is because large orogens, which tend to resist erosion, are more likely to warm up. They store their heat better than narrow ranges. Not unlike large animals, compared to skinny ones who are always cold.

The rocks of the continental crust are particularly rich in minerals containing radioactive elements (uranium, thorium, potassium, to name a few). Given that natural radioactivity is one of the main sources of terrestrial heat, the continents are good heat generators. Since this heat production is proportional to volume (i.e., to the cube of the length) and the loss of heat is proportional to the surface of heat exchange (i.e., to the square of the length), a large volume of thickened continental crust generates an excess of heat it cannot proportionately dissipate. Thus, the crust warms up. A similar hypothesis was proposed to account for the gigantic size of certain dinosaurs. A cold-blooded animal is better off the larger it is. Today, paleontologists tend to think that most dinosaurs, already warm-blooded, had no need for this stratagem. In any case, Tibet is warming up. Geysers and hot springs abound. So the crust must be softening to the point where the plateau has probably started to lose a little of its stature.

WEAR AND TEAR: THE INESCAPABLE FATE

The most common mountain death is also the least disputed. They succumb quite simply to the external force of erosion. Erosion wears down the relief's surface by abrasion: the higher the mountain, the greater the rate of erosion. The faster it rises, the faster it erodes.

At the summits, ice is the first to grind even the most resistant granites, with the efficiency of a giant sheet of sandpaper. With comparable efficiency, it transports huge rock masses down the slopes. Observe the polished surfaces of the Muztagh and Kongur domes and the creeping cataracts of ice that sculpt its 3,000-foot-high cliffs. Consider the chiseled narrow crests, or nunataks, and pointed pinnacles that alone have survived on some of Karakoram's highest summits, because they were the only relief to protrude above the huge ice caps that covered the range during the last glacial maxima, 20,000 and 40,000 years ago. Contemplate the large U-shaped Hunza and Shyok valleys, which were carved then by blue-ice glaciers 3,000 to 6,000 feet thick, later filled with hundreds of feet of gray, coarse alluvium deposited by rushing meltwaters from the fast-retreating glaciers, and finally incised by the present-day rivers. Notice the giant boulders abandoned in isolation and tilted precariously, or the chaotic, impassable heaps of barren debris—either once transported at the surface of the glaciers, or dragged along their edges as lateral and frontal moraines. Even in the mountains of Europe, now car-

peted with forests and meadows, the destructive power of the ice that once capped the summits remains visible. It was only 15,000 years ago. The primary witnesses are the large lakes, distributed along the northern and southern foothills of the Alps, dammed at the time by enormous frontal moraines. These moraines are the ridges, up to 1,000 feet tall, that overlook today the Po River plain south of Lake Garda, or at the mouth of the Aosta valley, for instance. And of course, there are also the Scottish lochs and Scandinavian fjords, dug deep into the ancient Caledonide mountains.

Downstream from the glaciers, water and the debris that it transports sculpt the relief with renewed ardor. Rivers carry rocks, transforming them into gravels, then sand, and finally mud, all the way to the ocean. For instance, around Nanga Parbat, where the western Himalayas make a hairpin turn—a syntaxis—the Indus, which hasn't yet smoothed out its profile and is still punctuated with waterfalls, incises the garnet peridotites of the Asian mantle on one side of the suture and the gneisses of the Indian crust on the other, at a rate of one centimeter per year. That's more than 30,000 feet of eroded rock per million years! At the opposite end of the Himalayas—the eastern syntaxis—where similar cataracts were recently rediscovered (they were first identified over 50 years ago by botanist-explorer Kingdon Ward and then forgotten), the Yarlung Zangbo (Brahmaputra) cuts with the same force around the Namche Barwa. This is because, even at the ends of the Himalayas—the only points where its two largest rivers stand a chance of crossing it, the world's highest mountain range rises about one centimeter each year, a dizzying rate in geological terms.

Erosion attacks the higher reliefs with greater force because they attract precipitation. The monsoonal rains, for instance, turn Asia's highest mountains into the planet's most plentiful natural water reservoir. Up to 40 feet of rain can fall on the Assam hills in the summer! The Karakoram feeds the world's longest mountain glaciers and, although far away from the poles, Tibet still harbors significant ice caps. More than 15 large rivers are born there: the Indus, the Ganges, and Brahmaputra, near Kailas; the Mekong, the Salween, the Irrawady, the Red River, and the Yangtze drain the east and the southeast of Tibet. The latter is so long, the third longest river in the world, that it changes names three times. Jinsha Jiang, or "River of Golden Sands" in Sichuan, it then becomes Chang Jiang, or "Great River," and finally Yangtze, near Shanghai. As

for the Yellow River, the quantity of mud it discharges into the Yellow Sea matches that of the Amazon into the Atlantic (1.2 billion tons a year). To the northwest, three large rivers disappear into desert sands. The Amu Darya, known in ancient times as the Oxus, and the Naryn (Syr Darya) flow into the Aral Sea, which is doomed due to over irrigation. The Tarim River (Yarkand Darya)—explored in the late nineteenth century by Swedish geographer Sven Hedin—dies in the swamps of the Lop Nur. And finally, the great Siberian rivers (Ob, Yenisey, Lena, and Amur), born in the Mongolian heights, travel up to 3,000 miles all the way to the glacial Arctic Ocean or to the Pacific.

The wind, too, abrades and removes. Around the mountains born of the India-Asia collision, for example, it has transported and dumped the world's thickest deposits of "yellow" loess: over 2,000 feet in the Wei He valley, cradle of the Middle Kingdom. The mass of these eolian layers is another measure of erosion's powerful onslaught against the planet's highest moutains.

As soon as the forces that push continents and crustal blocks toward one another start to flag, as soon as convergence, the engine of uplift, slows down or stops, erosion takes the upper hand. In due course, it smoothes everything out. The wearing down and removal of surface rocks enables deeper rocks to rise, as isostasy dictates: the lower the altitude, the less deep the roots. Gradually, the relief levels out, and the keels of the mountains shrink. In the end, the continental crust returns to its normal thickness.

How long does it take? Estimates remain very imprecise. Thirty million years might be all it takes to erase any trace of glittering, ice-covered peaks. But a much longer period is needed to erase the ranges themselves. The Ural mountain range, for example, born from the collision of Siberia with Russia 300 million years ago, stubbornly continues to separate the two with its modest 3,000 feet. And not one massif from Europe's Hercynian orogenic belt has been worn down to sea level. It is true that many of them—the Massif Central, the Vosges, the Black Forest, and even the Ardennes, Eifel-Taunus, or Armorican massif—have received a shot of youth from the Alpine collision.

Be that as it may, however, there is no question that erosion runs out of steam as the relief decreases. As glaciers vanish, erosion's attack of the summits is much reduced. The mechanical power of a tranquil stream does not match that of alpine torrents or great waterfalls. And, of course, low mountains attract less rain than tall ones.

MOUNTAINS THAT REFUSE TO DIE

In general, high mountains that stay sufficiently cold and robust not to collapse under their own weight cannot escape the harsh dictates of surface agents, pitiless scrubbers of the relief. Yet, some try to evade or delay such ordinary death. They do so by setting up effective defenses against fluvial erosion. Those that rise best to the challenge are the largest mountainous systems, whose surface area increases the fastest. They are strange and puzzling objects, resembling high plains rather than mountain ranges. Given that what is high should not in theory remain flat, they defy understanding at first. But, in fact, they illustrate a rather clever, if unexpected, survival strategy.

Most orogenic high plateaus turn out to be little more than collections of contiguous basins. The young, rising ranges that rim such plateaus prevent the escape of the waters and transported muds coming from the interior. In part, then, high plateaus are built with the debris from their own summits through a mechanism of interior leveling.

No example illustrates this mechanism better than the Tibetan plateau. One could say that it is "swollen" with the product of its own erosion. Contrary to most other mountainous regions, Tibet jealously hordes its sediments. To verify this, all we have to do is follow Ariadne's thread of water from the heart of the plateau. Generally, it doesn't lead to the ocean, as it does almost everywhere else, but to large lakes. In the northeast, the majority of Tibet's modern rivers—with the exception of the Yellow River and its tributaries—finish their course in high-altitude basins, which have been filling at times with alluvium, at times with gypsum-rich lake deposits. The largest of them all is the Qaidam basin, this immense salt desert at the remarkably constant altitude of nearly 9,000 feet, ancient floor of a shallow lake flooded and then drained time and again, according to the whims of the weather. It is filled with over 30,000 feet of sediments, two-thirds of which are barely 6 million years old. They've accumulated because the fluvial system that drained the basin was cut off by mountain uplift along its northern side. The level of deposition has been rising steadily ever since, as in a reservoir impounded by silt, or better yet, a bathtub with a clogged drain. A prisoner of its own mountain ring, the immense, closed basin was thus rapidly transformed into a high, flat expanse. With a surface already exceeding 60,000 square miles, this "baby Tibet" will one day become integrated into the larger, higher plateau, when it reaches the appropriate height. Another 6,000 feet to go, and Tibet will have grown by an area about one-third the size of France.

In the Qaidam, whose white vastness sparkles today with tiny, spearheaded gypsum crystals, the prevailing northwest winds incessantly sculpt the soft lake-beds into tight packs of narrow parallel crests called *yardangs* in Persian. Seen from afar, they rise like ghost cities between mirages that have replaced the water. On the very high plateau, south of the Kunlun Mountains, similar deposits once accumulated in comparable but older basins, and for a much longer time—at least 20 million years. Over time, the buff color of these now-hardened beds turned pink, then finally red. Large "desert roses" of gypsum replaced the innumerable spearheads. From the onset of the collision, therefore, the surface of Earth's highest plateau appears to have grown step after step, from south to north. The present is indeed the key to the past.

Land of white, turquoise, or pink saltwater lakes, the pristine kingdom of antelopes, wild asses, and yaks, the roof of the world still victoriously resists erosion by storing its sediments, a strategy to which it owes its high flatness. Yet it, too, may end up losing the long, protracted battle. Through a breach in its oldest flank, on the Sichuan and Yunnan side, three great rivers are well positioned to win. Rushing by the narrow passage of Sanjiang—"Three Rivers" in Chinese—in three long, parallel gorges, they are on their way to conquering new and higher headwaters. They have opened the rampart of the Tibetan stronghold to regressive erosion! Relentlessly, the sources of the Yangtze, the Mekong, the Salween, and their tributaries retreat upstream, capturing anew here a former maze of marshlands, there a hitherto-internal drainage catchment. Up to now, the invasion has been limited. The combined fluvial network of the three intruders covers only a quarter of Tibet. There still remains over one million square miles to overrun and colonize. However, if nothing hinders their progression, the three rivers are likely to carve up the plateau from the southeast inwards, from the very edge where it has lowered its guard, since its main lines of defense are now erected in the north. This is an alarming threat. Remember also that the heart of Tibet is in danger of collapsing. Even the most powerful and resourceful relief eventually meets its match.

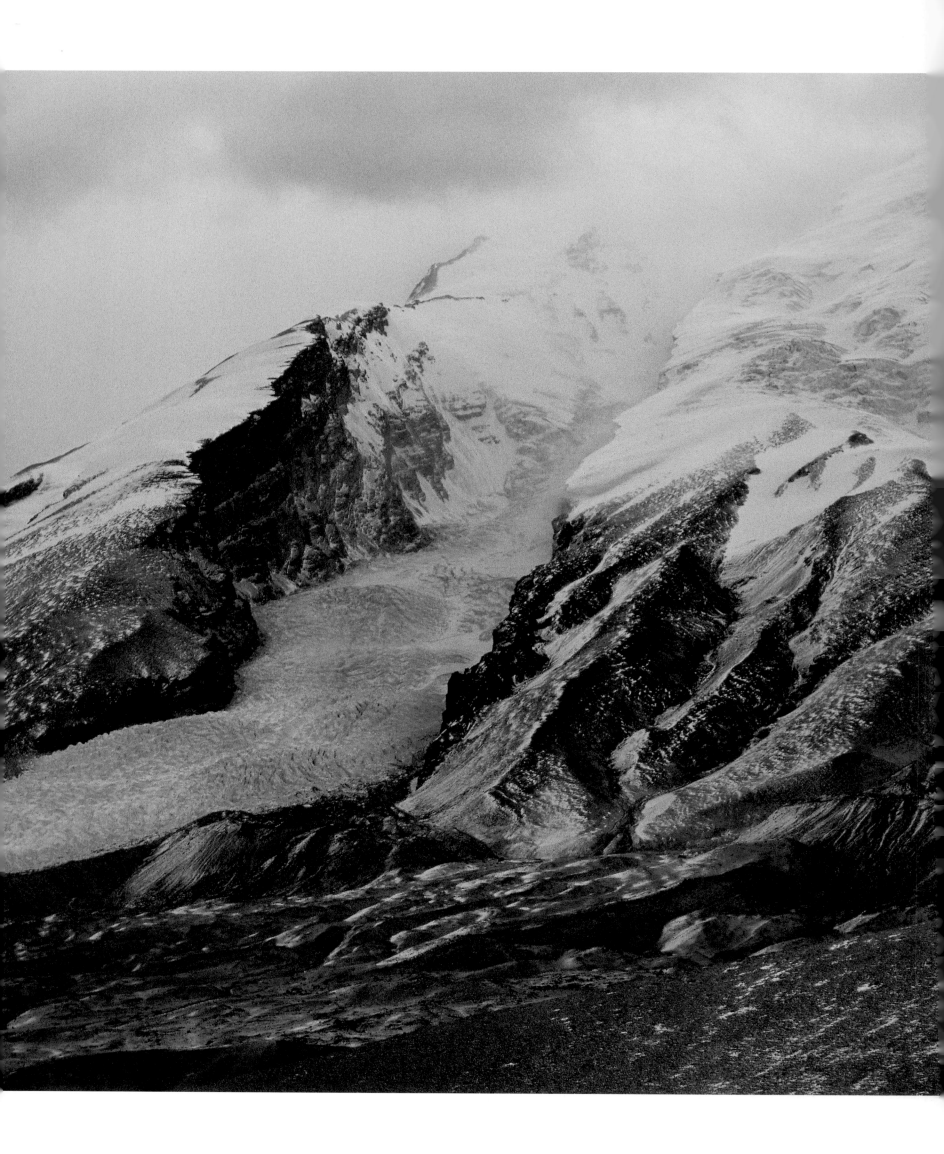

Glaciers,
LAKE KARAKUL,
PAMIR, XINJIANG

Nowhere is the power of erosion as impressive as above 16,000 feet. Its main agent, ice, abrades and cuts by using the rock debris it carries, like a sort of natural sandpaper. Here are two of the thirty glaciers that made such a lasting impression on Marco Polo when, as an adolescent, he first traveled to the court of Kublai Khan. They have cut deep troughs between vertical cliffs up to 2,000 feet high in the western flank of Muztagh Ata. Because the Central Asian climate is fairly dry (at most three feet of rainfall per year), glaciation is less intense than elsewhere, and it is easier to see the onset of the relief's destruction. The flow of the ice cap becomes localized into narrow channels. The flanks of the large fold thus become gouged by separated glacial troughs that terminate upward into receding, dark-tiered amphitheaters. Less than one million years from now, if Earth's climate doesn't warm up too much, such troughs and cirques will merge, and the divine dome shape of the mountain will disappear. This mighty young fold will have given way to a jagged crest, similar to those of more mundane mountains.

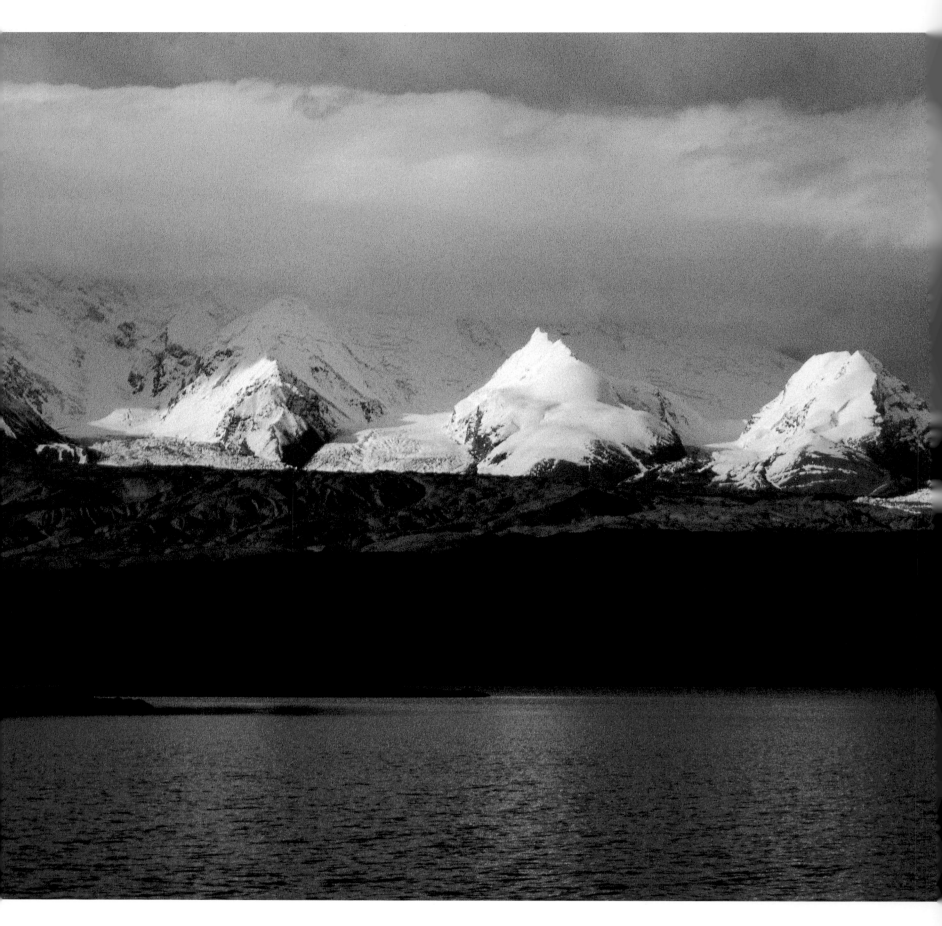

NUNATAKS, KONGUR SHAN, XINJIANG
Five adjacent glaciers have almost destroyed the mountain saddle that separates the Kongur and Muztagh Ata folds. Behind the gray moraines above the lake, the sharp crests, or nunataks, between the parallel valleys are all that remain of Kongur's southwest flank.

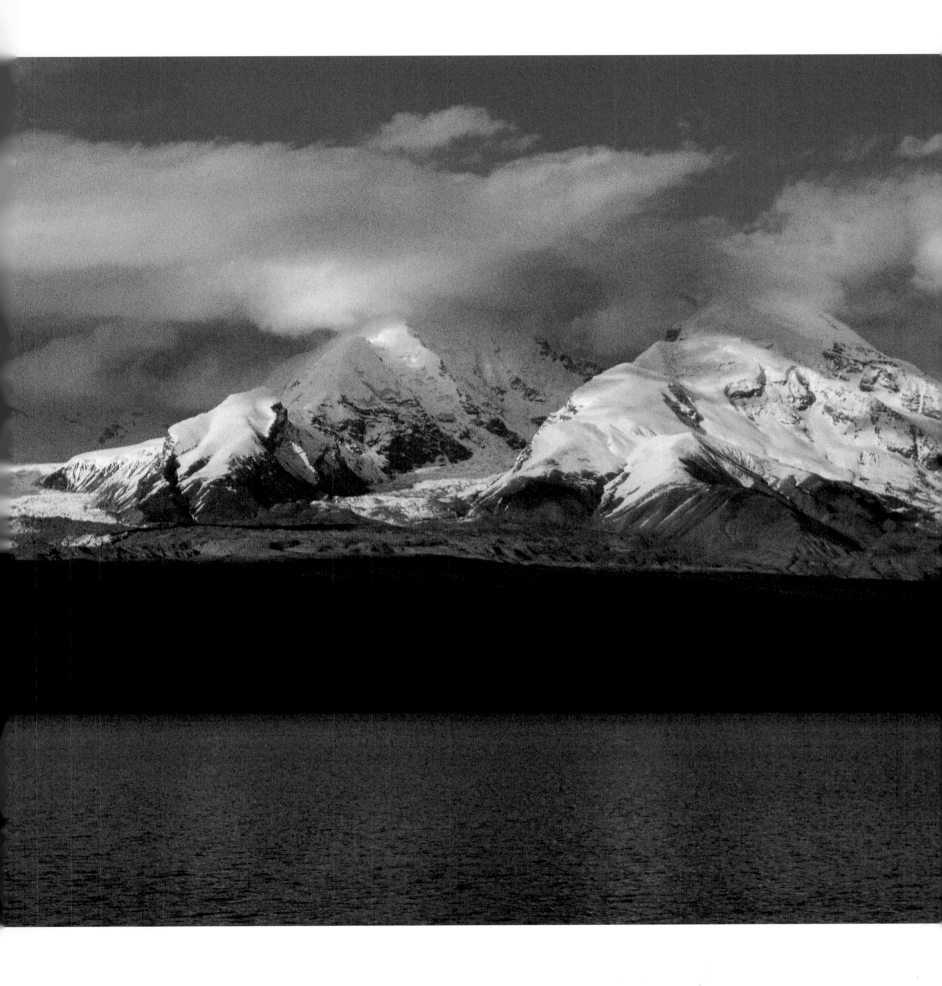

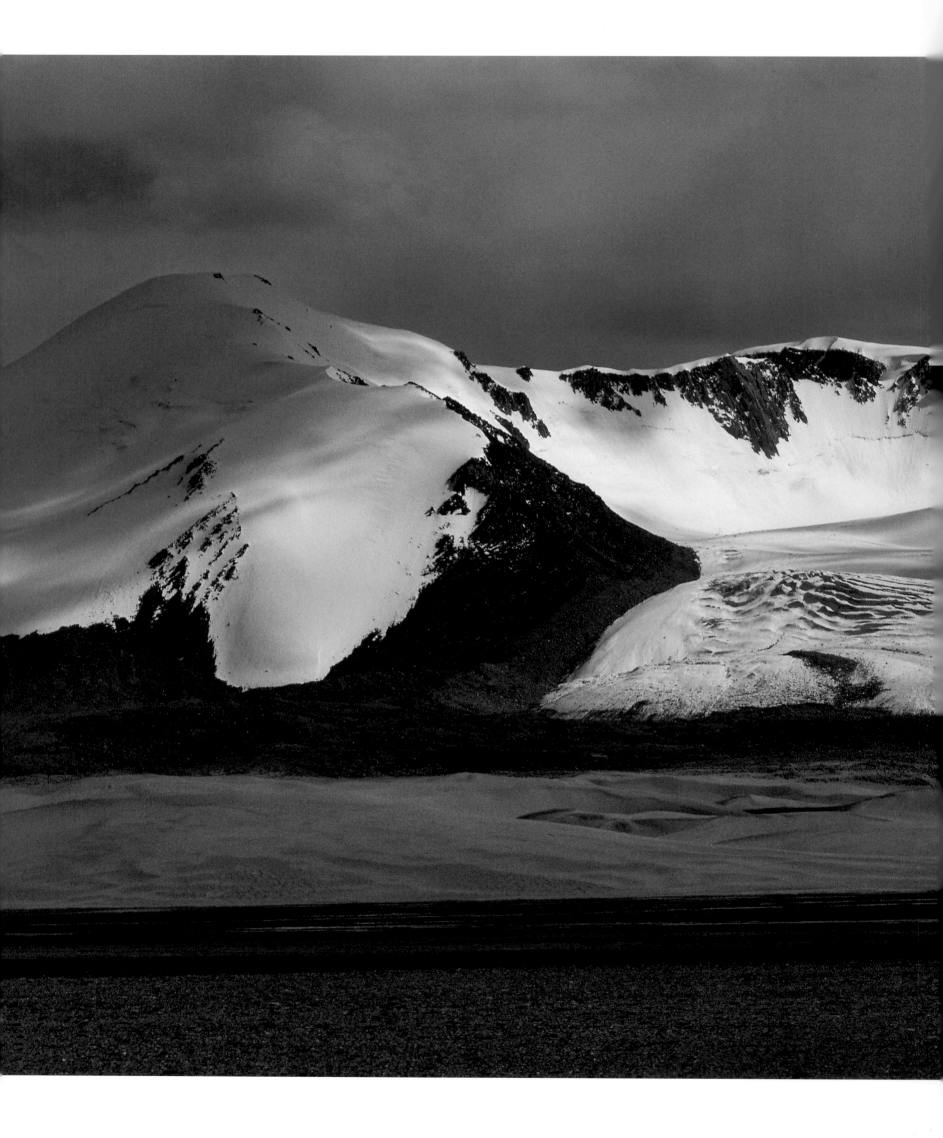

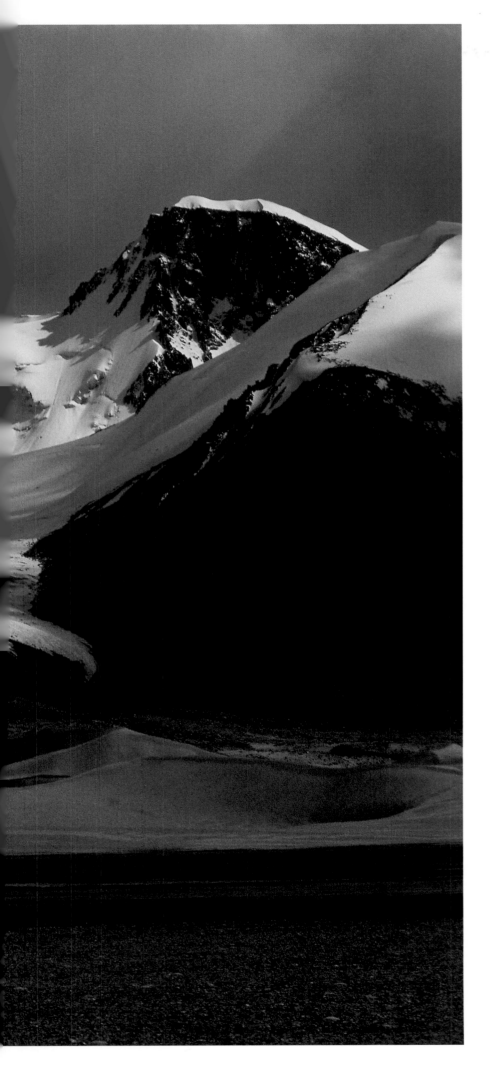

Ice tongue,
KOKOXILI, TIBET

Weixueh Shan (20,472 feet) is a little-known mountain lost in Tibet's most remote region, an area so high and barren that even shepherds do not dare trespass. Here summer blizzards can decimate small groups of gold prospectors in the span of one night: young, reckless peasants hired by Xinjiang city merchants, who drive up from the Tarim in caravans of *dongfeng*—the ubiquitous three-wheeled tractor of rural China. The mountain's north flank, which stands above the snow line, is a small-scale model of glacial erosion. On top, the large cirque gouged out of the summit, where accumulating snows compact into ice, feeding the glacier. Below, the creeping ice, cracked where it cascades past what remains of the steep mountain flank; and finally, the glacier terminus just behind the frontal moraine rings. Small, gray ridges freshly uncovered by glacial retreat, the lateral moraines are made of blocks torn away and carried downwards by the ice. Rock powder, first ground at the glacier's base, then washed down and deposited by melt waters, forms a field of crescent-shaped dunes—*barkhans*—in the foreground. In the center of Tibet, many glaciers show similarly lazy behavior: the plateau's base level is already so high that they are left with barely three thousand feet to descend.

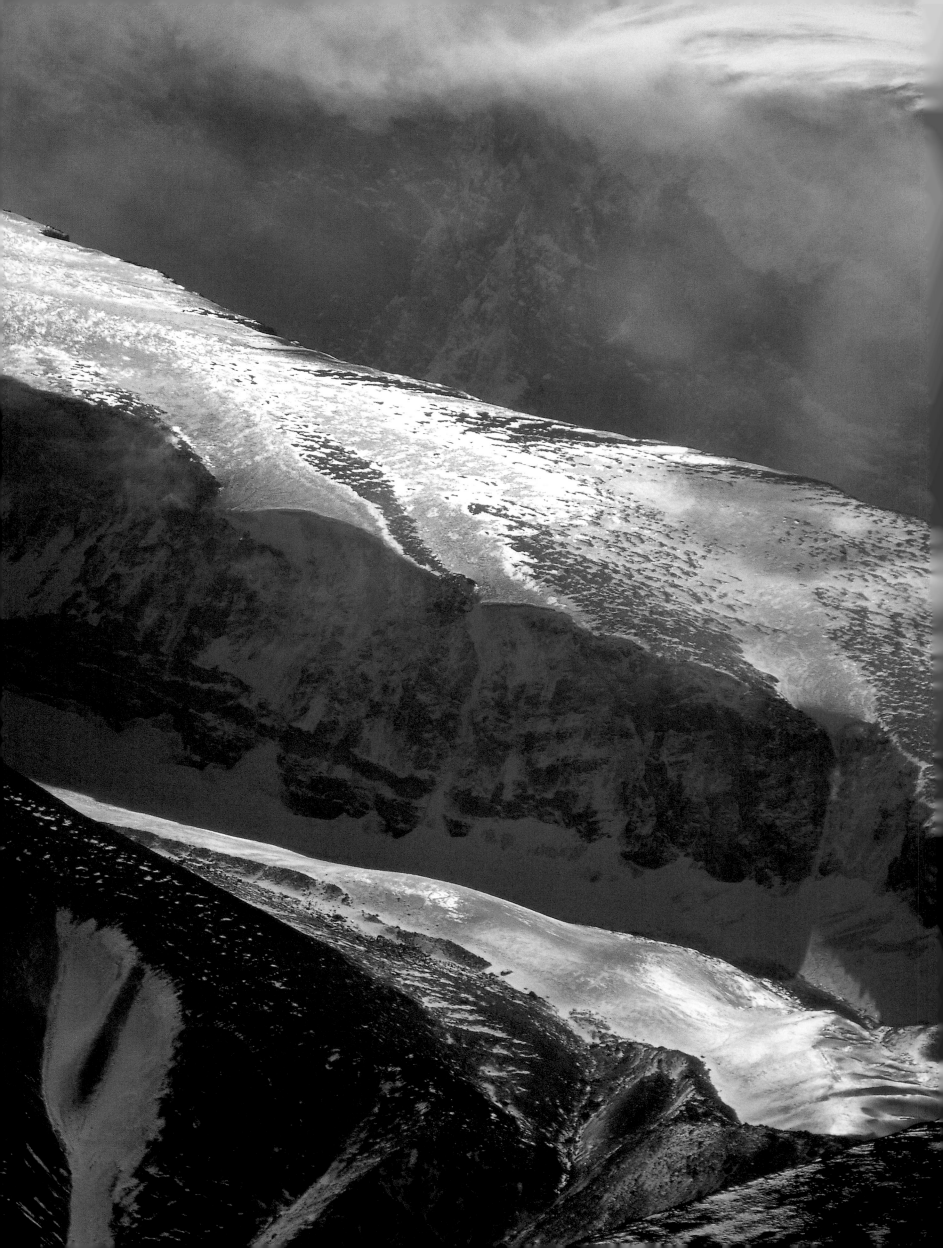

GLACIAL INCISION, MUZTAGH ATA, XINJIANG

The gentle surface of what remains of the ice cap on Muztagh Ata's west flank, between the vertical glacial valley walls, gleams in the sun.

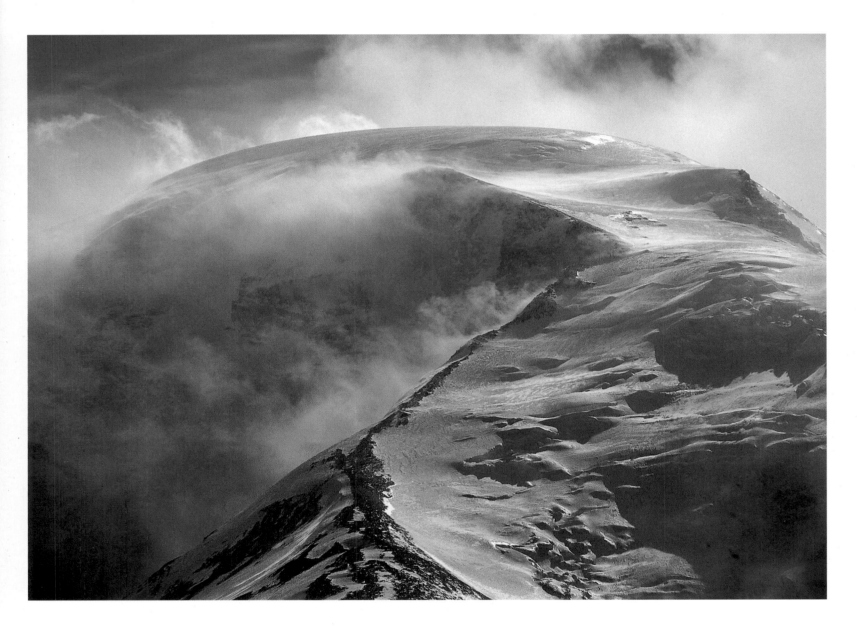

GLACIAL ABRASION, MUZTAGH ATA, XINJIANG

On the summit of Muztagh Ata's dome, it is the ice cap itself that abrades and smoothes its rounded shape.

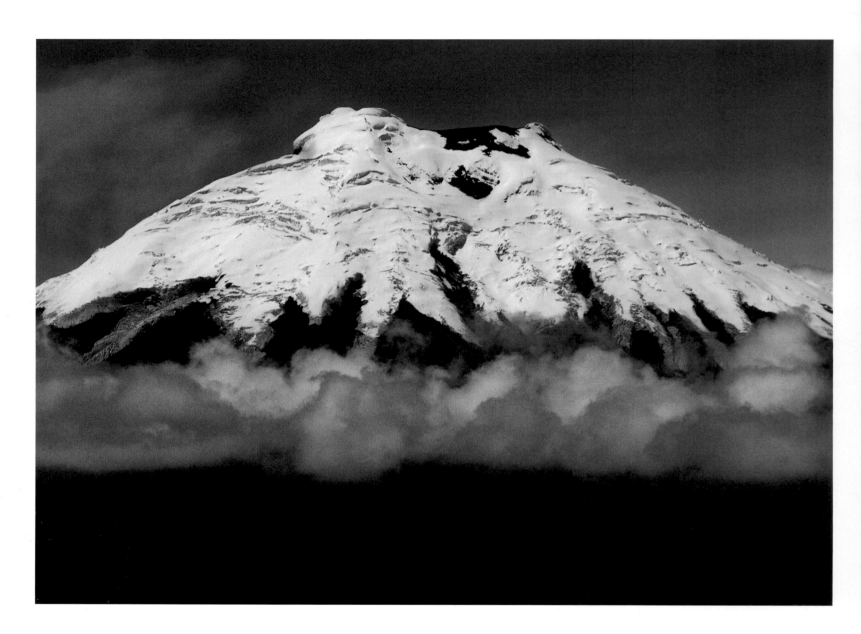

GLACIAL CROWN, COTOPAXI, ECUADOR

The ice crown of the Cotopaxi is "star-adorned" by the
radial, glacial tongues that it feeds.

GLACIAL RELIEF, KARAKORAM, PAKISTAN

Today, the longest mountain glaciers are found in the
Karakoram and Himalayan ranges. This is also where,
during the very cold periods of the last ice ages,
20,000, 40,000, 65,000, and 140,000 years ago, the
incision pcwer of these swollen, icy juggernauts was
strongest, creating awesome vertical relief, such as
that seen here between the Baltit poplars and Ultar
peak's summit.

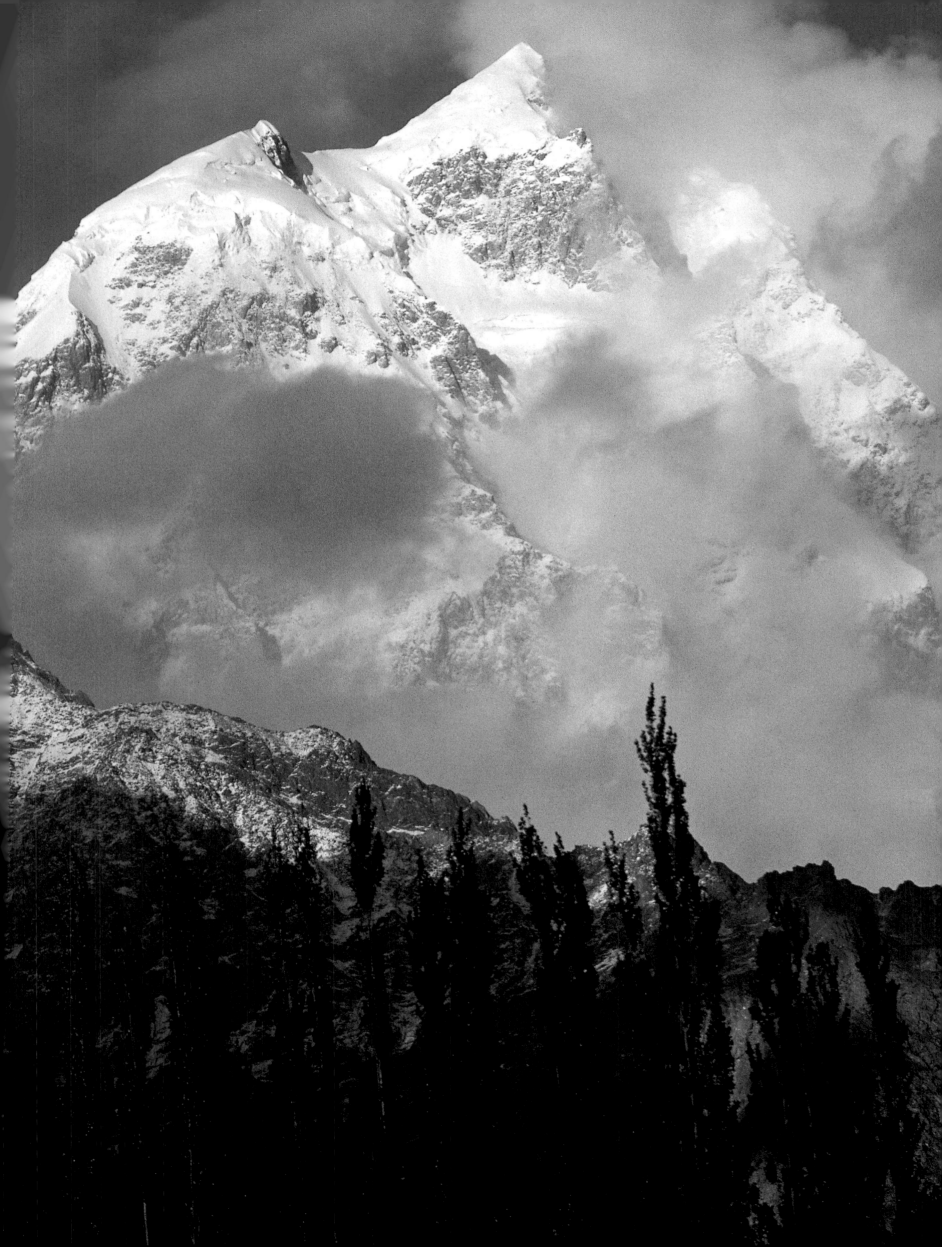

Glacial transport, Himalayas, Ladakh

From Pensi La (Pensi Pass), we can see how the Durung Drung glacier carts off boulders and smaller rock debris from its U-shaped valley walls, like an actual conveyer belt. These rocks, either mechanically torn off by the ice, or precipitated from the steep cliffs whose base it keeps cutting, gradually build up the lateral moraine ribbons.

following pages

AVALANCHE CORRIDORS, KARAKORAM, PAKISTAN

The narrow and steep corridors, today whitened by firns, are the furrows left by glaciers that formerly hung from an ice cap whose edge followed the crest line marked by sharp pinnacles.

269

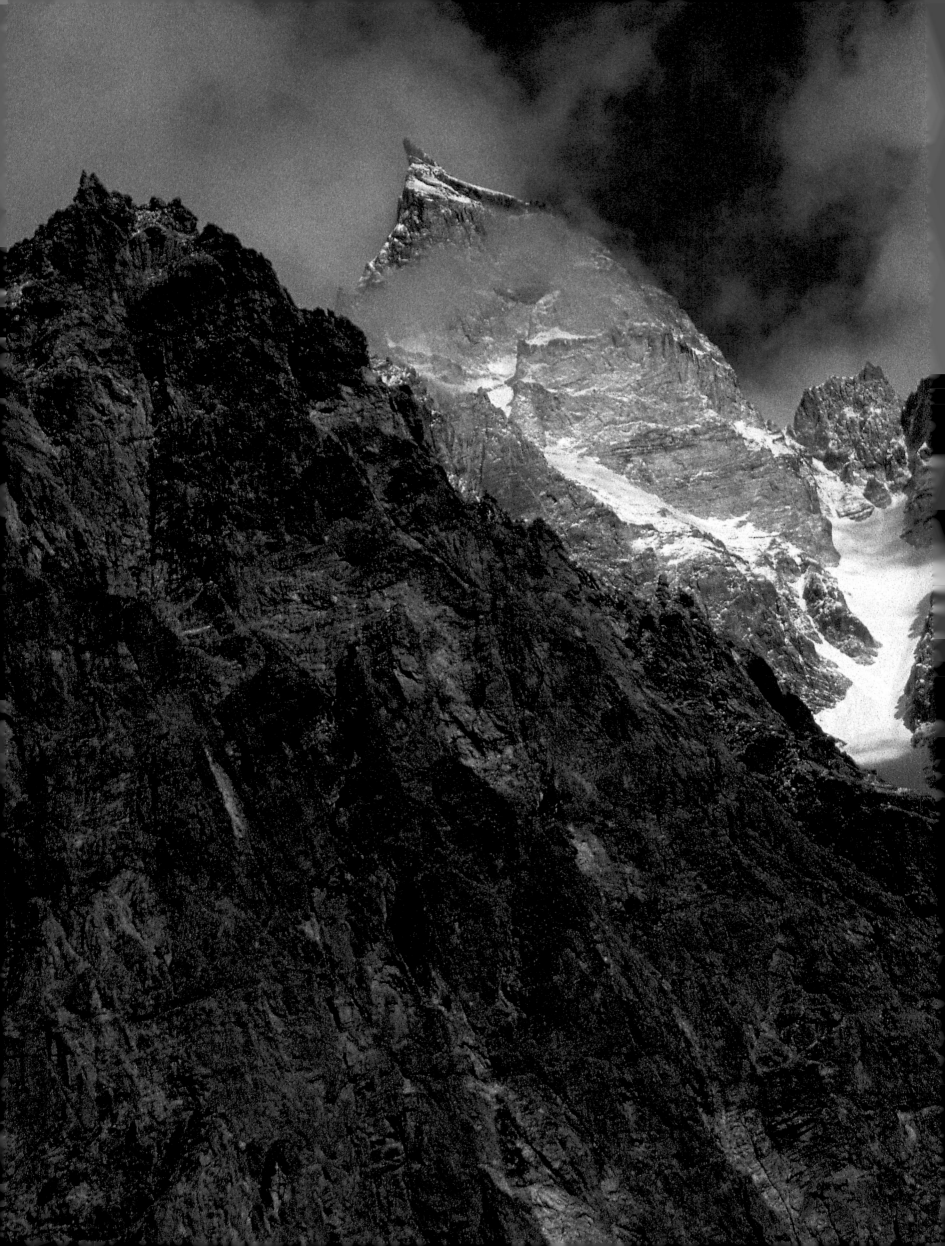

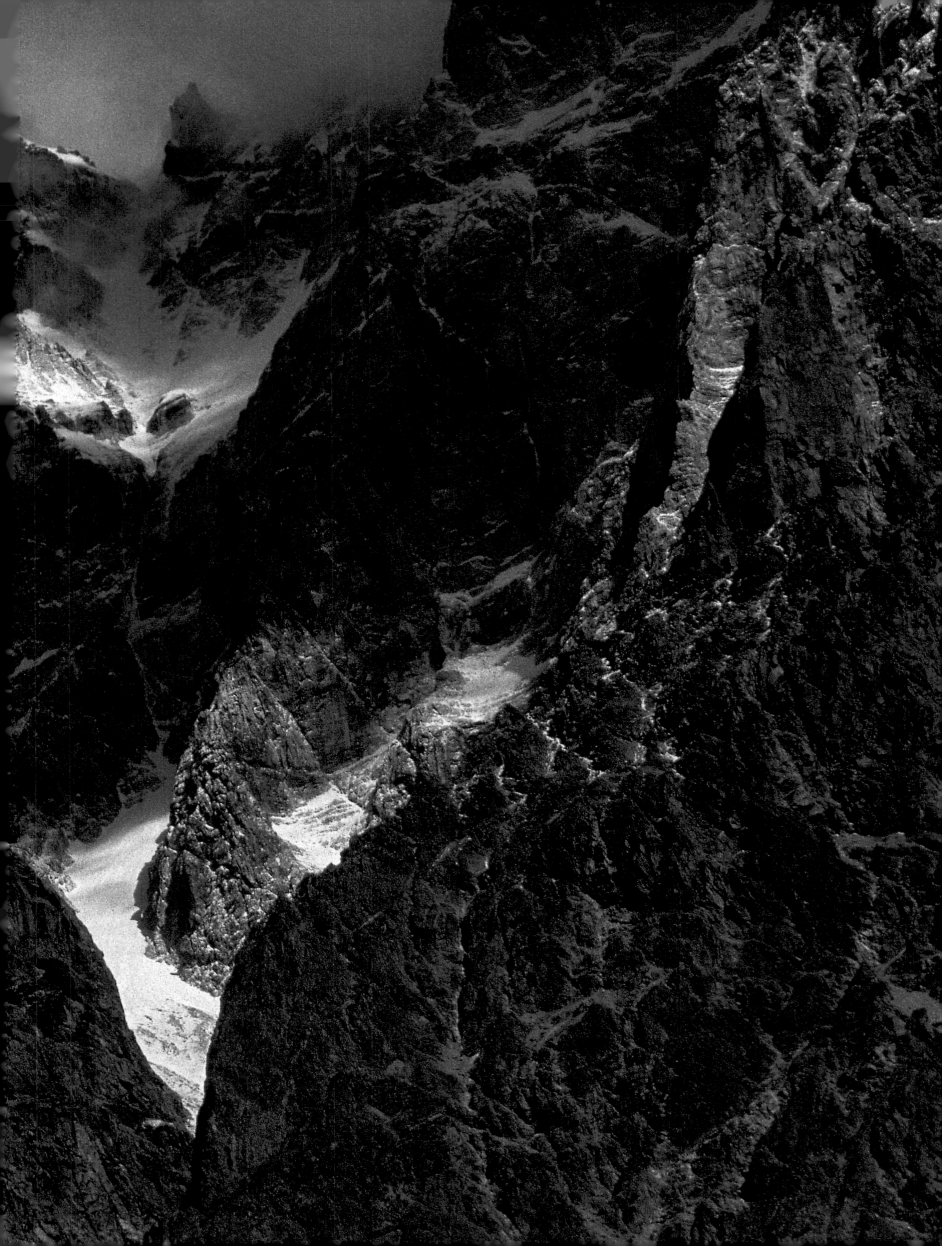

Ice cap,
ECUADOR, ANDES

Even under the equatorial sun, ice can accumulate to form thick caps. Here is the ice-cap covering Chimborazo, highest summit of the "avenue of volcanoes," at 20,110 feet above sea level and close to 1 degree of south latitude. Extremely abundant precipitation accounts for the existence of so much ice at such low latitudes, albeit above 17,000 feet. Bathed in moist air on both the Selva and Pacific sides, along a stretch of the Andes where they form the main relief, Ecuador's highest volcanoes are brightly crowned white amidst the lush green tropical landscape. It is this dazzling contrast that grants them access to the pantheon of the world's most beautiful mountains. Perched on active craters or on exiguous summits of red porphyry formerly torn asunder by eruptions, these ice caps have irregular and unstable forms. They vanish as soon as the climate warms up. The famous snows of Kilimanjaro, for instance, which are thawing today before our very eyes, may not last much longer than 10 more years. There would be little hope to retrieve a long record of Earth's ancient climate from a drill-core in such caps. Ephemeral, they melt rapidly, and grow back just as fast.

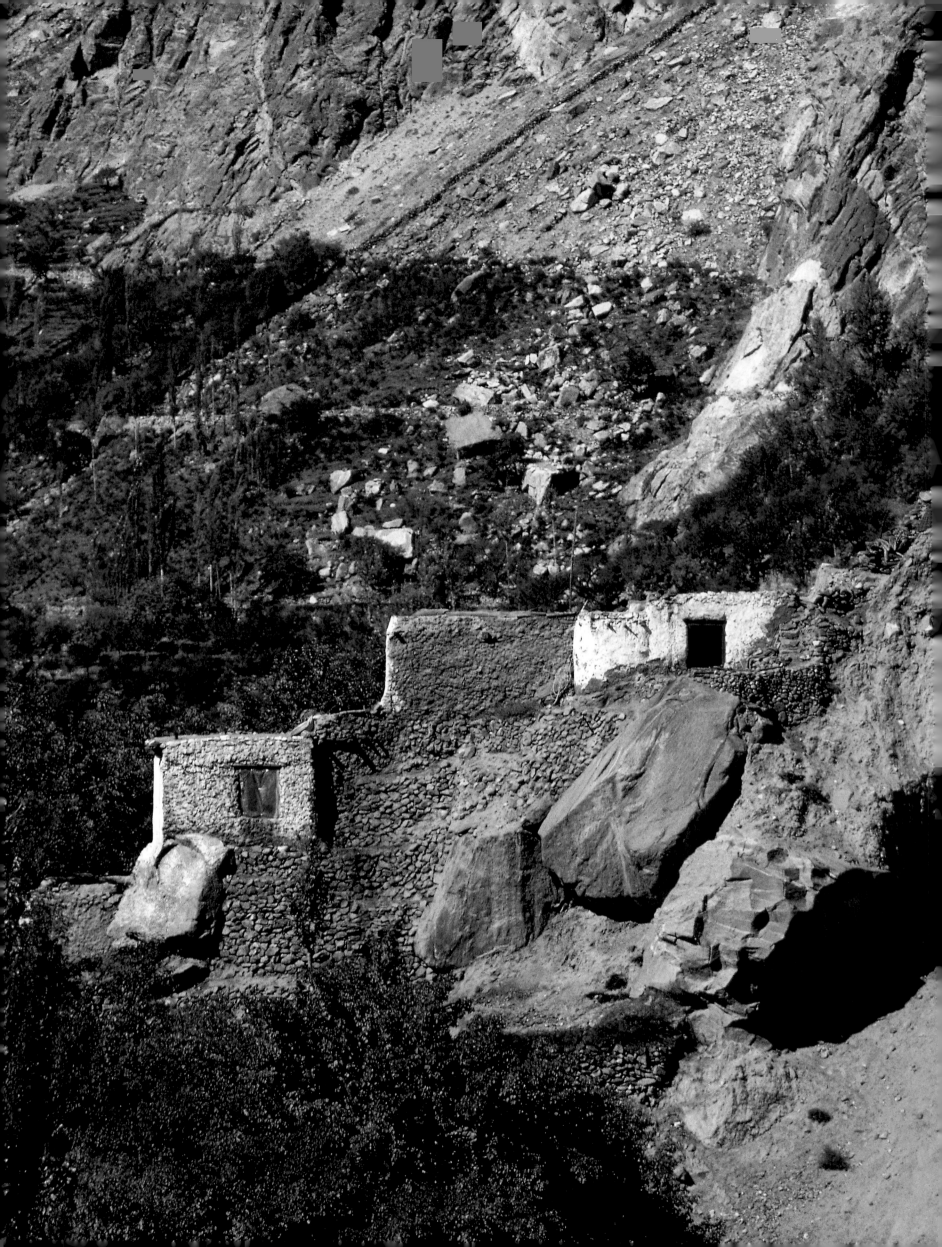

ERRATIC BLOCKS, KARIMABAD, PAKISTAN

Houses and terraces, built with mundane alluvial pebbles, lean on or between huge erratic blocks carried from
afar by the ancient Hunza glacier.

"ROCK" GLACIER, KARAKORAM, PAKISTAN

Near their terminus, glaciers sometimes transport so much surface debris that one can only catch a glimpse of
the ice in deep crevasses.

following pages

GULLIED SEDIMENTS, GEZ VALLEY, PAMIR, XINJIANG

Though quite recent, the gravels and mudstones of the high terraces of the Gez River are already deeply gullied
by runoff, illustrating the destructive power of meteoric water on poorly consolidated rock. In Central Asia's
semi-arid regions, a single storm can deepen gullies by 4 feet in one go.

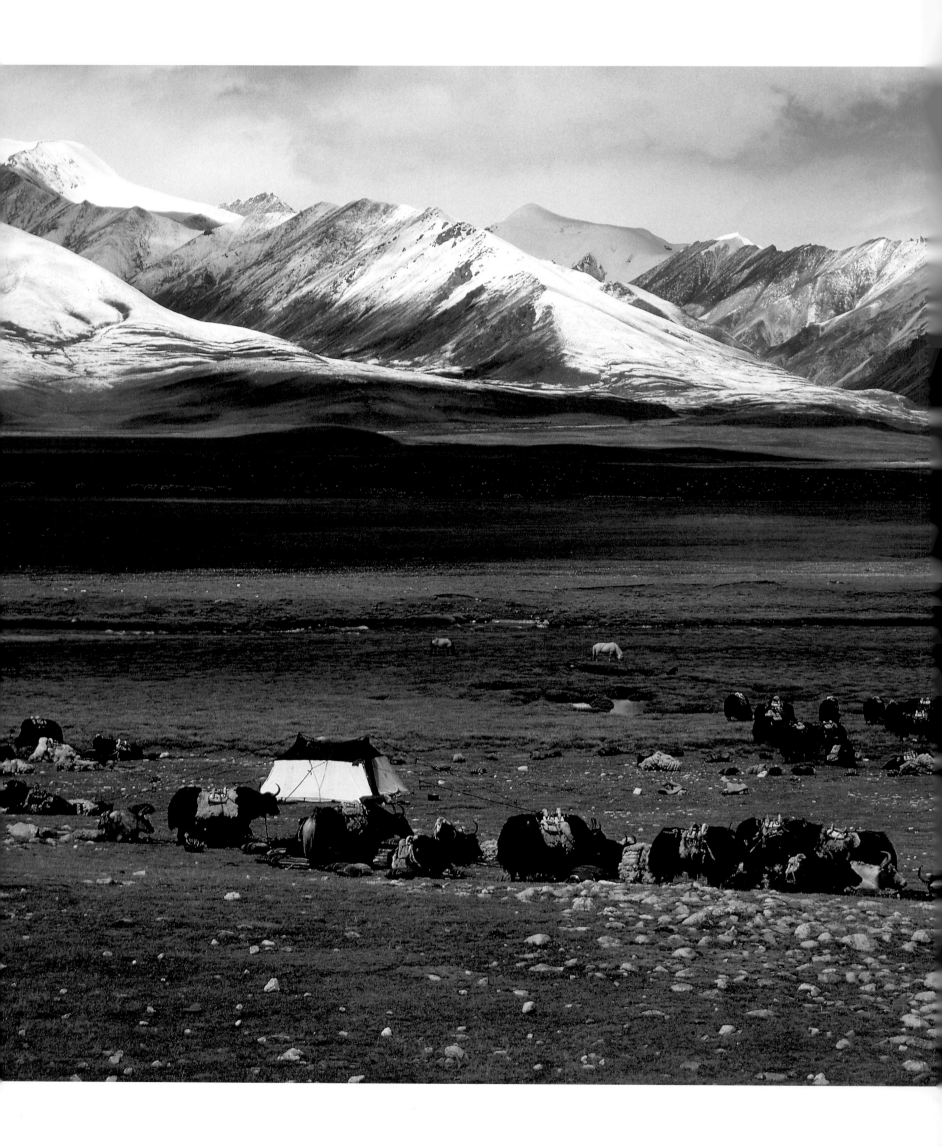

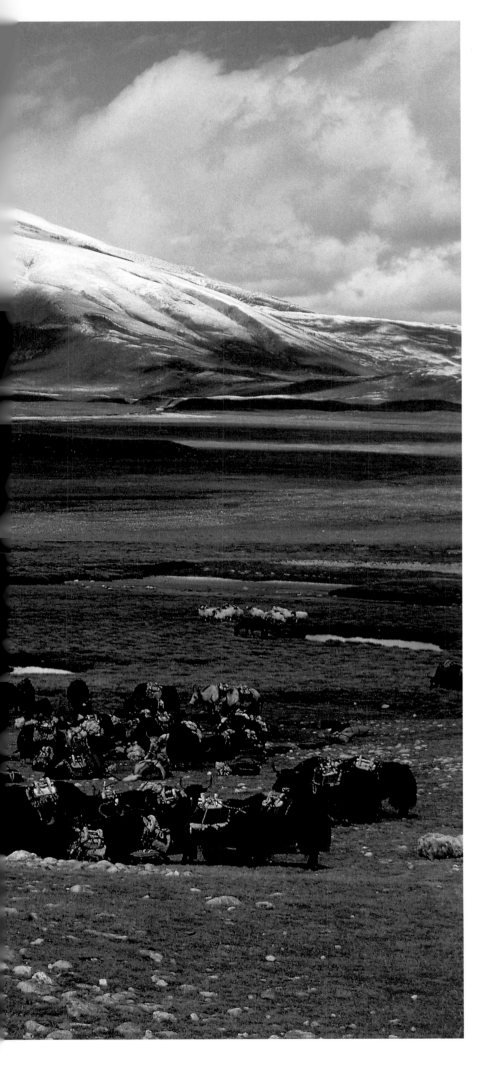

Normal faults, GULU CORRIDOR, TIBET

The caravan of yaks, which camped in a circle overnight, is about to resume its trek, following the flat-floored, north-south valley that has just become the route of the world's highest and newest railway. An easy passageway between Lhassa and the high plateau, the Gulu-Yangbaijing corridor cuts southward through the Gangdese mountains, then across the Zangbo Suture all the way to Bhutan. It is a down-faulted graben, one of seven rifts running perpendicular to the Himalayas, reflecting the current east–west extension of the Tibetan plateau, instead of the shortening one might expect due to India's mighty push. Such extension might herald the incipient collapse of the plateau, which would have started to stretch as it is warming up. An orogenic behemoth, Tibet would have become too large and too soft. Gravity would force its thick crust to thin down and, isostasy helping, its altitude to decrease. This is one of the lethal pathologies that can seal the fate of very large mountains. The normal faults bordering the Gulu corridor are very active. We can see them here running along the base of the snow-covered facets, forming multiple dark scarps, which grew by several feet during two large earthquakes in 1951.

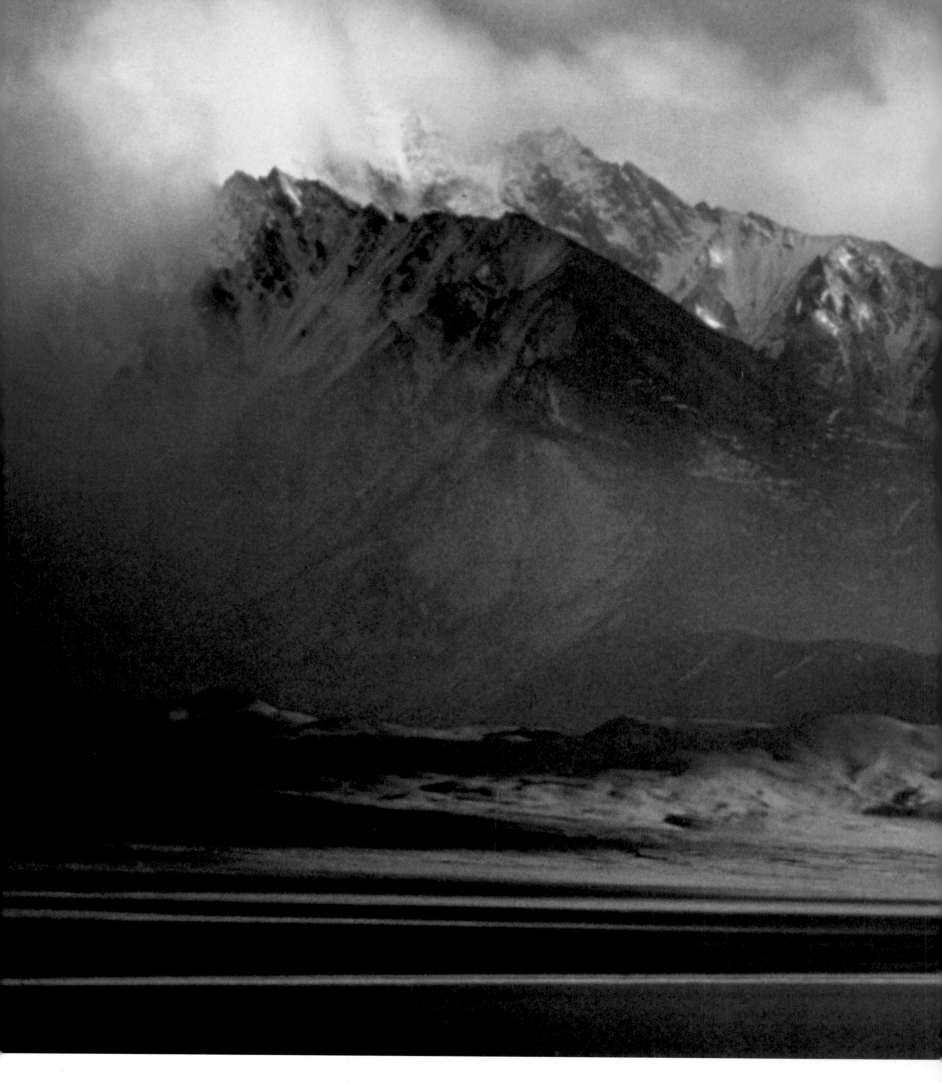

MORAINES, CHOMOLHARI, HIMALAYAS

Highlighted by the grazing evening light, the preferred time of day for geomorphologists, the hummocky ridges above the lake testify to the glacier's maximum advance. Baring the trench it dug between these two lateral moraines, the glacier has now withdrawn several miles upstream, well within the Chomolhari massif. The steepness of the mountain's flank, cut into triangular facets, is the result of active normal faulting, that caused the foreground to subside, thus creating a pass across the Himalayas, from Tibet to Bhutan.

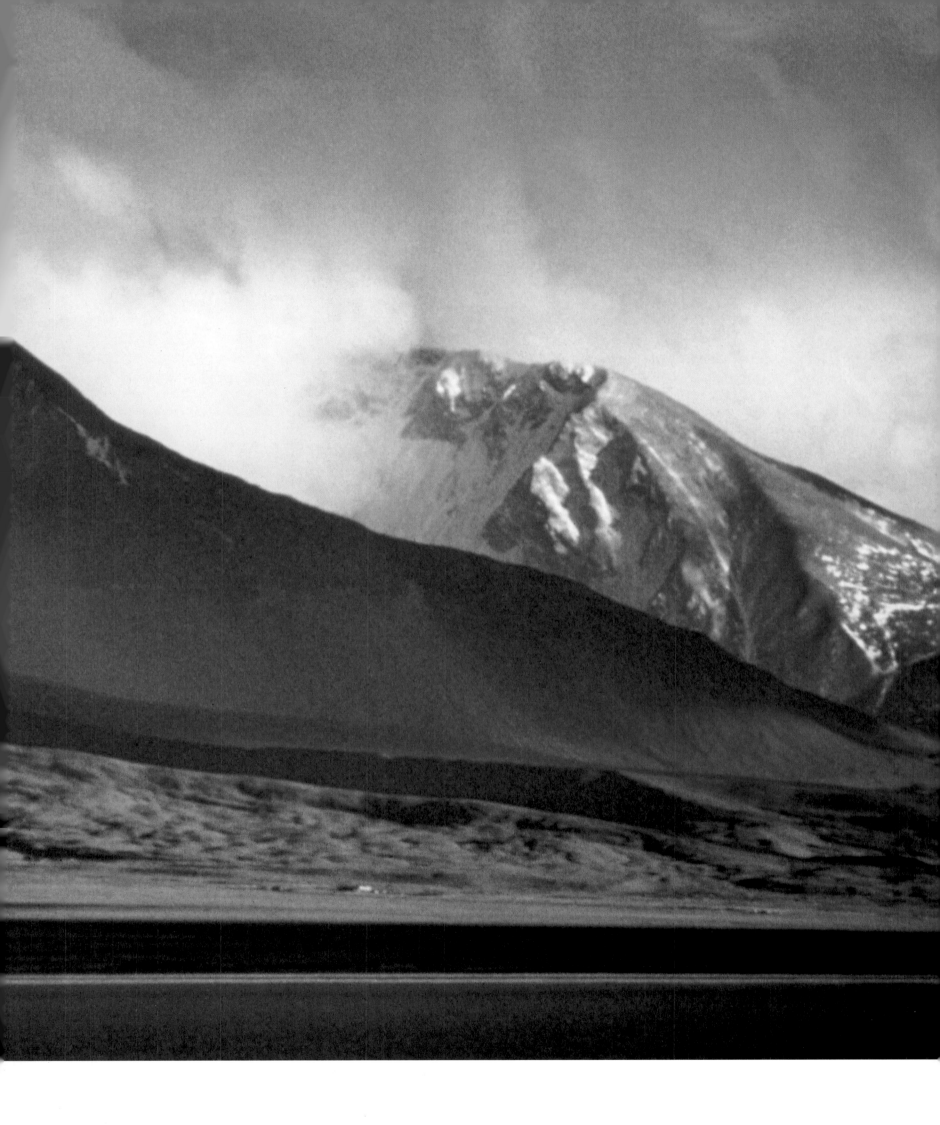

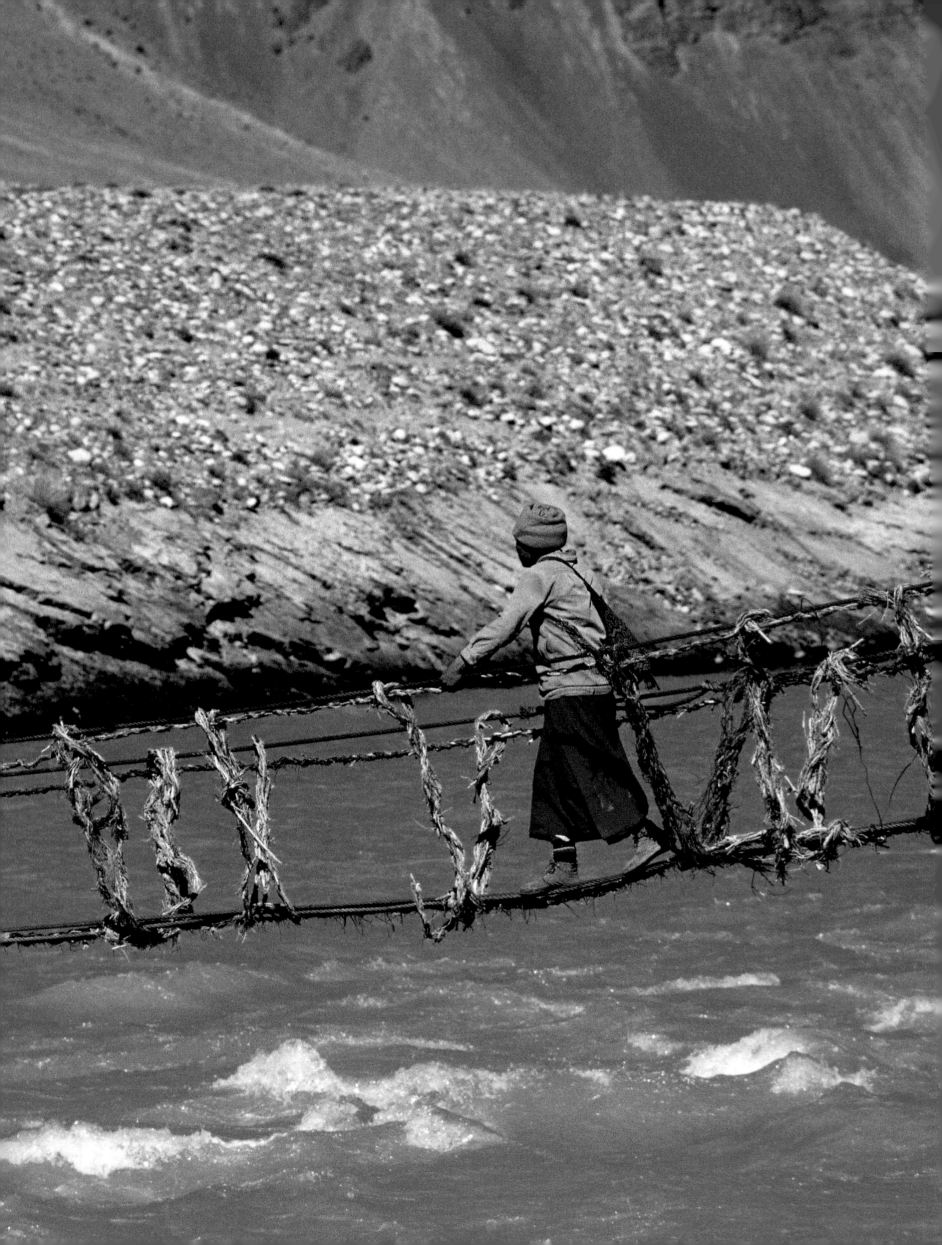

ABRASION TOOL, ZANSKAR, HIMALAYAS

The layer of smooth, rounded pebbles on the riverbank is a *strath,* or abrasion terrace. Observe the sharp limit between the base of this pebble layer and the dipping rock strata just above the rope bridge. Flat, parallel to the present water level, this limit is an ancient riverbed bottom. The pebbles rolled by the current are the tools with which the river planes the rocks underneath.

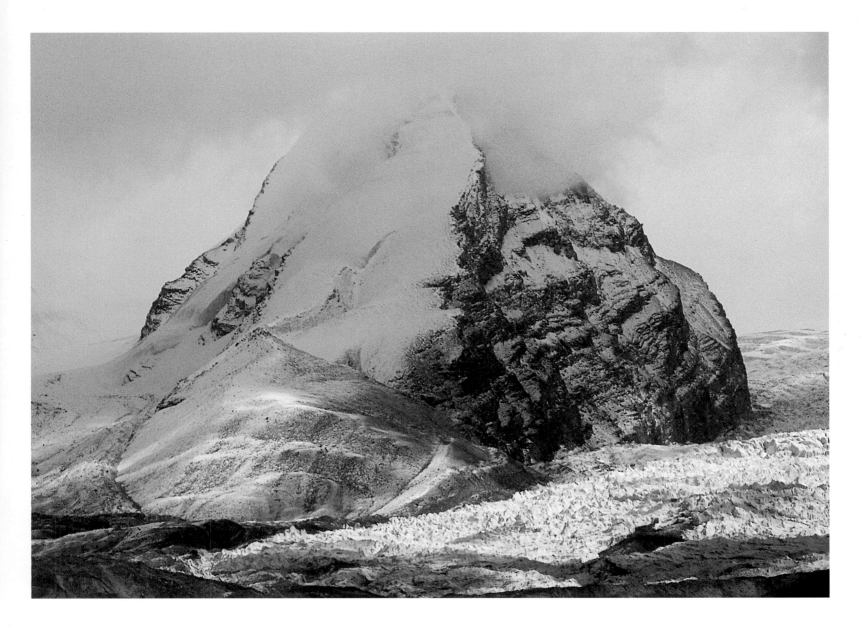

DEATH OF A HIGH SUMMIT, PAMIR, XINJIANG

The fog-shrouded peak of this pyramid of metamorphic rocks hardly exceeds 16,000 feet. An island encircled by powerful ice-streams, it is all that remains of a 23,000-foot-high mountain. It will not last for very long, unless man's continued assault on the climate banishes ice from the planet.

following pages

BRAIDED RIVER, LADAKH, HIMALAYAS

Down below the ice, rivers swollen by gray-green melt water carry away rock debris. Braided rivers are highly dynamic. The path and meanders of individual channels change day after day, even from one hour to the next.

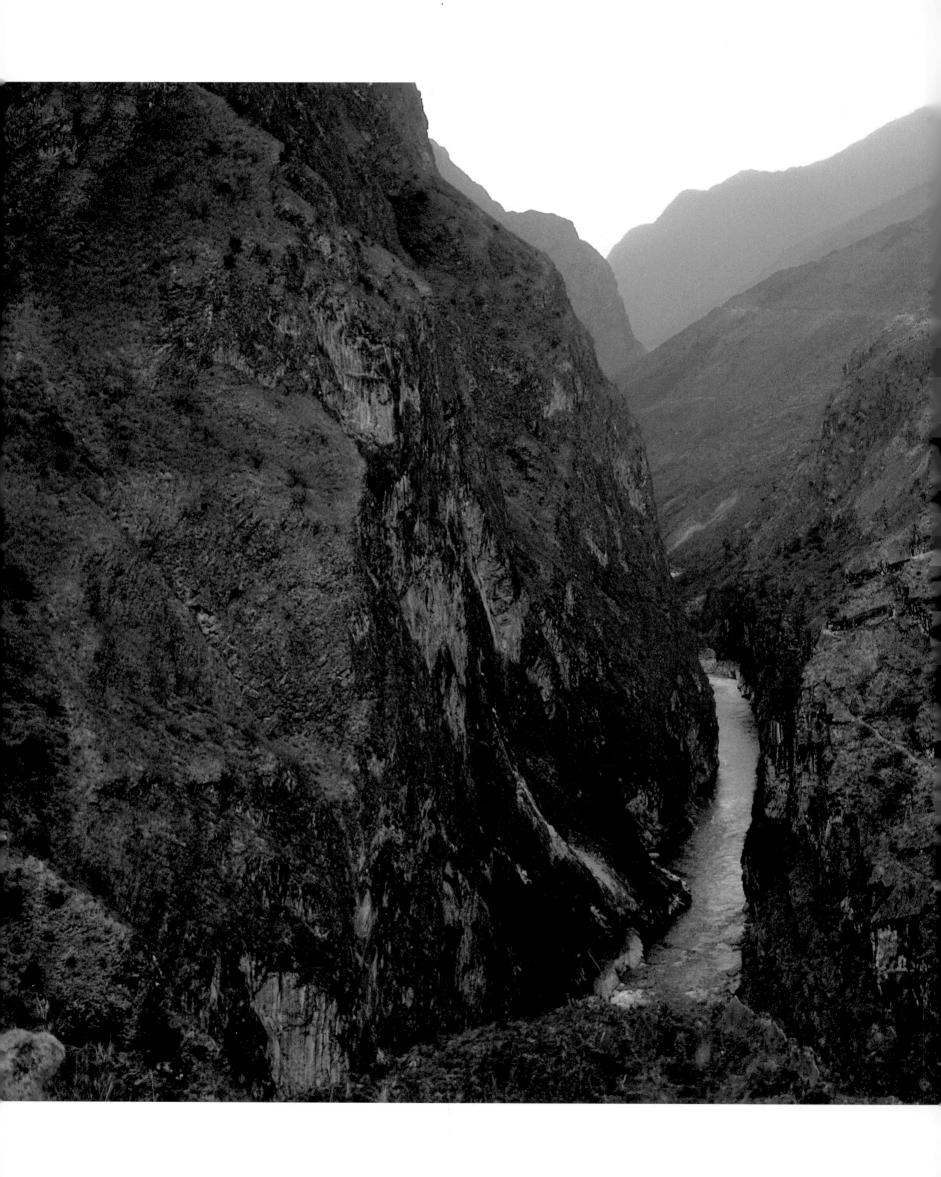

TIGER'S LEAP, YUNNAN, CHINA

The Jinsha Jiang (Golden Sand River), better known as the Yangtze River, is the longest in China (3,965 miles). This is not surprising given the complicated path it follows in northern Yunnan as it tries to escape from Tibet: a real obstacle course. While struggling to find its way across the maze of mountains and faults it meets, it changes direction three times. Two hairpin bends, then a third, broader one that brings it 600 miles towards the northeast, back across all of Sichuan.... While it should have continued in a straight line towards the gulf of Tonkin, the shortest route to sea! The most formidable barrier the river encounters is the Yulong Xue Shan (Snow Mountain of the Jade Dragon), a huge fold over 18,360 feet high that towers above the high plain of Lijiang (capital of the Naxi minority). Diverted northward along the mountain's east flank at the first bend, the Jinsha manages to cross it halfway before the second: in an awe-inspiring gorge, one of the world's deepest wind-gaps, cut down into 13,000 feet of metamorphic schist and marble. At the foot of the vertical walls created during the latest incision period, the river becomes a ribbon of water so narrow that a tiger can leap across it in a single bound, or so the legend goes. How long did it take the most powerful of Chinese rivers to incise this great mountain? No one knows yet, but what a fantastic example of fluvial erosion's might...

WATERFALL, INDUS, PAKISTAN

In the hairpin bend it makes around Nanga Parbat, the Indus River, whose course is punctuated by powerful waterfalls, digs a gorge with nearly vertical walls. Its rate of incision reaches a record three feet per century! On top of the photograph, the sunlit terrace planted with poplars, 300 feet or so above the water, used to be the riverbed, only 10,000 years ago.

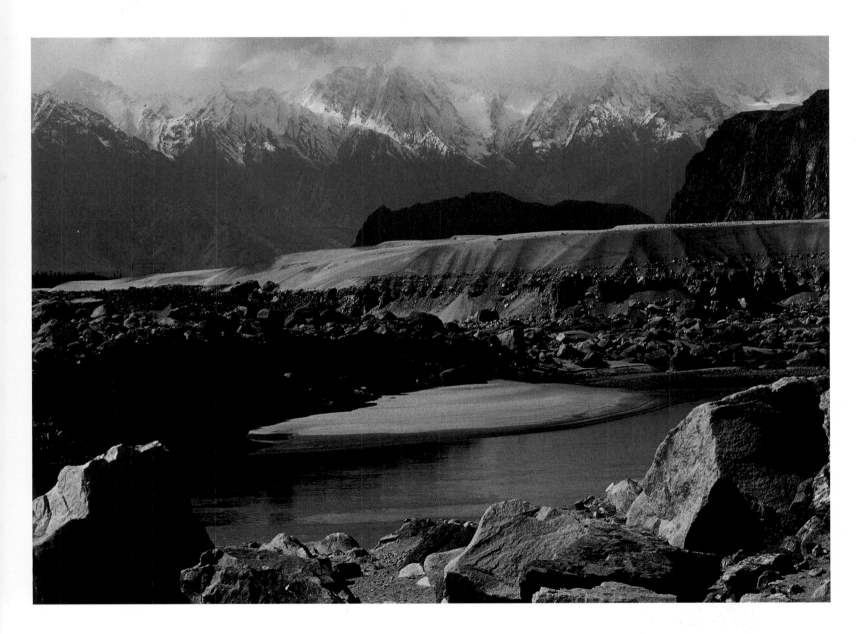

CLIMATE CHANGE, SKARDU, PAKISTAN

Before starting its impetuous crossing of the Himalayan syntaxis, the Indus River spreads out in the Skardu plain, which is locked within the mountains. Fine-grained, gray-beige deposits cap the beds of cobbles normally carried by the river. They are remnants of the vast lake that inundated this plain during postglacial warming, a lake fed by the rapid melting of the gigantic ice-stream that surged into it 20,000 years ago, at a time when Karakoram's largest glaciers—Baltoro and Biafo—were in full flood.

following pages
TISSISAT, LAKE TANA, ETHIOPIA
The Blue Nile crosses its first cataract as soon as it exits Lake Tana on the Ethiopian plateau.

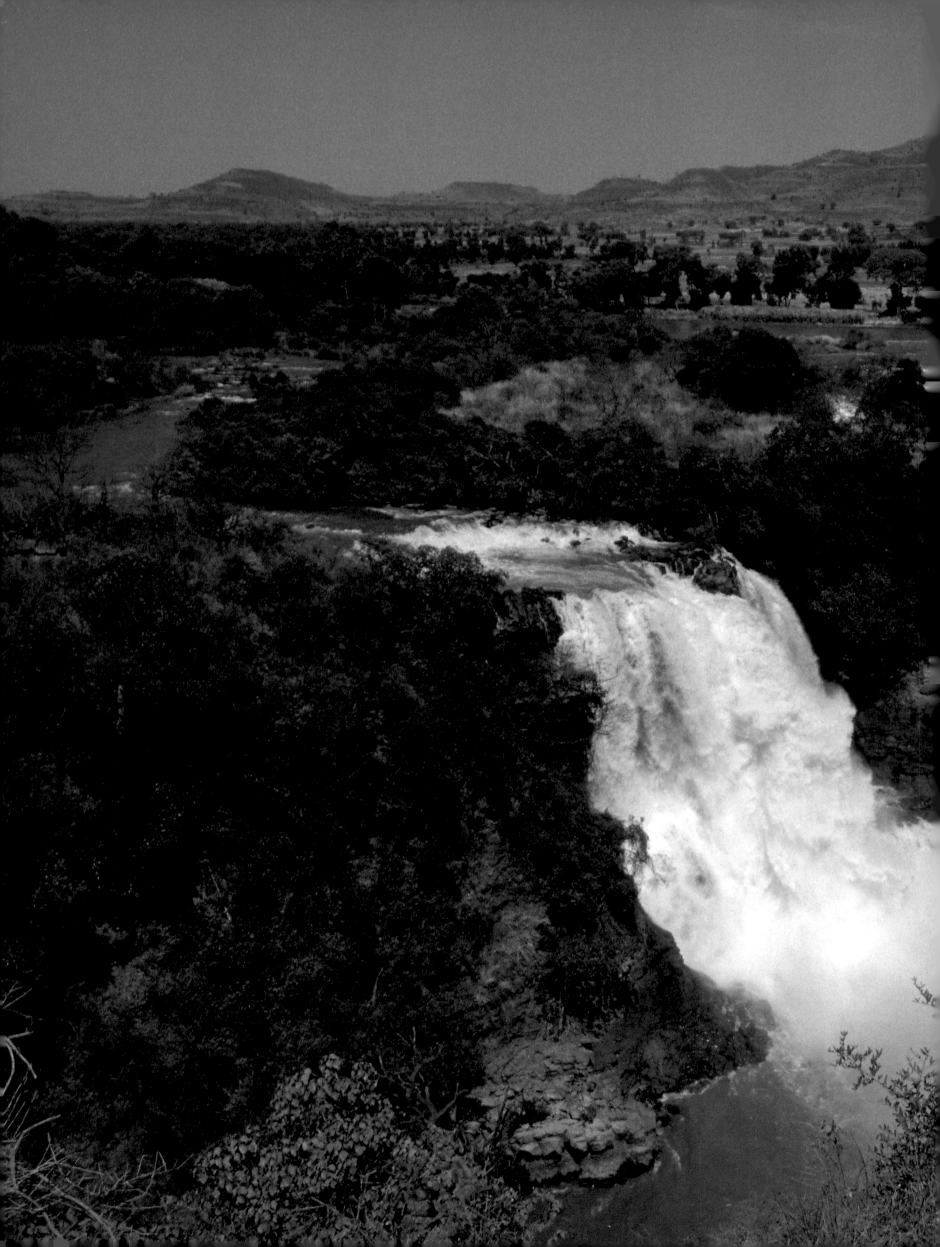

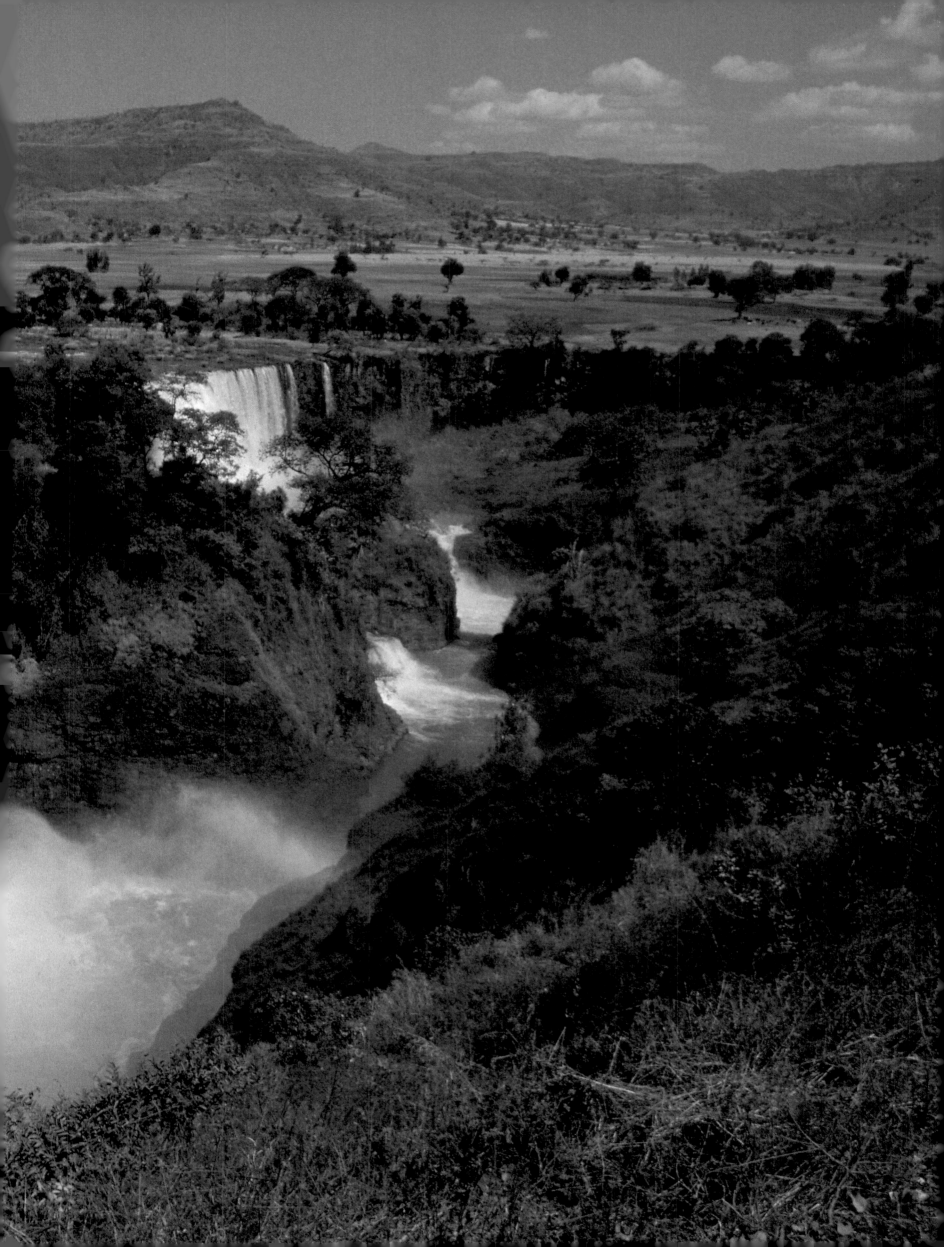

RAPIDS, BLUE NILE, ETHIOPIA

The incision power of a river augments as the speed of its current increases and the width of its channel decreases. In the narrow cleft shown here, the Blue Nile cuts down into basalts with enormous force.

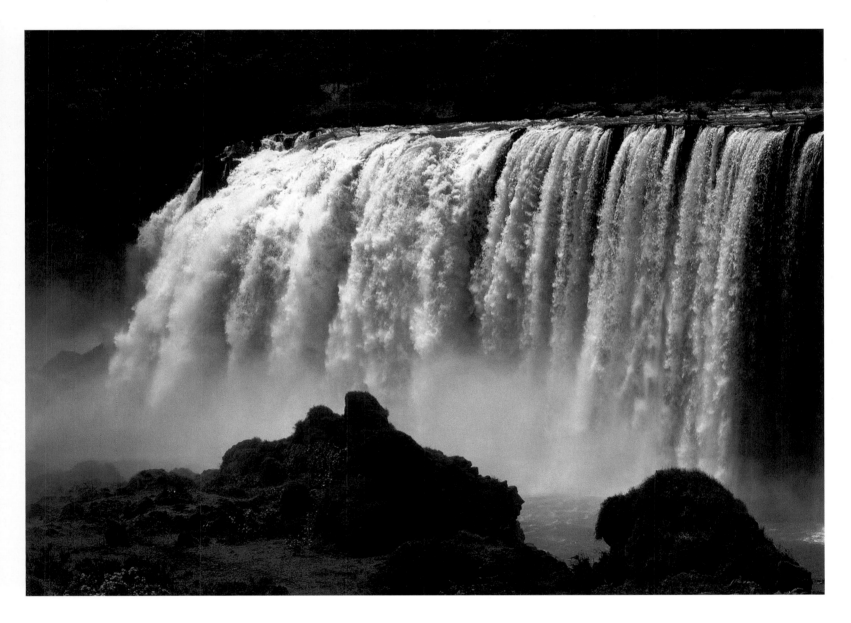

CATARACT, BLUE NILE, ETHIOPIA

All large cataracts recede rapidly, at rates that can exceed several meters per century.

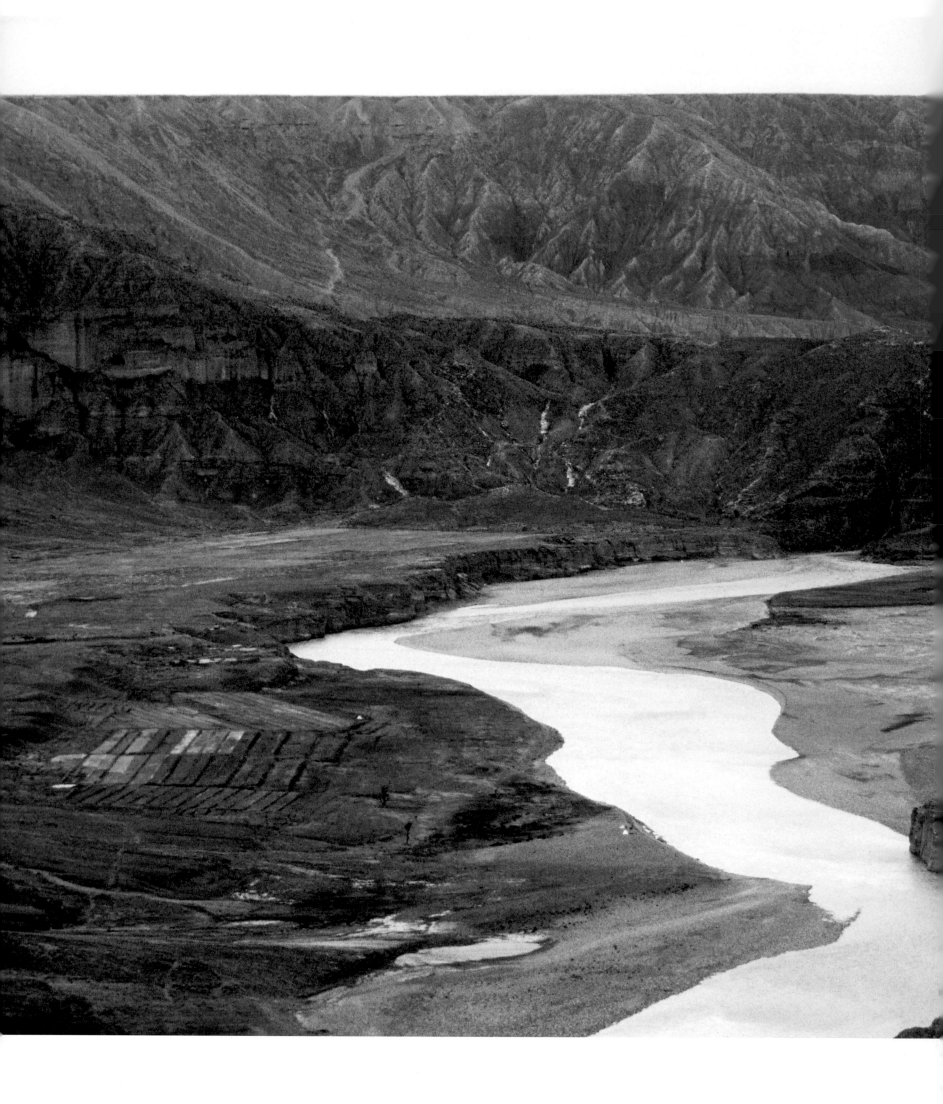

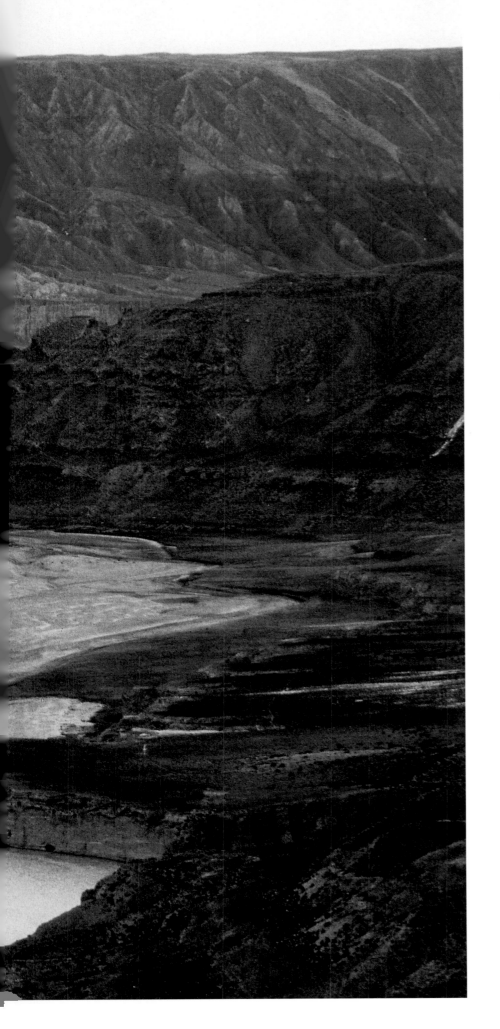

Struggling river,
GONGHE, QINGHAI

Like the Yangtze, the Yellow River sways back and forth before escaping its birthplace on the high Tibetan plateau, performing astonishing vertical acrobatics as well. Here, in the 2,000-foot-deep canyon that it has dug across the Gonghe basin, the river's level has repeatedly yo-yoed up and down. Several visual signs make it clear that its restless waters rose, fell, then rose again, and fell again. First, on top, the perfectly flat basin's surface, 9,800 feet high, floored by silts and gravels once deposited by the river. Next, the multiple, flat bevels of gravel and sand that can be traced along the canyon's flanks, new river terraces carved in more ancient Quaternary fluvial conglomerates. And in the middle ground, the vertical cut neatly sliced into the small transverse ridge, down to the present water-level. Why so many cycles of deposition and incision? Fifty miles or so downstream, as it exits the basin, the Huang He has been fighting relentlessly, for at least 150,000 years, to break through a granite "blade" that is rising like a closing sluice gate. Depending on the power derived from the water collected upstream, in tune with climate's moods, the river either decisively incised the granite or rose to flood its valley, dumping its load of gravel and mud. Today, the natural lock of Longxiang Xia has been replaced with an artificial dam. A thing of the past are the thousand-year cycles recorded in the cliffs. Forever flooded is the wooded valley where Nikolaï Prjewalski hunted "eared" pheasants on the way back from his third unsuccessful attempt to reach Lhasa, in 1880.

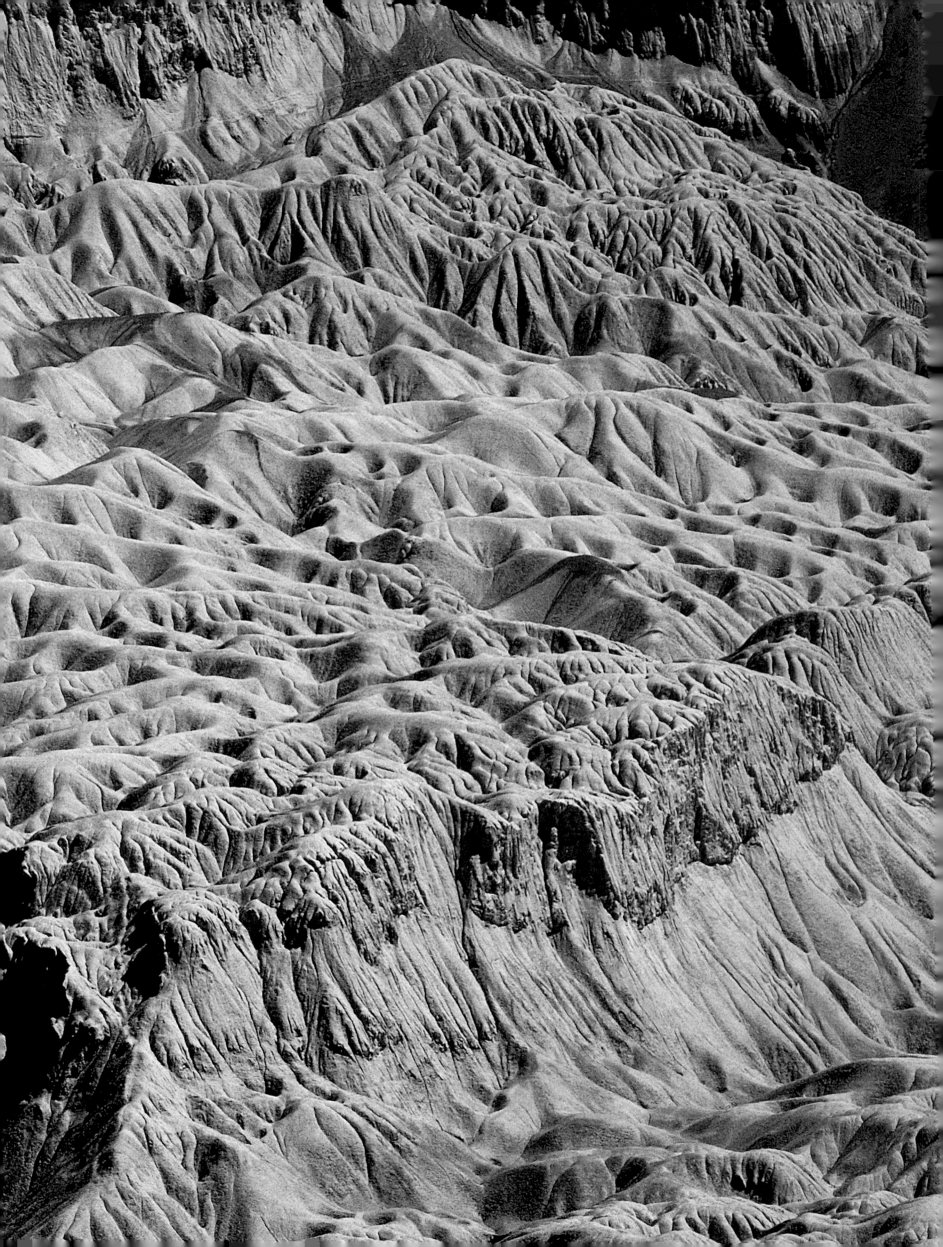

LACUSTRINE RUINS, LAMAYURU, LADAKH

This lunar-like geological landscape, poked with small craters and scratched by ravines, is the bottom of the ancient Lake of Lamayuru. The "craters" are miniature dolines, funnels from which calcareous and gypsum-rich lacustrine muds were dissolved by meteoric water after the lake drained. From the onset of mud deposition to the present-day "ruined" landscape, only 35,000 years have elapsed.

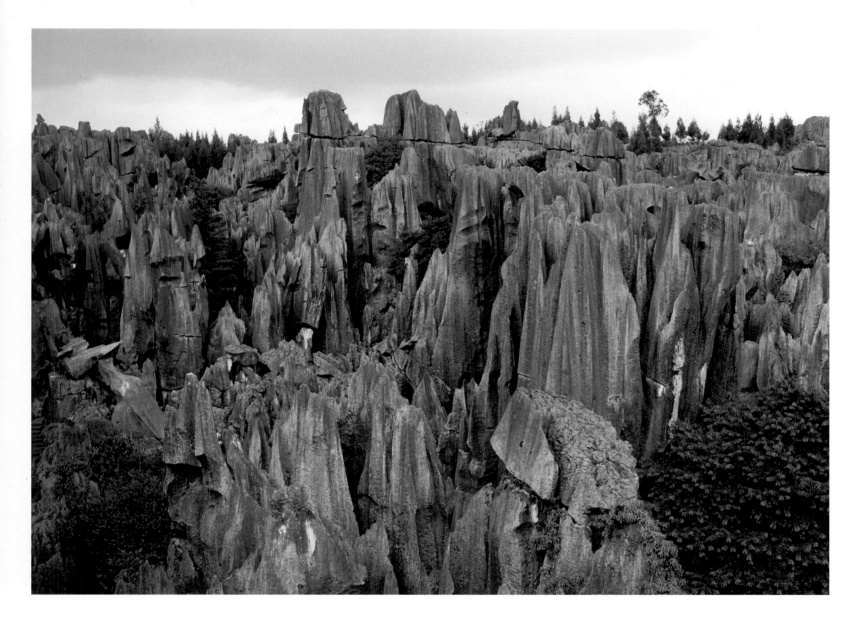

STONE FOREST, SHILIN, YUNNAN, CHINA

Efficiently dissolved by tropical rainfall, the thick limestone tables of Southeast Asia give rise to astonishing landscapes. On a large scale, the result is the thousands-of-feet-high, mist-shrouded, steep-walled pinnacles that have come to symbolize mountains on Chinese paintings. In reduced-model size, as we see here east of Kunming, such karstic dissolution creates labyrinths of small, craggy peaks with vertical furrows carved by water-runoff.

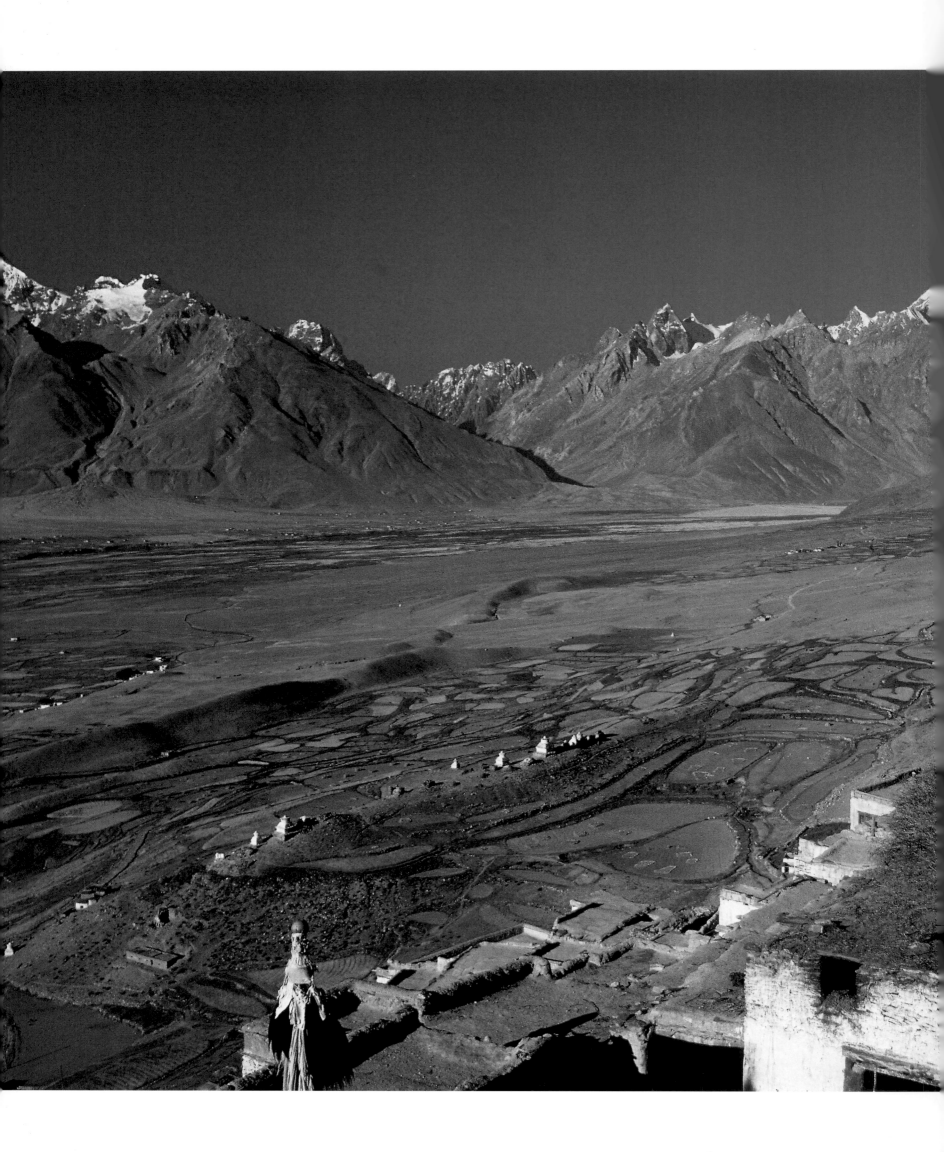

Vanished glaciers,
KARCHE GOMPA, LADAKH

High above the plain of Padum, where the Zanskar River flows out of the high Himalayan range, Karcha Gompa offers one of the broadest views in Ladakh. This vast open landscape was created by the confluence of two glaciers that disappeared. The largest one, that used to snake out of the valley in the right background, was born far to the west from a 19,000-foot-high ice cap near the Nun and Kun. Every landform serves as a reminder of the presence of the ice. The broad, flat-floored valley where the river meanders, today cultivated in small, contiguous plots, was the site of a large lake at the end of the ice age. The flat hanging surface at the base of the mountain slope facing the monastery marks one of the highest levels reached by ice. It has since been sliced by torrents flowing from the leftover firns in the cirque above. Finally, the abandoned lateral moraine ridges that still stand at the foot of the Gompa mark the successive limits of the glacial tongue as it retreated rapidly during the last glacial melting. The tallest ridge is crowned by an alignment of white stupas, built with boulders carried on site by the glacier. Two younger, smaller moraines snake underneath it, closer to the river. Powerful sculptors of landscapes, glaciers are also the premier assassins of mountains.

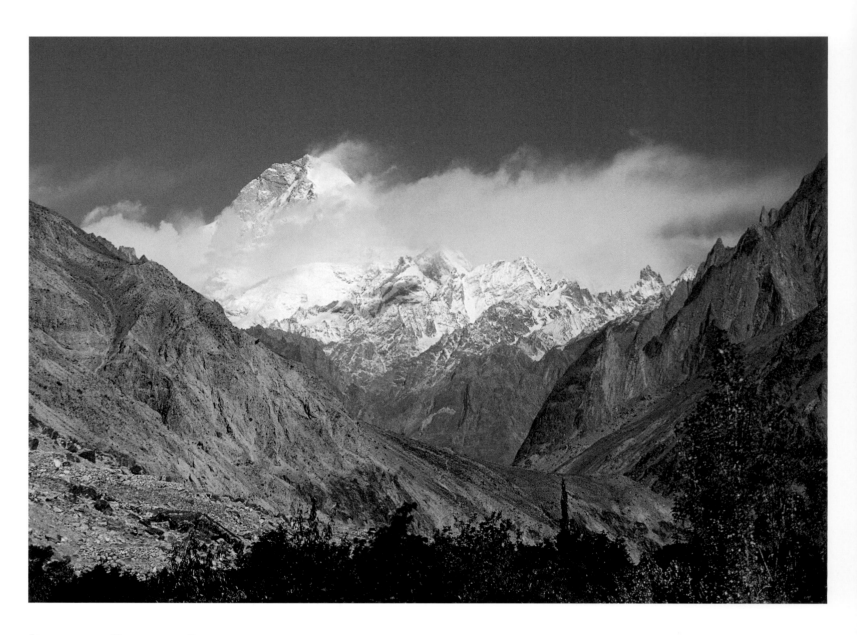

Source of ice, Karakoram, Pakistan

The largest glacial valleys always extend downstream
from the highest mountain summits—here the
Masherbrum.

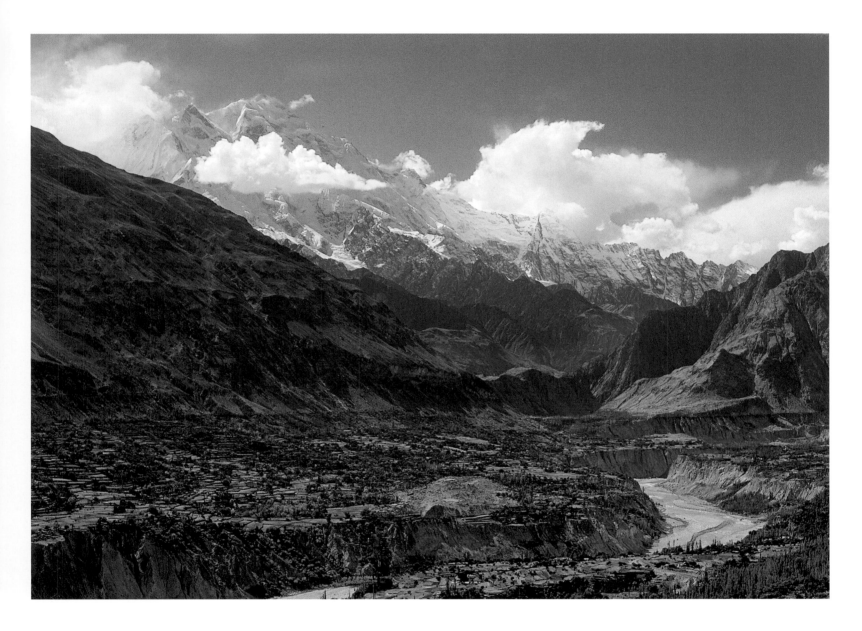

FORMER ICE HORIZON, HUNZA, PAKISTAN

In the Hunza valley, the highest level of cultivated terraces forms an extraordinarily flat horizon. It used to be the upper limit of the ice in the U-shaped glacial valley, filled later with hundreds of meters of gravel and silt, now vertically incised by the river.

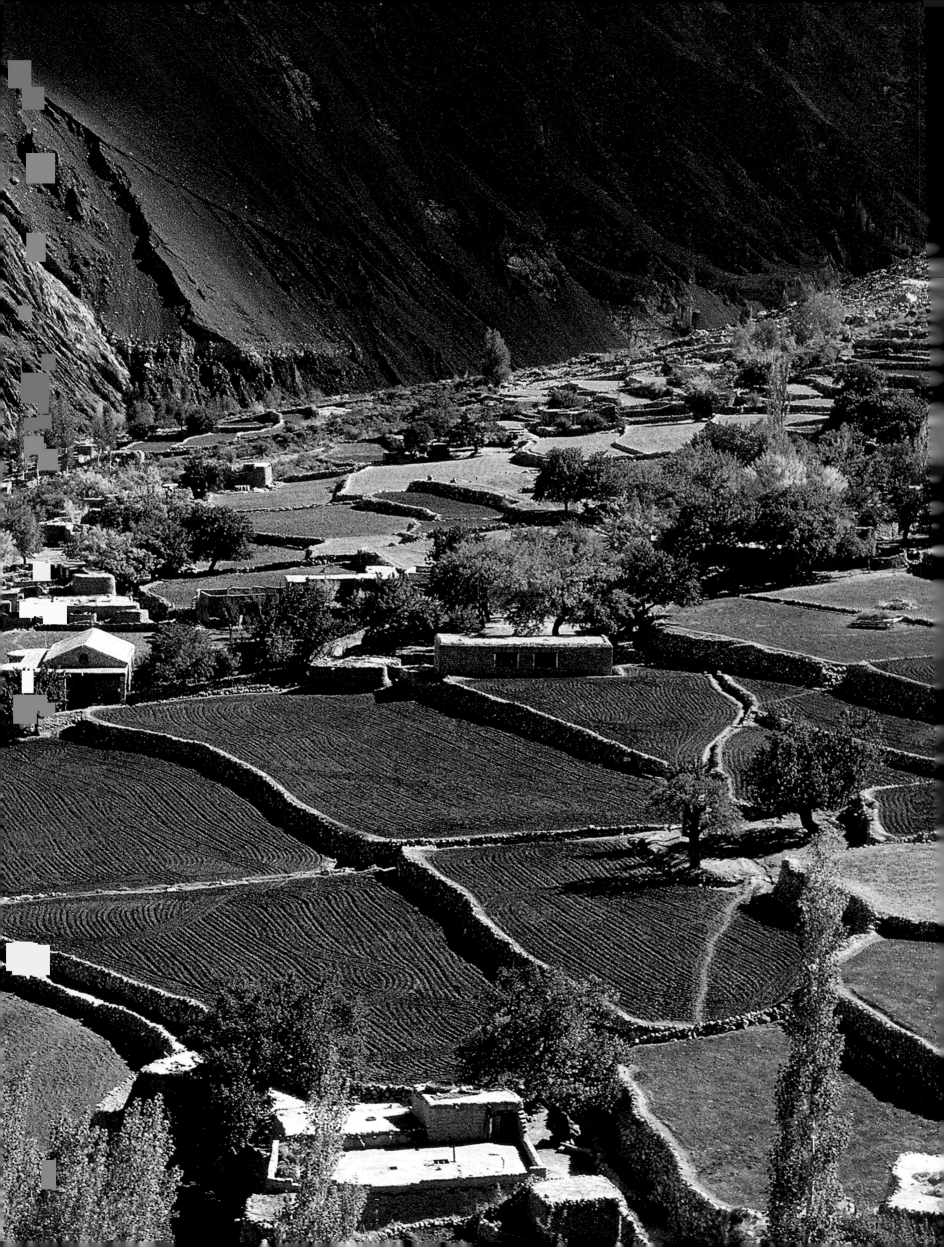

FLUVIAL TERRACES, NEAR PASU, KARAKORAM, PAKISTAN
The high Karakorum is so arid that mostly ancient riverbeds are cultivated. Sedentary life is concentrated along these narrow terrace ribbons.

AUTUMN, HUSHE, KARAKORAM, PAKISTAN
Peach and apricot trees are native to the mountains of Asia.

GLACIAL MELTWATERS, ZANSKAR
The limpid deep-blue waters of the main river do not mix readily with the greenish-gray glacial torrents that flow into it.

MONOLITH, INDUS VALLEY, PAKISTAN
Warmed by the midday sun, this massive block of gneiss once polished by the Indus' rushing current, is now used to dry apricots.

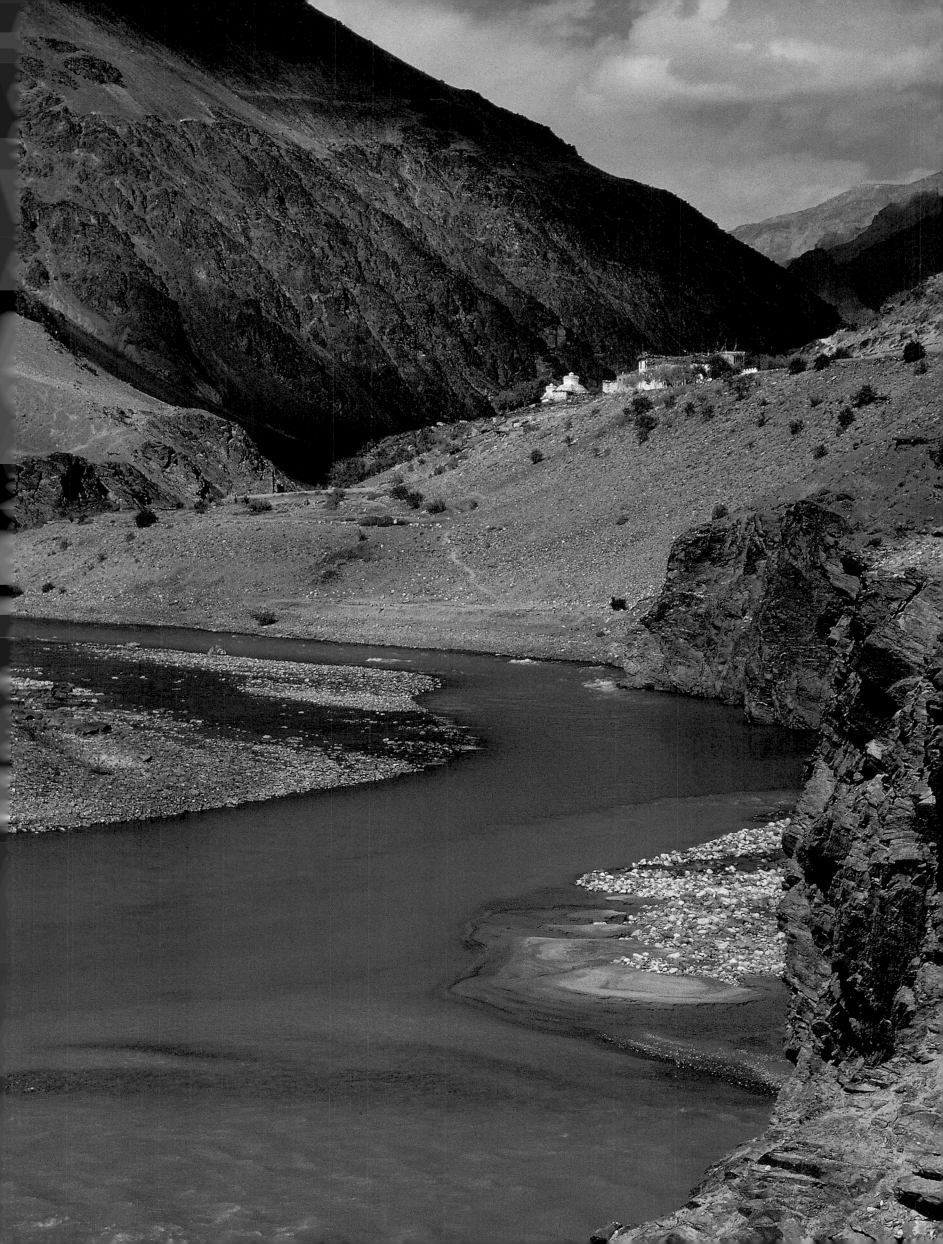

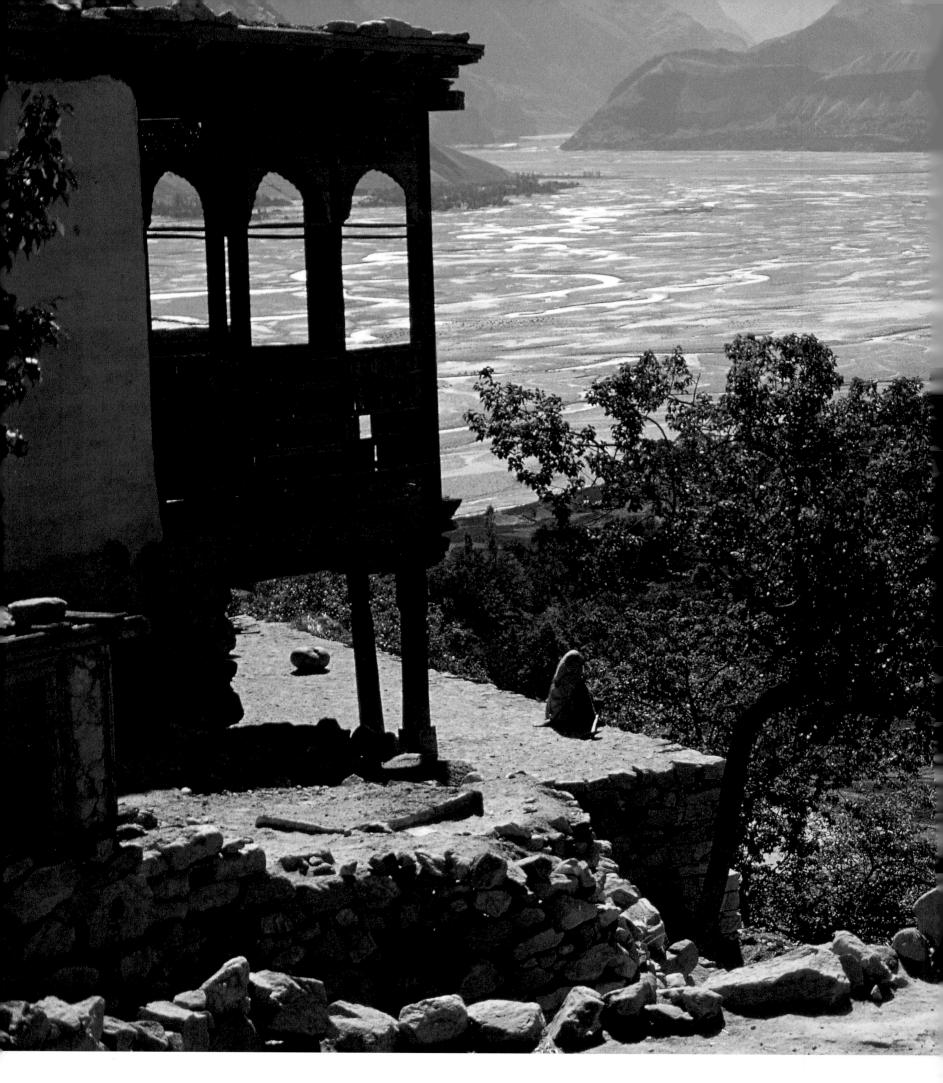

GLACIAL BARRIER, KHAPALU, PAKISTAN

Its flow hampered by the massive amount of debris brought by the Hushe glacier, the Shyok River divides into multiple braided branches that meander across a vast expanse of pebbles.

following pages

LAMAS, KARCHA GOMPA, LADAK

Monks gather for morning prayer.

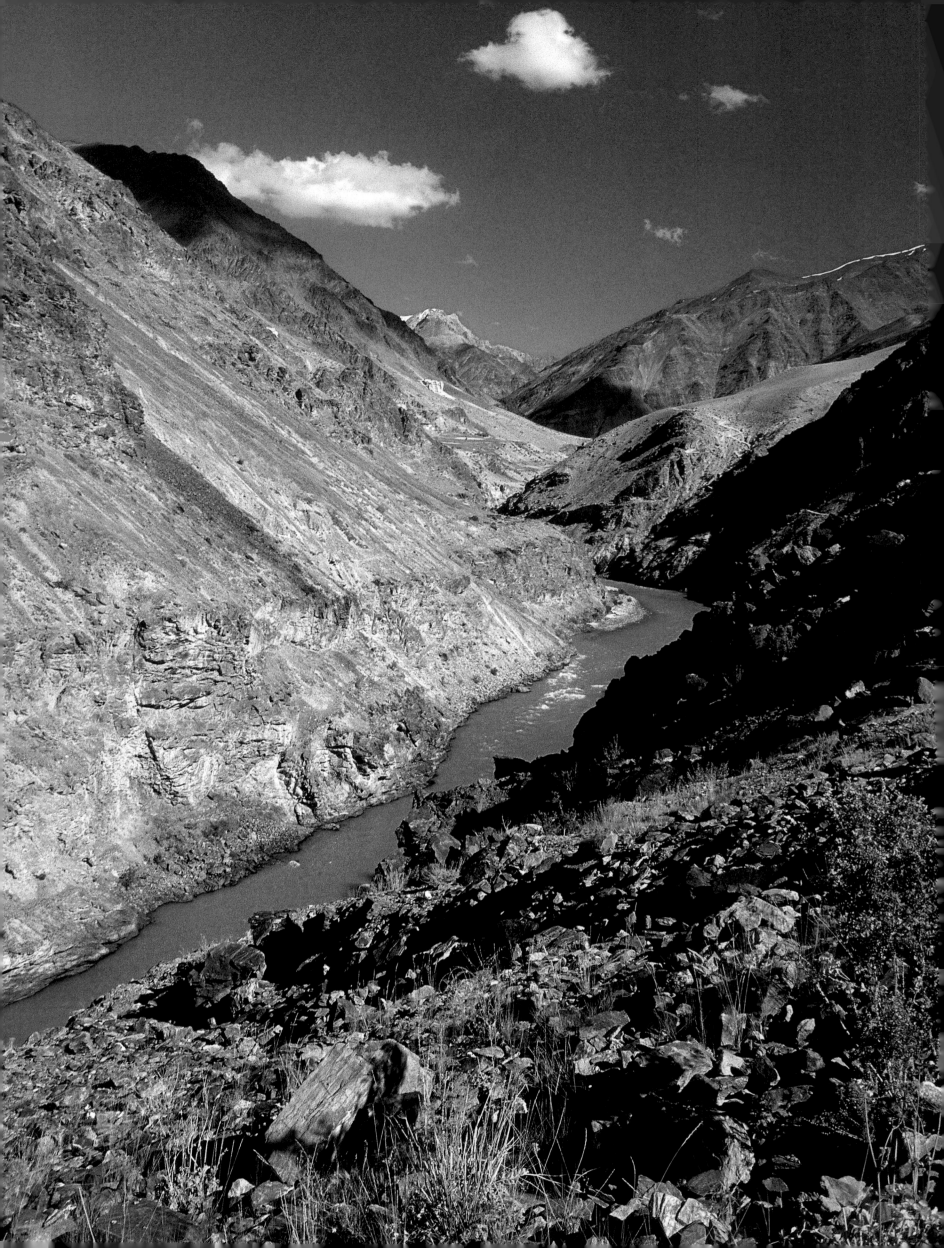

FLUVIAL INCISION,
ZANSKAR

In order to meet the
Indus, the Zanskar River
must first cut its way
northwards. The steep
slope beneath the ledge
on the right bank implies
a fast incision rate.

GOMPA, LADAKH

Leaning against Zanskar's colorful rocks, the monastery was built on a steep cliff, in a commanding position. The
village, by contrast, is on the level with the valley's fertile flat lands.

following pages
STANDING RUINS, ETHIOPIA

Disjoined mesas, steep columns, and a sharp, small "needle" are all that remain here of the Semien's basaltic
pile, dismembered by the tributaries of the Nile.

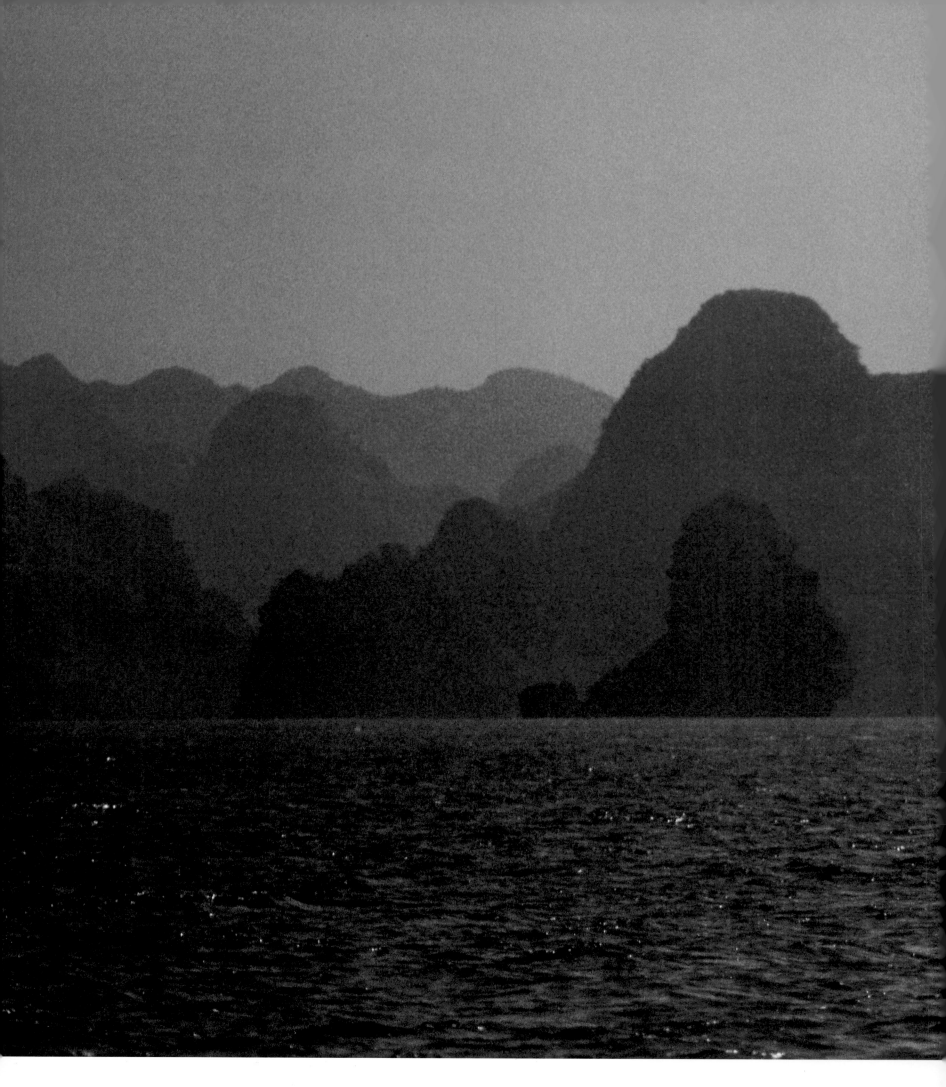

KARST TOWERS, HA LONG BAY, VIETNAM

The limestone karst towers of south China and Indochina are the planet's tallest. Those in Ha Long bay are now drowned by the South China Sea, which continues to invade a land that has subsided unabatedly since the opening of that sea ended, fifteen million years ago. The chemical attack of calcium carbonate by acid rainwater is a most effective mode of destruction, enhanced by the abundance of monsoon rains. A few million years is all it takes to dissolve the limestone surrounding the 1,000- to 2,500-foot-high towers that made Guilin and Ha Long Bay famous. Whether they are erased mechanically or chemically, all mountains ultimately end in the sea.

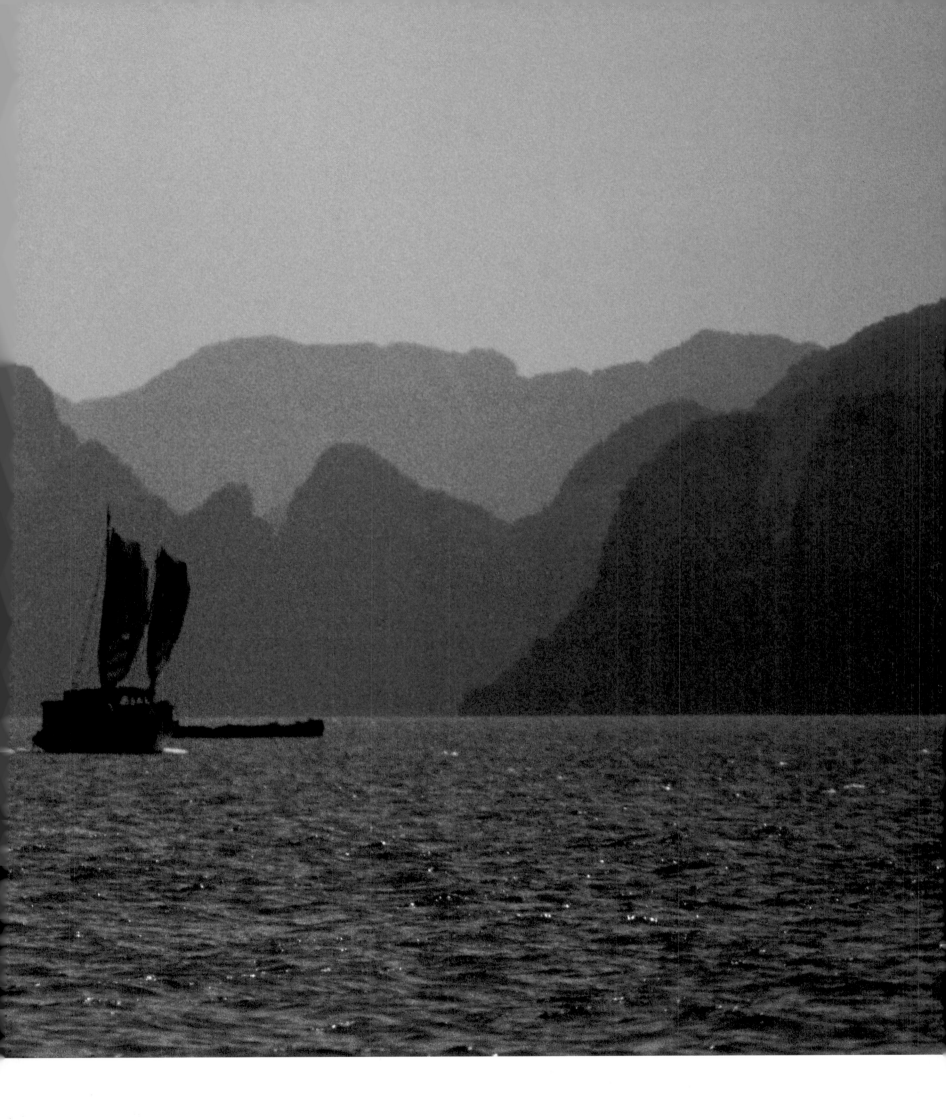

MOUNTAINS AND MAN

ALONG WITH OCEANS, mountains are perhaps the most precious gift Earth has bestowed upon us. They provide protection and refuge to human communities and to life overall. They build ecological niches and evolutionary environments that foster adaptation. Leaving aside the vast realm of mountain plants, many animal species directly or indirectly come from mountains. Some remain the foundation of local economies. This is the case, for instance, of the llamas, vicuñas, and alpacas in the Andes; or of the yak in Tibet, a cousin of the Stone Age aurochs and close relative of our oxen. The Tibetan wild ass (*Equus hemionus*) is the common ancestor of our horses and donkeys. And let's not forget that, before we domesticated them, goats and sheep originally roamed high mountain slopes and sheer rock cliffs.

In a way, wool fabrics, dairy products and many of the meats we like to grill all come straight from the mountains. This happened over the course of millennia of nomadism, this ancient way of life respectful of seasons, before it retreated under the pressure of our modern civilizations. It is in the high-altitude steppes and pastures where animal husbandry naturally takes precedence over agriculture, where herds can increase without limit, that nomads invented the cold-weather tent: the Tibetan *maikhan,* whose dark wool absorbs solar heat; or the windproof Mongolian *ger* (yurt) of white felt, easy to erect, disassemble, and transport. It was somewhere in the Central Asian highlands, thousands of years ago, that shepherds started spinning and weaving wool; that carpet-making, indispensable as insulation against the naked ground, was perfected into an art. Yogurt and cheese were also born here, likely out of a mistake turned beneficial. Immense are the contributions of mountains and herdsmen to the rest of the planet! At a time when sedentary lifestyles and consumer-based economies have come to prevail nearly everywhere, let us hope that the Tibetan plateau—with its

hundreds of millions of yaks and sheep, the world's greatest alpine pasture, and a land whose sheer size and height make it so difficult to desecrate—will become the ultimate, inviolable sanctuary that the nomads so rightfully deserve.

Mountains either separate people or unite them. They always shape traditions and set life rhythms. Many more distinct ethnic groups inhabit the mountains that stretch from Ladakh to Yunnan, passing through Assam and Burma, than live in the rest of Asia. Over 30 different minorities coexist in the valleys of the higher Himalayas and the hills of the golden triangle. They are close neighbors but nonetheless very diverse, forming a bewildering patchwork of cultures. Conversely, though physically separated by expanses so vast they forbid direct contact, the Kazakhs, Mongols, and Tibetans look and behave alike. This is because they all abide by the rules and customs dictated by *their* mountain, whose primary role is to ensure the prosperity of herds that graze in pastures extending from horizon to horizon.

Mountains have determined the Silk Road's path across the very heart of Asia for over 1,700 years. It stayed within the dunes, whose soft slopes are most deftly tackled by camels—the two-humped Bactrian camels, the only pack animal strong enough to cross 2,000 arid miles of formidable desert while withstanding, with equal endurance, the ice-cold (–10°F) winters and scorching hot (110°F) summers. But this millennial track also hugged the base of the relief, following without a single detour the string of oases that succeed one another, valley after valley. Without exception, all the oases of this long trade route—verdant havens at the meeting point of glacial meltwaters with the desert warmth—flourish where the sands skirt the mountain foothills. Without mountains, there would be no oases, no relays, and thus no caravans—no hope of ever crossing the harsh Gobi Desert or the barren Takla Makan. If the Tian Shan, Kunlun, and Qilian Shan had not

loomed 19,000 feet above the dunes, the history of commercial exchange between the Mediterranean and China would have been radically altered.

Despite the short growing season and the steep, restricted surfaces of their slopes, mountains also welcome many forms of agriculture. This is because they store a priceless resource, unlimited since constantly replenished—water. Whether in the Andes, in Nepal, Ladakh, or Yunnan, farmers display boundless ingenuity, covering hillsides as high as 3,000 feet with sophisticated systems of staired terraces. These sculpted landscapes are among the most monumental and delicate of all human constructions.

The profuse runoff gushing out of mountain ranges has been used since time immemorial to irrigate piedmonts. Convergent alpine waters brought wealth to the Po Valley, northern Italy's vibrant economic center since the Middle Ages. And the opulence of southeast Asia's tropical plains, gardens of abundance, is largely maintained by the great Himalayan rivers. It is surely no accident that 3 billion people—about half the world's population—inhabit the lands that stretch from the Indian Ocean to the three China Seas, at the foot of the world's highest ranges, where irrigated rice paddies produce three crops each year. And it comes as no surprise either that when the descendants of Tamerlane and Genghis Khan reached the fertile orchard of India in 1524, they never returned to the harsh northern regions from which they had come. Instead, they established the Mughal Empire and developed one of the most refined cultures in history.

A good part of the world's mineral resources come from mountain rocks. Andean copper, for instance, is extracted from the massive volcanic porphyries—"porphyry coppers"— that subduction produces. It was at the very surface of its eroded slopes that the range once generously exposed precious metals. Protruding out, because less tender than their host rocks, these dark and dense veins were easy to spot. The silver and gold of Peru, the cause of so much greed and bitter fighting! The conquistadors mined them so abundantly that they started the West's first great economic collapse.

It is under the long, smooth domes of the young folds, in the forelands of mountain ranges that the largest volume of oil and gas accumulate. An impermeable seal, or cap rock, act-

ing as a lid beneath the ideally shaped "whale backs," suffices to prevent the fluids from escaping to the surface. This is where most of the largest reservoirs of "black gold" in history were found—for instance in "front of" the Rocky Mountains, whether in Texas or Canada; and, above all, along the Zagros piedmont, which, from Syria to Saudi Arabia, still holds the bulk of the world's reserves.

More ordinary mountain stones are carved into artifacts, or used for the construction of dwellings and monuments that resist time. The famed laminated marbles of the Red River in Yunnan, *Dali Yen*—so artfully foliated and folded by nature 20 millions of years ago during the escape of Indochina—can be found throughout China. Polished into slabs of various sizes, inlaid in precious wood, they are the "dreamstones" so highly valued in the Middle Kingdom since the earliest dynasties. In the Eastern Andean cordillera, the Incas built indestructible citadels from the local granite. Because they were made of irregular polyhedral blocks, the walls of the two most famous—Saxahuaman and Machu Picchu—have withstood every earthquake since the fourteenth century AD. And in Tibet, from Thiktse to Lhasa, whether erected on steeply dipping Indus Molasse beds, on the granites of the Thetis subduction batholith, or on Himalayan gneiss and schist, all the lamaseries are a juxtaposition of slightly pyramidal buildings, with walls slanting inward. Could it be that here too we are looking at a form of anti-seismic design, based on technical know-how born from secular learning, as was the case of ancient Japanese temples? Is it merely a way of capturing more sunlight during the harsh highland winters? Or is it the lamas' intuitive impulse to emulate the sloping mountain flanks?

Almost everywhere, traditional urban landscapes owe their character and colors to the stones of the local mountains. Strasbourg's cathedral in Alsace displays the variegated purple-reds of the Vosges Triassic sandstones; the one in Clermont-Ferrand features the black basalts of Auvergne's volcanic hills. Germanic towns just north of the Alps are tinted with the greenish shades of the Danubian foreland molasse. All over Europe, the red Permian porphyry of the Verrucano in the Dolomites is used to pave city streets. Venice's most sumptuous palaces are built of a white Jurassic limestone,

extracted since the Middle Ages from quarries in the Italian Prealps. In Verona, the quarries are so close that one walks on large, pink flagstone containing dinner-plate-size fossilized ammonites. They come from a famous horizon of nodular pelagic carbonate, appropriately named "Ammonitico Rosso." Many stairs and landing piers in Venice are made of the less noble, but more resistant, brown lava erupted from the row of small volcanoes crossing the Po plain between Vicense and Este—the Euganean Hills. Unquestionably, the most enchanting of Italy's building stones is the *scaglia rossa,* the late Cretaceous lithographic limestone of the Apennines, which was deposited just before the dinosaurs' catastrophic demise. It is the *scaglia rossa's* shades of pink, running the spectrum from the deepest magenta to the palest ivory blush that unify Assisi, Spoleto, Gubbio, and other Umbrian hilltop villages, lending them a charm unmatched anywhere else along the Italian peninsula.

Father, lord, or king; mother, queen, or goddess; high mountains, rising in magnificent isolation, often take on a moral quality. Natural beacons, they have guided and inspired mankind since the dawn of time. This is reflected in the names most languages impart to them: *Khan* (Lord) Tengri, Ak *Ata* (Father) Tagh, Jbal al *Sheik* (Lord), the bible's Mount Hermon, *Nanga* Parbat (Naked Goddess), and Everest's name in Tibetan, Kangthon Thing Gyalmo (Queen of the High Snow-Blue Mountains). Their role is generally benevolent. They protect, hence *Taita* (Father) Chimborazo to the Puruhà Indians in the Ecuadorian Andes, and Muztagh *Ata,* to the Kazakh and Khirghiz mountain nomads. Some are venerated symbols and objects of worship. Pilgrims travel far to see them and, in Tibet, to circle them clockwise on foot. The very devout do so on their knees, in keeping with the purest Buddhist tradition. Such circuits are called *Koras.* The most famous one snakes around Mount Kailas. But the Golok nomads of northern Tibet also circle their own sacred mountain, Anyemaqen, which owes its lonesome presence to the tectonic encounter of two faults. Other mountains are a natural dwelling place for the gods. Zeus sat enthroned on top of Olympus, the highest summit in northern Greece. Etna, the highest active volcano of the Mediterranean, sheltered Vulcan; and Pele, goddess of fire, resides in the great Hawaiian

volcanoes. Of course, it is there that the chosen retire to receive the word of God, as did Moses on the summit of Mount Sinai.

Guardians, benevolent protectors… Alas, not always. We know that during very brief moments, mountains can generate the most deadly of catastrophes: avalanches of snow or ice, landslides and mudflows, and, above all, large earthquakes, which can trigger all the above. It took the October 8, 2005, 7.5-magnitude earthquake that devastated Pakistani Kashmir only 30 seconds to level houses to the ground, cut bridges, and destroy roads in the mountainous region between Muzaffarabad and Balakot. This violent, 15-foot upthrust of the Pir Panjal foothills resulted in more than 50,000 deaths. Seismic events of the same type, albeit of larger size, threaten to bring even greater ruin to the Himalayan foothills and foreland farther east. How soon? Since the latest growth jolts of the range occurred six or eight centuries ago, depending how far east one looks, it might be very soon indeed!

In spite of such sudden outbursts of blind ferocity, it might very well be in the mountains that life will seek refuge many hundred million years from now. When the slow but inexorable rise in power radiated by our sun will have transformed all lowlands into uninhabitable furnaces, and the oceans into steaming cauldrons, mountaintops, then ice-free, may offer to the last living beings their ultimate haven. Slowly, they will be then forced to migrate nearer to the poles. Let us hope that when this happens, there will still be cordilleras as suitable for such a voyage as those that now stretch the entire length of the Americas from Alaska to Tierra del Fuego. Will we still be here for this last journey?

From the beginning of time, mountains have challenged man to ever exceed his own limits—to explore their labyrinths, to conquer their highest summits… Perhaps they even led humankind to tame the sea! The Aramaic word for Lebanon is *Loubnan,* which means "white mountain." White indeed is Mount Lebanon, this singular 10,000-foot-high mountain that rises straight out of the Mediterranean, due to a right turn of the Levant Fault, the boundary between the Arabian and African plates. It is white in summer because of the pale, naked Cretaceous limestone that caps its summit

plateau; white in winter because of the tens-of-feet-thick lay-
ers of snow that uniformly enshroud it for four long months.
How can one not be seduced by the idea that if, many thou-
sands of years ago, the Phoenicians became the greatest
sailors of antiquity, it was in part due to this giant white bea-
con of theirs, shining in all seasons. That it was by the grace
of this faithful landmark, visible more than a hundred miles
from the coast, that adventures on the high seas could hope
to end with a safe return back to port. That is was this reassur-
ing guide that emboldened them to sail farther and farther
westwards to conquer the "inner sea."

Today, when few virgin summits remain, it is the con-
quest of the self that attracts the myriad of climbers and hik-
ers, professional and recreational alike, to the mountains. May
they become ardent students of geology along the way, devel-
oping their third eye so as to contemplate the landscapes
more profoundly.

*In the beginning, there is Earth, forging and sculpting our
mountains.* ▲

Translated from the French by Catherine Ruello and Heather Mallory

Editors, English-language edition: Dorothy Fink and Paul Tapponnier
Designer, English-language edition: Neil Egan
Jacket design, English-language edition: Jonathan Sainsbury and Neil Egan

Library of Congress Cataloging-in-Publication Data

Tapponnier, Paul.
 Mountains / text by Paul Tapponnier ; photographs by Kevin Kling.
 p. cm.
 ISBN 10: 0-8109-3083-8
 ISBN 13: 978-0-8109-3083-4
 1. Mountains. 2. Mountains—Pictorial works. I. Kling, Kevin. II. Title.
 GB511.T37 2006
 551.43'2—DC22
 2006022026

Printed and bound in France
10 9 8 7 6 5 4 3 2 1

harry n. abrams, inc.
a subsidiary of La Martinière Groupe
115 West 18th Street
New York, NY 10011
www.hnabooks.com